Leonard and Reva Brooks

Leonard and Reva Brooks

Artists in Exile in San Miguel de Allende

JOHN VIRTUE

McGill-Queen's University Press

Montreal & Kingston • London • Ithaca

© McGill-Queen's University Press 2001
ISBN 0-7735-2298-0

Legal deposit fourth quarter 2001
Bibliothèque nationale du Québec

Printed in Canada on acid-free paper

McGill-Queen's University Press acknowledges
the financial support of the Government of
Canada through the Book Publishing Industry
Development Program (BPIDP) for its publishing
activities. It also acknowledges the support of the
Canada Council for the Arts for its publishing
program.

Acknowledgment for permission to reproduce
material can be found on page 390.

**National Library of Canada Cataloguing in
Publication Data**

Virtue, John, 1934
 Leonard and Reva Brooks: artists in exile in
San Miguel de Allende

Includes index.
ISBN 0-7735-2298-0

1. Brooks, Leonard, 1911- 2. Brooks, Reva, 1913-
3. Artists – Canada – Biography. I. Title.

ND249.B766V57 2001 709'.2'271 C2001-900486-9

To the Virtue family:

Anna, Mark, Laura, and Madeline

~ Contents ~

~ *Foreword* ~

The biography of Leonard and Reva Brooks is an adventure story in its own right. I cannot quickly think of any element it does not contain. Rags to riches, yes, it's there. Deportations, shootouts, spy and CIA factors, all there. Murders, murder attempts, suicide, the sexual picaresque, marital devotion, failures, triumphs, all duly accounted for. Not to mention an attendant array of personalities, non-personalities, life-clowns, and philosophers.

Leonard and Reva Brooks each came of poor, not to say impoverished, backgrounds. And each received scant education. They ended up hobnobbing with the nabobs, ambassadors, and other artists as distinguished as themselves. The Canadian art scene beat a path to their door in San Miguel de Allende, Mexico. Dear friends as varied as Marshall McLuhan, Earle Birney, and the York Wilsons were frequently there.

Not only Canadians, but as well the Mexican art élite recognized them and sought them out. Siqueiros was a great admirer, as was Gunther Gerzso. And Mexico, including the Mexican State, recognized their worth long before their home city of Toronto took real notice of them.

In many ways it can be said that Toronto's neglect of the Brooks made them! They fled the frequent meanness of spirit in Toronto and settled in San Miguel de Allende soon after the Second World War, Leonard living off a small veterans' grant and his wits. Teaching at Bellas Artes, the fine arts school, in San Miguel.

No, they didn't intend to settle there. But force of circumstances, lack of art jobs in Canada and the pervasive hostility of the Canadian art scene, kept them there. To their benefit, and finally to posterity's benefit.

All that is to oversimplify. There is an entire Brooks story and trajectory prior to their Mexico years. Leonard's time in England, in Spain, travelling threadbare. Sometimes helped by artists as distinguished as Sir Frank Brangwyn. A picaresque time, yes, and picturesque, very.

But the core story is the years in San Miguel de Allende, from 1947 to the present. Story culminating in San Miguel as Leonardbrooksland. Or as famous cellist Gilberto Munguía put it recently: "I consider Leonard to be the inspiration, the impulse, the catalyst, that set off the marvellous migration of northerners to San Miguel. Not only did he inspire the art scene but also the music scene ..."

It was all triggered by the American GI Bill, which allowed American veterans to study art in San Miguel. And the artistic scene began to burgeon. Some taught, like Leonard, at the fine arts school. Many were students, or just amateurs. But all were attracted by San Miguel as an historic and startlingly beautiful small town. Its high plateau setting, long vistas, and Spanish colonial architecture with Mexican variants mesmerized visitors.

By the 1960s it was a well-known cultural and artistic spa. After several earlier attempts by others, the Instituto Allende was founded by Nell Fernández and her husband Enrique. The government then opened its own fine arts school, Bellas Artes. Two art teaching centres. And as well a writing centre. The P.E.N. International Association of Poets, Playwrights, Editors, Essayists and Novelists established a major school there – the largest English-speaking P.E.N. school in all Latin America. And every year a new book or two appeared on the American market from a P.E.N. writer or student. The roster of visiting professors was impressive. Germaine Greer or Gloria Steinem flying in from Ms. Magazine. Tom Scott and Bob Sommerlott who founded and ran the school were a major sparkplug in San Miguel. Tom with his eyewitness stories from the Battle of the Bulge in the Second World War, his explosive temper and penny-pinching ways. Bob the prolific author (See Here, Mr. Splitfoot), and fae Mordred of the duo – he also wrote Harlequin romance-style best-sellers under the pen name of Jessica North!

As well writers such as Kate Simon of New York and Cam Grey, perhaps the only author of her day in North America living on her short stories, graced the town. As did Pierre de Lattre (Tales from the Dalai Lama), Leonard Robinson (The Cardinal) and his poet-wife, Patricia Goedecke.

San Miguel also boasted an Episcopalian Church – of the Better-Homes-and-Gardens kind, yes. But the English-language Eucharist was there, with all the sonorities of the King James Bible. Plus restaurants, cafes, many founded by anti-Franco refugees from Spain – such as La Fragua or Carmina's, set in their own large Spanish colonial mansions. And of course its own bullfight arena, where any fool could watch splendid bulls chopped to pieces, and sometimes a matador or picador chopped too.

Not least, the annual Mexican fiestas and holidays were vibrantly colourful. Easter in San Miguel was a pageant, Calvary revisited. And the Day of the Dead invariably added its own shootouts and macabre deaths. To which could be added the various shootouts in the Cucaracha Bar during "Happy Hour"! Death was an integral part of life in San Miguel, as in Mexico at large.

To that add a flotilla of artists, craftsmen and residents of the foreign community in the town, the human flora and fauna. I think of Stirling Dickinson,

a graduate of high society Chicago of the 1930s, who created one of the world's great orchid gardens, open to all who visited San Miguel.

Or Fred Powell, tormented Torontonian whose sculpting stands, I believe, pre-eminent in Canadian art of the period.

Or Jeanette and Mack Reynolds and their belligerent macaw as guardian. Mack one of the world's foremost science fiction writers. And Jeanette perhaps the finest cook in San Miguel – she ended up hosting major town restaurants. And never ceased being what she claimed to be, a hillbilly from Louisiana. Her face shone when her hotel received Lady Bird Johnson. Or snuff-toting Kingsley Amis.

Or Ben and Eugenia Lewis. He a one-time clothing salesman from the northern states, of dubious contacts – a personality right out of Damon Runyon. And she a Mexican who updated Le Douanier Rousseau in totally Mexican ways.

Not to mention *"le tout San Miguel,"* the upper social crust, local equivalent of the Surrey "gin and tonic belt." Famous McGill brain surgeon Frank Echlin and wife Letitia were part of this circuit. So too, Fred Taylor, brother of financier "E.P." Fred at once painter, tweed-clad hunter and social dignitary. Jules Roskin and his wife, Phyllis, presided with a savage local Debrett's efficiency. And Admiral and Mrs. Lex (Von) Charlton added dignity and democracy. Social climbers broke their ankles to get invitations to "le tout San Miguel" parties. Or a mention in the snooty English-language paper, *Atención*.

Add "the snowbirds" – the annual winter migrants of which Larry and Corgi Beamer are distinguished examples.

It all added up to a cultural centre of sizeable and forceful kin. Like all such spas it was easy to sneer at, but difficult to match. Other centres had preceded it – Tangiers, Capri, San Tropez, Collioure, Palma. Each had its heyday of a decade or two. Each had its "great man" – Robert Graves in Majorca/Minorca, Paul Bowles in Tangiers, even Norman Douglas in Capri.

In San Miguel, at the centre of it all, were Leonard and Reva Brooks. And it is their story biographer John Virtue focuses on. Neither Leonard nor Reva were easy personalities. Each of them complex, emotionally turbulent, certainly creative in so many ways.

It is Virtue's portrait of Reva which strikes me as a revelation. He unravels the hidden torments – the failure to have children, the decision to subordinate her art to her husband's success, her vehement empathy for the poor. In particular, using elements of her diary, he presents us a woman to respect and love. Along with her warm-hearted brother David and sister Sophie.

Many who saw her only from the outside did not enjoy Reva at all – found her possessive, strident, a busybody. All culminating in her determination to construct a very large new home in the 1970s which Leonard didn't really want at all! It was a battle ...

But by the end of the book you know that Reva, with all her voluble kind of failings, is some kind of martyr, an internationally acclaimed photographer and Leonard's necessary mainstay through thick and thin.

Leonard is even more complex. To me (and with me) he was indefatigably generous, supportive, and helpful. I remember well when, in 1979, I was granted a first-ever personal media interview with Mexican President (and author) José Lopez Portillo – and Leonard was more excited and proud than I was!

Overall he was not so much a rebel (much less a revolutionary) as a scamp – a grown up gamin. But he was also one of the few Renaissance men – the *homo universalis* – I have ever known well. By that I mean he was a professional musician (he played with professional orchestras in Mexico and the United States), a vivid conversationalist who was widely read, author of eight books on painting, and a multifarious artist – watercolours, acrylics, collages, large tapestries.

I certainly heard of his famous or infamous social outbursts from time to time, but in some two decades of knowing him, never witnessed one. He termed them his "nasty self." What I do know is that he is one of the few artists I have ever known who treated black as a colour! And handled it with subtlety, force and verve, as integral to his palette and his paintings.

I recall soirées at his large home replete with the good, the great, and the reprobate. And in sheer delight as the evening progressed Leonard would sneak away to find his violin, and return to stand off to one side and play – background music for the entire party – and a look of almost manic joy on his face.

His great chum, of course, was York Wilson, the Toronto painter. And evenings with the two together were shoutingly hilarious. York was the bitchier, getting off devastating lines, insights, character demolitions. Leonard always egging him on. The next day, Reva and Lela, York's wife, going around to apologize to various people who had been sideswiped.

The only one who could take on Leonard and York together was the redoubtable Kate Simon. I was there at the 1968 dinner-evening when York and Leonard were loudly discussing male prowess. Kate squelched them fast by announcing that men would have to get better sexual equipment to be interesting at all.

The most difficult story in this biography is that of Leonard and Fred Taylor. I heard the famous "shooting accident" story from Leonard himself several

times. John Virtue has recounted it with balance and dispassion, leaving the reader to make up his or her mind. That Leonard came very close to being killed is clear. That eighteen years later Fred shot himself (with the same gun) is equally clear. Any study of the longstanding friendship of Fred and Leonard has to remind one of the story of explorer Richard Burton and hunter John Speke: a case of opposite personalities culminating in violent death.

The selection of photos is telling. Thus that of Leonard at five, looking for all the world like Leonard of the 1970s, including stance. Leonard in London in 1933, looking very Charlie Chaplin. Reva's mother, Jenny, spitting image of her son, David, in later years. Reva's famous *Dead Child* photo is rightly included – death as its own king. Several of the 1950s' photos capture Leonard in his Ernest Hemingway stance and set of jaw. Not least the photo of Leonard and Reva in 1976 captures them as a deeply devoted couple, showing Leonard's pride in Reva.

The Chronology allows the reader to follow the very varied trajectory of each of Leonard and Reva. Without it the size of their achievement could be missed.

In 1983 I approached my old alma mater, Trinity College in the University of Toronto, to see if they would care to receive the Brooks paintings, photographs, and papers in gift – the lifework of perhaps Toronto's most distinguished art couple of their time. I remember well the provost of the day, George Ignatieff, unfurling his most sympathetic smile and, in effect, asking just who were the Brooks! In light of that, it is pleasing to see that this book is published by the McGill-Queen's University Press. And to know that the Leonard and Reva Brooks Foundation, established at Queen's University in 1993, now gives permanent home to such an impressive collection.

It is appropriate that John Virtue, like the Brooks, is himself a Canadian "in exile," on the journalism faculty of Florida International University. During the years he was researching this biography, he was in constant touch with me. I've never known a biography more thoroughly researched. Whatever there is to know about the Brooks, Virtue knows. He himself is an old Mexico (and San Miguel) hand. And a highly accredited reporter on Latin America, including a book. I remember once discussing Mexican politics with him and saying, "Why don't you write that, Jack?" His reply was simple, and back in the 1970s perfectly correct, "because I would then disappear without a trace."

It's time for the Brooks story first hand!

Enough of prologue.

SCOTT SYMONS
Essaouira, Morocco
August 1999

~ *Author's Note* ~

I met Leonard and Reva Brooks on a spring day in 1979 when we were looking for a weekend house to buy in San Miguel de Allende, Mexico. As our son was just ten years old, we thought the best thing we could do for him was to occasionally take his young lungs out of the polluted air of Mexico City, where I was the regional manager for United Press International news agency. The Brooks had moved into their new home and had put on the market their previous house at No. 109 Quebrada Street. While my wife, Anna, and Reva reached agreement on the sale of the property, Leonard and I adjourned to the terrace and had the first of what would be gallons of rum together.

Over the next couple of years, as Leonard told me stories of his life, I would write them down at the end of the evening. I thought this material might be of interest to some future biographer, never thinking that I might be that person. I left Mexico to become editor of a daily newspaper in Puerto Rico, but I was back in San Miguel in 1994 for a visit, staying as a houseguest of the Brooks. The idea of a biography was on Leonard's mind as he brought up the subject with me, saying who could not write it – an American – and listing other requirements. I soon realized he was describing me, so I asked him, "Leonard, do you want me to write your biography?"

The resultant biography is just that, a biography of two artists. It is not intended as a critique of their works, for I am neither an art historian nor a critic. If Leonard and Reva are the outstanding artists many believe them to be, there will be other books which will evaluate their art. Let this biography introduce them.

Before returning to San Miguel with a tape recorder, I had occasion to mention to Canadian writer Scott Symons that I was going to undertake the biography. Scott, then living in Essaouira, Morocco, immediately offered to critique the manuscript, write the foreword, and provide any other assistance. All that he did. I could not have found better help or guidance. Scott knew the Toronto and San Miguel scenes intimately and was acquainted with most of the key players in the lives of Leonard and Reva Brooks. He is himself a professional art historian and critic. During the research, writing, and editing, we exchanged sixty-three letters, as well as meeting over two days in Toronto in 1996.

An assiduous reader of biographies, Leonard acknowledged from the beginning that I would write a warts-and-all book. He gave me full access to

his correspondence, journals, and diaries and sat for more than fifty hours of taping. He also played the role of interviewer himself, when Reva was reluctant to answer questions. As I talked to Leonard, the tape recorder running unobtrusively, he would invite Reva to join us and then proceed to do the questioning. I was convinced that Reva resented this intrusion into their lives until one day when I was unpacking after a trip to San Miguel. I had put twenty-five of Leonard's diaries into a carryon bag for reading back home in Miami; I found among the books an extra diary: Reva's. She had taken the pages from various notebooks in which she had written over the years and stapled them together. I realized then that Reva also wished me to tell her story and had herself slipped her writings into my bag.

But my picture of Reva would not have been complete without the assistance of Karen Close, of Shanty Bay, Ontario, and Jill Kilburn, of Ottawa, best friends since childhood. When the two met the Brooks in 1996, Reva opened up to them as she had not done previously with anyone. Most of the conversations were taped, as Karen and Jill hoped to realize one of Reva's dreams, the publication of a book of her photographs. They gave me access to more than eight hours of taped conversations with Reva and their recollections from those that were not taped.

A fourth person whose help was essential was Lucile Finsten, of Ottawa, co-author of *Fire on Parliament Hill*. She read the manuscript with a critical eye at various stages, proof-read the final version, and read the galley proofs, as well as doing invaluable research at the National Archives and the National Gallery. She and her husband, Lawrence, who also did research, hosted me on many trips to Ottawa.

The biography would not look the way it does without the help of Toronto photographer Marilyn Westlake. She took the photographs of most of the works reproduced in colour, an expertise she learned photographing the paintings of her late husband, Toronto artist Michael. J. Kuczer. I know a lot about news photography, but Marilyn showed me how that differed from the fine arts photography Reva practised. She also read and critiqued the chapters on photography.

An invaluable source of information was Esther Birney, Reva's best friend. Of the 238 people I interviewed, Esther was the one person who stood out. After exchanging letters with her and interviewing her by telephone several times, I told her – only half-facetiously – that I was going to Vancouver to put a face to her beautiful English voice. When I telephoned her on her ninetieth birthday, she said, "There's a new man in my life and he says he loves me." That did not surprise me.

Two other women, whom I only know through correspondence and numerous telephone calls, helped greatly with the early years in San Miguel. Lysia Brossard Whiteaker's first husband, Ray Brossard, was Leonard's studio mate during the first years in San Miguel. Bunny Baldwin's husband, Jack, was a fellow teacher who was deported from Mexico along with the Brooks in 1950. After several telephone interviews, I met painter Joy Laville, who not only was a great source of information but had me as her guest at her Cuernavaca home.

Stirling Dickinson, who was killed in a car accident in 1998, gave me access to his papers and sat for several interviews, including a joint interview with the Brooks.

As well as granting me several interviews, Lela Wilson, of Toronto, gave me access to her correspondence and that of her late husband, York, and consulted her little black book of addresses whenever I had difficulty locating someone. I am indebted to Elmer Phillips, of Toronto, who helped me reconstruct the days of the Navy Show during the Second World War. Joan Murray, former executive director of the Robert McLaughlin Gallery in Oshawa, Ontario, not only contributed her art expertise but also gave advice based on her experiences writing biographies.

Besides Marilyn Westlake, several other people read chapters and made valuable comments and corrections. They included my South Florida neighbours Bob Hunter, former director of the Norton Gallery in West Palm Beach, and artist Kay McKeen, of Pompano Beach; artist Sylvia Tait and poet-husband Eldon Grier, of West Vancouver; and Helene Mazelow, who also gave me a thorough grounding in the Toronto art scene over several telephone conversations.

John Guerin, of Austin, Texas, sent me an unpublished manuscript of his students days as an ex-GI in San Miguel. Gregory Strong, who was researching a biography of Vancouver painter Toni Onley, sent me taped interviews he had made with Leonard Brooks and Stirling Dickinson. Hiliry Harvey, of Sacramento, California, loaned me her parents' correspondence with the Brooks as well as taped conversations between her father, Ken, and Leonard. Mona and Will Allister, of Delta, British Columbia, went through their collection of tapes made in San Miguel and made copies for me. Barbara Mitchell, of Toronto, loaned me taped conversations with the Brooks. April Fletcher, of Tijeras, New Mexico, provided me with correspondence exchanged between the Brooks and her father, Stanley.

Two of Leonard's cousins in England, Donald Brooks and Queenie Chard, sought out information about both sides of the Brooks family. Brother Bert, who lives in Florida and became a dear friend, was invaluable. Reva's brothers David and George and sisters Sophie Sherman and Sylvia Marks added their reminiscences. So did the next generation: nieces Nancy and Goldie Sherman.

The chapters on Fred Taylor could not have been written without the frank contributions by Fen Taylor in San Miguel and Noreen Taylor and Jeremy Taylor in Toronto, as well as that of the late Letitia Echlin, the bridesmaid at Fred's first wedding, and Montreal Renaissance man Harry Mayerovitch. Alan Klinkhoff, of the Galerie Walter Klinkhoff in Montreal, gave me access to the manuscript of an unfinished autobiography by Fred. Costas Vakaris, a retired public servant in Ottawa and an avid hunter, gave me a lesson on shotguns and what they can do.

I want to thank Leonard's former students at Northern Vocational who contributed their reminiscences: John Bennett, Christopher Chapman, Thomas Chatfield, Frederick Hagan, John A. Hall, James Houston, Gordon Laws, William Sherman, and Murray Stewart. I also want to thank the official Second World War artists whom I interviewed: Aba Bayefsky, Bruno Bobak, Mary Bobak, Alex Colville, Michael Forster, Jack Nichols, and Tom Wood.

Special thanks go to Wanda Wallace of the Nipissing (North Bay) Board of Education for finding Leonard's school records and locating a classmate, and to Mary Neelands of the Toronto Board of Education, also for locating Leonard's records. Reva's school records were not found. Other institutions that co-operated in the research were the War Museum, the National Archives, and the National Gallery in Ottawa, Queen's University archives in Kingston, Ontario, the Metropolitan Toronto Reference Library, the Thomas Fisher Rare Book Library of the University of Toronto, the Archives of the Center for Creative Photography of the University of Arizona, Hunter College Archives, New York, and the library of the Universidad Nacional Autónoma de México.

I would not have enjoyed the research in Toronto as much as I did had it not been for good friends Barrie and Betty Martland, who hosted and wined and dined me during five visits. George Lance, a friend since childhood, housed me in Vancouver and chauffeured me to and from my appointments and copied tapes and letters.

I was shameless in asking people, mainly relatives, to help me in my research. So my thanks to brother-in-law François Leduc, who researched as well as drove me around Montreal; niece Geneviève Vaillancourt, who did research in Montreal; goddaughter Dr. Ariane Finsten, who did likewise in Toronto; and sister-in-law Jacqueline Wojdak, of Ottawa, whom I consulted on medical matters and Polish geography.

I want to thank Toronto media lawyer Brian MacLeod Rogers for donating his legal advice. Also Dr. Helen Boigon, of New York City, and Norma Jean Brunsell, of Carmichael, California, for their professional expertise.

Three colleagues at Florida International University deserve special thanks. Writing guru Kevin Hall read the manuscript in a 20-hour stretch and made many excellent observations. Chuck Green of the International Media Center made it easy for me to piggyback research during my many travels on university business. Sandra Marina transcribed my Spanish-language interviews and handled the e-mailed photographs.

I was fortunate in having an editor in the family, my wife, Anna, who brought to the biography the same keen eye and inquiring mind that she uses as a senior researcher in the Miami bureau of the *Los Angeles Times*. Son Mark and his wife, Laura, in Seattle, answered all my calls for help, solved many of my computer problems, and prepared the final manuscript.

Besides those mentioned above, I am indebted to the following people who contributed their memories to the biography: Naomi Adaskin, Betty Anne Affleck, Anselmo Aguascalientes, Daniel Aguascalientes, José Luis Aguascalientes, Lionel Aguascalientes, Rita Greer Allen, Buford Anderson, Tom Andre, Mr. and Mrs. Itzvan Anhalt, Evelyn Anselevicius, Franklin (Archie) Arbuckle, Alfredo Arzola, Milton Barnes, Carmen Beckmann, Sue Beere, Bob Benjamin, Warren Benson, James Bessey, Wailan Low Birney, William Birney, Mary Blair, John Bland, Ron Bolt, Mary Bonkemeyer, Casimira Bowman, Christine Boyanoski, Eileen Boyd, Liona Boyd, Allison Brigden, Eric Brittan, Erica Brossard, Steven Bulger, Servando Canela, Gordon Chabot, Marguerite Charland, José Chávez Morado, Barbara Chilcott, Van Deren Coke, Stanley Cosgrove, Irma Coucill, Gabrielle Couillard, Constance Lebrun Crown, Leighton Davis, Carmen Delgadillo, Barbara Dobarganes, Paul Duval, Johanna Echlin, Mary Elmendorf, Sorel Etrog, Martine Feaver, Nell Fernández, Marcelle Ferron, Claire Watson Fisher, Flory Franck, Edmund Fuller, Margaret Galloway, Lou García, Gunther Gerzso, Clyde Gilmour, Raúl Godinez, Bernard Goodman, Jim Gordaneer, Carmen Govea, Kathleen Graham, Helmut Gransow, Evan Greene, Veila Guinn, Bobby Haggart, E.G. (Sandy) Hall, John Hall, Pomona Hallenbeck, Esperanza Harmon, Jim Harmon, Aileen Harris, Jim Hawkins, Gavin Henderson, Jeanie Hersenhoren, Lois Hobart, Bill Hollowell, Cleeve Horne, Jean Horne, D. Mackay Houstoun, Stephen Irwin, Eugene Jennings, Eugene Kash, Martin Kazdan, Bill Kennedy, John Keogh, Josh Kligerman, Walter Klinkhoff, Erica Kortlang, Kay Kritzwiser, Ebe Kuckein, James Langley, Anthony Law, Gabrielle Léger, Virgina Luz, Beatriz Mandelman, Dr. Norman Marcon, Nell Markle, Danny Marks, Laura Marks, Carmen Masip, Robert Maxwell, Isabel McLaughlin, Corinne McLuhan, Marciana Méndez, Ruby Mercer, Carl J. Migdail, David Mitchell, Walter Moos, Jack Muir, Gilberto Munguía, Cass Nevius, Margaríta Olsina, Peter Olwyler, Toni Onley, Mai Onnu,

Rubén Ortiz, Carmen Padín, William Pearson, Marion Perlet, Roland Pincoe, Lupe Powell, Lois Rae, Saul Rae, Esther Reindorf, Joan Roberts, Jules Roskin, Harold Rosnick, Abe Rothstein, Harriet Rothstein, Naomi Rosenblum, Sylvia Samuelson, Alicia Sánchez Govea, Tom Sawyer, Ed Scheier, Mary Scheier, David Scopick, Mildred Selznick, Jack Shadbolt, J.H. (Herb) Sherwood, Beverley Silverman, Anne Marie Slipper, Gary Slipper, Harry Somers, Mr. and Mrs. George Sopkin, Philip Stein, Berul Sugarman, Jefferson Sulzer, Nina Tabuena, Romeo Tabuena, Charles Taylor, Latiné Temple, Jean Townsend-Field, Kay Tremaine, Marie Trott, Francisco Valenzuela, Adrienne K. Veninger, Dorothy and Pepe Vidargas, Roget von Gunten, Miriam Waddington, Katy Walch, Sylvia Warner, Helen Watson, Herbert Whittaker, Jennie Wildridge, Paul Wildridge, David J.S. Winfield, Barbara Yager and Ayala Zacks.

All the photogaphs in this book which do not carry a credit are from the collection of Leonard and Reva; it would be repetitive to acknowledge them individually. The same is true of the paintings: those not credited are in the Brooks' possession or, in several cases, there is no record of the current owner. I want to thank all those involved for their assistance and cooperation.

My thanks and appreciation go to all the above and to the editors at the McGill-Queen's University Press: Joan McGilvray and Susanne McAdam at the Montreal end, and freelance editor Rachel Mansfield, who saw the book to completion, and Don Akenson, Roger Martin, and Joan Harcourt at the Kingston end, who got it started.

Beginnings

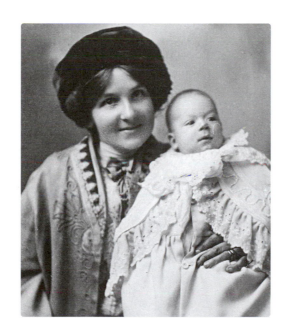

*Y*ou have thrown in your lot with me

They took an immediate dislike to each other, or so they believed at the time. At age twenty-three, he was seemingly a worldly artist, long hair, reddish beard, a black Basque beret perched insouciantly on his rather large head. He prided himself on his bohemian persona, although streetcar riders would jerk his chin whiskers and indecorously call him "nanny goat," so unusual was a beard in staid Toronto of 1934. She, too, wore a beret, brown, matching her skirt, as befitting the twenty-one-year-old company secretary that she was. She wore no makeup, but needed none to highlight her best feature, her dark, darting, expressive eyes, which soon glared at him. He found her appearance "mousy" and considered her to be naïve and unworldly; she found him so presumptuous that she admitted she was rude to him at their first meeting. Yet they were alike in so many ways: highly intelligent, self-educated, independent, inquisitive, high-school dropouts with socialist views and a common love of art, music, and literature. But there was one big difference: he was a British-born Gentile while she was the daughter of Polish-Jewish immigrants.

Within a year of that first meeting, Leonard Brooks would marry Reva Silverman. At the height of his popularity as a Second World War artist and one of the country's rising young painters, they would leave Canada, never to return again to live there. As his renown back home faded, he became well known as a painter in Mexico, where they would live for more than half a century, and in the United States. Yet he remained a vociferously proud Canadian, even being dubbed "Canada's ambassador *extraordinaire*" by one former diplomat.[1]

Back in Canada, Leonard had known the nation's most famous painters, the Group of Seven, whose landscapes greatly influenced his own works. Once in Mexico, he became a close friend of one of the three icons of the Mexican Mural Movement, David Alfaro Siqueiros, knew a second, Diego Rivera, and met the third, José Clemente Orozco.

Leonard would write and publish in the United States eight widely acclaimed books on painting techniques for the professional artist and the advanced amateur; one was an industry book-of-the-month selection. At the

Previous page: Ellen (Nell) Brooks and infant Frank Leonard, 1912.

request of the Mexican government, he founded a music school that he ran for twenty-five years, producing some of Mexico's finest musicians.

At age thirty-four, Reva would pick up a camera for the first time and almost overnight win international recognition as a photographer. Like Leonard, Reva met and was encouraged by the greats in her field, American photographers Ansel Adams and Edward Weston. She would be selected one of the top fifty women photographers of all time.

The art colony of San Miguel de Allende, nestled in the Sierra Madre mountains of Central Mexico, would not have become a world-famous cultural centre had Leonard not fought the government agents who deported its first art teachers at gunpoint.

Leonard and Reva met that November day in 1934 in Leonard's quarters at a rooming house at 56 Grenville Street in "The Village," home to many of Toronto's artists. He was planning a show of his paintings in one of the vacant rooms there. When he had held a show the previous year, the art critics ignored him and the only two sales were to people he knew. But since then he had held two exhibitions in Spain and two in England, drawing favourable comment in London's demanding press.

Reva had volunteered to help him prepare the paintings he had brought back from eighteen months in Europe. More accurately, another tenant, Catherine Robinson, had offered to help him but fell sick and asked Reva to replace her. Mrs. Robinson's room at 56 Grenville was a *pied à terre* for the arty wife of an out-of-town doctor. Mrs. Robinson, who had met Reva socially, told her, "I have a nice young man ..."[2] Reva would always say she showed up not to help the young man but to please Mrs. Robinson.

Reva's initial antipathy was fuelled in part by a letter that Leonard had pinned prominently on a wall next to some of his paintings. It was from an older, married lover in London who wrote that Leonard was the "greatest man" she had ever met, heady stuff for the shy artist who had gone to England on a cattle boat. Nor did he endear himself to Reva when he offered her gratuitous advice, not realizing that her apparent vulnerability masked a steely resolve. "Young lady," he told her, "you may be idealistic, but if you go out into this world, you're going to get hurt."[3] Leonard might never know that she had already been out in the world and been hurt, experiences which would haunt her for the rest of her life.

But something sparked Leonard's interest in the young lady, for he telephoned her at Rogers Radio Tube Co., where she worked. He asked for Miss Silver, having forgotten that her name was Silverman. Whatever the reason, henceforth he always asked for Miss Silver when he called. Accepting his

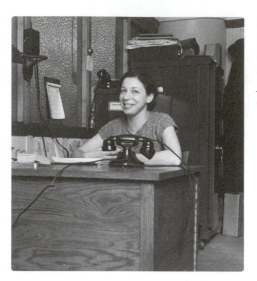

Reva as a working wife at Rogers Radio Tube while Leonard studied for his teaching certificate, 1936.

request for a date, she invited him to her room in a boarding house at 6 Spadina Avenue. She would never forget that first date because she felt she was being stood up when minutes turned into hours and still he had not arrived. He had taken the streetcar to Spadina Road in the Jewish market district, assuming that was where she lived. Realizing his mistake, he headed for Spadina Avenue, arriving more than two hours late. "I was very upset, very angry," he recalled his mood when Reva opened the door.

Leonard calmed down once he stepped inside and saw the reproductions Reva had hung on the wall, including a da Vinci and a Monet, and the scores of books on display. Soon they were talking poetry. "Do you know Swinburne?" he asked, and Reva pulled a Swinburne volume from the bookshelves. "Auden?" At one point, Leonard started to recite from memory British poet Siegfried Sassoon's "The Heart's Journey":

> I thought of age, and loneliness, and change
> I thought how strange we grow when we're alone
> And how unlike the selves that meet, and talk,
> And blow the candles out, and say good-night.

And then Reva interrupted Leonard and completed the poem herself:

> *Alone . . .* The word is life endured and known.
> It is the stillness where our spirits walk
> And all but inmost faith is overthrown.[4]

If there was a matchmaker in the lives of Reva Silverman and Leonard Brooks, it was Sassoon. The combined recitation of the poem clinched, at least in Leonard's mind, the belief that he had found a woman who fully shared his interests.

While Leonard, or Len as he was then known, considered himself worldly and sophisticated, Reva had a different opinion of this nervous young man whose mind raced so fast he seldom finished articulating one thought before launching into the next. When he became excited, he would run a hand through his brown hair, move his head up and down as he talked, hazel eyes sparkling, and unconsciously light a second cigarette before finishing the first one. Said Reva:

My first feelings were tenderness for what I sensed was his vulnerability and boyish shyness; also I felt an overwhelming respect for his integrity, talent, and his hardworking way of life. Also, immediately, he showed that he needed me – in fact, we complemented each other. This made me feel very feminine, womanly and desirable, and I discovered that I liked those feelings in myself. Here we were, breaking away and disassociating ourselves from the middle-class mores of our very different family backgrounds, reaching out and searching in exactly the same way. We each came from different racial and religious backgrounds, but we found we had everything in common because we had rejected and emerged from those stifling, limited patterns, and we were on a heady and intoxicating voyage of rebirth and discovery.[5]

Reva also soon found a role for herself in Leonard's life: "He was impetuous, moody, touchy, with an overwhelming compulsion to create. He didn't seem to be able to cope very well with the mundane, domestic details of life – I was more orderly and practical and he needed that."[6]

If Leonard was shy, Reva was outgoing and forward. As a conversationalist, she had a directness that might have seemed undiplomatic and naïve but ended up being charmingly quaint. Her wordings were dubbed "Reva-isms" by one awed witness.[7] She once described herself in the following, third-person terms:

Reva is a handsome, good-looking amiable person, has a strong disposition
To look always on the happiest side of any matter
To give *blow* for blow with anyone
To have *courageous intellectual* INTEGRITY
To have reverential scepticism
Character and intellectual curiosity.
Reva has an ordered and logical sensibility.
This enables her to make sense of everything that happens from day to day and to realise her attitude to life.[8]

Recognizing Reva's best physical attributes, Leonard took his violin to her room one day and played "Dark Eyes" for her. Another time when Reva visited him at his room, he whispered in her ear, "If I had the money, I'd marry you." "I did not reply," recalled Reva, "but from that time on we had the implicit understanding that it would happen some day."

While Leonard thought he was going to save this young lady from a life of boredom, she was doing just fine during the five years she had lived on her own. When Leonard arrived on the scene, she was dating a dentist who had matrimony in mind. An earlier, wealthy friend, Spencer Clark, who founded The Guild of All Arts in Toronto, confided later to Leonard that he had wanted to marry Reva.

Among her suitors, before he moved to Vancouver, was man-about-town architect Fred Leserre. On an outing with Leserre, he carried her in his arms after she had fallen down the Scarborough Bluffs. She also showed her liberal bent and defied custom by dating a Jamaican.[9] That she had so many suitors was not surprising as she was very attractive, although not pretty. She knew how to use her eyes and had a knack for choosing flattering clothes.

Leonard moved in the spring to 667A Spadina Avenue, which allowed him to be nearer to Reva. Located over a garage, the room had originally been used as a science laboratory by the owner, who lived in a house in front. The refrigerator had stored bacteria while the sink was for scrubbing. A newspaper account described the apartment: "The wildest posters of bullfights you ever saw and Spanish souvenirs galore adorn the walls of Leonard Brooks' new studio on Spadina Avenue near Bloor ... and just to give you an extra thrill a real Moroccan goat bell hangs just inside the door and clangs as you come in ... Leonard picked it up in the Pyrenees when he was there recently ... two years painting in Spain, France and the Balearic Islands have resulted in much interesting baggage which the artist has only just got unpacked."[10]

Reva then did something virtually unheard of in Toronto of the 1930s: she moved in with Leonard. The live-in relationship challenged the moral standards of the city's White Anglo-Saxon Protestant (WASP) majority. Leonard quickly dropped some WASP friends when they questioned his relationship with a Jew. "Do you know she's a Jewess?" "What's a Jewess?" asked Leonard. "A whoess? This is Reva."

Leonard and Reva had met just a year after the worst incident of anti-Semitism in the history of Toronto, which was still eighty percent WASP in the 1930s. The 12 July Orange Day Parade, which commemorated the victory of Protestant William III over Catholic James II at the battle of the Boyne and the battle of Aughrim in 1690, was the biggest event of the summer of 1933 in

Toronto. The influx of Jewish and Italian immigrants was beginning to chew away at the WASP predominance. Adolf Hitler's rise to power in Germany that year spawned pro-Nazi – and anti-Semitic – marches and demonstrations in Toronto during the summer. Young toughs from a "Swastika Club" intimidated and attacked Jewish families and other "undesirables" who flocked to the lakefront on sunny weekends. Fights and small-scale riots flared around the city as the hot summer wore on. The spark for a riot was a playoff baseball game on 16 August at a ballpark in Christie Pits in central Toronto between a Catholic team and a largely Jewish team. When a group of bystanders unfurled a huge swastika, Jews and Italians united against gangs of young WASPs. Rioting lasted eight hours and involved more than 10,000 people; no one was killed, although there were many injuries. In the riot's wake, the city council belatedly cracked down on swastikas, Nazi salutes, and other overt displays of racism.[11]

The living arrangement between Leonard and Reva was too much for one of his friends, Rudy Renzius, a Swedish potter. "I know you love this girl," he told Leonard. "Why the hell don't you get married?"[12] Leonard agreed they should.

On 17 October 1935, the eve of the wedding, Leonard wrote to Reva:

My darling Reva –

I am writing this to you on the eve of our wedding night. I want to put down here and now – my pledge to you. If I have ever desired anything in my life – it is as nothing compared to what I desire for both of us – contentment, happiness, security.

Remember – Reva dearest, that you have thrown in your lot with me from the first – whole-heartedly – faithfully. If only for your sincerity, I shall always respect and admire you for this, apart from your love.

When – in later years – things close in on us, when the fight gets us down – when we find ourselves caught up in the sordidness of circumstance – let us cling together – and keep faith in ourselves always – Sometimes, when I seem wrapped in my own selfish aims, be patient with me – keep that fineness that you alone possess and know that I shall fight for it and *you* as selfishly as I have and will *always* – fight for myself – *ourselves*.

These are poor words – but I feel that they will help you to get through the final business a little easier.

I love you –
Len B.

Motorists and pedestrians on busy Spadina Avenue that late Friday afternoon must have been surprised to see a well-dressed young woman wearing a hat with a veil careen around the corner chased by a man. Little could they suspect they were bride and groom minutes away from their wedding. The

realization that she was inviting opprobrium by marrying outside her Jewish faith rattled Reva as she and Leonard waited for guests to arrive for the ceremony to be held in their apartment. "At the last minute I got very frantic," she recalled. "Here I was, a Jewish girl marrying a Gentile. That was a great sin in those days. I was so terrified." So she jumped up, ran down the stairs, up the lane and onto Spadina Avenue, Leonard in pursuit. When he caught up to her, he said, "Come on, Reva. If not, it's off." As they walked back together, he told her, "I don't blame you." Reva agreed to go through with the wedding, especially since it had been difficult to even find someone willing to perform the ceremony.

After bowing to the supplication of Rudy Renzius that they marry, they had gone to see the rabbi in Reva's district. He told them flatly that he could not perform a ceremony for a mixed couple. The answer was the same from the Anglican minister they approached. Either Leonard had to convert to Judaism or Reva to a Protestant faith, neither option appealing to a couple of non-believers or, at best, doubters. Nor could they be married in a civil ceremony as such did not exist at that time in the province of Ontario. So they gave the bad news to their friend Rudy. Several days later, Renzius found a Lutheran minister named Eugene Rizsa, a Hungarian who spoke no English but who assured him the marriage would be legal. "Let's do it then," said Leonard.

The witnesses were Leonard's friend Kenneth Wells, a *Toronto Telegram* art critic and columnist, and Reva's friend Dvora (Koki) Kortsman, a portrait photographer. There were no more than eight guests, including Renzius and his wife, the Hungarian painter Soltan Rakos, and Berul Sugarman, a violinist with the Toronto Symphony, all squeezed into the studio apartment. "Reva was taking a difficult step by marrying a Gentile," Sugarman would recall later.[13] After the wedding, held late in the day so no one would miss work, they adjourned to a Jewish restaurant to celebrate.

Neither Leonard nor Reva had told their parents of the impending wedding. Leonard had never met Jenny and Morris Silverman, although Reva had met Nell and Herb Brooks on one of their trips to Toronto from North Bay, where they lived. When Leonard advised his parents that he had married Reva, his father sent a telegram, which read: I HOPE YOU KNOW WHAT YOU ARE DOING. There was no gift forthcoming. Leonard read anti-Semitic overtones in the telegram and attributed this sentiment to his mother. "He should never have sent that telegram," Leonard told the author.

When friends of the elder Brooks, the Hollowells, with whom Leonard had once boarded, heard the news, they were sympathetic to his parents. "I remember my parents used to talk about this terrible thing of Leonard marrying a

Jewish lady," recalled son Bill Hollowell. "My people were so WASPish it was hard for them to take that kind of thing."[14] Nell Brooks, at least, must have shared their sentiments.

Before leaving on a honeymoon, Reva had written to her parents. Gathering up the mail, sister Sophie, then fifteen, had recognised Reva's handwriting and opened the letter to read to her mother, who was busy at the time. "The letter said Reva and Leonard were married," recalled Sophie.[15] Not knowing how her parents would react to the news, Reva asked her mother to send word via Koki Kortsman, the witness at the wedding, if it would be all right for her to bring over Leonard.

Leonard and Reva enjoyed a weekend honeymoon in Orillia, sixty miles north of Toronto on Lake Simcoe. To finance the wedding and honeymoon, Leonard had painted a mural of galloping horses in the Brunswick House, at 481 Bloor West, for which he was paid eighty dollars. After buying a new shirt, paying the minister and the restaurant bill, Leonard used the leftover money for train fare and a hotel in Orillia. "Now we're going to live our life together and to hell with everybody," Leonard told his bride. He, of course, took along his painting gear.

Back from the honeymoon and hunched over against the cold, Leonard paced up and down the sidewalk outside of 459 Shaw Street as Reva faced her parents inside the house. David Silverman and his brothers peeked out the window at their new brother-in-law. "My mother was upset that Reva married a Gentile and she cried," recalled David.[16] Sophie hid behind the kitchen door so she could eavesdrop on the conversation. "There was a lot of crying," she recalled. "Then I heard Reva say, 'Can I ask Leonard to come in now?' My father said yes."[17] Morris Silverman offered Leonard a stiff drink and some hot tea to warm him up. "As long as they love each other, that's all that counts," he said. "He sort of blessed them in that way," recalled Reva's sister Sylvia. "That was very nice because my father was a very volatile man."[18]

Jewish neighbours on Shaw Street gossiped that Reva must have been pregnant; otherwise she would not have married a Gentile. "It was like a death," said sister Sophie. "Your child has died."[19]

Leonard would find in the boisterous Silverman household the support and encouragement he never believed he had received from his own parents. "When I married Reva, I felt, maybe now I'm going to be part of something," he recalled. "I was not really part of anything before."

He's a robin's egg in a sparrow's nest

Like his father and his father's father, Leonard Brooks was an affable man who married a strong, serious, no-nonsense woman. Grandfather Frederick Henry Brooks was a gentle London bookbinder who died relatively young of throat cancer. Accompanied by one of his three sons to help him navigate home, he would frequent public houses and pour his whiskey directly into his throat through a funnel and tube that bypassed the cancerous blockage.

Grandmother Clara was a formidable Victorian figure who, as befitted a widow, dressed all in black, including a bonnet she wore indoors and out. Leonard's cousin, Donald Brooks, likened to an "eerie church crypt" the darkened bedroom with a coloured glass window where she spent her days.[1] As she emerged each morning, those seated around the breakfast table would rise and stand at attention. She greeted each one individually, waiting for a response before moving on to the next person; then she took her plate and cup of tea and marched back to her room. At times she took something stronger to the room because her sons would often find her passed out drunk on the floor when they returned from work and would lift her – with some difficulty, given her weight – into bed.

Leonard's father, Herbert, was the middle son, born 23 August 1880 in Enfield, then a small, countrified market town about ten miles north of central London. Herb, older brother Fred, and younger brother Frank worked as clerks on the Great Eastern Railway in London. Fred and his wife had one child, a daughter named Grace, who showed enough artistic flair to design her own clothes but later became a recluse and remained one for most of her life. Donald, a photographer who became a faith healer, was Frank's only child. Donald recalled all three sons being terrified of their mother until her death in the mid-thirties.

Herb was the most handsome of the sons, compared in looks to swashbuckling silent movie star Douglas Fairbanks.[2] He stood just over five-foot-five, had blue eyes and wavy brown hair parted just off-centre. The woman he was to marry, Ellen Barnard, was as beautiful as he was handsome. Almost Herb's height, she was dark-haired, had penetrating dark eyes, was slim and had shapely legs that still drew appreciative glances from men when she was in her nineties in a retirement home.

Nell, as she was always called, was born 25 September 1883, the daughter of Eliza and Thomas Barnard of Avonmouth, Bristol. The Barnards, who believed their roots led back to Normandy, had moved to Avonmouth in the 1870s, attracted by work at the new dock, where Thomas Barnard eventually became a foreman.³ Nell was the middle child of five girls and four boys. All the daughters but the youngest went to London one by one to work as maids – a common custom in pre-Great War England – and look for men with more potential as husbands than those in Avonmouth. Nell started as a housemaid for a well-to-do family and eventually graduated to a sales job in a sweet shop, or candy store, at 41 Three Colt Street in London's Limehouse, a tough east-end district noted for its squalor. Herb worked across the street at Limehouse Station, a Great Eastern Railway Goods Depot, from where he could see the neighbourhood toughs picking the pockets of the unwary. He would joke that he had rescued Nell from Limehouse by marrying her.

Herb and Nell were wed 31 July 1910 at St. Mark's Anglican Church in Bush Hill, Middlesex, near where Nell lived. The witnesses were brother Frank, after whom Leonard would be named, and boyhood friend Horace Turner, soon to emigrate to Canada. Frank Leonard Brooks was born fourteen months later on 7 November 1911 in Enfield.

Herb was disappointed when brother Frank, a later hire, was promoted a grade above him at the railway. So he was receptive when Horace Turner wrote about the good life in Canada and suggested he and Nell emigrate. Nell did not want to leave her sisters, but for one of the few times in their lives she accepted her husband's lead.

They were the only members of their generation of Barnards and Brooks to emigrate, as 500,000 British citizens did to Canada between 1910 and 1913. Like most of the passengers on the Dominion White Line's *Megantic*, one of many immigrant ships plying the Atlantic, they booked steerage class, which cost as little as five pounds, or twenty-five dollars, per family. They were listed on the ship's manifest as "Herbert, 32, Ellen, 30, and Frank L.,1." and were among 1,619 "souls" who disembarked in Montreal 21 May 1913. Herb had in his pocket his life savings, one hundred and twenty dollars, considerably more than the minimum twenty-five dollars subsistence money required of immigrant families by the Canadian government.

Turner, a carpenter who became reasonably affluent building two or three houses a year in Toronto, took in the Brooks while Herb looked for a job. Given his railway experience in London, he found employment on the Canadian National Railways (CNR) as a clerk, a lowly position he would hold for the rest of his working life.

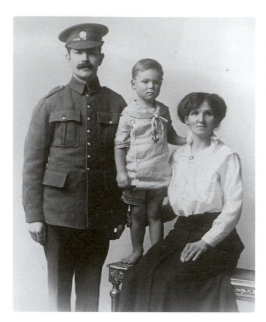

Cpl. Herbert Brooks, Frank, shortly before he became Lennie, and Nell, 1916.

Herb Brooks enlisted in the Canadian Expeditionary Force in 1916, two years into the Great War. At age thirty-six, he joined during a push to bring the Canadian forces up to four divisions. When Herb was posted overseas, the family gave up the lease on their rented house, stored their possessions in the Turners' basement and returned to England, as Nell had few friends in Canada. Herb's background as a railroad clerk prompted his assignment to the railway battalion and shipment to France, where he spent the next eighteen months in the trenches, never rising above the rank of corporal. Nell wanted to remain near London in case Herb could get back on home leave, but she did not want to endanger her son's life during the bombing attacks by Zeppelins. When the dirigibles were sighted, she used to push young Leonard to the floor and mother and son would huddle under a table. But more often he was safely farmed out to aunts in Bristol, Somerset, Essex, and Devonshire, while Nell stayed near London.

Like so many artists, Leonard in later life would blame his mother for failing to understand him and for lack of support. If this were the case, it probably had its origins during this period, as the young boy spent months without the nurturing presence of his mother. He also greatly missed his father and longed for the companionship of any adult male, but most of the men were in France fighting. "I remember being very confused and thinking, 'Oh, God, is this the way life is going to be?'" he later recalled. He was defenceless when one of his aunts let his hair grow long and dressed him as a girl. His aunts

would enrol him in school, but by the time he had made friends, he would be pulled out and moved elsewhere. He loved Bristol's Avon River, its smell and the mud squelching up between his toes when he played with his Barnard cousins along its banks at low tide. He credited his love of the sea to this boyhood experience. A spinster aunt in Essex took him for long walks and introduced him to the woods, instructing him on which leaves were edible. He would later credit these aunts with playing an important role in his early life and intellectual development.

He stopped being young Frank and became Leonard to avoid being confused with his uncle Frank when he and his mother stayed with him and his wife, Daisy. Although he signed his paintings Frank L. Brooks until he was in his twenties, he was Len or Lennie to the family from then on.

He would play with his young cousin, Donnie, who found him a bit of a show-off. Donald remembered seeing Leonard stand on a stool and pretend he was playing a musical instrument, much to the amusement of most of the adults present. One who was not amused was Daisy, defensive about her son Donnie, whose stutter contributed to a feeling of inferiority when compared to his older cousin. This exacerbated relations between Daisy and Nell. Scribbled on the back of a yellowing photograph of Nell and Herb in Daisy's handwriting is a caustic allusion to Nell bossing her husband about: "Herbert, do so-and-so. Do you hear me?" Nell, for her part, felt that the more successful Frank and Daisy "put on airs" as they moved up socially.

One day Leonard woke from his sleep and looked up into the face of a uniformed man, smelly, dirty, a helmet perched on his head. It was his father, home on a three-day leave, bending over his cot. "Carry up, Dad," he would say, and Herb would hoist his young son on his shoulders.

By the time he was six, Leonard was writing to his father in France, enclosing drawings he made. Herb would write back and send his son sketches, drawn by a tent mate, for him to colour. Herb wrote on 17 March 1918: "I am sure if you try hard enough you can be very good to your Mum, and that will please me more than anything. You must send me another letter soon wont [sic] you, and some pictures."[4]

Leonard sent some drawings as requested and his father replied on 5 May: "I was pleased to get your letter and your picture of me in the gas mask. Everybody recognised it."

On 14 May Herb included pressed flowers in a letter, flowers being a passion he passed on to his son: "I went out in the woods on Sunday evening and wished you and Mummie were with me. There were all kinds of flowers like these, violets and blue bells and others you don't see in England."

Leonard did some more drawings and earned another letter 13 June: "Thanks very much for pictures. I am pleased to get them, so I am sending you a little letter all to yourself, just like Mum's. One of these days, I hope to be coming back again and then I shall want to know all kinds of things and if you have been very good to Mum, I shall have to be very good to you."

Although the war ended 11 November 1918, the Brooks did not return to Canada until the following spring. Nell and Leonard travelled back to Canada alone on a troop ship while Herb came later. Dressed in an army uniform his mother had made him, Leonard was a hit with the homebound soldiers, making up for his wartime lack of male companionship. Nell often found him entertaining the troops. If they were not carrying him around on their shoulders, he would be dancing and waving the flag or singing "It's a Long Way to Tipperary," "Keep the Home Fires Burning," and other patriotic songs he had learned.

Once back in Canada, Leonard's career path was literally beaten into him in the schoolyard of Toronto's McMurrich Public School on Winona Drive. Instead of placing him in grade two, where he had been in England, the Board of Education put him back to grade one. There he stood out, not only for his greater height but his funny clothes and English accent. Either not having the money to buy him new school clothes or unaware of Canadian customs, his mother dressed him in the same knickers and pea cap he had worn in England. He quickly became the target of other children, who taunted him as "Limey," grabbed and tossed his cap about, and when he protested, beat him.

Bewildered at first, Leonard soon realized that he had nothing in common with his tormentors; nor did he want their friendship even if it were offered. "I want to be different from you boys," he shouted at them once when they waylaid him. "Different, you little bastard?" challenged one of them.[5] Len stood his ground, as he would during many confrontations over the rest of his life.

This traumatic reintroduction to Canada had a lasting effect on the sensitive boy and the future man. Leonard would say later that he was "badly hurt" emotionally by the taunting and fighting which he said forced him to "get within myself" and helped forge the introspective, private person he became.

Years later, Leonard wrote in his diary: "When I was young I developed an inner core, a self which was my universe and world of inner thoughts and visions. When I managed to go on – I developed this inner thought and it protected me against failures – and hurts – and I became impregnable – and unassailable – no matter what happened to me in my dubious daily life. It helped me develop [a] sense of humour – wry as it was – and to laugh at the ridiculousness of it all when the blows fell."[6]

The taunting and beatings Leonard endured affected his studies; he considered himself an indifferent student as a result. When he looked back at his time at McMurrich, he could recall nothing that went on in the classroom, only the schoolyard.

It would take Leonard several years to lose his English accent, during which time only a boy named Norman Trenchard dared to befriend him at school. By then, Leonard had shunned the team sports where he was not welcomed and sought solace in the three solitary activities that would distinguish his long life: painting, writing, and music.

His parents were surprised at his artistic interests. Herb once commented to Nell, "He's a robin's egg in a sparrow's nest."[7] That nest did not resonate with classical music, there were no shelves stocked with literary masterpieces, nor did the walls boast more than calendar art.

One week after Leonard was enrolled in school, his father was discharged from the army. The Brooks had rented a house at 3 Earlsdale Avenue, about a ten-block walk from the school, and Herb returned to his old clerking job at the CNR.

Shortly after enrolling at McMurrich, a bit of vocabulary building in the schoolyard got Len into trouble at home. The consequences haunted him for years and he would say the incident deepened his feeling of resentment toward his mother. As he told it:

When I was about eight years of age, I came home from a run to the corner store to buy a pound of butter for my mother. I stopped on the way to see a curious animal activity taking place, one I had seen a few times before. Two dogs were stuck together, standing and glued backside to backside, looking rather foolish I thought. I told my mother, "There are two dogs stuck together. They're fucking." "Leonard, if you ever say that word again I'll wash your mouth out with soap. Never, remember, never." And I never did use that word for years, cringed when I heard it in jokes, felt the soap already gagging me. It was not until I was in the navy and heard the petty officer of our corvette yell to the crew, "What is the fuckin' fuck-up?" that I laughed about it in relief and was able to shake off the guilt. I had picked up the word at school.[8]

Despite the scolding and the threat of soap, Nell was to do something else that affected Leonard positively for the rest of his life. He was in the backyard when he heard strange music. "What's that sound? What's going on?" he asked his mother. She told him a violin produced the sound. "I've got to have a violin," he recalled shouting. On his eighth birthday his mother gave him a violin she had purchased for thirty-five dollars – a lot of money in 1919 – and arranged

for a weekly lesson which cost her one dollar. When the teacher realized her young student had talent, she introduced him to Mr. Housego, the manual training teacher at Victoria Public School who was putting together a young boys orchestra. The concertmaster was Eugene (Jackie) Kash, later the internationally known conductor of the Ottawa Philharmonic and music director of the National Film Board. A child prodigy, Kash had already played in public so he was the logical choice as leader. The orchestra, together for three years, played at conventions and picnics, on the ferry at Niagara Falls, and in little towns around Toronto. Once they had a week-long engagement providing the music for a soprano who sang Gounod's "Ave Maria" during a silent movie presentation.

Leonard would say later that joining the orchestra and experiencing the camaraderie of fellow musicians assuaged the hurt caused by the boys at McMurrich school, even though he was still the oddity. He was the only Gentile among eight or nine Jews. His early friendship with these Jewish musicians helped immunize him against anti-Semitism and prepared him for his entry into the Silverman family.

His mother envisioned a musical career for Leonard, but he knew better. Although he would eventually play with a professional orchestra in the United States and another in Mexico, he felt that he had started his training too late ever to become a top musician. Told by the author that many of his music colleagues felt he was talented enough to play second violin in a professional symphony, he replied, "I'd never play second violinist. I'm always first violinist." But he would make a name for himself as a much-beloved music teacher in Mexico.

Besides playing the violin, at the urging of his mother Leonard spent several years in the choir of St. Michael's and All Angels Anglican Church in Toronto. The nickel she gave him every Sunday for the collection plate, money he always pocketed for his own use, probably encouraged him. He also enjoyed Sunday school, not for the teachings but because of the Boys Christian Companion, a book whose stories piqued his interest in writing. "Words always fascinated me – and the clean lines of print adding up into adventure – ideas – hope – imagination," he said of the Sunday school book.[9] Although Nell remained a faithful communicant, Leonard followed his father's lead and abandoned the church after leaving the choir. Herb had been told as a boy that the devil would come after him with a pitchfork if he did anything wrong. When the devil failed to make an appearance after Herb had committed some boyhood sin, the young lad decided there was no longer any need to attend church, so he never did again.

As a Christmas gift from "uncle" Horace and "aunt" Ada when he was nine, Leonard received his first set of watercolour paints. He recalled what happened next:

I remember slipping away that afternoon from the festivities around the Christmas tree to the willow-lined creek behind the house. I worked on a borrowed writing pad, scrubbing at the tiny, hard cakes of colour, trying to put down the heavy, grey sky, the orange and scarlet willow branches fringing the bank. Somehow I caught some of it on paper and ran back to the house thrilled – and chilled to the bone.

It was not until I reached the warmth of the room that I noticed that the still wet washes had partially crystallized and frozen. I watched in horror as my masterpiece melted and dissolved, the colours running in odd patterns into each other. The reds and blacks softened, creeping across the sky in arabesques of fine branches.

Entranced I watched the watercolour make a new life of its own. By some magic the mood of that winter day spread its charm on the hard niggling washes I had painted.

It looked good! Without mentioning the fact that my picture had practically painted itself, I presented my work of art proudly to my uncle. His words were like music in my ears.

"My! That really feels like winter!"[10]

As Leonard's interest in painting deepened, Nell could not have been pleased. She could visualize him as a professional violinist, but was bewildered at the thought of him trying to make a career as a painter. Unlike "uncle" Horace, Mum gave him no encouragement. When Leonard showed her his sketches, she would snap, "What's that?"[11]

As relatively older parents to begin with, the Brooks had not planned to have any more children, but Nell found herself pregnant and, on the eve of her thirty-seventh birthday, gave birth prematurely in 1920 to a four-pound son,

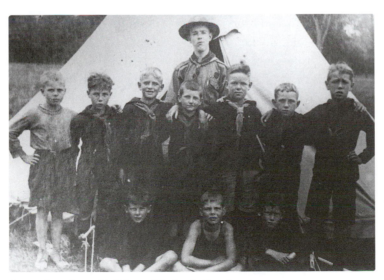

Leonard, or Len, third from right, in the Boy Scouts, c. 1923.

Herbert, named after his father. Because forceps were used, Bert, as he was to be known, was paralyzed on the left side. The doctors diagnosed his condition as spastic paralysis. Although Herb's clerk salary was modest, the Brooks realized that they were being faced with two unexpected expenditures: a larger house needed by a family of four and medical treatment for Bert. For $1,500 they bought a twelve-year-old, three-storey wooden house at 10 Conway Avenue, not far from where they had been living. The house lacked running water and had an outhouse at the end of the lot, but there was enough space for Herb to plant a flower garden.

Although Leonard remained at McMurrich school, the move to Conway Avenue hastened his transition from foreigner to typical Canadian school-boy. He made new friends on the street: George Damer, who shared his interest in art and became a cartoonist on *The Toronto Star*, and Jim Caswell. They swam nude in a creek under the St. Clair Avenue bridge and scooped up minnows. The three joined the Boy Scouts together. A round-faced Leonard appears in a photograph with nine fellow Scouts standing in front of a tent on a camping expedition at Weston, Ontario. He looked older than his years, and very serious, as he would in all photos up to early manhood. There was little laughter or humour in the household of the senior Brooks; Leonard's sly sense of humour and of the ridiculous would shine only after he was out on his own.

An only child for nine years, Leonard must have been as traumatized by Bert's birth as were his parents. No longer was he the sole centre of attention, especially as Nell and Herb had to devote much of their time to the care of Bert. They babied their infant son, whose problems were more understandable to them than Leonard's ambitions.

When Bert was four, doctors at the Children's Hospital operated on him to provide better circulation and warm his otherwise cold, crippled left arm. When Bert was ten, his parents took him to England where he spent eight months undergoing ultra-violet ray treatment on his arm and leg at a religious hospital. The treatment failed to help, but Bert ended up knowing the Bible from cover to cover.

The Conway Avenue house was large enough to accommodate more than the four family members, which enabled Nell to take in boarders for seven dollars a week, breakfast and a packed lunch included. She demanded exemplary conduct from family members and boarders alike. Once Herb brought home a bottle of whiskey to celebrate a visit by Horace Turner, but when he pulled it out, Nell shouted at him. "She frightened the shit out of him," recalled Leonard, who never forgave his mother for the way she bullied and hen-pecked his father. When Herb overindulged one evening at a Canadian

Legion affair, a livid Nell met him at the door and screamed at him in front of his sons. It was the only time the two boys ever saw their father intoxicated. "It wasn't a very loving household," recalled Bert.[12]

Nell was famous for her temper, her drive and her high degree of nervous energy; Herb for his quietness, good nature, gentle disposition, and honourableness. Friends and neighbours often called him Honest Herb. Leonard inherited all these traits from his parents, but they were too disparate to be comfortably contained in a single being. At the most unexpected times and places, Leonard would find his father's gentleness giving way suddenly to his mother's anger, to the bewilderment of those around him. As an adult, these emotional outbursts would be marked by shouting and obscenities, including the F-word he never used until he was in the navy. If in public or at someone's home, he would march out. "My nasty self," he jocularly called the blow-ups.[13] He would say his mother was besting his father. Leonard was aware of the dichotomy, once describing himself as "two characters" in one.[14] The outbursts would follow a pattern. He would become depressed, and the depression often led to an angry outburst, almost always triggered by someone's innocent remark that he interpreted as a justification to react. The emotional release usually would be followed by a spate of creativity, during which he did some of his best work. The work completed, the depression would often return. Leonard became a master at dissimulation, showing a happy face in public in the midst of severe depression. "When he's around," said his nephew Danny Marks, a professional guitarist, "everybody just feels that much better. He seems to elevate everybody's feelings about themselves and about life."[15] His diaries show that many times when he was boosting other people's feelings he was deeply depressed himself.

When Leonard was ten, he started to add to the family exchequer, selling *The Toronto Star* on the corner of Oakwood and St. Clair Avenues. A boy selling newspapers on the opposite corner during the same period was another future painter, R. York Wilson. Although they were not to meet for another fifteen years, they would become the best of friends, painting together in various countries and indulging in ribald, almost juvenile hijinks.

Leonard confected paper flowers, a precursor of the flowers found in many of the collages he would later produce. The flowers he sold door-to-door on Conway Avenue and nearby St. Clair Avenue. When his flower sales and a paper route took him further afield, he would look with envy into the windows of affluent homes, admiring the artwork on the walls and occasionally seeing someone playing a violin or piano. "How are these people doing it?" he would ask himself. "I never saw a way that I could emerge, certainly not by doing what my father did."

While Toronto's wealthy might have had music as one of their diversions, Nell and Herb had cards. They were inveterate players, usually of bridge and euchre, sometimes cribbage. Convinced at an early age that such games were inane and a waste of time, Leonard would crawl under the table and cry while cards were being shuffled and dealt overhead. "Is this what people do?" he would ask himself. "I'm never going to do this. There must be more to life than this." He never did learn a single card game, something he regretted as he got older. But he did take up chess, which he considered intellectual and mathematical, like music. He gave chess sets to Bert and others.

As he approached his teens, Leonard was painting, playing the violin, and writing poetry. "When I was twelve, I knew the kind of life I was born in was not the life that I could exist in," he said. "I knew there must be something beyond the circumference of what I saw."

The change that Leonard longed for came in 1925 when Herb was transferred to North Bay, 230 miles north of Toronto, as a clerk in the CNR's mechanical department. He sold 10 Conway Avenue, making a profit of three hundred dollars, but the new owners defaulted on their payments and he ended up repossessing the house.

Unlike most children, who hate moving because they leave behind their friends, Leonard was delighted at the prospect of going to North Bay. He would escape the bad memories of McMurrich school and be in the land of Tom Thomson and the Group of Seven. He could hardly wait.

~ *3* ~
*S*he was two people

The Silvermans, in a way, adopted the entire Brooks family when Leonard married Reva. Everyone loved Herb Brooks and Jenny Silverman. Not everyone loved Nell Brooks and Morris Silverman, but the two came to respect and like each other, which was hardly surprising given their commonality. They were a terrible-tempered pair, out of frustration for their station in life. Those who knew Nell felt she would have been successful in business had she had the education denied the lower class in nineteenth century England. Morris, too, had intelligence and drive, but lacked the business acumen necessary for success. Morris's son, George, especially liked the challenge of dealing with Mrs. Brooks. "She was

Reva's father, Moritz (Morris) Silverman and her mother, Jenny Silverman.

a very disciplined person," he recalled. "You didn't just lay back when she made a remark. You challenged her. When she had problems, she'd phone me. She considered me a very good friend."[1] George became a lifelong best friend of Bert Brooks, a regular guest at Silverman family functions.

The one Silverman who did not like Nell was Reva. The feeling was mutual. "Reva was as bossy as Mrs. Brooks," said sister Sophie. "They were two bossy ladies. I don't think Mrs. Brooks liked another bossy lady in the family."[2] Nor did Reva. She tried to keep Leonard's family at arm's length from the moment she became the younger Mrs. Brooks.

The day Leonard and Reva first compared notes on their backgrounds, he must have realized that she carried a greater burden than did he. The Silvermans were poor, so poor that when Sophie went for her first job interview at age sixteen, she had to borrow a pair of shoes because she had none fit to wear in public.[3] Reva, Sophie, and Sylvia slept three to a bed.

Had Reva's parents remained in Poland, where both were born, Moritz Silverman in 1883 and Jenny Kleinberg in 1889, they would probably have enjoyed a more affluent life, for both came from substantial families. The Silvermans were involved in farming and forestry, while Jenny's father was a notary public and her uncles doctors and dentists. They were childhood sweethearts in Slypia, a place that enjoyed a reputation for rebellion against the Russian occupiers. But young Moritz – he became Morris in Toronto – rebelled not only against the Russians but against the precepts of the rabbinical school where he studied.

Moritz inherited the raging temper of his father, which was magnified by his height: he stood over six feet and was broad-shouldered. Outdoorsmen,

the male members of his family boasted of their physical strength. His uncles could hoist a sack of wheat with their teeth. Moritz probably could too.

The elder Silverman was not pleased with his son's rebellious nature. Trying to maintain peace in the family, his stepmother – his mother had died in childbirth when he was young – arranged for Moritz to go to Canada. He told Jenny that he would send for her as soon as he had settled down.

Arriving in Toronto in 1905, he did what many turn-of-the-century Jewish immigrants did: he sought work in the garment industry on Spadina Avenue. He was hired by a *landsman*, Yiddish for fellow-countryman, and soon found himself pressing clothes, a demeaning job for such a husky young man. His speciality was preparing clothes for shows attended by buyers from Eaton's and other department stores. Within three years he had saved enough money to send for Jenny. They were married immediately and Morris went into business for himself, setting up a tailoring and pressing shop. The children arrived at two- to four-year intervals over the next seventeen years: Alex in 1910, Reva in 1913, Sylvia in 1917, Sophie in 1920, George in 1923, Bernard in 1925 and David in 1927. Both parents quickly learned English, but Jenny spoke mainly Yiddish to the children, who answered her in English. The Silvermans helped bring over Jenny's older brother, who in turn brought over his middle brother and finally the youngest; one of Morris's brothers also emigrated.

Morris' life was one of frustration because he longed to do something more meaningful than operating a tailoring and pressing shop. The family moved constantly – Wallace Avenue, Westmoreland Avenue, Roxton Road, Shaw Street, Manning Avenue – evicted when Morris failed to make rent payments. Usually he looked for a shop to rent with living premises above to cut costs.

Sometimes he became overwhelmed by feelings of melancholy, his thoughts carrying him back to Poland and his beloved mother. "Many a night when he had too much schnapps he would cry and I would go into the room and sit beside him," recalled daughter Sophie. "He'd cry for his mother."[4] Often the dominant emotion would be his anger. "There were times when he would come into the house and everything stopped," recalled David.[5] Said Reva: "We were all frightened of him."

Morris's solace was politics and the labour movement, interests that kept him away from home for long periods, much to the relief of his family. He joined the socialist Co-operative Commonwealth Federation (CCF) shortly after its formation in 1933 and became one of its organisers. Party founder J.S. Woodsworth was a familiar sight to the children. Morris managed the successful electoral campaign of the first woman elected to the Ontario Legislature, Rae Luckock, who took the Toronto-Bracondale riding with a majority of 286 votes

over the sitting Liberal member in 1941. But Morris later had a falling out with the CCF and abandoned politics.

His own learning cut short, Morris wanted his children to become educated, especially Reva, his favourite. When Reva was twelve, Morris bought her a piano he could ill afford. Reva took lessons for many years until she realized her playing was not of professional potential. Her sisters were envious when their father bought Reva the rage doll of those days, the American Beauty.

Maybe Morris saw a lot of himself in Reva and the possibility that she could achieve what was out of his reach. Reva and her siblings agree she inherited his intelligence, his sensitivity, stunted as it was at times for him, but also his temper. While he loved her in his way, this love was not always reciprocated.

Writing in her diary years later, Reva noted the turbulence of her early life:

There was always so much turmoil, wrangling dissatisfaction in the family. My father always complaining and criticizing, making everyone feel guilty. I wasn't so conscious, at the beginning, but always aware of the lack of tenderness and love.

My father's constant criticisms, angers and uncontrolled outbursts were probably because of his longing for a better life, but he did not seem to have the physical or mental ability to educate himself or get ahead. My mother could not cope with all the children coming one after the other and the lack of money. Thus the home atmosphere was largely frightening to me as a child.

I loved going to school and have a very vivid memory of crying bitterly at the top of the stairs one morning when my mother would not let me go as she said I was ill.[6]

Knowledge was so important for Reva that she used to look at books at the nearby Dovercourt Public Library even before she knew how to read them. By age five, she would read by flashlight under the bed covers after her mother had tucked her in and turned off the light.

Since there were five children younger than herself, Reva – not yet in her teens – became a second mother to the youngest. She diapered George, Bernard, and David. "I had to help my mother since she was worn out from having baby after baby after baby," she said.

Escape from the drudgery of home came when Reva enrolled at the High School of Commerce. "I just loved my school and I loved my teachers," she said. "I was just enchanted." To help the family finances, she worked Saturdays at Woolworth's department store, turning over her earnings to her mother.

Enchanted as she was, Reva suffered two traumatic childhood experiences while living at home that would affect her forever. The first occurred when she was thirteen and used to play in the park a block from the shop and living

Reva Brooks, age seventeen, in 1931.

quarters on Westmoreland Avenue. When Reva told her parents a man had exposed himself to her in the park, they decided it was no place for a proper girl. Then they learned that Reva, against their orders, had befriended another frequenter of the park, the infamous "Dovercourt girl" who, at age thirteen, was known to already have had boyfriends. Fearful that Reva might be led astray or just frustrated at his situation, Morris took the belt off his Singer sewing machine and beat her. "He did this in a violent, insane fury of anger," she later recounted in a diary. "I remember trying to run from him around the room, screaming, crying, my mother ineffectually trying to prevent him."[7] Noticing the welts on Reva's body, a policeman named Daniels who lived across the street went to see Morris. He told the father that this was not the way that children were disciplined in Canada. Recounting the story to the author, Reva said, "My father nearly killed me."

How ironic that Morris should have feared the influence of a neighbour-hood girl on Reva's morals because it was another family member who caused the second trauma. An uncle, one of her mother's three brothers, sexually abused Reva when she was probably fifteen. Reva kept the incident to herself for more than sixty years. She blurted out the story and named the uncle when a visiting niece, Goldie Sherman, Sophie's daughter, was telling her of an unhappy relationship she had had. "She wept in my arms and said it felt like

yesterday," Goldie said. "I don't know if there was a continuation. I think there was. It was something she had totally blocked out."[8]

This must have been a devastating period for the sensitive young girl, the second mother her sisters turned to for advice. She could not tell her mother what one of her uncles had done, nor could she tell her father, who certainly would have reacted physically and violently against his brother-in-law. So Reva, who loved education so much, withdrew from high school at fifteen and found a job so that she could leave the family and be on her own.

For Goldie Sherman, a gifted potter, knowledge of the molestation explains Reva's ambivalent relationship with her family, the "push-pull," as her niece called it. "I understood why it was, 'come close, I love you; no, go away,'" she said. This dichotomy of love of family accompanied by punishment would account for much of Reva's perplexing treatment of relatives: why she would invite brother David for his first restaurant meal and then insist he order liver, which she knew he hated, or why she would give gifts one day and take them back the next, or make promises she never kept. "She was two people, I think," said sister Sophie.[9]

The freedom that Reva found while living alone had consequences which would plague her throughout her lifetime. When she was in her late teens, she became pregnant by "a very impetuous wild man" and had an abortion. It was to be a secret she kept for most of her life.[10] Over the years, Reva often jotted down thoughts on the handiest piece of paper, and she repeatedly returned to this theme. "I was so *unprotected* when I was growing up," she wrote on a blank page in a 1996 guest book.

Reva would blame herself for being unable to bear Leonard's children, believing these experiences had denied her the motherhood she so passionately wanted.

~ 4 ~
From now on, I'm going to be a painter

Nose pressed against the glass, the boy fought his reflection in the train window as he searched the darkness for familiar scenes. He was looking for silhouettes of pine trees, rocks, and other outcroppings he had seen in reproductions of the north-country paintings of the Group of Seven. Hadn't that tree been in an A.Y. Jackson? Didn't Fred Varley do something over there? Past Barrie, Orillia,

Gravenhurst, Huntsville, and Burk's Falls, the steam-driven CNR locomotive lugged the passenger and freight cars, stopping often on its eight-hour run from Toronto. He was certain he would return to these places and sketch, but little did the thirteen-year-old boy sitting with his parents and young brother know that he would eventually meet all the members of the Group of Seven, become their disciple and take one of them into his home. He was still awake after midnight when the train finally pulled into North Bay, population 10,000. Although he was to spend less than two years there, they were probably the most important two years of his life. He was confident he could make a living as a writer or musician, but it was in North Bay he decided that henceforth he was going to be Leonard Brooks, painter.

Never having been north before, Leonard soon made himself an expert on the wilderness, exploring the places he would later put in his paintings of landscapes. Sometimes the learning was painful. Once, when he went trout fishing with new best friend George Pennock, he was so badly bitten by black flies that his eyes were swollen shut. During the winter, he bought a set of snowshoes and tramped the hills near town. He skied across Lake Nipissing to the Manitou islands; he sawed through the ice and fished. Always at home with the backwoodsmen he met, he would sometimes return to their shacks with his violin to entertain at their parties. He enjoyed the rugged life so much that he once toyed with the idea of becoming a trapper. But it was the opportunity to paint landscapes like the Group of Seven that was foremost in his mind. He would seldom be without his watercolour kit.

As George Pennock's father was an engineer on the CNR, he often took his son and Leonard on his train runs. When he was first experimenting with oils, Leonard did several paintings on one of the trips, but he was not pleased with the results. "Oh, Jesus, I've got a long ways to go yet and to hell with these," he said, tossing the paintings in a bush alongside the train track, not the last time he would throw out or destroy paintings. Luckily for Leonard, Pennock retrieved one of the works and submitted it in a painting exhibition at a town fair on his run. It won first prize.

Shortly after arriving in North Bay, the nightmare of Leonard's McMurrich school tormentors returned. Leonard was painting when three boys started taunting him for indulging in such a sissy activity instead of playing football. Hardened by the fights in Toronto and wanting to establish his individuality once and for all, he lost his temper and lunged at the leader, known as the "major's son" because of his father's rank in the Army. He so overpowered the other boy that his two companions had to intervene and drag off Leonard

before he did serious harm. "I would have killed that young man," he later recalled. He was not taunted again.

The person who was to play the most important role in Leonard's life in North Bay was not a painter, writer, or musician but a stern school teacher. Donald C. Grassik was the principal of North Bay Public School on Worthington Avenue where Leonard enrolled in grade eight on 4 September 1925. Grassik obviously realised that Leonard had more potential than he had shown in Toronto. He ingrained in him the need to study and apply himself scholastically. "Son, you have a brain," he told Leonard. "Use it." "Mr. Grassik changed me from a mixed up, dull student in Toronto and somehow got me to be the brightest student in North Bay," he recalled. "North Bay was a turning point in my life." He won the medal for top marks in grade eight.

Leonard was already working on a long-range plan when he started high school at the North Bay Collegiate Institute. Although he was now excelling scholastically, he decided to enter the commercial rather than the academic stream. He wanted to learn to touch type because he knew that he was destined to become a writer as well as a painter. A grade nine English teacher, Miss Brown, introduced him to literature and encouraged him to write poetry and short stories. He started to haunt the library, carting home books. He became somewhat of an authority on Walt Whitman and read everything he could on the Bloomsbury crowd, an admitted search for his English identity.

A high school teacher assigned as an art advisor gave him lessons, but Leonard found a better instructor painting houses, Don Betteridge. Betteridge was also known as the only artist in North Bay since he painted landscapes in his spare time – and sold them. The high school student and the house painter would sketch together. Leonard also made his own first sale, one dollar for a line drawing of a landscape he mailed to the children's section of the *Buffalo News*. He had come upon a copy of the New York newspaper in North Bay. Ironically, as an established painter he would have more success selling to American collectors than to Canadians.

Leonard was named to the art committee of the high school magazine, *The Northland Echo*. Bill Kennedy, the art editor, recalled Leonard "made us two or three nice little drawings" for the magazine. He remembered Leonard as somewhat of a loner at school.[1]

Leonard found time to continue his music in North Bay, taking lessons from a teacher and joining the school symphony. As one of the more accomplished musicians, he and several other members of the symphony would be chosen to give concerts in nearby towns. Sometimes he would perform as a soloist. "I'd play a minuet in G, give them a little concert." He also joined a

semi-professional dance band as a fiddler, but half the time the members were not paid.

During grade nine, the event Leonard described as the "greatest" in his life to that point occurred: he was invited by Miss Brown to accompany her to a lecture on Canadian art by Arthur Lismer, one of the Group of Seven. This tall, gangling, balding man extolled the Canadianness of painting trees and rocks. Leonard recalled Lismer telling the audience, "You don't have to paint English rose-coloured cottages. This is a vast, magnificent land. Look around you at the landscape, the rocks and the snow and the pine trees." Leonard could not sleep that night. "That's the way I've been thinking," he mulled. "Here are all these great rocks and pine trees and I've been out trying to paint them." He took Lismer's words as an affirmation that he was on the right track. "From now on," he told himself, "I'm going to be a painter."

When he accompanied his father to Toronto on a rail pass shortly after hearing Lismer's talk, Leonard was able to put into action a plan to return to the city of bad memories, convinced that was where his future lay. While Herb was dealing with the tenants at 10 Conway Avenue, Leonard went to Eaton's department store across from the old City Hall and inquired about employment. He was told there were always openings as a dishwasher in the cafeteria. Assured that he could earn money while studying art, he confided to his father on the train home that he planned to quit school and move to Toronto.

Herb was upset at his son's plans. "Well, I don't know if he should go to Toronto," he confided to Nell. She recognized the inevitability of Leonard's departure and made a decision few mothers would make: "If he's going to Toronto, then I'd better go down and look after him."[2] Looking back, brother Bert was not surprised at what happened. "Len expected everyone to do things his way," he said, not without admiration. "He just takes it for granted."[3]

Nell advised their tenants in Toronto that they had to vacate, told Herb to move into a rooming house to save money and pulled Bert out of school. Leonard left the North Bay Collegiate Institute on 19 May 1927, just a month before the school term was to end, and boarded the train with his mother and Bert for the return to Toronto. He was fifteen and a half years old and had lived in North Bay for less than two years, but he identified in later life more with that northern Ontario city than with the glamorous provincial capital.

William Colgate, one of the leading art critics of the day, wrote of Leonard, "He found something in those two years that has been the basis of anything he has or will ever accomplish. He was in touch with the 'eternal verities,' then, if ever."[4]

～ 5 ～
I'm a real artist and I'm being paid

Leonard found that washing dishes in Eaton's basement cafeteria for eight dollars a week was a full-time commitment that drained him, leaving little time or energy for study. For a year he took art classes at night at Central Technical High School at 725 Bathurst Street. Many nights he was so tired from work that he dozed in class.

The lack of formal art training haunted Leonard then – as would the lack of a university degree later – and led him at sixteen to suicidal thoughts, thoughts that would reoccur throughout his life during times of depression. He wrote down these feelings in a 1928 diary he destroyed twenty-three years later because he said he did not want to read it nor have it read. "I was so frustrated at times that I thought it wasn't worth going on," he said. "But what can you do when you're sixteen?" Yet his self-education was so successful that the likes of Joan Murray, then executive director of the Robert McLaughlin Gallery in Oshawa, Ontario, was surprised to learn he did not hold a post-graduate degree.[1] Every morning and evening he read books on the streetcar going to and from work. He started his own personal library, buying books on sale at Eaton's whenever he had extra money.

A neighbour told Leonard of a janitorial opening at Willard's chocolate plant off Oakwood Avenue, so he quit washing dishes at Eaton's. The factory had a design department, which soon learned its new hire was an aspiring artist, so Leonard split his time between the broom and the brush. He was asked to design a candy bar wrapper! The purple and gold wrapper was printed but never used. The Willard's job would have been ideal, had it not been for the hard-boiled women who wrapped the candy bars. They groped the shy young man in the crowded elevator, made teasing comments about his anatomy and jokingly accused him of trying to peer down their bodices as he swept the floor and to look up their dresses when he stooped to use the dust pan. "I was very sensitive and felt embarrassed by all this," he decided, so he quit and returned to dishwashing.

But he soon left Eaton's cafeteria, being promoted to the ground-floor perfume department as a parcel wrapper. During lulls between wrapping, he would avail himself of all that brown paper to sketch and draw. The department manager was upbraiding him one day when art director Ivor Lewis passed by, overheard the conversation, glanced at the offending artwork and intervened. He told Leonard to do some drawings at home – not on the job – and bring

them to the advertising department. Days later Lewis stopped by and said, "Young man, you'd better get upstairs."[2] There was an opening for a runner in the advertising department, but there was also a chance he would be able to draw. One day Lewis, who was a well-known sculptor, asked Leonard to sketch a dish. "I went home and took that dish and sat up all night drawing," he recalled. The drawing was incorporated in one of Eaton's ads and Leonard was subsequently given a desk of his own and a salary of twelve dollars a week. "I'm a real artist and I'm being paid," he exclaimed.

When Leonard was seventeen, Nell decided that he was now old enough to live on his own, so she and Bert returned to North Bay after eighteen months in Toronto. Nell would later remind Leonard that his father had to spend "two years alone" in North Bay while she was in Toronto.[3] Before leaving, Nell made arrangements with a neighbour, Mrs. Robbins, to take Leonard as a boarder for seven dollars a week.

During lunch hour at Eaton's, Leonard would wolf down a sandwich packed by Mrs. Robbins and go to nearby Chinatown to sketch or read a book. He was able to expand his noonday activities when he met Albert Franck, a former Dutch swimming champion twelve years his elder. A restorer and framer in the fine art department of Simpsons department store across the street, Franck would let Leonard into the storage area under the stairs, there to study paintings. Franck also gave Leonard old frames and invited him home for dinner with his young bride, Florence. When Franck himself took up painting, he and Leonard would often go together to the St. Lawrence Market on weekends to sketch. Franck stood behind Leonard in York Mills to watch him paint *Muggy January*, one of his better-known winter scenes, Leonard giving him tips on painting snow. This would not be the last time Leonard's advice was sought by an older painter.

Leonard left Mrs. Robbins and moved in as a boarder with the Hollowells, friends of his mother at 277 Atlas Avenue. If anything, the Hollowells were more sceptical of Leonard's artistic endeavours than were his parents. "He couldn't paint a face to save his life," George Hollowell said. "All he paints is old, rundown shacks." He also said Leonard's violin-playing sounded like a strangling cat and banished him to a closet to muffle the sound when he practised.[4] Son Bill, in a 1978 letter to Leonard, said of his parents, "I think you must have been one of the greatest perplexities they ever met." Leonard's parents would probably have agreed.

One night the streetcar ride home from Eaton's resulted in Leonard being published in *The Toronto Telegram*. When he discovered that he was a penny short of the three-cent fare, the driver ordered him off the streetcar; a passenger stepped forward and gave him a penny. Leonard was so impressed by the

Toronto artist Albie Franck, who learned how to paint snow scenes from Leonard, watched him paint Muggy January, *a 20-inch by 30-inch oil on canvas done in one outdoor session, 1938.*

man's kindness that he recounted the story in a letter to the editor of the *Telegram*. The editor published the letter as a news story with Leonard's by-line and the headline "The Good Samaritan."

Leonard's dream when he left North Bay was to study at the Ontario College of Art, founded in 1876 by the Ontario Society of Artists. Considered Canada's best art school, it had on its faculty many of the country's top artists, including members of the Group of Seven. Located downtown in a Georgian building at 100 McCaul Street, it was next door to the Art Gallery of Ontario, then known as the Art Gallery of Toronto. An opportunity to study arose when Eaton's offered limited scholarships at the college to winners of its Employee Art Competition. Leonard received a scholarship, good for several months of night classes, and managed to stay on for an extra month in exchange for sweeping the floors.

The opportunity to resume full-time studies came when Leonard went home on vacation to North Bay in the summer of 1929. He learned that survey crews were being recruited to work on the construction of the Trans-Canada Highway. Here was an opportunity to save money for tuition and board. Hired for three months at twenty-five dollars a week as a surveyor's helper, he submitted his resignation to Eaton's.

Not yet eighteen and with the delicate hands of an artist and violinist, Leonard was again teased and made the butt of jokes, this time by the hardened road crew working in the Pembroke, Ontario, area. He won their respect with his hard work, good humour, and fiddle playing. "They were testing my manhood," Leonard recalled. "I loved it." The boss, a dour Scot who seldom spoke to anyone, invited Leonard to accompany him to the Quebec side of the Ottawa River where beer was available. Already looking older than his years, Leonard added a pipe and had no difficulty passing for twenty-one for his first drink of beer in a tavern. Unfortunately, the boss got drunk and went out to his truck where he passed out with a lighted cigarette in his hand. When smoke started billowing from the burning upholstery, Leonard was summoned, managed to put out the fire and drive back to the work camp. The following year he sold a story about his adventures, "The Road Must Go On," to *The Canadian Motorist* magazine for fifteen dollars.

The joy of returning to the Ontario College of Art was tempered by the Wall Street crash on 29 October 1929, which ushered in the Great Depression, less than a month after Leonard had resumed classes. He registered for two terms, October 1–January 18 and January 20–May 5, paying forty dollars a term. He found a room on Grange Road, around the corner from the college, in a building housing other students, but he left after six weeks. "Too much frivolity, too many girls and boys with time and money to play at being bohemian," he said was the reason for seeking a room elsewhere.[5] Wealthy dilettante artists and those who did not work hard and pay their dues the way he did would always be abhorrent to Leonard.

But he soon met two students from affluent families, Robert Hunter and Evan Greene, becoming a fast friend with the latter. Bob Hunter's maternal grandfather, Sir Edmund Walker, was president of the Bank of Commerce and the first chairman of the board of the National Gallery in Ottawa. Bob lived with his parents in Rosedale and had the use of a car, so he often chauffeured Leonard and Evan about. Evan was the son of Dr. Evan Greene, an anatomy professor at the University of Alberta who had become wealthy in private practice in Edmonton. He sent his son thirty dollars a month, five dollars less than Hunter's allowance. When Greene learned Leonard was seeking new lodgings, he suggested the rooming house where he lived at the corner of Bay and Bloor, twenty blocks from the college. But they soon cut the distance almost in half by moving to 56 Grenville Street in "The Village." Depending on his finances, over the next few years Leonard either had his own room there or shared Greene's. The room became a popular meeting place for students.

The shared quarters consisted of a third-floor, front room reached by a creaky staircase. There was barely any furniture, according to Bob Hunter, a frequent

visitor. The bathroom was on the ground floor, so Leonard, Evan, and their guests would often relieve themselves in empty beer bottles to avoid the walk downstairs. Once Hunter mistook a "piss-filled beer bottle" for a real brew and gagged when he realized the nature of the contents. One day Leonard's father came to Toronto unannounced and, in his son's absence, asked the landlord to let him into the room. Herb was shocked at what he saw. The walls were adorned with murals of women in various stages of undress while empty beer bottles littered the floor from a party the previous night. That was probably around the time when he told Leonard, "You get a job on the railroad and stop all this nonsense."[6]

Leonard was obviously impressed by Greene, as were most people who met him. He was a year older than Leonard, six-foot-two, a lanky, blue-eyed blond, and a charmer. "My father might have a nickel in his pocket but he could go anywhere and charm people into doing what he wanted," recalled his son, also named Evan.[7] Greene so captivated Hunter's mother that she worried about him being alone so far from home.

Hunter, later a long-time director of the Norton Gallery in West Palm Beach, Florida, remembered Leonard as a serious, dedicated student liked by everyone with whom he came in contact. "He had lots of spunk," he recalled. "He knew what he was doing. He was the only one among us who had it the hard way. Evan was spoiled and I didn't have to work because my family had a little money." He said he knew that colleagues Alan Collier and Franklin (Archie) Arbuckle, also teenagers at the time, would be successful, but that Leonard had something additional. "Leonard was the serious one who seemed to reach outside the circle. He seemed to have a little fuzz on the edge that was different. I can't explain it; you feel it."[8]

Leonard and his fellow students attended classes given by some of the most illustrious artist-teachers in Canada. The principal of the college was J.E.H. MacDonald, one of the Group of Seven, while two other members taught, Franklin Carmichael and Frank H. Johnston. Leonard enjoyed a course Johnston taught on dynamic symmetry and ways to break up space. He used to visit another member, Arthur Lismer, at the Art Students League near the college, met Lawren Harris socially, sketched with A.Y. Jackson in the 1930s and became close friends with Fred Varley during the Second World War, so he ended up knowing all seven.

As a student, Leonard did not limit his works to shows at the college but submitted them to the Ontario Society of Artists and the Royal Canadian Academy of Arts, prestigious professional societies to which he would be admitted at an early age. Not only did he paint, but he found outlets for his poetry. One poem, entitled "Barrier," appeared in the May 1930 issue of *Tangent*, a student publication:

Tear down the wall
So near I am and yet I cannot see;
Could I but peer beyond
Where lost in mist the quiet night
Bears no voice, lying deep
Like still brown waters.

Another poem, "Old Barns," was published in the yearbook along with a sketch of a barn.

Leonard registered for the 1930 fall term but dropped out after several weeks because of lack of funds. When he returned to Eaton's to try and get back his old job, Ivor Lewis told him that the art department had suffered cutbacks because of the Great Depression. Lewis found him a position as sales clerk in the boyswear department at Eaton's College Street store.

After being in the art department, Leonard found clerking demeaning and demoralizing. Since the department was on the ground floor, he felt embarrassed when people he knew recognized him. Often students would stop and chat, much to the annoyance of the manager. His sales career in Eaton's ended when a beautiful young lady, nicknamed "Daphne, the model" because she posed nude for the students, stopped by. Leonard ignored several customers trying to get his attention and continued talking to her. When she left, the manager publicly scolded him. Leonard's temper flared, he walked to the cash register, picked up a bag of coins and hurled it at the manager. "You don't speak to an artist that way," he shouted. He marched back to his room, not even bothering to pick up the half-week's salary owed him. The date was 19 June 1931 and he was nineteen-years-old, now unemployed and with less than eight dollars to his name.

Leonard's sympathy for colleagues left behind – and for the working stiff in general – showed through when he reminisced about the incident. "I can assure you that the hatred, not only from myself but from some of the other employees, was such that I could easily see how somebody could get a pistol and go and shoot Timothy Eaton," he recalled, referring to the founder of the department store chain. "Those great Methodist Torontonians with their millions and their slaves working their asses off."

Soon there was to be a sequel to Leonard's departure from Eaton's. Days before, Albie Franck had told Leonard to bring in some paintings for a show at Simpsons. Leonard had already quit Eaton's when Franck advised him that four of the paintings had been sold and there was a cheque for one hundred dollars waiting to be picked up. Leonard used fifteen dollars to buy a Harris tweed suit with waistcoat, which he wore for the first time on a visit back to

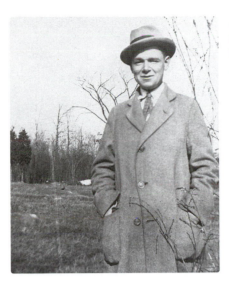

*A dapper Len, as
befitting a clerk in
Eaton's boyswear,
1931.*

Eaton's. On the way, he bought a cigar and lit it before reaching the boyswear department. There are several versions of what happened next. The most dramatic recounting has Leonard blowing smoke in the face of the manager; the mildest, he just smokes the cigar and asks the manager, "How are you doing?" Whatever happened, Leonard re-established his credentials as an artist and not a sales clerk, to such an extent that for years until the Eaton's store was torn down he used to go back to the boyswear department whenever he was in Toronto and chuckle at the memories. "My ego finally coming to the fore," he told art critic William Colgate. "I thank the gods for that moment."[9] The confrontation must have amused the staff, most of whose members got to like the spunky kid in the eight or nine months he worked there, and they would show their appreciation months later when they learned he was penniless.

Since Leonard was jobless, Evan Greene invited him to stay free in his room. Although Greene received a monthly cheque from his father, he tended to blow it immediately on good food and drink, mostly the latter. So both Leonard and Evan would be ingenious when it came to cooking. Leonard's brother, Bert, would often go to Toronto on one of his father's rail passes and stay at 56 Grenville. He remembered the menu as potato salad, potato soup, boiled potatoes, roast potatoes or fried potatoes, nothing but potatoes. Often there was no money to buy anything else.[10]

Now that Leonard was virtually a permanent guest, Greene ordered some additional furniture from Eaton's. The store sent two men to repossess it when they were unable to make the monthly payments. An older artist who had a studio at 56 Grenville, Manly MacDonald, became incensed and ordered the crew

to leave the furniture where it was. Leonard and a writer, John (Jack) Bingham, who lived next door, then amused themselves for a few weeks by writing outlandish letters to Eaton's explaining why the payments could not be made at that time. Eaton's kept writing back, prolonging the exchange. Impressed with their correspondence, Leonard and Jack wrote an article that was published by a Toronto humour magazine. The fate of the furniture is unknown.

Bingham, whose father was a Toronto businessman, took Leonard under his wing and taught him social graces, such as standing up when a woman entered the room. The test took place at a tea in Rosedale given in honour of a Lady Grey, who lived on Douglas Crescent, and to which Bingham invited Leonard. Bingham, who became head of an advertising agency in Toronto, also introduced Leonard to Frankie Peters, who became his first serious girlfriend. They sometimes double-dated, but often Leonard was so poor that Frankie had to settle for a stroll along Bloor Street.

August Strodayak, a Hungarian who owned the Village Gallery across from Eaton's, enlisted Leonard to copy works of Frans Hals, the seventeenth century Dutch portraitist. Leonard's potter friend, Rudy Renzius, would invite him for a meal at home and occasionally buy one of his sketches. *Toronto Star* cartoonists Jimmy Frise and Galbraith O'Leary and writer Gordon Sinclair would give him five dollars for a drawing when he needed the money. The odd bit of freelance work for Simpsons' art department also brought in a bit of income.

After selling only the occasional painting at the shows of the Toronto art societies where most artists sold their works, Leonard decided to put on his first one-man show himself in the quarters he shared with Greene. He posted a sign on a chestnut tree in front of 56 Grenville and "slept not a wink" that night. Only two paintings were purchased, both by friends. He concluded that few potential buyers were willing to walk up three flights of stairs to view paintings.

When Evan Greene returned from a visit to his parents in Edmonton to discover Leonard was still penniless, the two agreed that if they had to starve, they would be better off doing so in Europe. Leonard told his mother of his plans, and in a follow-up letter on 2 April 1933, explained what he was doing to raise money for the trip: "I discover that I have 30-40 paintings 50 drawings etc. ... I am making a visit to everyone I know – and selling for what I'm offered – $1 up – everything ... if you will as you mentioned contribute something – the good cause is likely to go through – and we will be leaving at the end of this month."

But by the time he and Greene hitchhiked on a truck to Montreal ten weeks later, he had raised virtually nothing. On 18 May 1933 they boarded a cattle boat, the *Manchester Citizen*, bound for England.

A Career Is Launched

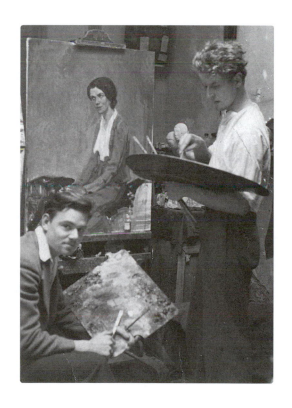

You've got to get out of this environment

Cattle boats were the Great Depression era's equivalent of the Cunard Line for impoverished artists, writers, professors, teachers, students, and those of lesser stations in life who wanted to escape to Europe. Although it was assumed one could work one's way over, reality was different. Someone on the dock had to be bought off in order to obtain a working passage. Leonard Brooks and Evan Greene paid ten dollars each for the privilege of tending cattle on the *Manchester Citizen* on the thirteen-day trans-Atlantic crossing. During that time they did not remove their clothes, even though they spent much of the day wading in excrement and vomit from over five hundred head of seasick cattle, penned on two decks. They slept on straw, not unlike the cattle they fed and watered. Food was stew and a bit of bread and marmalade. Strange hands would snatch their bread as they ate; the looks of the men doing the pilfering did not encourage protests. When the boat reached Manchester, Leonard and Evan discarded as much of their rancid clothing as they could afford to do without, got onto the highway and again hitchhiked, this time the 165 miles to London.

Since they had only two dollars between them, they spent the first night in London sleeping in a park. Next day they went to nearby Enfield to see Leonard's uncle and aunt, Frank and Daisy, arriving unannounced at 10:30 p.m. on a Saturday during the Whitsun Holiday. Frank worried there would not be enough food, since stores were closed, but they managed to feed two hungry young men. Frank knew the pair was coming because he was holding for Leonard a cheque for thirteen pounds, about fifty-five dollars, money sent by his parents. "I asked Len if he would rather I kept the cash and paid it out as required and he agreed it would be best," Frank told brother Herb in a letter.

"We sure think Len is a fine chap and very earnest in everything he says and does," Frank wrote. "Don't worry about your son and heir. I think he has it in him to get on." Frank was not quite so sure about Greene. "Evan is a good fellow too but does not seem such a sticker as Len." Frank revealed that Greene had a fuzzy beard when he arrived, "but much to our delight he shaved it off and exposed himself as quite an Adonis."[1] He charmed Leonard's aunt because someone took a picture of a laughing Daisy perched on Evan's lap.

Previous page: Leonard and Evan Greene at their studio in London's Chelsea district, 1933.

Daisy was not laughing when she and Frank were later stuck with bills that Greene ran up, invoking their name. "A lot of bills came in from local department stores of stuff that had been bought and not paid for," said cousin Donald.[2] When Daisy wrote to Nell about the unpaid bills, she replied that Leonard had done the same thing at Eaton's. That would have been a reference to the furniture Greene had ordered and that Eaton's tried to repossess.

Daisy tracked down Leonard and Greene at the studio they shared off the King's Road in London's Chelsea district, famed for its resident artists and writers. She was shocked at what she saw. "She said it was absolutely filthy," Donald quoted his mother. A real estate agent and Chelsea character named Mabel Lethbridge, who had lost a leg in the Great War, found the room for the two destitute artists. Taking pity on them, she even donated furniture discarded by a painter who had met with success and moved on.

An admittedly shy person, Leonard needed an extrovert to bring out the clown in him; then there was no stopping him. Greene was the first of many friends who played this role. When they went into a pub, everyone soon knew these two charming rascals were Canadian artists, so someone would buy them a drink or two. They made up a name for their favourite targets: snurges. These were wealthy young men – and some women – who were either slumming or wanted to be artists but were not willing to make the sacrifices. After the drinking, the pair would gather up the empty beer bottles and sell them elsewhere. Sometimes pub owners would invite them in with their sketchpads and sport them to drinks as an attraction to lure paying customers.

When they literally had nothing to eat, they would go out early in the morning and steal bottles of milk from neighbourhood doorsteps. Sometimes Leonard would pawn his violin, retrieving it when he and Evan had the money. Occasionally they did a poster for a butcher shop and received payment in meat and produce. They did Santa Claus posters for a grocery store. Several waitresses, including one in Soho named Joan Wolfenden, let Leonard eat and did not ring up the bill.

The King's Road studio proved too cramped for two artists, so they moved to Redcliffe Road to a larger room, which they subsequently shared with two women, Cynthia Bowen and May Gannon, the former English and the latter Irish. Leonard experienced his first serious romance with Cynthia; Greene would eventually have a tempestuous marriage with May. It was probably at the Goat-in-Boots, a local pub, where Leonard met Cynthia, a "great-looking babe" several years his senior and separated from her husband, Dick Brook, the son of a wealthy cotton manufacturer.

Cynthia's mother tried to warn Leonard off her daughter, to no avail. "She ain't good for yuh, lad," she told Leonard. "She's a bad un."[3] But she had looks, a beautifully modulated English voice and charm in excess. "I had sex overflowing in the Chelsea phase," he wrote at the time about Cynthia. That she might become pregnant did not escape him. "I once lay all night telling C. what I would do if a child did come."[4] Once when they were broke, Cynthia sent a telegram to her understanding husband: POCKET PICKED PLEASE POST POUND. He sent the money.

When Leonard and Greene earned a bit of money, they would go to Paris for a few days of sketching, visiting the Louvre and other art galleries and enjoying the nightlife. On one trip, Greene insisted on taking with them a pair of pet white rats. They talked their way out of customs at Dieppe after the agent had opened Greene's bag and been surprised by the rodents. The concierge of their hotel in Paris was not as understanding. He met them at dawn as they staggered home from a night in arty bars and their first drink of absinthe. While they were away, the rats had escaped from Greene's suitcase and gnawed the bedspread. Rats and men were soon out in the street.

Given his writing talents, Leonard entered an essay contest on the relationship between Canada and the mother country sponsored by the Canadian High Commission in London. He was so confident of winning the hundred-dollar prize that mentally he had already spent the money. "Some miserable girl got the money I could use so well at this juncture," he wrote in his diary, "Some miserable wench who doesn't know what trying to be a painter means."[5]

Leonard kept up a steady stream of communication with friends back in Canada. According to one Toronto newspaper account, "The envelope of his letter to Rudy Renzius must have given his postman a good time. It was covered with little sketches of the writer, the receiver, the house it was going to and the house it had been sent from, not to mention a few odd sketches of Renzius' pewter work and some murals Leonard did on the walls of his house just before he left."[6]

As he had done in Toronto, Leonard befriended as many artists as possible, meeting them at their shows. He was especially interested in etching and soon had several etchers teaching him the techniques of spreading a mixture of wax and resin on a copper plate, drawing through the mixture and then cleaning the plate in acid and making prints. Leonard also met Haydon McKay, a well-known fortyish portrait painter who did an oil of a young, long-haired Leonard with a wispy beard. It was a gift, from one artist to another.

Augustus John, the portrait painter of contemporaries such as George Bernard Shaw, Dylan Thomas, and James Joyce, befriended Greene. One of John's former mistresses, Lillian Shelley, developed a soft spot for Leonard. John invited Greene

to a formal dinner party, so Evan went to his father's bespoke tailor in London to be fitted for "tails" for the evening. The morning after the dinner, he pawned the outfit. Upon receiving the bill, Dr. Greene decided it was time to see what his son was doing, so he headed for London.

When Evan and Leonard, accompanied by May and Cynthia, took Dr. Greene to the Antelope Club, a nightspot popular with artists and writers, a bloody fight erupted among some patrons. Leonard had to protect Dr. Greene, then sixty, from harm.

Leonard began to feel that the "Chelsea binge" had gone on long enough. He was not drinking as much as Greene, but he felt that the life he himself was leading was one of debauchery and degradation that did nothing to advance his artistic career. Snatches of this life are scattered throughout a diary kept by Leonard: "... a visit to Dirty Joe's where Lesbians danced in men's clothing" ... "Sonia talking at Doyle Jones affectedly about her attempted suicide over a lost girl-lover" ... "stopping the ears with wool while the creditors banged on the door" ... "drab penniless days [and] liquor flowing from richer pockets" ... "Don't get caught in that gutter again" ... "the world a loathsome, evil place" ... "the last cigarette made from butts picked up in the street" ... "the 'jitter' days of endless pub searching" ... "sitting gigolo-like while women inveigled cigarettes ..."

Leonard increasingly felt out of place, the outsider, as he had in Toronto as an immigrant boy. For one thing, he was more serious about his art than most of the others, especially his friend Evan. He was also from a lower social class, while people like Greene could depend on payments from home, or were just temporarily short of funds. His colleagues scoffed at his "common sense" when they wanted to continue the party and called him "proletarist" for his sympathy with the working man.[7]

"I can't stand this any more," he told Cynthia. He already knew his next destination: Spain.

His escape from Chelsea came via a most unusual person, a British-born flamenco dancer whose stage name was La Tintoresca. On a visit to England, Elizabeth Pedlington Hopf had approached Leonard while he was sketching London's Battersea Bridge. "My daughter wants to be a painter," she told him. During tea with her one day, Leonard voiced his misgivings about the life that he had been leading. "Young man, you've got to get out of this environment," she lectured him. She invited him to join her family in Spain, where she was trying to establish a Mazdaznan religious colony in the Pyrenees mountains. "Write me as soon as you know when you're going to come,"[8] she said. "This sounds great to me," thought Leonard as he wrote down the address: 132 Paseo de Gràcia, Barcelona, Spain. Now he took up her offer.

Needing money for the trip, Leonard held a show at The Tea Room of Chelsea Old Church, located in a three-hundred-year-old building owned by a Miss Voules. She had a weak spot for artists and encouraged their activities. His show brought few sales, but one of the buyers was Frank Brangwyn, a leading watercolourist of the day, later knighted. Later, when trying to get *out* of Spain, Leonard would appeal to Brangwyn for help. The show drew the attention of the "Talk of the Day Column" in the London *Express*. The writer of the column noted that Brangwyn had shown interest in Leonard's paintings.[9] He had better luck with a publishing house, selling two drawings of snow scenes for Christmas cards for five pounds, about twenty-two dollars.

One of the people Leonard visited while making his farewells was Lillian Shelley. The visit was fortuitous because Shelley relived some of the moments of an extended trip she had made to Spain with Augustus John. "Leonard, we're going to celebrate your leaving,"[10] she told him, uncorking a bottle of wine. Then she brought out a small crucifix and gave it him. "It's the one I bought for Augustus John in Barcelona," she said, stuffing it in his pocket. "This will bring you good luck." Then she added a couple of pounds.

The final morning he and Cynthia embraced on Cheyne Walk on the embankment of the Thames near Albert Bridge and made their farewells, promising to write each other every week. They did for a while. That evening his friends came down to Victoria Station to see him off on the train to Dover and the crossing to France and then onwards to Spain. He brought out his violin while the friends passed the hat among the onlookers. Added to what he had received from Lillian Shelley and his sales, he had forty dollars to his name. He would not see that much money again for a while. When he boarded the train that April day in 1934, he was travelling by himself for the first time since he and Evan had left Canada.

~ 7 ~

Dad, I'll come through all right

Leonard Brooks could not have imagined a more unusual family than the Hopfs', with whom he was to spend the next six months, dividing his time between their apartment in Barcelona and their farm above the town of Martinet, some one hundred miles north in the Pyrenees mountains near the

French border. While in Spain learning flamenco dancing, the mother, Elizabeth, had met *Herr* Hopf, a German salesman of agricultural equipment, a business that kept him on the road much of the time. The family had settled in Spain after years of living in the Americas. There were three sons and one daughter: Carlos, twenty-three, born in Berlin, was a militant member of the Hitler Youth; Roberto, twenty, born in Edmonton, Alberta, became Leonard's confidant; Arturo, nineteen, born in Guatemala, wanted to be an international businessman like his father; and Carlota, seventeen, born in England, was a troubled, would-be artist who soon gained Leonard's understanding. Nor could Leonard have chosen a more unusual time, for Barcelona was a city of intrigue on the eve of the Spanish Civil War; some of the Hopfs were participants in that intrigue and all were believed to have perished in the war.

The American embassy in Mexico City would later claim that Leonard was a pilot in the leftist Abraham Lincoln Brigade, but by the time the war started in 1936 he was already back in Canada. This misinformation would create problems for the Brooks in their dealings with the u.s. Immigration and Naturalization Service, which was trying to keep communists out of the country. The fighting eventually evolved into a "world war in miniature" that pitted Germany and Italy against Russia.

Leonard had thought about returning to Spain during the war as a member of Canada's volunteer Mackenzie-Papineau Battalion. The embattled Spanish government had promoted a social revolution under which workers managed factories and peasants organized collective farms. Given the high unemployment during the Great Depression, Canada's socialists, communists and progressives, especially those in British Columbia, responded immediately to the call to defend the Republican cause against General Francisco Franco's insurgent Nationalists.

The response of Canadians was proportionately greater than that of Americans. From a citizenry of 11 million, Canada had produced by the autumn of 1937 1,200 volunteers. American volunteers numbered only 2,800 out of a population of 130 million.[1] The "Mac-Paps," as the battalion was known, boasted one of the heroes of the war, Dr. Norman Bethune of Gravenhurst, Ontario, who performed the first battlefield blood transfusions. A communist, he later gained fame in China, where he died in 1939, ministering to the troops of Mao Tse-tung.

Once fighting began and war coverage occupied the front pages of newspapers, Leonard back in Canada became a sought-after expert on Spain in the social circles in which he moved. But for now, he was a young artist trying to shake off his Chelsea days and do some serious painting.

Leonard's path to Barcelona had taken him to Paris, where he caught a train that deposited him in Port Vendres, on the Mediterranean. From there he

crossed into Spain.[2] He wrote in a journal he bought especially to jot down what happened in Spain: "This last year has done many things to change me – but the same F.L. Brooks is under it all – still a boy of 22 – enjoying life – yet a little frightened sometimes at his insecure future – and then gloriously vibrant with the light that lies just ahead."[3]

After settling in with the Hopfs, Leonard introduced himself to the British consul in Barcelona, Norman King, who happened to be an avid watercolour painter. The two often sketched together. King gave Leonard a letter of introduction to a Mr. Dennis, the secretary of the British Club of Barcelona. Carlota Hopf took him to local galleries where she introduced him to the art people she knew. He ordered business cards reading, "Frank L. Brooks, artist." All this was aimed at establishing his name prior to a showing of his paintings at the Hopf apartment on Paseo de Gràcia, a wide street in downtown Barcelona.

Mrs. Hopf let Leonard strip a downstairs room of furniture and paintings and pound nails in the walls to hang his own works. Once they were up, he wrote, "I sit here – in the room hung with my watercolours – fifty of them. What pathetic attempts some of them are! And yet here and there the ghost of a fine thing – the glowing colour of some moment – somewhere – that has delighted me – and made me forget everything except that moment."[4] For the opening of his show, Leonard borrowed a suit from Roberto Hopf. Although the amateur setting was not unlike that of his show at 56 Grenville Street a year earlier, Mrs. Hopf did what she could to create the proper atmosphere. When the front door was opened at 10:00 a.m., she was there as hostess, wearing a long gown. Flowers were on display and a pianist ready to play. But by 3:00 p.m. no one had passed through the door except someone to see Mrs. Hopf.

But they did come later, a "motley assortment" of people speaking Spanish, Catalan, French, German, and English. They included local artists, writers, and journalists, plus members of the consular corps and expatriate community. The artists complimented Leonard on his work; the diplomats and "expats" invited him to lunch and dinner. Unfortunately, no one bought any of his paintings. "I'll conclude," he wrote, "by saying that my poor children have been well received – given a certain amount of attention – and then have been silently left still wanting a home."[5]

After the close of the show, the family loaded provisions onto an old Ford truck for the drive into the mountains and Leonard's introduction to the ascetic life of the nascent Mazdaznan colony, called Can Carlos. Leonard found Quefordat, where they left the truck, a painter's dream. "Nature as seen here is a new experience to me – the mountain range – the sky – and purity of the snow – the omnipotent solemnity of the rocky heights astound and hush me

Leonard in the Spanish Pyrenees mountains, his painting gear on the back of Marquita, a donkey belonging to the Hopf family, with whom he lived, 1934.

– they frighten me with their grandeur."[6] Next day they lashed the provisions on the back of a diminutive donkey named Marquita and started on foot for the farm, three hours distant.

Leonard was not the first impoverished young man Mrs. Hopf had inveigled to the farm in hopes of recruiting him into the Mazdaznan movement. An off-shoot of Zoroastrianism, the movement was established in New York in 1902 by Dr. Otoman Zar-Adhusht Hanish. A vegetarian, he taught a discipline of breathing, rhythmic prayers, and chants.

Leonard loved the lonely feeling of the humble, two-acre farm, in the snow-capped Sierra del Cadi mountains. He likened the wooden farmhouse where he slept in a room with the boys to a Canadian summer cottage. Aside from the solitude and the landscape, little else did he like. He soon tired of meals of rice smeared with olive oil and maybe a side order of beans and some lettuce. He had to eat a lot of such fare to keep up his strength.

Surrounded by majestic mountains, Leonard found himself unable to paint to his satisfaction. He soon attributed this to the celibate life he was leading. "I suspect that some sex connection has something to do with it – for I have been so chaste – and unmindful of it for the last month – that the contrast to Chelsea is sure to have some reaction." Leonard became a firm believer in the credo that "an artist paints with his penis" and that there was a correlation between sexual and artistic satisfaction.

Leonard had good relations with all the Hopfs except Carlos, the eldest. A member of the Hitler Youth, he went to Germany every few weeks for training and manoeuvres. He disliked having a son of England at the farm and constantly tried to upstage Leonard. He would arise at 3:00 a.m. to dig in the fields, a challenge that Leonard often accepted, blistering his painter's hands. Carlos would enlist in the German Army and return to Spain to fight alongside Franco's troops during the Civil War. Besides Leonard, the only other non-family member at

Can Carlos was a young German carpenter named Willy, who spent much of his time mapping the area, obviously for future military use. Carlota supported the Republican cause.

When Can Carlos became too oppressive for him, Leonard would hike down the mountain to Martinet and rent a room for the night for twenty cents. There he would paint and write letters home and to friends in Toronto, and chapters of a book he had started, *Wanderlust Year*. He offered chapters to the Toronto *Star Weekly* and *Chatelaine* magazine, but both rejected them.

Sometimes he was overwhelmed by feelings of loneliness, which he committed to the pages of his journal. "I have lived in a world of the present – with moments when I desire the past – when I want to talk to old friends – to get drunk with Evan – to go to a party – to do all the things I never ever think of doing here – a party!"[7] Nor could he seek refuge in literature, for the only books at the farm were in Spanish or German. He vowed never again to travel without a book of poetry, preferably by Walt Whitman.

Leonard returned to Barcelona with the Hopfs, who had moved up the street to a new apartment at 114 Paseo de Gràcia, and organised a second exhibition. However, it was no more successful than the first one a month earlier: again, the room was filled with people congratulating him on his work, but the only sales were two watercolours bought by British consul King.

The mail was more encouraging. His mother wrote a letter of chitchat and told him Herb envied his son's sojourn in Europe. A wealthy Toronto acquaintance named Waldie sent a check for three pounds for a sketch that Leonard had sent him on spec. Girlfriend Frankie Peters wrote, as did Jack Bingham from 56 Grenville and Bill Haddock, a colleague from Eaton's art department who had moved to Montreal. "I'm anxious to see all these old faces again – but if I can see them with a new suit and money in my pocket how much better!"[8]

While still in London, Leonard had anticipated a possible trip to Majorca, looking up pictures of the Spanish island and doing a series of small watercolours. So when Mrs. Hopf encouraged him to go there, he was prepared. When the boat docked, he jumped off first and sold the paintings to disembarking passengers. Then he staked out a place on the beach where he felt he could sleep safe from muggers, but two days later he was ensconced in the Pensión Ibérica, a clean room with two meals a day. His luck had changed, if only briefly. He found a colleague from London, Kenneth Graham, in Victor's Bar, a hangout for tourists, in the company of a British art student with a problem. She had abandoned her studies and gone to Majorca with a lover. Now her father was about to show up, anxious to see her work. "Would I sell her some old sketches I didn't want?"[9] Leonard had none available, but the next

day he did enough to more than satisfy the father. The student paid him the equivalent of twenty-five dollars.

His resentment of those who did not need to work for a living now showed through in his journal: "I write this chewing a dry piece of bread with nothing else (fortunately left over from dinner) – Downstairs – [Kenneth] Graham sits – eating a large full-course dinner. He is spending money as fast as he can – drinking continually – money that was left to him – The irony of Fate! That Graham – the waster – should be left money to squander! Where is the hand controlling these things?"[10]

When he returned to the Hopfs' apartment after an absence of two weeks, he had forty cents in his pocket. But there was a letter waiting for him from his friend Rudy Renzius containing three dollars.

Leonard now decided he would return to Toronto as soon as he could raise the money. First, he reluctantly asked his parents for help. Then he wrote to three men, enclosing sketches and asking them to send him money if they wanted to keep the work. The letters went to Lawren Harris, prime mover of the Group of Seven whose independent wealth came from the Massey Harris agricultural equipment company; Toronto art patron A. John Hind-Harris; and British painter Frank Brangwyn, who had visited his show in London earlier in the year. Harris and Hind-Harris ignored his letters, much to Leonard's disgust, but Brangwyn, who had spent time in Spain himself as a youth, encouraged him. He wrote back on 29 July, "I am sorry to hear that your money up. Best way to get back is to get to Bordeaux and take the Steam Navigation Co. ship to London. PS Many thanks for the sketch. If there is a bridge in your parts, send me a sketch." There were many bridges in the area, so Leonard quickly got off a sepia sketch of one of them.

While he waited to hear again from Brangwyn, the mails brought some good news. Jack Bingham, who had been in touch with Leonard's parents, reported they were beginning to appreciate his ambitions. "They are proud of me," a satisfied Leonard wrote.[11] The other was news that Bill Haynes had collected twenty-five dollars from former colleagues in the boyswear department of Eaton's and sent the money to London.

By mid-August Leonard had received a registered letter from Brangwyn with a postal order slip to pick up nine pounds he had sent. After trudging down to Martinet several times over a week and finding the money had not arrived, Leonard wrote Brangwyn again, enclosing a lino cut as well as the postal slip.

On a trip back to Barcelona he found a letter from his parents containing twenty-five dollars. He wrote back immediately, 29 August, addressing the letter to "Dear Dad and Mum" but only referring to his father in the text:

I am a self-centred person – But, Dad, it's a lone game – and the stakes are high – and I'm playing them to the limit – and so far I'm the first to admit the winnings have been small – rebounding too often on others – and dragging in you who certainly should not be involved.

But Dad – I feel certain something will come out of these struggles – and they *are* struggles – I could be much easier served by the existence of T. Eaton Co.

I look in the mirror and see an intelligent eye (sometimes) – Mum's eyes! – my impulsiveness and quiet nervous actions – Mum again – and sober reflection and that streak of common sense I've got – you – down through the firm-lipped strong-minded women I saw in Enfield – who looked me over and said, "You look as if you've got some stuff in you."

So Dad, if you can make anything of this scribble – I want you to know that though I am wandering about – and seem to disregard you all – except to my own selfish ends – bear with me – and realize there is a destiny and a scheme behind all of these things – and that I can thank the Gods I am a Brooks – and perhaps someday can make that name mean something more than it is now – and reward ourselves at the same time for a few of the comforts of life – and the security – so illusive – that I cannot get while I am so young in this game.

Then came another letter from Frank Brangwyn: "I have made a claim at the post office for repayment so do not bother anyone. I will try to get some Spanish notes. In any case I can get them in London. I will post them in a regular envelope which, I hope, will do the trick." By mid-September Leonard had received four hundred pesetas – about eighty dollars – from Brangwyn. He had also sold a watercolour to the British consul for twenty dollars and the mother of a violinist he met bought a Chelsea sketch for three dollars. Now he had enough money to buy a new pair of corduroy pants and a suitcase.

On a final trip to Can Carlos to pick up his belongings, he bid his farewells to the Hopfs and said, under his breath, "Goodbye, Hitler Youth." He caught the Sunday train in Puigcerda, near the border, but because of the holiday, no currency exchange offices were open on the French side where he could change pesetas into francs. He was told a Madame Bouland could help him, but he was unable to locate her. So he stood in the middle of the street shouting, *"Change la monnaie, change la monnaie."* Finally someone took the crazy foreigner to Madame Bouland's and two hours later he was on his way to Paris, London, and home.

~ 8 ~
*T*raffled off your paintings

The Leonard Brooks who arrived at London's Victoria Station at 9 o'clock on a September morning in 1934 was far different from the young man who had played his violin there for coins just six months earlier. He looked older, for now his red-tinted beard was fuller; he was harder and leaner from physical labour at the Mazdaznan farm; and increasingly he was becoming the handsome man to whom women were attracted. But the most important changes could not be readily perceived. The independence he had shown since childhood had been put to the test in Spain, where he had been truly on his own: a resourceful, penniless artist living by his wits and captivating people with his boyish enthusiasm and disarming personality. Those he met in Spain felt compelled to help him, a second-hand shirt here or two pesetas slipped into his hand there. His two suitcases contained paintings the likes of which he had never done before, forced to improvise for lack of supplies but inspired by the landscape and the colours of Spain. As he stood in front of the station waiting for the King's Road Chelsea bus, he must have felt confident of his artistic skills and pleased with his ability to survive in a sometimes hostile environment.

Normally Leonard would have sought out Evan Greene for a place to stay during his stopover in London. But his letters had gone unanswered. Kenneth Graham had told him of a house at 47 Bramerton owned by Cecilia Hamilton, another one-time model of Augustus John. "She'll give you a place to stay," he had assured Leonard.[1] He now alighted from the bus and made his way there.

Miss Hamilton came quickly to the door. "She did look rather the 'queer duck' Kenneth had told me about," he wrote in his journal. "She had a kindly and not wrinkled face under an old-fashioned black grannie bonnet the kind my English grandmother used to wear when I was a child."

Like her friend Lillian Shelley, who had given Leonard a couple of pounds when he left for Spain, Miss Hamilton had a weak spot for artists and writers. The only available space she had was a room off the hallway under the stairs with a window which looked out at what had been the garden of Charles Kingsley, a Victorian writer. It had a cot and a wooden box on which stood a wash basin and jug of water. "It was perfect, a cocoon, a harbour out of the storm, a life-saving hideaway for a romantic poet or artist," he told his journal. It also turned out to be a place where he entertained overnight an unnamed lady friend, probably Cynthia Bowen.

Cynthia would have been the person who apprised Leonard of Evan Greene's whereabouts. He was in jail, charged with beating up his girl friend and future wife, May Gannon. Leonard was not surprised. After Greene's release, they ran into each other several times in a pub, but the close bond between the two young men had been broken.[2]

Leonard took his *Wanderlust Year* manuscript to Cecil Palmer, a publisher to whom he was referred by an Irish writer he had met in Spain. Judging by early references to the manuscript, it must have contained over 50,000 words by then. Palmer rejected the work, which never found its way back to Canada.

Leonard held a watercolour show at the Lombard Restaurant, 65 Cheyne Walk, Chelsea. He displayed works of Chelsea, Sussex, Paris, and Spain. Miss Hamilton, who would boost Leonard's morale with tea, toast, and tales of her early life with artists, put on her best bonnet and shawl and arrived at the restaurant before any of the invited guests. "She brought a bunch of flowers and went about studying the drawings I had done of Whistler's house, the Battersea Bridge, and Turner's old haunts," Leonard wrote. He sold enough works during the show, which ran 2–31 October 1934, to buy passage back to Montreal with enough left over to pay for his room at Miss Hamilton's. But when she refused to accept any money, Leonard took one of his best water-colours of the Chelsea Embankment, matted it and presented it to her. He would see the painting again a decade later.

One visit Leonard never made, an omission that would bother him for the rest of his life, was to Frank Brangwyn to thank him personally for his mone-tary rescue efforts. Brangwyn would have known of Leonard's presence in London because of the show, which was mentioned in *The Times*. "My great regret is that I never went to see him because he asked me to," Leonard recalled. "I felt ashamed since he had helped me so much. It was like I didn't want to impose on him." When Sir Frank died, his executors wrote to Leonard. They had found some of his paintings in the estate and wanted Leonard to give them some background on the works. He did.

One of those paintings, a small oil entitled *Lake Story*, eventually ended up in the possession of Frank Lewis of F. Lewis Publishers Limited, Leigh-on-Sea, England. Many years later, when he was about to publish a book of Brangwyn's paintings, Lewis wrote to Leonard: "I have seen one or two illus-trations of your work, and admired them – and having one or two friends in Canada, I am told that you are one of the leading Canadian painters – at all events your little oil that we have gives my wife much pleasure."[3]

There was one negative aspect to Leonard's experience in Europe. The hand-to-mouth existence and days of poverty scarred him for life. Leonard would

often hark back to this period as the reason why he was never able to fully enjoy the wealth he later achieved: he could not bring himself to spend money on other than necessities.

Leonard made his third trip to Canada in November 1934 aboard the *Ausonia*, once again in steerage with immigrants as fellow passengers. The shy, sexually inexperienced youth who had arrived on a fetid cattle boat sixteen months earlier was now a worldly young man who romanced and shared his bunk with a fellow steerage passenger, a tall Czechoslovakian girl. Smitten with Leonard and impressed by his painting, she slipped up to the second-class deck and spread the word there was an artist in steerage. An Irish passenger was intrigued, sought out Leonard and asked to see his works. "I'd like to hold a raffle," he said. "Just give me a couple of your paintings." Several days later the man returned and gave Leonard twenty-five dollars. "I raffled off your paintings," he said.4 Once the ship docked in Montreal, the romance was over and Leonard and the girl were never to see each other again.

Bill Haddock, a colleague from Eaton's art department who now worked in Montreal, met Leonard at dockside and took him back to his apartment. Upon seeing Leonard's output, Haddock offered to help him mount a show at a local coffeehouse. Together they cut mats and prepared some forty paintings. A column in *The Gazette* of 17 November mentions the author had been "walking down Church Street, on my way to see the charming sketches in oil and watercolour of Leonard Brooks, the young Toronto artist whose work has been praised by Brangwyn." Leonard sold eight or nine paintings.

Leonard's next show was back in Toronto less than a month later. By then, he had met Reva Silverman, who helped him organize his show and then his life.

~ 9 ~

No wealthy parent bolstering his courage with monthly cheques

Leonard Brooks was in Spain when the news out of North Bay stunned a world looking for something to cheer about during the depths of the Great Depression: on 28 May 1934, Elzire Dionne, a twenty-five-year-old mother of six children living on a farm near the little village of Corbeil had given birth to quintuplets: Annette, Cécile, Emilie, Marie, and Yvonne. Before joining his

parents for his first Christmas back from Europe, Leonard asked the Toronto *Star Weekly* if it would like a painting of the Dionne home. Armed with a commission, he borrowed his father's 1929 Chevrolet and drove half an hour southeast of North Bay to Corbeil. There, in weather so cold he had to paint with mittens on, he did a watercolour of the two-storey, snow-capped clapboard farmhouse, *A Famous Birthplace.* Nell and Herb had mentioned the quints in letters to Leonard in Spain, but unable to read Spanish newspapers or magazines, he was unaware of the worldwide renown of their birth. So when he sold the painting, he did not realize its potential worth. Mr. Vincent of Vincent & Hughes, a picture framing company at 156 Yonge Street, obtained world distribution rights to the painting from the *Star* and ordered thousands of printed copies in two sizes for framing. Vincent gave Leonard some frames for his participation as well as train fare and lodgings in Chicago where he went to oversee the printing. But he received very little of the profit generated. "I was so disgusted that I threw out all the copies and never kept a single one," he recalled. The original painting ended up on display in the Dionne Quints Museum in North Bay.

While at his parents, he wrote an article for the local newspaper, *The North Bay Nugget*, in which he expressed his gratitude to North Bay. Entitled "Incomparable North," the article said in part:

I have sketched Constable's birthplace at Dedham ... have drawn the sizzling sun-baked landscapes where in Majorca George Sand and Chopin once lived. But did it stir me to the depths I reach when I see the multicoloured sleigh drawing birch-wood along the snowy winding road that leads from Trout Lake, that wood from trees I have loved as a boy, that sleigh I have had rides on, that road I have tramped along so many times as a youngster going hiking or hunting?

No ... [I] had to come back to the land I know, and the cold invigorating winter days, the patterned solemnity of a cedar grove at sundown, to really find myself. I have a criticism before me of an exhibition I held in Toronto. The critic writes, "will he survive the whirlpool of European influence?" I think I can answer his question now. It was necessary to go away, to study abroad, to find by contrast the true meaning of "incomparable north."

Leonard was a bit harsh in his comment on press reaction to the December show that Reva had helped him prepare upon his return to Toronto from Europe. The reaction was favourable. *The Globe* (it was not yet *The Globe and Mail*) said: "Londoners and those who have felt the mysterious, enthralling lure of that city at the heart of our Empire will be gratified

by the art exhibit of Frank Leonard Brooks, a Canadian-born *[sic]* artist, who has travelled far. The colouring and style employed by the artist is definite and clear, harmonious in effect, and pleasing and suggestive to the eye."[1] *The Toronto Star* reported, "These studies give an intimate delightful glimpse of the 24 months' wanderings of the painter in France, Spain, and England."[2]

When he returned to Toronto after the Christmas holidays and started dating Reva, he found that she was moving in the very society to which he aspired. Reva had found her secretarial job at Rogers Radio Tube through a high school classmate's mother who was a cook at the home of the company founder, radio pioneer Ted Rogers. Soon after joining Rogers, Reva was appointed secretary to Henry W. Parker, vice president for research. She would hold that job for ten years, reaching a salary of eighteen dollars a week.

Colleagues at work, Maude Watts and Fred Haslam, introduced this bright young lady to artist Barker Fairley and his wife. The Fairleys invited her to meetings on Isabella Street of the Theosophist Society, a New York-based movement based on Brahmanic and Buddhist teachings. There she met the Group of Seven's Lawren Harris, who had ignored Leonard's plea for help when he was stranded in the Pyrenees. Located in the same building was the Literary Society, which also attracted Reva to its weekly meetings. There she met poet G.D. Roberts.

Even when she moved out on her own, Reva felt duty-bound to the family. Since Rogers was located at 100 Sterling Road, not too far from her parents' home, she was able to lunch every day with her mother and siblings, avoiding her father. She also gave part of her weekly paycheque to her mother.

Reva bought her family their first radio set, so they were able to listen to "Fibber McGee and Molly," "Jack Benny," and "Fred Allen" on CFRB, the Rogers radio station. It was the first radio set in the neighbourhood, so neighbours would drop by to listen to the programs. One day she brought home a puppy for the family. But always she was the second mother to the youngest, listening to their complaints and correcting their English. "There was a sense of duty," said David, the brother closest to her.[3]

The money from his December show long gone, Leonard had to resort to the ingenuity he had shown in England and Spain. One of his ideas – bartering paintings for anything saleable and of equal value – was so novel that his friend, art critic Kenneth Wells, wrote about it in *The Toronto Telegram*: "Surely among the many who will go to [Brooks'] unique exhibition with the idea of picking up a bargain there will be at least a small percentage of

those who believe that the artist, like the workman, is worthy of his hire. The gesture is courageous enough, and unique enough to warrant substantial support."[4]

Leonard was joined in the barter, held at August Strodayak's Village Gallery, by a handful of colleagues. Among other items, Leonard ended up with a can of oil for his father's car and a rug for the apartment at 667A Spadina Avenue where Reva would soon join him. Millionaire collector Charles S. Band left twenty dollars for the only oil painting Leonard had done in Spain. Leonard was angry with Strodayak for letting it go for so little and tried vainly to retrieve it. Years later, Band invited Leonard to his home in Rosedale and showed him the painting. "He was gloating about getting it so cheap," said Leonard.

The publicity from the show spawned interest in Leonard and brought commissions for murals in four restaurants, Swiss Chalet, Little Italy, Little Denmark, and Angelo's, in return for meals. A man who claimed he owned a hotel in Sudbury, Ontario, asked Leonard to do a mural there. What Leonard found was a barn that needed shingling. Broke, he worked on the job in the hot sun for several days before telephoning Reva and explaining his predicament. "I sent him the money to get back," recalled Reva.

Bill Finlayson, whose father was Ontario Mines minister, at this time bought many of Leonard's paintings, which he eventually donated to the Art Gallery of Ontario. Finlayson was to become director of the gallery. Another person who helped struggling artists – among them Leonard – was Douglas Duncan, who opened a picture-loan business. Artists borrowed money against the expected rent, or even sought loans with no collateral. When Duncan died, artists' cheques that he had never bothered to deposit were found stuffed in drawers.

The Toronto Telegram's Wells leapt to Leonard's defence in a dispute with the Canadian National Exhibition. Leonard had submitted a painting to the Fine and Graphic Arts summer exhibition, but was told that Fred S. Haines, the exhibition's art director, had received too many submissions. Leonard was advised to try again the following year. Wells, in a column in *The Toronto Telegram* 7 July 1935, told Leonard's story:

He comes back to Canada and Toronto and attempts bravely that which compared with biting the moon is nothing. He attempts to live by his art. He has no wealthy parent bolstering his courage with monthly cheques. He has no social background that would enable him to suck undeserved commissions out of his friends and acquaintances. He has no job in a gallery or museum to provide him with food, rent, and clothes. He has

nothing but his youth, his talent, and his courage. Surely he is deserving of, if not actual support, at least sympathy.

Wells must have worked with Leonard on the column because it accurately reflected the artist's view that those with social graces and wealthy parents enjoyed an unfair advantage in the race for recognition in Canada. Wells quoted from a letter Leonard had written him: "As a young man devoting all my time to the art of painting, I resent the fact that I am not even allowed to submit my work, while those tender young things who have such a pleasant time playing 'arty' – generally with the aid of a blank cheque on the family account – are given room for their miserable experiments."[5]

Haines himself was moved to reply to Wells' column. He said invitations to submit works for the exhibition were sent out in June by an "impartial committee" that had visited the Royal Canadian Academy, the Ontario Society of Artists, the Canadian Society of Painters in Water Colour, and the Society of Graphic Art, and that Leonard had only applied in July.

One reason why Leonard had good relations with Toronto journalists was that he himself was writing. The *Canadian National Railways Magazine* in its March 1935 issue published "Pyrenees Nightmare" about Leonard's train trip to Paris. He was paid thirty-five dollars. The Toronto *Star Weekly* also paid him thirty-five dollars in May for "Knapsack and Ropecoil" which told the story of his trip to Majorca.[6] Leonard said that he envisaged himself as another Ernest Hemingway, *The Toronto Star* correspondent who a decade earlier had departed for Europe where he set his first novel, *The Sun Also Rises*, in Spain.

~ 10 ~
Gentlemen, give me a test

No Canadian artist at this time could live solely from sales of his or her works, not even members of the Group of Seven, who had begun to exhibit together in 1920. As often happens with Canadian artists, actors, and writers, the group earned the accolades of critics in New York, London, and Paris while being ignored or ridiculed at home. Disbanded in 1933, the group would take years to become the icons of art in Canada. Yet, during their

lifetime, few were able to live on their art; they either taught or worked as commercial artists.

Leonard Brooks faced the same dilemma, but in his case the options were more limited. He never considered himself a good illustrator, so he could not seek employment at Sampson Matthews Limited or Brigdens Limited, the major creators of advertising art in Toronto, or the printing house of Rous and Mann, which also hired artists. That left teaching, but Leonard had not even finished grade nine, let alone attended university. A painter friend who taught at Northern Vocational High School in Toronto, Luke Bradley, suggested as a first step that Leonard try to obtain his high school equivalence. Leonard asked Ivor Lewis, his old boss at Eaton's art department, to write a letter of recommendation to the Board of Education. Stretching the truth a bit, Lewis said Leonard had worked as a commercial artist from 2 November 1927 to 19 June 1931, a period that included Leonard's work on the Trans-Canada Highway and clerking in boyswear. "During this time he made good progress and gave us real satisfaction with the commercial art he produced," Lewis wrote. "We found him clever, reliable, and industrious."

Armed with the letter, Leonard successfully pleaded his case before the board. He asked to be credited with the equivalent of a high school matriculation, based on life experiences, so he could study for a teacher's certificate. "Gentlemen, give me a test," he asked. "You'll see that I have, in my own way, acquired an education in Europe that no high school could give me."

Leonard enrolled for the fall term at the Ontario Training College for Technical Teachers in Hamilton, Ontario. During the week he shared a room in a boarding house with a Toronto friend, Cory Brigden. Both good writers, they teamed up to produce a class newspaper. Leonard thoroughly enjoyed the classes at the red brick school, especially those on teaching techniques and psychology. Leonard and Brigden were only two of five students seeking a certificate to teach art. The other two dozen were involved in home economics, carpentry, auto mechanics, and similar subjects.

At a time when all jobs were scarce, Leonard was hired by the one school where he wanted to work: Northern Vocational. The only other post open in the province was in Hamilton. Northern Vocational, located at 851 Mount Pleasant Road, was a new school that had started art, commercial, and technical classes just two years earlier and soon had more than 2,000 students. Samuel S. Finlay, director of the art department, interviewed Leonard and hired him on the spot to start in September at a salary of $1,800 a year.

Leonard and Reva left the tiny Spadina Avenue apartment and rented a house at 55 Roehampton Avenue, just two blocks from the school, for the

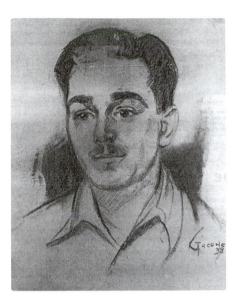

A charcoal sketch of Leonard, the high school art teacher, by Evan Greene, 1938.

BRIDLE & GOLFER
JAN.-FEB. *1939.*

munificent sum, for the Great Depression, of fifty dollars a month. He also bought his father's '29 Chevrolet for six hundred dollars, payable in instalments.

Either the $1,800 looked like a lot of money to Leonard, or, like most men of the day, he felt that a woman's place was in the home. He insisted that Reva quit her job, then paying eighteen dollars a week, half what he was making as a teacher for ten months' work. "You had to look after me," he reminded her in later years. "You had to make my lunch; not only that but you helped me with my paintings." Reva became, in effect, Leonard's business manager, a role for which she would be praised by some and criticized by others for more than sixty years. Much of their social life would be geared to promoting Leonard, a not unworthy objective given the need to sell his paintings and enhance his reputation.

Pianist Naomi Adaskin, who became one of her best friends, marvelled at Reva's efforts on Leonard's behalf. "There aren't many women who can help their husbands as much as she did," she said. "He really did appreciate her because he did absolutely nothing – but nothing – about the financial and selling ends, which are distasteful in a way to most artists."[1]

But poet Miriam Waddington, another close Toronto friend, termed "persistent and blatant" Reva's promotional activities. "Reva was very ambitious," she said. "She was one of those childless women who did not live through herself, but through the success of her husband."[2]

Leonard's teaching load left little time for painting. Artist William Sherman recalled him pacing about room 322, constantly glancing at his watch as the

day drew to a close. Northern Vocational was then practically on the outskirts of Toronto, so it did not take Leonard a long drive to find the landscapes he wanted to paint.

Leonard could not always slip away easily. He had to monitor football, a sport about which he knew little, and teach several night classes. He also played in the school orchestra and taught music to some students, a pleasure rather than a chore.

When he started teaching he was twenty-six, not that much older than some of his students. Having had a truncated education at the Ontario College of Art, he found he himself had to study just to keep ahead of his students and to present the teaching plans required by a committee of his peers. "How can you construct geometrically the shadow of an oval thrown on the ceiling? I'd have to go to the library and get out books on geometrical perspective I hadn't even thought of in my life," he recalled.

Having a young, inexperienced teacher, many of the male students challenged Leonard's authority. His response was to be a disciplinarian, grabbing by the scruff of the neck any student who acted up and marching him to the principal's office.

Leonard counted among his admirers many female students, even ones who did not attend his classes. They would stand in the doorway and ogle him. "He was a very handsome man," recalled former student Mildred Selznick, whose future husband, Morris, would become Reva's gynaecologist and probably saved her life. "All of the women at the school were gaga over him in those days."[3]

Leonard developed a trait that would remain with him: he would devote his energy to those students who showed promise and shared his dedication to art, ignoring or giving short shrift to the others. He invited the promising ones to go sketching with him, such as Thomas Chatfield, Gordon Laws, and Murray Stewart. Stewart recalled that outings with Leonard were not without risk as he seldom looked at the road when he drove; he was searching for places to sketch. "I was afraid we were going to go into the ditch before we got back home," he said.[4] Stewart credited Leonard with instilling in him a love of the Canadian landscape.

Laws recalled Leonard taking him to the Don Valley to sketch. "I didn't have much money in those days and he gave me watercolours and everything to paint with, took me to his home, introduced me to Reva."[5] Chatfield recalled being in awe of the speed with which Leonard painted on their outings together. "My God, how could he do it so quickly?" he asked. "He had a beautiful colour sense. He always made it quite spectacular."[6]

Christopher Chapman, another student, was unsure about continuing as an artist. But he found Leonard appreciated his creativity and encouraged him as he went on to become a successful filmmaker. "He has always appreciated what I've done in film," he said.[7]

Ironically, the only former student the author interviewed who did not praise Leonard as a teacher was the school's best known graduate, James Houston, the discoverer of Inuit art, a novelist, and fine painter in his own right. "He wasn't interested in the students," he said. "If you wanted to know anything about watercolour, you had to ask him."[8] Since Houston attended the school during Leonard's first year as a teacher, he probably had not yet acquired the ability to reach out and connect with the promising students.

Leonard was to enjoy teaching a lot less the following year. Samuel Finlay stepped down as director of the art department. He was replaced by L.A.C. Panton, an Englishman seventeen years Leonard's senior who had emigrated to Canada in 1911 and took night classes at the Ontario College of Art while working as a bookkeeper.

A man who always questioned authority, Leonard was fated to have a confrontation with Panton, who was unlike him in so many ways. Leonard was very casual while Panton was very formal. Leonard tended to have a sloppy workplace while Panton was a fusspot. "A caustic wit and a driving work schedule did not always endear him to his co-workers in the arts, though it may have ultimately benefited his hard-working students," Leonard wrote of Panton.[9] The director always addressed Leonard formally as "Mr. Brooks" in countless notes and in personal conversation. "Mr. Brooks, have you observed that the floor of your teaching room is a little dusty this morning?"[10]

A blow-up occurred when Panton left a note commenting on the broken handle of a clay pot used for still life. Marching into Panton's office, Leonard demanded, "Did you put this note on my desk, Alex?" purposely addressing him familiarly. Panton looked aghast as Leonard smashed the pot on the desk in front of him. "I quit," he said, walking out. Panton made the first overtures for his return, but it was not until Leonard had talked over the situation with Reva that he finally agreed to go back, provided he be addressed as Leonard and not Mr. Brooks and that Panton not observe his teaching.

Artist Cleeve Horne, who knew both men well, said, "Panton was very demanding, both academically and professionally. He gave Len a rough time at the beginning."[11]

The two men eventually came to understand and respect each other's idiosyncrasies and developed a friendship of sorts. When Panton became

principal of the Ontario College of Art in 1952, he invited Leonard to join him there. However, by then Leonard no longer wanted the confinement of the classroom.

∽ *11* ∽

I didn't want to be stuck like A.Y. Jackson

Had the term been in use then, Reva and Leonard Brooks might have been considered among the "beautiful people" in the latter half of the 1930s in Toronto. They were young, handsome, talented, intelligent, and moving into a social circle of like people. Wealthy they were not, but Leonard had a guaranteed income as an art teacher during the Great Depression when jobs were scarce. Their friends had names that would become well known in artistic, literary, and musical arenas: Adaskin, Birney, Mazzoleni, Sumberg.

One of those young, rising figures played a key role at this point in Leonard's career. Just two years older than Leonard, Gavin Henderson was already running the Fine Arts Gallery at Eaton's College Street store, the very store where Leonard had his brief sales career in the boyswear department. Leonard was one of the first persons Henderson met after emigrating from England in 1935. United by their common birthplace, the two men became friends and fishing buddies.

Leonard's major source of income during their first year of marriage was from etchings, done on a press built by his former landlord, George Hollowell. Leonard sold the etchings for five, ten or fifteen dollars each. Once Henderson bought thirty etchings for framing and sale by Eaton's. If Leonard was in need of money, Henderson would help by buying for himself a sketch or two for ten or twenty dollars.

Shortly after meeting Leonard, Henderson hurriedly organised in 1935 the first of what would be seven one-man shows at Eaton's over the next eight years. Said *The Toronto Star*: "Leonard Brooks, young Canadian artist, has found his native land a vigorous subject after the contrast of two years abroad." The following year Henderson mounted the first major exhibition of Leonard's works. The review in *The Toronto Star* could not have been better. Wrote critic Augustus Bridle:

Star readers know Brooks' paintercraft from a number of graphic stories about his hard-luck wanderlusting. These are on display with the paintings which – both Canadian

and foreign – show amazing vitality of painting medium. Brooks goes as near the palette-knife gob technique as any artist can who cares for pastoral beauty as a foil to the gloriously ugly. These paintings are wonderfully stimulating, by a Canadian who learned in weary old artist-ridden Europe something of the ecstasy and vigorous enchantment that makes a Canadian shack, country road or clump of trees sing and shout with joy.[1]

According to the Eaton's ad, the works sold for $12.50 to one hundred dollars framed. Although they were department stores, Eaton's and, to a lesser extent, Simpsons, operated important art galleries. Aside from a few minor galleries, like that of J. Merritt Malloney's, the only stand-alone gallery in Toronto in the 1930s was the Roberts Gallery, then on Grenville Street. Founded in 1842, it was the oldest art gallery in Canada, if not all of North America. Most artists sold through their associations: Royal Canadian Academy of Arts, which was subsidized by the federal government; Ontario Society of Artists, which received provincial funds; Canadian Society of Graphic Arts; Society of Canadian Painter-Etchers; Canadian Society of Painters in Water Colour; Canadian Group of Painters; and the Arts and Letters Club. The shows were usually held in public galleries like the Art Gallery of Ontario. Most organizations accepted or selected submissions from members and non-members alike for their shows.

Besides launching his teaching career in 1937, Leonard was busy that year with exhibitions, all of which brought him favourable reviews. The first was a show of the Society of Canadian Painter-Etchers, which Leonard had joined at age twenty-three. Commenting on the show, *The Toronto Telegram* said: "The clear and cool lighting of Leonard Brooks' *Bleak Shore, North Bay* brings one back again and again to this beautiful treatment of an austere theme."[2] *Saturday Night* magazine, in its May issue, said: "Leonard Brooks manages to convey in his aquatints the succulent quality that distinguishes his oils."[3]

Leonard joined the company of Arthur Lismer, Lawren Harris, and A.J. Casson of the Group of Seven for a show of Commonwealth artists held at the Royal Institute galleries in Piccadilly. All told, 430 works were presented. W. T. Cranfield, the London correspondent of *The Toronto Telegram*, singled out Leonard for recognition. "One of my personal favourites in the exhibition ... is by [an] as yet unhonoured graduate of the Ontario College of Art. I refer to Leonard Brooks's *Creek in Winter North Bay*. Here you have a true artist's reaction to a scene of desolation, his triumph over death by extracting beauty from the banal in one of Nature's less pretentious latitudes."[4]

William Colgate, writing in the October issue of *Bridle & Golfer*, gave Leonard an encouraging review for his one-man show at Eaton's in the fall of 1937: "Improvement shows itself, especially in the handling of his colour, indicating a gradual mastery of his medium."[5]

At age twenty-five, Leonard was called a "rising young Canadian artist" in *The Toronto Telegram's* review of the Eaton's show: "When Mr. Brooks studied in Spain three years ago, he doubtless did not know that the civil war there in 1937 would add zest to his collection of Spanish sketches."[6]

Of all the friendships Leonard and Reva made at this time, none would be more important than that with poet Earle Birney and his wife Esther. Leonard would henceforth refer to Earle as his best friend and Reva would do the same with Esther. Both Leonard and Earle were in London in 1934, but their paths did not cross then. A future faculty member at the University of Toronto and the University of British Columbia, Birney was there researching his doctoral thesis on Chaucer when he met Esther Bull, British-born daughter of Russian-Jewish parents. Both had been previously married. Both were communists and fervent supporters of Leon Trotsky, who had split with Josef Stalin after the Russian Revolution. Birney, who had been a communist organiser, met with Trotsky in Norway in 1936, the year he returned to Canada with his new wife.

"I don't remember when we met but it was probably at an 'evening' somewhere," recalled Esther. "Reva and I, sharing a similar background, Jewish, immigrant parents, love of art and books and so on and a genuine liking for each other, quickly became friends, and as our husbands appeared to get along well we often had meals together and met at gatherings of university and leftish people."[7]

Leonard and Earle also had similar backgrounds. Both were of English stock, although Earle was born in Canada. Both came from families of modest means. Both had strong, domineering mothers, "critical, non-joyous, non-intellectual."[8] Earle was an only child as Leonard had been for nine years. Both were highly charged and had creative energy. Both had explosive tempers. Both were basically shy men. The main outward difference was that Leonard was a high-school dropout while Earle was a Ph.D. But both men could speak knowledgeably on a wide range of subjects. "They communicated in a way that was exclusively their own," said Wailan Low, Earle's third and last wife and now a justice of Ontario's Superior Court.[9]

The Brooks moved several times over the first couple of years of married life, from Roehampton to 163 Rochester Avenue, even further north, then south to Governor's Mansion on Douglas Crescent in Rosedale, until they established themselves at what became a popular address for artists, writers and musicians,

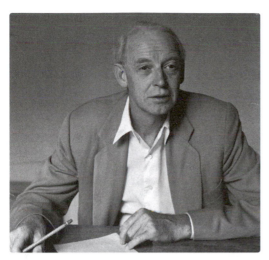

Esther Birney, Reva's best friend, whom she met in 1938.

Poet Earle Birney, Leonard's best friend and lifelong soulmate. "They communicated in a way that was exclusively their own."

39 Boswell Avenue just off Avenue Road. They rented the top two floors of a three-storey brick house for twenty-five dollars a month. Leonard's studio was under the street-side gable, while in back was a small guest room.

Birney reminisced about being with Leonard at the Boswell apartment:

I still remember ... evenings in the thirties when we sat in his diminutive attic studio on Toronto's Boswell Avenue, and I pored over many fat sketchbooks and hundreds of loose drawings, pastels, washes, etchings. Much of that work he had done when a wandering and sometimes penniless teenager in London or Paris, or stranded in the Valley of Andorra.

There was also a pile of newer watercolours and sketches of Ontario towns and countryside, developed from roughs made over weekends stolen from his heavy teaching duties in a Toronto high school. All of that work seemed to me then, as now, to have already the mark of his sensitive, energetic and perceptive personality.[10]

Among the regulars at Boswell Avenue were Naomi and John Adaskin. She was a concert pianist and he was a cellist with the Toronto Symphony Orchestra, as well as being the first program director of the Canadian Broadcasting Corporation (CBC). Naomi gave piano lessons to Reva, as did Ettore Mazzoleni, director of the Royal Conservatory of Music in Toronto. The Adaskins and the Brooks met at the home of Toronto Symphony violinist Harold Sumberg, who also became a regular at Boswell Avenue. Not to be outdone by Reva, Leonard took violin lessons from Sumberg.

"One of the pleasures of going there was the people you met and you could laugh with them," said Esther Birney. "Reva did not have a sense of humour. If you don't have one thing, you have another, and she had patience, warmth."[11]

Reva, Esther, and Naomi were very close. "We were like a trio," said Naomi, "husbands and wives, because Earle had a delightful sense of humour, as also did my husband, John, and Leonard too. Leonard and Earle were a scream."[12]

The Group of Seven's A.Y. Jackson was a dinner guest, while fellow member Fred Varley would live for a while at Boswell when he was down and out. Charles Jefferys, well-known illustrator of Canadian history textbooks, was also invited.

While the Brooks lived on Boswell, Reva's mother would send over meals with one of the children, usually on Friday. George, Sophie, and then David would lug over bags and pots and jars, doing the round trip on foot in about an hour, no matter how cold or hot it was. "One snowy night I went over and my toes got frost bitten," recalled Sophie.[13]

Besides taking over food, George would make the rounds of art galleries with Reva to see if there were any damaged or old frames they could salvage for Leonard's paintings.

Money was especially scarce for the Brooks during the summer vacation when Leonard was not paid. He would usually take out a loan of $500, repayable when the school term resumed. During the summer, Leonard would paint on trips he and Reva would make. Twice Leonard painted Reva in the nude on such trips, once in 1936 when they stayed at Ivor Lewis's cottage on Georgian Bay, and again in 1938 when he attended American painter John F. Carlson's workshop at Woodstock, New York. Reva posed in the Big Deep, a favourite swimming hole near Carlson's art school.

The Birneys always felt that the Brooks were more than socialists. "Earle and I just took for granted that they shared our [political] opinions," said Esther. "We felt that they were sympathetic – we were Trotskyites – otherwise we couldn't have been close friends."[14] Leonard did attend one Communist Party meeting in Toronto at the invitation of a lawyer friend and was asked to write for the party organ, *New Masses*. "I wrote an article on how to do linoleum cuts," he recalled. "It had nothing to do with communism."

The need for additional income prompted Leonard to seek outside teaching work. He placed ads in the Toronto newspapers: "Leonard Brooks takes pupils, sketching and studio classes, drawing, oils, watercolours, private tuition; reasonable rates. Waverly 1370."

After one young man had inquired about lessons, Leonard discovered several sketchbooks were missing from his studio. He learned the fellow was

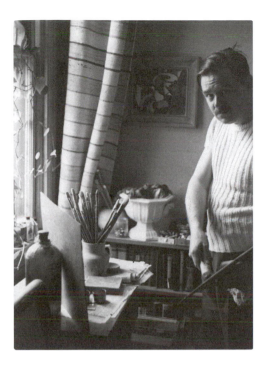

Leonard painting in his studio at 39 Boswell Avenue, 1938.

removing the sketches and selling them. "I found out where he lived and walked in and found all this stuff," Leonard recalled. "I got him by the scruff of the neck and beat the hell out of him. I just lost my temper. To do that to me was an insult."

A German who went to Leonard's studio to buy a painting found himself bouncing down two flights of stairs at Boswell Avenue. Not knowing that Reva was Jewish, he had started to spout anti-Semitic remarks, prompting Leonard to disregard the sale and physically eject the man.

One day J.W. Beatty, a painter and teacher at the Ontario College of Art, called Leonard down to 25 Severn Street, where he had his studio and where many of the Group of Seven painted. "We want you to become a member of the Academy," he told Leonard, then twenty-seven.[15] Leonard was elected 17 November 1939. "I did literally hundreds of panels and paintings on snow," Leonard said. "I was made a member of the Royal Canadian Academy on the strength of those."

Painting winter scenes required a bit of masochism. Leonard would mix his paints the previous night, very thin to impede freezing. Before dawn, he would be out awaiting the sunrise. If it were colder than 20 degrees Fahrenheit below zero, he would go home, because at that temperature his paints would freeze immediately.

After William Colgate praised his snow paintings in an article in *Bridle &
Golfer* magazine, Leonard made a major decision: "I decided to stop painting
snow because I didn't want to be stuck like A.Y. Jackson or identified with a
given subject. They called him Daddy Snowshoes." However, Leonard con-
fessed later that he did better work in winter than summer. "I don't do my best
work on summer landscapes," he said, "because summer is the grand illusion
that camouflages half the subtle beauties of landscape even more than snow
does."[16]

As the decade drew to a close, Leonard found himself a member of all the
major art organizations except one. A dream came true when Tom MacLean, a
commercial artist at Sampson Matthews, proposed his membership in the Arts
and Letters Club at 14 Elm Street. "When I was living on Grenville Street before
I met Reva, I used to see the 'Arts and Letters Club' used by artists, and I used
to dream, 'Arts and Letters Club,'" he recalled. "'Is there such a place in the
world?' If I could ever put my foot in that place. They were gods." He was also
elected in 1939 to the Ontario Society of Artists.

Membership in the societies was important for teachers, especially those
like Leonard who did not have a university degree. They were able to put the
initials of the societies after their names: Leonard Brooks, O.S.A., R.C.A.A.

Ironically, the one society he was unable to join was the one that addressed
his speciality: watercolours. "Because of Carl Schaefer and a few others, who
didn't like me or something, I was never made member of the Canadian
Society of Painters in Water Colour," he said. "Yet I became the most famous
watercolour painter of them all."

As Leonard's experience with the watercolour society showed, admission
was not automatic. While he blamed Schaefer for keeping him out, painter
George Broomfield blamed Leonard for doing the same thing to him in the
Ontario Society of Artists.[17] For Leonard, who used to go on sketching trips
with Broomfield, it was a question of the societies keeping high membership
standards. "Broomfield was a nice guy, but he wasn't a particularly good
painter," he said.

Leonard showed with the Ontario Society of Artists and the Royal Canadian
Academy in 1938. *Saturday Night* magazine used Leonard's *Before Snow* as one
of seven paintings on its cover. As well, Leonard participated in a show enti-
tled "A Century of Canadian Art" at the Tate Gallery in London, England.
Leonard submitted *The Creek, winter*, painted in North Bay in 1935. He later
donated it to St. Joseph's Hospital in North Bay.

Leonard exhibited outside of Canada again the following year in the
Canadian pavilion at the 1939 New York World's Fair. He was one of fifty-three

artists sponsored by the National Gallery and selected by the watercolour society. Sister-in-law Sophie Sherman later bought Leonard's painting – *North Bay in the snow* – for fifty dollars. The *New York Herald Tribune* on 25 June mentioned works by Carl Schaefer and Charles Comfort. "With these are several poetic landscapes by Leonard Brooks, Arthur Lismer and John Patterson, who make their observations in the conventional manner but with good feeling."

Leonard also received positive reviews that year for his one-man show of one hundred paintings at Eaton's gallery. Art critic Pearl McCarthy, writing in *The Globe and Mail*, said: "Leonard Brooks' painting is expanding in interest. His current exhibition at Eaton's-College Street is admirable and broader in scope than those formerly presented. The winter pictures, which we feared at one time might slip into a rut, offer varied approaches."[18] Augustus Bridle, writing in *The Toronto Star*, said, "Leonard Brooks opened a picture show at Eaton's today, which will be talked about, as paintings by a young artist who refuses to go freakish or just graphic, preferring to paint Canada with the energy of youth, not just as he sees it but as he feels it.[19] Said *The Toronto*

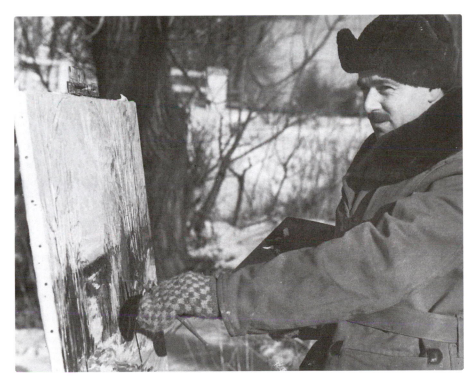

Leonard was well known for his snow scenes, c. 1939.
VICTOR CRICH

Telegram: "Mr. Brooks has developed a technique rather specially his own, very much concerned with solution of lighting problems."[20] *Saturday Night* said: "Mr. Brooks rings the bell about a half dozen times in a hundred sketches and canvasses – a pretty good average in this fallible world."[21]

The most prescient comment of the year was made by William Colgate in *Bridle & Golfer* magazine: "The lack of time and his inability to be at his etching and painting when he has finished the day and two nights teaching at school, may temporarily retard his progress as a painter. But he is perforce content to be a 'Sunday' painter for a time, for in Canada there are few who are not."[22]

The Second World War, which was just beginning, would change all of that for Leonard Brooks.

The War Years

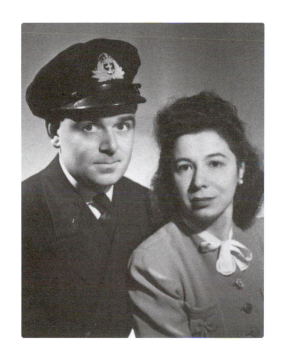

$\mathscr{I}t$ was devastating for Reva

Although Leonard Brooks did not enlist in the navy until 1943, he had been actively involved in the war effort at Northern Vocational for the previous three-and-a-half years. As soon as war was declared, the Toronto Board of Education assigned schools – especially technical schools such as Northern Vocational – the task of preparing students for their eventual military service with Cadet and National Defence Training. Teachers were encouraged to remain on the job and were trained to teach skills deemed necessary or useful for national security, such as aircraft identification. "I was doing more of that than teaching art," Leonard recalled.

But there were two other reasons why Leonard did not volunteer earlier for military service. He was hoping that Canada would appoint official war artists as it had during the Great War when Lord Beaverbrook, in charge of Canadian War Records, conceived the idea of employing painters to record the activities of the armed forces abroad. Secondly, Reva was hoping to start a family.

Meanwhile, Leonard continued to receive enthusiastic reviews for his exhibitions. Writing in *The Globe and Mail*, Pearl McCarthy said of his 1940 one-man show at Eaton's: "This painter has almost too much facility. The sketches and little pictures seem to jump precociously into being important."[1] Augustus Bridle of *The Toronto Star* said: "Leonard Brooks' exhibition ... illustrates the fact that a man who does art work all week at Northern Vocational finds time to paint enough pictures in a year to fill a gallery – and very few of them in summer holidays at that."[2] *The Toronto Telegram*, in an unsigned critique, said: "Mr. Brooks has been rapidly and steadily coming to the fore among the younger Canadian painters."[3]

As much as Leonard might have wanted to drop snow-painting, he was unable to do so, judging from two shows in March of 1941 which brought praise for his winter scenes. He appeared with his friends Manly MacDonald, Franklin (Archie) Arbuckle and Frank Hennessey at the then Art Gallery of Toronto. *The Toronto Telegram* said: "The most powerful of Mr. Brooks' inclusions is his *Northern Lake, Winter*, a large canvas, austere, massive, immensely interesting treatment involving blue shadows. We should say this was the strongest thing

Previous page: Moustache newly shaved off, Petty Officer Brooks poses with Reva, 1943.

Mr. Brooks has yet shown." Of Leonard's participation in the sixty-ninth annual exhibition of the Ontario Society of Artists, the *Telegram* said: "Leonard Brooks continues to be held in spell by the winter landscapes ..."

That summer, Leonard and Reva accompanied their friend Albert Franck on a sales trip to the Maritimes. The Great Depression had cost Franck his job in Simpsons art gallery, so he became a travelling salesman of picture frames. Leonard did amusing caricatures of the three of them for enclosure in the letters Franck sent his wife, Flory. Among the clients Franck introduced to Leonard was Leroy Zwicker, who ran Zwicker's Gallery in Halifax. Zwicker's was to become the first gallery to sell Leonard's works on a regular basis.

That same summer Leonard was among 150 artists, museum directors, critics, art historians, and interested laymen who attended the Conference of Canadian Artists at Queen's University, Kingston, Ontario, 26–29 June 1941. The conference was organized by André Biéler, resident artist at Queen's, and financed in great part by a grant from the Carnegie Foundation; the National Gallery in Ottawa also co-operated. Canadian artists envied their American colleagues who had been helped during the Great Depression by the Works Progress Administration, better known by its initials: WPA. Started in 1933 by President Franklin D. Roosevelt, the WPA's Federal Art Project earmarked for murals one percent of the funding destined for all new public buildings.

"American artists were getting murals to paint and stamps to design, so they were being pulled up out of the Depression," said Harry Mayerovitch, a Montreal artist, photographer, and architect who attended the conference. "There was no equivalent in Canada. So the Kingston conference was a kind of rallying call for artists to get the government involved in responsibility for the arts."[4]

The discussion at the conference centred on the role of the artist in society, a role well-defined in countries like Mexico, where many artists were political activists. When Biéler said, "The comparatively simple racial pattern of Mexico and its rich artistic background have enabled that country to develop a strong national art," did Leonard bury the words in his subconscious?[5] Mexico was to be his destiny.

The leading American artist invited to the conference was Thomas Hart Benton. "My idea of bringing Benton," said Biéler, "was not at all the style of his art but more on the style of the man, the dynamism of him, the feeling that with his tremendous personality he would be the one who could create excitement."[6]

Leonard and Vancouver sculptor Donald Stewart thought what Benton needed was a stiff drink after listening to their Canadian colleagues. Stewart told Benton they were going to invite a few artists up to their room. "Benton came

and stayed up all night, talking about art," recalled Leonard. "The next morning he got up with a hangover and Carl Schaeffer drove him back to the States."

A committee including Biéler and the Group of Seven's A.Y. Jackson and Arthur Lismer drafted a resolution. Out of this grew the Federation of Canadian Artists and eventually the Canada Council, founded in 1957.

When the Addison Gallery of American Art in Andover, Massachusetts, held a show 18 September–8 November 1942, entitled "Aspects of Contemporary Painting in Canada," it asked Martin Baldwin, Director of the Art Gallery of Toronto, to explain the position of the Canadian artist. He echoed the sentiments of the Kingston conference:

It is important to remember that these painters must earn their living by other work, for it also indicates the failure of a democracy to find a real use for its artists. True also of the United States and of England, this indifference to the artist is, in Canada, heavier, more stolid, mitigated only by the interest of the few. He wants to contribute to the life around him, to be part of it.[7]

Although not represented by the Roberts Gallery, Leonard was honoured as one of only thirty artists selected for its hundredth anniversary show 17 April 1942. Other artists included two of the Group of Seven, Jackson and Frank Carmichael. Sydney Wildridge, who owned and ran the gallery with his son, Jack, had earlier purchased one of Leonard's snow scenes.

Leonard at this time made his first sale of a major piece, to the London (Ontario) Regional Art Museum, then under the directorship of Clare Bice. Bice bought a 24- by 20-inch oil on canvas titled *Northern River*. There is no available record of the sale price.

Leonard also traded musical director Sammy Hersenhoren a 40- by 50-inch oil on canvas, titled *March Light* and painted in 1939, for a French violin. When Hersenhoren divorced his wife, Marion, in 1945, she wanted the painting as part of her settlement. Hersenhoren refused to give it up. Years later, Leonard wrote to Hersenhoren: "Yesterday I struggled through a Beethoven quartet with a group here on your violin which has been a constant companion to me for forty years now since we did that famous trade!! I have other violins, but it is still my favourite and I am so happy for the day you decided you'd like a painting of mine, and I needed an instrument."[8]

Reva, who always dreamed of having five children, must have felt abandoned by the fates when Esther Birney gave birth in 1941 to her only child, William, and when painter Cleeve Horne's sculptor wife, Jean, the following year had her first child. To Jean, Reva sent a flowerpot filled with earth with a

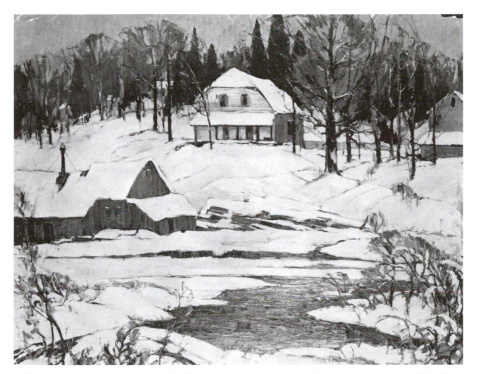

Yellow House, *a 40- by 50-inch oil on canvas, a snow scene that was instrumental in his election to the Royal Canadian Academy of the Arts in 1938.*

bit of moss sitting on top. She wrote on the attached card that she thought Jean would love to stick her fingers in earth after living in a sterile hospital environment. Not knowing what to make of the gift, Jean called Reva. "I knew you'd be thrilled by it," Reva said.[9] Her niece, Nancy Sherman, would say Reva was an environmentalist well before her time.

Then Reva found herself pregnant, but she wasn't destined to join her friends in motherhood. She started to haemorrhage and suffering severe blood loss was rushed to the Women's College Hospital where she needed several transfusions, but the pregnancy could not be saved. One of the blood donors was brother David.

Afterward, Leonard took David, who at fifteen was big for his age, to the King Cole Room of the Park Plaza Hotel for a beer. "I couldn't wait to get to school the next day and tell my friends I was in a bar in a hotel," David recalled. "The pregnancy was devastating for Reva," he said. "Leonard did not show as much emotion as Reva did, but I know he felt it."[10]

One result of the aborted pregnancy was that now, in 1943, Leonard was free to go to war.

We were handsome young men in our white shorts

By 1943, stories of Nazi atrocities against European Jews were reaching America. Identifying as he did with Reva's Jewish heritage, Leonard Brooks was determined to join the armed forces and serve in combat, preferably as an official war artist. "I had this Jewish thing in me," he said. Increasingly, fellow artists and friends were enlisting, and Leonard did not want to be left behind, even though he was encouraged by Northern Vocational to remain on the faculty. Probably because of the Great War stories told him by his father, he did not want to join the army, although best friend Earle Birney had been appointed a second lieutenant in the infantry the previous year. So he opted for the navy. "I've always loved water, loved ships," said Leonard.

That love of water and ships had earlier prompted Leonard to embark on his own spare-time war effort. Over the previous summer, fall, and winter, he had spent weekends and holidays painting freighters and the industries they served on the Great Lakes, a kind of Canada at War series. This led to perhaps his most unusual exhibition, which solidified his rapport with the working man. Upon learning about the paintings, Dewar Ferguson, secretary of the Seamen's Union, asked Leonard to show them in the union headquarters on Wellington Street East in Toronto.

The day before the 19 April 1943 opening, five husky men folded and stored the card tables and swept the floor in the clubroom as Leonard hung his works. "I felt nervous," he said later. "This was unlike any other exhibitions I had held. No fancy pile rugs or concealed lighting here." The show was a hit among the men. "What surprised me most ... was the naturalness with which these men accepted art when it was related to their own experience," he wrote in an article in *Canadian Art* magazine. "They seemed to take it as a matter of course that I had gone down into boiler rooms, sat on smoky decks, and painted."[1] Said *The Toronto Star*: "An exhibit of 32 marine and shipping paintings from the brush of Leonard Brooks, art teacher at Northern Vocational school, is creating a 'homey' atmosphere for sailors who spend their spare time waiting for ships at the clubrooms of the Canadian Seamen's Union."[2]

Leonard wrote about the show to fellow artist Frederick B. Taylor, brother of industrialist E.P. Taylor, one of Canada's wealthiest men. "I have had a show at the Canadian Seamen's Union of about 30 w. colours of the lake shipping – and had a fine reaction from it. Hard-boiled seamen in their clubroom are

fine critics – and as they enjoyed the stuff – both as works of art (?) and technically (from their angle) I felt quite relieved."[3]

The scion of a prominent Ottawa family, Taylor then used his connections to promote Leonard, inevitably increasing the odds on his appointment as a war artist. Taylor was on a first-name basis with the man he visited: H.O. (Harry) McCurry, director of the National Gallery of Canada and future head of the committee that would select the war artists. The following day Fred wrote to Leonard about the meeting. "I told him of the great work you had done on the Lakes this spring on the shipping and industrial front there generally. He is anxious that it should be continued and extended."[4]

Since Canada had pioneered the use of war artists in the Great War, Taylor had been pushing for a renewal of the program. "It is a matter of keen disappointment – I might say a keenly felt sense of frustration – on the part of all the art workers of Canada, that the Federal Government has not thus far made time to co-opt them in the war effort," he told a Symposium on Art in War Time.

Leonard himself had been delivering speeches on the subject. "Canada is now beginning to realize that she has been slow about asking her artists to paint the war record," he told the Women's Art Association in Hamilton. "Although much good photography has been done, a camera sees from the lens outward while an artist sees from the eye inward."[5]

Leonard held what was to be his last wartime one-man show at Eaton's, receiving a congratulatory letter from Taylor. In his reply, Leonard spelled out his frustrations and gave an accurate evaluation of his status in the art world:

I must confess that I do not feel very pleased with my work – as most boys who score overnight and are rapidly forgotten when some new innovation or fashion crops up to give a jaded aesthete a new and more fleeting peppery thrill.

We are all upset today: yet I feel that to be oneself – in spite of all those things – and go on doing something – the best in us – looking not for praise – or blame – saving something out of the chaos to help others to see the truth behind it all – is the artist's only chance for survival.

That I may change – branch out – is not to be doubted.

The North Country was my home at my most impressionable age – It was the starting point that made me want to paint – moody days – a hut huddling in a waste of snow – seems to move me to expression. That I have adapted a very rigid manner of expression – invented no new techniques that shout "how different" – damns me in the eyes of many who must have originality at all costs. I feel I must evolve through a natural growth and be sincere with myself at all cost.[6]

On 27 May, Leonard reported to the Royal Canadian Navy Volunteer Reserve, as the service was then known, but was not given a commission. Instead, he was accepted as a petty officer. According to his navy file, he stood five-foot-eight, weighed one hundred and fifty-eight pounds, had a thirty-eight-inch chest, brown hair and hazel eyes. "At this moment I sit here shorn of my moustache and look like a seventeen-year-old stripling," he wrote to Birney. "The navy business went through so quickly that I am still dazed. I went sketching and trout fishing over the 24th. Three days of sunshine and laziness with a feeling that it would be my last for some time. Reva had the goodness to not wire me or let me know that they were phoning frantically for me to report. 'Let him have his fun' she thought. I came back with four little trout in my knapsack and found a message saying that I was in the navy."[7]

By the time Leonard joined the navy, Ottawa had finally approved the war-artist program and artists were being appointed. But rather than a war artist, he was made set director for the Navy Show that was going into rehearsal at the University of Toronto's Hart House Theatre. For that, he could thank his navy friend Oscar Natzke, a New Zealand baritone who cornered him at a party at the Adaskins and told him his services were needed for the show. "I'm not a set designer," Leonard protested.

The idea for the show came from Captain Joseph P. Connolly, in civilian life a lawyer with a love of show business but now the navy's director of Special Services. He wanted an armed forces revue like Irving Berlin's "This is the Army," which had opened the previous year in the United States. The purpose of the navy's show was three-fold: "Entertainment of naval, army, and air force personnel on active service; promotion of recruiting; [and] maintenance of public morale and goodwill."[8] A friend in the Canadian navy, Hollywood screenwriter and director John Farrow, father of actress Mia Farrow, counselled Connolly. Farrow would be assigned to the project.

Leonard was rushed through ten days of basic training at HMCS York in Toronto, given countless shots against exotic diseases, outfitted with navy pants, jackets and five white shirts and hustled over to Hart House, where he was put in charge of forty carpenters and other workmen. For several weeks he juggled his naval duties with the final classes at Northern Vocational. On his last day, the teachers and students gave him a watch and a bracelet and he donated a painting to the school.

Some of the top people in Hollywood and on Broadway advised the neophyte set designer: stage designer Paul DuPont, musical director Louis Silvers, and choreographer Larry Ceballos, all of whom were in Toronto working on the show, thanks to John Farrow. Leonard spent several weeks in New York

where he saw first-hand the design and construction of Broadway sets. He worked closely with DuPont, set designer for "Porgy and Bess" and "Time of Your Life." When the Americans were in Toronto, Leonard invited them to 39 Boswell. "I do feel a certain liveness coming up in me again," he wrote to Earle Birney. "That teaching racket took more out of me than I liked to admit. I want to get into touch with life again even if it means pulling on the end of a rope. It's hard work, is going to be damn boring at times – but I feel I am in the thing – even if it's in the screwiest of all businesses – show business." Then he added: "Girls wink and look at me with that come-on look that certainly does prove that all the NICE girls love a sailor."9

Reva wrote a prophetic letter to Birney on 2 August: "It seems to be in the air that people who want to do anything creative are talking about getting out of Canada after the war. I know we have often discussed it together but I always had the hope at the back of my mind, that somehow things would drastically change and open up and we could break through this stultifying atmosphere."10

Surrounded by books on stagecraft, Leonard did much of the designing in his studio on Boswell Avenue, from where he could walk to Hart House in twenty minutes. Leonard told Fred Taylor in one letter that he had been up for thirty-six straight hours to finish the more than thirty sets. "So bear with me until I recover my temper, calm, etc."11 A frequent visitor to Hart House, Reva was the one who pacified Leonard. Actress Barbara Chilcott, a dancer in the Navy Show, recalled Leonard often being frustrated and upset at the work. "Reva came in and was calming him down," she said.12

The "Meet the Navy Show" opened to an overflow crowd at the 1,400-seat Victoria Theatre in Toronto on 11 September 1943. The performers, all of them enlisted men and women, received enthusiastic reviews from the Toronto newspapers for their songs, dances, and skits. "Any Broadway dance produc-er would envy such a coterie of fresh and lovely girls and the 40 'Wrens' who danced so gracefully and untiringly," said *The Globe and Mail* review."13 *The Toronto Star* assigned its art critic, Augustus Bridle, to do the review, and he praised the "swaggering scenics" of Leonard Brooks.14 The Hollywood and Broadway men made sure a photographer from *Life* magazine was on hand to record the opening. Two days later Prime Minister Mackenzie King gave a reception for the cast and crew at the Chateau Laurier hotel before the Ottawa opening. Then the show, aboard fifteen railway cars, left on a 10,000-mile Trans-Canada tour before heading for Europe; Leonard was sent out as an advance man.

Partnered with Lieutenant Harry Kelman, they would arrive in town a few days before the show, check out the theatre, solicit local businessmen for

contributions and get the program printed free of charge, as no government funds were to be used. "We were handsome young men in our white shorts," Leonard reminisced. "A case of beer would arrive and liquor at the hotel and four or five of the town's girls to look after the boys in blue. That was the hardest part: to handle all that."

Once in London, Ontario, they found themselves the only sailors in a hotel full of Battle of Britain veterans who questioned the way the navy was fighting the war. "Six guys broke in and marched right over our bed," he recalled. Dressed in their whites, they crossed over to Detroit from Windsor and sampled the nightlife until they discovered they had wandered into a dangerous part of town. Leonard's watch was stolen at one nightclub. Someone tried to inveigle them into a darkened building, obviously with robbery in mind. Leonard brought Earle Birney up-to-date on his travels in a letter written from the Hotel Victoria in Quebec City after show stops in Halifax and Truro, Nova Scotia, and Moncton, New Brunswick:

Got out on a minesweeper on the patrol for 20 hours. Sketched all day. Did several half decent sketches and sent them to Ottawa. In Moncton I got up in a two-man fighter plane – and did a couple of loops. We bamboozled the RCAF into getting us a ride from Moncton to Montreal in a 5-man bomber – and I saw wilderness from the air that was beautiful and very frightening ... I love crowds and dirty alleys, and sluts giving me the eye, and colour, fussy messy streets and all the throb of a bewildered happy war sad throng ... at the moment I am travelling with a quiet stuttering New Glasgow boy who is so innocent I could scream at times. He doesn't drink – he goes to bed early. He's married to a starry-eyed innocent Nova Scotian who wonders why he doesn't try to bring her to life. Previously I travelled with a hard-boiled yet interesting young chap – Jewish, who used to write poetry, drinks like a madman and sleeps with a new woman every night. I wish I could travel with someone somewhere between the two.[15]

The version of his activities that Leonard gave to Reva was not as exhilarating. "Sometimes I am heartsick when I think how Leonard has to spend his time away from his real work," she wrote to Fred Taylor.[16]

That winter the Brooks spent a dream Christmas in New York, staying with Paul DuPont during Leonard's two-week leave. Through DuPont's connection with showman Billy Rose, the Brooks were able to get scarce tickets to see Oscar Hammerstein II's hit musical "Carmen Jones" on Broadway. Reva stayed on in New York and saw Paul Robeson in "Othello," "One Touch of Venus," "Connecticut Yankee," and Verdi's "The Masked Ball." DuPont took her to a party where she met actor José Ferrer.

But her thoughts were not entirely on Broadway. "I am still busy looking after Leonard's affairs and glad to report the after-the-war painting [fund] is growing and that he will have at least a year in which to do nothing but paint and study and go where he will be most happy doing it," she wrote Birney.[17]

If Leonard had expected to find a Christmas present from the navy when he returned to Canada, he was mistaken. While he was away, the Selection Board in Ottawa had turned down Captain Connolly's recommendation that he be appointed a sub-lieutenant. The 20 December decision said: "The board considers that this rating, while possessing rather wide and unusual qualifications as an Artist and Teacher, does not at present possess the personal manner and outlook of an Officer."

The lack of a commission almost became a moot point, for Leonard was to do something when the Navy Show was in western Canada that could have brought about his court-martial.

~ 14 ~

The gods have looked down

Leonard Brooks was at the Palliser Hotel while making arrangements for the Calgary, Alberta, stopover when he received orders from the Navy Show's commanding officer, Lieutenant Roy Locksley, to return immediately to Winnipeg, Manitoba. Leonard was in for a couple of unpleasant surprises when he arrived. Locksley, who had been director of music and programming for radio station CFRB in Toronto, ordered Leonard to the Capitol Theatre to sell tickets for the show, which was to be in Winnipeg for an unusually long, two-week engagement, 29 January to 12 February. The temperature reached 27 degrees Fahrenheit below zero, the coldest weather that Leonard would ever experience in his lifetime.

After selling tickets for a week, Leonard announced he was quitting the show. "I am not selling any more tickets," he told colleagues. "They can court-martial me if they want to. I'm through." He then bought a bottle of gin and retired to his room at the Fort Garry Hotel, muttering about committing suicide. He did not advise Reva, but singer Oscar Natzke did. After talking to Leonard, Natzke, who would die a few years later on the stage of the Metropolitan Opera in New York, telephoned Reva and told her, "Leonard's got himself into a situation. I don't know what they're going to do."[1]

The next morning, Locksley went to see Leonard. "What's wrong?" he asked.[2] "I'm not going to do this any more, Roy," Leonard replied. "I'm an artist." Well aware of Leonard's growing reputation as a painter, Locksley must have sympathized with his insubordinate petty officer. Instead of disciplining or reprimanding Leonard, as a career officer would have done, Locksley told him to catch a train to Ottawa and explain the situation to Captain Connolly, the director of Special Services.

According to Leonard's recollection, the conversation with Connolly went like this:

Connolly: Okay, Petty Officer Brooks, what's the matter with you?
Leonard: Sir, I've had it. You know that many men break down. I've broken down. I can't continue like this. I left a good job as a teacher to join the navy. I've done a good job, I've done the sets. Now you don't know what to do with me.
Connolly: (laughing) What is it you want to do?
Leonard: If you can, use me as an artist. I'm a well known artist.
Connolly: Okay. Go down to the Naval Art Service on Sparks Street.

As he would do so many times in his life, Leonard had stood firm, defied authority and convention and ended up getting his own way. When he showed up at 185 Sparks Street, he announced he was not about to do any anti-syphilis posters – "She may look like your sister, but ..." – because he was not a commercial artist.

Either because of Leonard's personality or sheer stubbornness, Lieutenant Alan B. Beddoe of the Naval Art Service told him to place an order for canvases, set up a studio in a back room, and paint what he wanted. The word soon got out that Leonard was there painting, so navy officers started to drop by and select his works for their offices or ships. He declined to affix his name to any of those paintings. Through a mix-up, the supplier of canvases delivered sixty-six instead of the six Leonard had ordered, which turned out to be fortuitous for a visitor to 185 Sparks Street.

One day Ottawa painter Tom Wood, soon to be appointed a war artist, brought in the Group of Seven's Fred Varley. Varley had been one of Canada's Great War artists, but 1944 found him destitute and drinking heavily. Leonard was delighted to meet Varley because he was one of two war artists he admired, the other being Augustus John, who had served with the British army. All the Naval Art Service members felt honoured to have Varley in their midst, so there was no opposition when Leonard made him a proposal: "Look, Fred, I'm not sure we can use all these canvases," Leonard said. "There's enough paint here,

so why don't you just come into the back room with me when you want to work." Varley did. "I'd work on some things in one corner and he'd work in the other," Leonard recalled.

If Leonard had a role model among artists, it was Varley, who had patterned his bohemian lifestyle after that of Augustus John. Slim like Leonard's father, Varley was the same age as Herb Brooks and looked not unlike him. A Yorkshireman, Varley had emigrated to Canada in 1912, a year before the Brooks. Leonard shared many of Varley's traits: a disregard for authority; periodic anti-social behaviour he justified as the artist's right; moodiness, restlessness and impatience; boundless energy; charm; and a penchant for drink. Both were serious as young men, for which they compensated in later years, and neither suffered fools gladly.

Varley went often to Leonard's rooming house where the two men would engage in discussions and arguments about art and other subjects. Once Leonard was playing his violin when Varley arrived. An accomplished pianist, Varley pretended a table was a piano and played a mute Mozart sonata to accompany Leonard. Varley so appreciated the friendship that he gave Leonard one of his large paintings, that of a birch tree, which the Roberts Gallery years later valued at $10,000.[3]

Leonard often escaped from the back room in Ottawa, especially to go to Halifax, the departure point for most of the ships bound for Europe. On one such trip he did a painting which, more than any other, brought him to the attention of the war-artist committee. Titled *North and Barrington Street, Halifax*, it was a large silk screen depicting a group of shivering sailors on a snowy day as they trudged down Barrington Street to their waiting ship. Leonard sketched the scene from a window overlooking the street. Fortunately for him, the work was selected for reproduction under The Silk Screen Project, conceived by A.Y. Jackson and supported by the National Gallery, to provide paintings to decorate servicemen's quarters. Production was done by Sampson Matthews Limited under the supervision of another member of the Group of Seven, A.J. Casson. The Barrington Street reproduction was hung in many Navy facilities and canteens in Canada and abroad.

Another of Leonard's silk screens also became well known, *Haliburton Village*, one of his snow scenes. *The Times* of London reproduced it in its weekly edition. The newspaper noted that the silk screen was one of a number of Canadian landscapes that hung in army facilities in England.[4] *Haliburton Village* was also one of fourteen silk-screen prints shown at the Arts Club, 2927 Victoria Street, Montreal. Said Montreal's *The Gazette*: "There is good contrast and broad handling in *Haliburton Village*, by Leonard Brooks, who succeeds

Leonard was not yet an official war artist when he painted Halifax's North and Barrington Street *showing sailors returning to their ship. A silk screen, it was reproduced and hung in barracks in Canada and England, 1944.*

NATIONAL GALLERY, OTTAWA

with his interpretation of winter – steep-roofed barn, bit of open water and a stretch of land on which a sleigh travels towards a church near a group of buildings."[5] *Canadian Art*, in its June 1944 issue, reproduced the very first silk screen Leonard did, *Winter Farm*. "This print is the outcome of the artist's first experiment with the silk screen process and was undertaken as an exploratory exercise rather than a final production," the magazine said.

During one trip to Halifax, Leonard was painting when someone reported him to the Royal Canadian Mounted Police. "I was gently led to jail by a red-coated mountie who thought I was a spy drawing the railway yards," he explained.[6] He was released upon presentation of his navy credentials.

Leonard gathered many of the paintings he considered were done on his own – and not navy – time and mounted a small show at Zwicker's Granville Gallery in Halifax. This was obviously not what most artists in the armed forces did.

On another trip to Halifax he did one of the things that prompted the Selection Board to question whether he had officer-like qualities. He provoked Commander Harold Beament, a colleague in the Royal Canadian Academy and war artist since March of 1943. Leonard remained seated at his easel when

a Wren, a member of the Women's Royal Navy Service, came in to serve them tea. After the woman withdrew, Beament said, "Petty Officer Brooks, you know you should have been standing in the presence of an officer."[7] "Come on, Harold," Leonard replied. "Are you kidding me?" Another version of the incident has Leonard shouting an obscenity at Beament.

Leonard finally got his own commission, thanks in part to competition for his services. A.L. Cawthorn-Page, Chairman of the Murals Committee in Ottawa, wrote on 7 April 1944 to Angus L. MacDonald, Minister of Naval Services, proposing three murals "depicting Canada's war effort" be done in the nation's capital.

"Firstly, it was suggested and unanimously agreed upon that Petty Officer Leonard Brooks is the logical choice as Art Director of this undertaking," Cawthorn-Page wrote. "Secondly, if Brooks is allowed to proceed with this undertaking, that the best location for him would be in a room within the Naval Art Department." It was recommended the murals be on loan to the YMCA Red Triangle Club at 66 Slater Street where 80,000 people a year participated in activities.

Lieutenant Beddoe of the Naval Art Service on 4 May told the Chief of Navy Personnel that the Navy's Hobby Hut Project, designed to provide idle servicemen with an outlet for their time and energy, was more important than the murals project and Leonard's talent should be used there. Beddoe argued that the venereal disease rate was lowered when servicemen were occupied with hobbies in their free time. The chief agreed. Beddoe then made a pitch to Captain Connolly, the director of Special Services, to again try to obtain a commission for Leonard. He argued Leonard's new duties with the Hobby Hut Project required he have greater authority than that of a petty officer. "Brooks' experience as a teacher and his standing as an artist makes him particularly essential to the success of this task," he added. "He joined the navy purely out of patriotic reasons, and did not hold back because he was not given a commission at the start."[8] On 19 July Connolly recommended to the Selection Board in Ottawa that Leonard be given a probationary commission. "He has in my opinion officer-like qualities and can be relied on to conduct himself in a proper manner at all times," Connolly said.

During his interview with Leonard, Sub-Lieutenant E.A. Wilkinson, the Personnel Selection officer, did not entirely agree with Connolly's evaluation. His "special" report said:

Mature, intelligent, industrious and ambitious. Brooks is a self-confident, aggressive person. He is also one of Canada's outstanding young artists, and brings to the Service a wealth of knowledge in the field of art and crafts. He feels that in his new position – that

of directing the development of the Hobby Hut program and art generally – that he is considerably hampered in his present rank. Although lacking in some officer-like qualities, it is considered that this rating is well qualified from a professional point of view and is deserving of commissioned rank.[9]

Along with the commission came a full beard that Leonard proceeded to grow, just as he had a decade earlier as a bohemian artist.

Within days after receiving his probationary commission on 1 August, Leonard was back in Halifax on a Hobby Hut assignment. He walked into Beament's studio, just as he had done at Eaton's after the run-in with the boyswear manager in 1931. "Am I supposed to stand up now?" he asked the commander. "He never forgave me for that," recalled Leonard.

Now that Leonard's career was finally on an even keel, Reva visited him in Ottawa. They were walking down Sparks Street near the Naval Art Service offices when a man shouted to Leonard, "Get off the street, you dirty Jew," which showed him one did not have to go to Nazi Germany to find anti-Semites. Leonard caught up with the man and punched him.[10] When she got back to Toronto, Reva did her part for the war effort as a secretary in a wartime office of the provincial government at Queen's Park.

Fred Varley now asked Reva if he could stay in the guestroom at 39 Boswell Avenue; she consulted Leonard, who gave his approval. But given Varley's well-deserved reputation as a womaniser, Reva took some precautions. When she went to bed, she locked the door of her second-floor bedroom. She also asked her brother David, then sixteen, to move in as a type of chaperone. "He tried to seduce Reva," David said of Varley, who was then sixty-three. "He used to go out and drink and phone her. He'd send her flowers and what-not."[11]

Varley would hold long discussions with Reva, trying to convince her to think more like him. "It used to make me rather angry when he did that, because I had my own ideas," she said. "I used to love to listen to him, and he'd tell me about his life in Montreal with a cruel landlady who kept a lot of his paintings because he owed her rent. Then he used to play the piano and try to create a tremendous mood, an emotional mood of influencing me too, which I didn't like very much."

Varley did a charcoal sketch of Reva on brown paper. He borrowed her lipstick to colour her cheeks and a scarf in the sketch. More than half a century later, the sketch would hang on the wall over her bed.

Varley stayed with Reva for several months before moving in with Esther Birney. "He was one of the most important influences on my life at that time," said Leonard.

Finally, in early September, Leonard received the telephone call he had been hoping for from the National Gallery: his appointment as official war artist was being processed. "The gods have looked down," he said at the time. "My Chelsea days all over again." Reva did not share his enthusiasm. "Naturally when I phoned Reva she was very upset and it was quite a shock to her," he told Earle Birney, "but at the same time she knows what it means to come to life and how necessary it is for me if I am to go ahead."[12]

Nine days after his 26 September official appointment, Leonard boarded a corvette in St. John's, Newfoundland, bound for England on convoy escort duty.

~ *15* ~

\mathcal{I} *was terrified*

Leonard Brooks painted his way across the North Atlantic. He had been aboard many ships in Halifax, but this time he was on a corvette escorting a convoy on the dangerous run to his native England. The small, fast, manoeuvrable corvettes would roam around the convoys, always searching for signs of German submarines. "It is dawn in a convoy of hundreds of freighters – we are patrolling for subs – zigzagging up and down in the rough seas," Leonard wrote. "I made a quick watercolour of the giant waves and black sky." One day he told the captain he would like to know how rescues at sea were carried out so he could do a sketch. "That's no problem," the captain said, and dropped four men overboard into the frigid waters and brought them up drenched in a net. "This is how men look when they're plucked from the sea."[1]

On the train to London, he struck up a conversation with another corvette captain, a young man from Calgary on a three-day pass. Leonard soon realized the officer's nerves were shaken from the pressure of convoy duty, so he suggested they stick together. Reaching back to his knowledge of London from his Chelsea days, Leonard offered his services as a guide. "The blackout was on and we walked down the street holding hands with two women officers so that someone would be touching the curb and someone the wall," Leonard recalled. "We invited them to accompany us for a drink at a club for the Polish and French Resistance officers. I don't remember what I did, but he disappeared with one of the women. Three days later he showed up in time to catch his train." Years later, a man accompanied by his wife and children came up to

see Leonard after a lecture in Vancouver. "Remember me?" he asked. "We went to London together. You saved my life."[2]

From London Leonard went to the Isle of Wight, where all the Canadian naval artists were based, but he had no intention of staying there if he could help it. He wanted to get as far away as he could from his nemesis, Harold Beament, who had preceded him there. All told, there were seven naval artists, the others being Michael Forster, Donald Cameron Mackay, Rowley Murphy, Jack Nichols, and Tom Wood. That was fewer than the air force, which had fourteen artists, and the army, which had eleven.

So Leonard wrote to Harry McCurry, director of the National Gallery. "Some of the stuff I've seen shows more action and bombings and such than being aboard a ship," he said. "Would you be averse to my painting a few things of bombed out buildings and call it a navy man's viewpoint of London?" To Leonard's astonishment, McCurry agreed that he could be based in London. The director obviously stretched the "purpose" of the war artist, as enunciated by the Canadian War Artists Committee, which he headed: "As a War Artist appointed to one of the Canadian Services, you are charged with the portrayal of significant events, scenes, phases and episodes in the experience of the Canadian armed forces, especially those which cannot be adequately rendered in any other way."

Leonard found a studio at 55 Oakley Street in Chelsea, where he was soon joined by Michael Forster. Another resident soon came to Leonard's attention: Helga Overoff, tall, slim, blonde, young, attractive. German-born, she had been raised in Cairo. She claimed a distant kinship with Rudolf Hess, Hitler's former deputy who was also in Britain at the time, imprisoned after he flew to Scotland in an attempt to single-handedly negotiate an end to the war. After being interned for three and a half years on the Isle of Man, she was released and now worked for the Red Cross in London. "She was quite attractive," Michael Forster recalled. "Leonard liked her very much."[3] Leonard and Helga soon became lovers in a wartime romance that bordered on becoming something more serious. As his friend Fred Varley had done during the Great War, Leonard had found companionship at a time when one lived for the day at hand.

Helga would often prepare Leonard's meals and bring tea to his studio when she left for work. She would also stand in line at stores to buy scarce food items for both of them. Once, Lieutenant Commander Tovell Massey, a member of the Massey family and head of Canadian Naval Intelligence in London, scheduled a visit to 55 Oakley Street to see what Leonard and Forster were doing. Hoping to impress Massey, the two artists had Helga pose as a maid and serve them tea. Unfortunately, she tripped, sending a clutter of teacups, saucers, and plates to the floor.

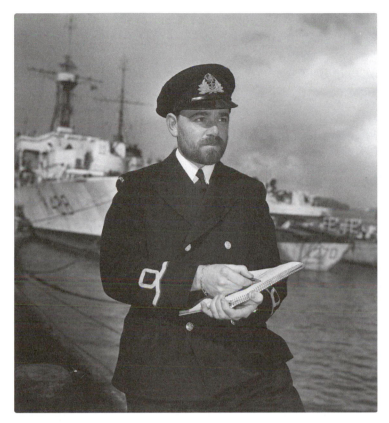

Sub-Lieutenant Brooks, official Navy war artist, 1945.
PHOTOGRAPHER ROY KEMP, ROYAL CANADIAN NAVY

Earle Birney at this time was involved with British writer Margaret Crosland. Leonard and Helga sometimes double-dated with them. Leonard and Earle had renewed their friendship shortly after Leonard had settled in London, Birney staying overnight with him. They were sitting in the parlour when the night sky lit up and sirens announced a German V-1 bomb attack. Leonard grabbed his coat and headed for the door to witness the aerial show, but Birney, with two years experience overseas, knew better. "You're nuts," he told Leonard.[4] He dragged Leonard under a table, just as Nell Brooks had done during the Great War's Zeppelin attacks.

Known in Canada for his moody, grey snow scenes, Leonard tried to capture "the feeling of gloom" in wartime London. Inspecting the aftermath of a bombing attack, he found himself one day on Bramerton Street, where he had stayed with the eccentric Cecilia Hamilton on his way back to Canada from Spain a decade earlier. There were gaps around No. 47 where houses had been

destroyed. Looking at the house, he thought, "That old lady still can't be there." But she was.

Miss Hamilton refused to let him in because of the disarray caused by the bombings, but he begged her to let him peer down the hallway to the room under the stairs where he had stayed. Overcome by emotion, Leonard cried at the memories. He saw the watercolour he had given her when she refused to accept rent for the room. He took money out of his pocket and some chocolate bars and pressed them into her hands. As he looked back, he heard a flutter of wings and saw some pigeons fly out of her bedroom. They were her only companions amidst the rubble.

While Leonard was living in Chelsea much as he did as a young painter, albeit eating better, he enjoyed the perquisites of a commissioned officer. He was elected a member of The Churchill Club, established the previous year in Ashburnham House as part of Westminster School. Leonard met British artists at the club and frequented the few wartime exhibitions, always anxious to see what fellow painters were doing. Out of this came his use of crayon resist and watercolour wash, a technique pioneered by British painters like John Piper and adopted by Leonard. The wax from the crayon resists water and gives the painting a distinctive texture. Leonard used this technique in *Minesweepers and Chimneys, The Solent, Isle of Wight,* and *Pink Room, V-2 Damage.*[5]

A proud day for Leonard was the opening of the Navy Show on 1 February, which he attended at London's Hippodrome where the sets he had designed were in place. Playwright Noel Coward addressed the cast after the show, congratulating them on their performance. King George VI and the rest of the Royal Family attended a matinee the following afternoon.

The war artists mainly chose their own assignments. Leonard would go down to Naval Intelligence to find out which ships were travelling to interesting areas and then go on board. For security reasons, the finished works were turned in to Naval Intelligence, which photographed them and passed them on to the National Gallery in London, which ruled on their appropriateness and quality. The Admiralty pass that the artists carried authorized them to board any Canadian or British ship, whether the captain approved or not.

Leonard always kept McCurry of Canada's National Gallery apprised of what he was doing. On board ship after a stopover in Cherbourg, he wrote to McCurry on 2 December:

Forgive the scrawl – We are rolling along in great style and the wardroom table gives a kick every so often. I have managed to work out a system of scribbling and taking notes on this kind of rough day. By devious ways I scribble a note or two on rough

paper – dodge the spray and find my way below to re-draw and fill in as much information as I can – dash up again and repeat the performance. It looks rather ridiculous – but is very effective.

Leonard went ashore at Cherbourg harbour and painted the arrival of troops reinforcing those that had invaded France in June. He also sketched abandoned German gun emplacements that had defended the harbour.

Leonard wrote McCurry again on 4 February: "Some of the best material has of course – nothing to do with Canadian navy. Forster and I gaze with longing at V-2 holes – and walls – sleepers in the tubes etc. – but try and remember it is *navy* material we should deal with."

McCurry replied on 21 February: "I am sure you will be getting plenty of good material, and I would not even pass up the V-2 holes, the sleepers in the tubes, or anything else. It will all add to the picture of Canada at war, and, while you are attached to the navy, I do not think that there is anything that says you must do exclusively naval stuff, although your superiors will undoubtedly expect this."

McCurry would not have been surprised at Leonard's ability to paint under adverse conditions. When seeking candidates for the war artist posts, he had canvassed the heads of the art societies for their recommendations. The Group of Seven's A.Y. Jackson, then president of the Royal Canadian Academy, said of Leonard: "Might respond – he can stand cold weather. Good outdoor guy."[6] Jackson had sketched with Leonard, so he knew he could paint in the cold.

Of one hundred and thirteen works of Leonard's listed by the War Museum in Ottawa, most were sketches made on the spot, rather than renderings done back in the studio. Since action at sea was very intermittent, Leonard would wander over the ship he happened to be aboard, looking for a mundane slice of navy life that he could bring alive in a sketch. Such was the source of his best-known war painting, *Potato Peelers*, a gouache of two seamen wearing life jackets and seated beside a couple of oil drums as they peeled potatoes, a convoy sailing in the background. Leonard's quickness in painting was a great asset for him as a war artist, but he did have one failing, to which he was prompt to admit. As Joan Murray said in her book, *Canadian Artists of the Second World War*, "A strong background in commercial art and particularly design helped."[7] This background Leonard did not have. "I'm essentially not a figure draftsman and I have to struggle with that aspect," he told Murray. "Yet I was able to catch sometimes on-the-spot authenticity, a mood, and that carries a long way in any expressive figurative painting."[8]

Leonard learned that there was to be a commissioning ceremony at Londonderry in Northern Ireland at which the HMS *Puncher*, a u.s.-built freighter converted into an aircraft carrier, was to be turned over to a Canadian crew, so he made arrangements to travel north by train. A late night out preceded his departure, so he was in no mood to talk to the officer slouched in the facing seat. When the train arrived in Londonderry, the two passengers realized that both wore the insignia of Special Services, so they introduced themselves. The other officer was Clyde Gilmour, then a war correspondent but later movie critic for *Maclean's* magazine and *The Toronto Star* and host of the CBC's Sunday morning "Gilmour's Albums" for forty-one years.

The two men shared a taxi to their quarters where they decided to avail themselves of the officers date service for an evening of dining and dancing. The hostess at the service arranged for two girls; Leonard suggested to Clyde that they flip a coin to see who got the first girl to arrive. Leonard won.

"Leonard's girlfriend for the evening was every man's dream of an Irish colleen," recalled Gilmour. "I picture her as a young Maureen O'Hara with a soft Irish lift to her voice. My girl looked like William Bendix. She had a slight moustache, very strong-looking wrists. She was quite tall, lanky and she looked like she could easily beat me to death in a fair fist fight."[9]

William Bendix was the homely actor who had the lead role in "The Life of Riley" on radio and television in the 1940s and 1950s. Despite the inauspicious beginning, Leonard and Clyde became lifelong friends.

Leonard got together in London with a brother-in-law, George Silverman, one of the few Jewish flying officers in the Royal Canadian Air Force. He was known as the Brylcreem Boy for his dashing good looks. Leonard took George "to meet some of the Battersea maids" at the Six Bells and Prince Ted pubs.[10] "We were like brothers," said George. "He raised my sights." At one of the pubs, Leonard told the woman behind the bar – her husband was in Africa fighting – that it was George's birthday. "She brought up a special little cask, all dusty," recalled George.[11] So they celebrated a fictional birthday. Another brother-in-law, David, observed, "Women were very, very attracted to Leonard."[12]

Leonard liked to go down to Felixstone on the coast because the commander of one of the Canadian torpedo boats based there, Anthony (Tony) Law, was also a fine painter. Michael Forster once joined Leonard in Felixstone and the two men attended a late afternoon movie. When they came out, it was into a pitch-black night as an air raid was in progress and a blackout had been ordered. Neither man had brought his tin hat nor a flashlight. "We were showered with shrapnel all over the place," recalled Forster.[13] Forster, who had been

born in India, marvelled at how Leonard, using the directional instincts honed in the woods around North Bay, led the way in the darkness back to the naval base. "Leonard had a very good sense of where he was," he said.

Reva, meanwhile, had been corresponding with McCurry of the National Gallery. On 25 April she wrote him: "If, as you write, the Canadian artists might stay over there for any length of time after peace is declared, I might throw myself on your mercy and ask you to try and get permission for me to get over as soon as possible!" There is no record of a reply from McCurry.

When Germany surrendered on 8 May 1945, Leonard and Earle Birney celebrated v-e Day together, although Birney was still recovering from a case of diphtheria. They stood in a War Office window three stories above the street and listened as Prime Minister Winston Churchill delivered his victory speech. Then they hit the pubs, like thousands of Londoners, relieved after nearly six years of hostilities.

But the war had not ended for Leonard. Five days after v-e Day, fifteen German submarines left Trondheim, Norway, for Scapa Flow in Scotland, where they were to be turned over by their German crews. Since there were no docking facilities, the submarines anchored offshore for boarding and volunteers were sought to accept them.[14] Leonard volunteered.

Apprised at Naval Intelligence headquarters of the imminent arrival of the submarines, Leonard had flown north with a naval photographer to record the event. The isolated naval base nearest to Scapa Flow was still in a state of drunken euphoria over the end of the war, which was probably why the commanding officer asked for volunteers to board the subs. "I, like a stupe, put up my hand," said Leonard. "The photographer with me did too." Leonard was issued a side arm and, accompanied by a seaman with a Sten gun, he and the photographer were taken by a motor transport boat to one of the subs. "I was terrified," confessed Leonard. "I had never even met a German sailor before, let alone a submarine crew." The trio boarded the sub at 4:00 p.m. and replaced the white flag of surrender with a British flag: "I remember the young U-boat captain very politely motioning me to go first down the conning tower. I climbed down and faced twenty longhaired boys, some of them spitting at me and getting their first glimpse of an 'Englisher.' They were playing the Horst Wessel song on a record and getting ready, I thought, to do their traditional blowing up of themselves."[15]

When Leonard ordered the seamen to pass up on deck all liquor on board, the seamen took gulps out of the bottles as they passed them along. As a result, their hostility increased as they became intoxicated. Leonard also had them hand over all guns and knives. Leonard stayed up all night with the captain in

his quarters, fearful that the Germans would scuttle the sub with him on board. The captain, who was in his late twenties, spoke a bit of English and told Leonard they would blow up the fleet were it not for the fact that the Russians were holding German prisoners whom they might harm in reprisal. Glancing around the cabin, Leonard spied an art magazine and realized his host was an amateur painter. So the two men talked about art and Leonard had the captain write a word or two in the magazine as a memento. When Leonard saw that the captain wrote that Russia represented a threat to the west, he gave the magazine to Naval Intelligence.

Leonard was relieved the next morning and left the sub in a shower of spit from the submariners on board. The only incident in the entire operation occurred when a Canadian seaman on another sub shot himself in the leg.

By July, when Leonard was scheduled to return home, Helga Overoff realized that their affair was fast coming to an end, even though she had hoped he would stay behind with her. "Helga has got the jitters and is very upset naturally at the realization of my departure," Leonard wrote to Earle Birney. He asked Birney to have Margaret Crosland call Helga occasionally to see if she was all right.

Leonard had told Reva that he had someone "looking after him" in London, but he obviously did not tell her that this person was a beautiful blonde who shared his bed. Helga and Leonard exchanged letters once he was back in Canada, one of them coming to Reva's attention. Leonard must have told Helga that Reva knew of the affair because she subsequently sent Reva a bolt of plaid, maybe her way of thanking Reva for the loan of her husband. "I hear from England occasionally," he wrote to Birney on 18 November. "Things are coming out better for Helga and she is back in Scotland, toying with the idea of marrying a chap there who is pursuing her. I hope things clear up for her."

Appropriately, Leonard had returned to Canada on 18 July 1945 on a corvette, the same type of vessel that had carried him to war nine months earlier. This time he travelled with his friends Clyde Gilmour and Michael Forster, but they were unable to disembark because of an arsenal fire in Halifax in which some one hundred persons were injured.

Little could Leonard imagine that he was starting the countdown for the last two years of his life in Canada. Exactly two years to the day, Leonard and Reva would awaken for the first time in the Mexican town where they would live for more than half a century.

A Photographer Is Born
in Mexico

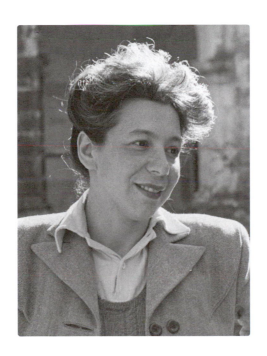

*F*rankly, I think you'll fall flat on your face

Canada fought the Second World War not just on the battlefield, the skies and the seas but in the classroom and the workplace. The front-line troops in the battle back home were the war artists, whose reputations were being burnished in the process. The government considered their role in the war effort to be vital, especially building morale. During the Great Depression, art was out of the reach of most Canadians. Once the war artists were abroad, the National Gallery of Canada had three travelling exhibitions of their paintings, one of them, in April–June 1944, being called *Artists for Victory*. Reproductions and posters of their works, and those of the Group of Seven, were displayed in schools, public buildings, and even banks. Companies that bought the works often displayed them for years. So the Second World War introduced a new generation of Canadians to art.

The war artists initially had been expected, during every six-month period, to produce two oil paintings 40 by 48 inches, two 24 by 20 inches, ten watercolours 22 by 30 and fifteen 11 by 15.[1] The National Gallery soon realized its goals were unrealistic and they were dropped. But there was one artist who could easily have met them: Leonard Brooks. He was the most productive of the seven naval artists. During the almost nine months he was officially listed as an active war artist – 22 September 1944 to 12 June 1945 – he was credited with 113 works by the War Museum in Ottawa. Only one Navy artist had more, Lieutenant Donald Cameron Mackay, who did 138, but his tour was three times as long as that of Leonard. Commander C. E. Todd, in a confidential report on Leonard's "termination of appointment" overseas, noted his productivity: "As a naval artist this officer is a very competent artistic recorder. He is a quick, painstaking artist."[2]

The war artists were allowed to choose the city in which to live while they completed the paintings they had in progress or in the planning stage, so Leonard opted for Halifax. He and Reva rented space in the suburban home of painter Bill de Garthe. Leonard probably chose Halifax for two reasons. First, he was near the sea he loved and, secondly, he was near Zwicker's gallery where he had held a successful exhibition the previous year. Leonard was already

Previous page: Just a year after picking up a camera for the first time, Reva took a series of photographs in 1948 of a dead child that catapulted her into the first rank of women photographers.

feeling neglected by the Toronto art establishment, not the art critics on the newspapers – they were always very supportive – but the directors and curators of the major public galleries who were not purchasing his works. "To be a curator in Canada, generally, it seems you have to be a member of a 'good old family,' marry a local deb, or be born south of the border," Leonard told *Saturday Night* magazine. "How can we expect vital art leadership when gallery heads are chosen so often by the yardstick of being politically safe or socially acceptable?"[3] Those gallery heads did not inspire Leonard's confidence, so it was natural that he should turn again to Leroy Zwicker in November for a one-man show of more than thirty paintings done during a two-week leave at Peggy's Cove near Halifax and on weekends. He must have questioned the propriety of painting for himself while on the navy's payroll for he alluded to this in a letter to Earle Birney. "What the hell is Brooks up to now ... I thought he was in the navy'... which I am ... but shouldn't an artist have freedom to do some of his 'own' work too? You're damn right he should, say you."[4]

Leonard sold three hundred dollars-worth of paintings the first two days and drew a good review in the *Halifax Herald*: "Colourful autumn scenes and powerful seascapes highlight the display of Maritime Art by Leonard Brooks ... Brooks' seascapes have a salty tang and his woodland scenes are brilliant with reds, yellows, and blues."[5] *The Globe and Mail* in Toronto ran a photo from the Canadian Press. The caption said: "Lt. Leonard Brooks of Toronto stands alongside his painting, *Rough Water*, an oil depiction of surf breaking in Peggy's Cove."

The period in Halifax gave Leonard and Reva an opportunity to ponder their future while there was still time to act. Reva obviously felt that Leonard, supported by her managerial and marketing skills, should dedicate his time exclusively to painting. But he believed this to be too risky, so he decided to return to Northern Vocational for at least another school term. He explained why in a letter to Earle Birney:

Because I can't see turning down 3,000 bucks with holidays at the present moment ... and I want to see what is doing there in the way of getting a part-time job or if I feel like it a transfer to another school ... In spite of selling pictures I cannot see that I would be wise to depend on it totally at the moment. Besides, I have a very great desire to get a car ... some decent clothes, to gather all my books and belongings all about me and consolidate things before I go on to the next step. I don't feel up to depending on the whims of the picture buyer for my money.[6]

While in Halifax, Leonard and Reva collaborated on an educational book about a twelve-year-old boy in a lumber camp. Leonard illustrated it and both

wrote the text. Leonard reached back for inspiration to his teen days working on the Trans-Canada Highway. A literary agent named Miss Hutchinson looked at the manuscript. The Brooks had written about young boys gathering around the fire: "They all took out their peckers and put out the fire with a hissing pissing sound."[7] Miss Hutchinson was aghast at the passage, but Reva tried to pacify her. "Well, you're a big girl now and won't mind that," she said. Miss Hutchinson thought the manuscript had possibilities and promised to shop it around to publishers, but nothing came of the endeavour.

Leonard joined other war artists in Ottawa in May when the National Gallery of Canada held the first exhibition of their works. The *Ottawa Citizen* said the opening night turnout of 2,300 was believed to have been the largest ever for an art exhibit in the capital, but it was not because of the artists or their works. They came to see the new Governor General, Viscount Alexander of Tunis. "It must be admitted that far more people looked at the handsome vice-regal couple than at the paintings, however worthy," said the newspaper. Leonard met and chatted with the Governor General and later did a report on the event for the CBC's international service.

When the exhibition reached Toronto, Paul Duval critiqued it for *Saturday Night* magazine. "The exhibition under review comprises a most revealing cross-section of the character of that Canadian painting which derives from English schools," he wrote. Among those Duval singled out for praise was Leonard. "Mention might also be made here of Sub-Lieutenant Leonard Brooks whose *Shore Leave–Cherbourg*, so different from his other canvases on view, has a Utrillo-like background."[8] The painting was among the first that Leonard did overseas.

The National Gallery, which put on the touring show, rejected a large painting that Leonard had done, which sank him into a depressed state. While expressing his frustrations during a visit to Leroy Zwicker's studio in Halifax, Leonard was offered paints and brushes so he could relax by sketching something. "I'll show you what they want," he told Zwicker. "I was angry and so was my brush, angry enough to forget the usual habits of former years of painting, yet relaxed in a consciously nervous manner," he recalled later. "It was an angry picture, not at all pleasant, a bit messy, but somehow alive. I left it in my friend's studio."

Zwicker asked Leonard if he could enter the painting in a watercolour show. He agreed on condition that a fictitious name be affixed to the work. Leonard was later walking through the National Gallery with director Harry McCurry when he saw a watercolour of Halifax harbour named *Wartime Mood* signed by someone named Zick. It was the painting he had done in anger. "It took

manoeuvring but I was able to edge myself and the curator into another part of the gallery," he said.[9]

Leonard was demobilized 27 May 1946, receiving a rehabilitation grant of $419; Reva received $86. They put aside the money for future travel, as Leonard had agreed to return to Northern Vocational in September at a salary of $3,100 for the ten-month school term.

Back in civilian life, Leonard immediately went on a three-week painting trip with wartime colleague Tom Wood to the north shore of Quebec in the Baie St. Paul and Les Eboulements area. "He was great fun – full of good humour and energy," recalled Wood. "He was very prolific, producing two or three pictures to my one, and sometimes finding time for some stream fishing on the side."[10]

Leonard spent time in Toronto with another former naval artist, Jack Nichols, also a musician. Nichols played the mandolin, but he did not know how to read music. "Leonard tried to browbeat me into learning to read music and he gave me some simple violin pieces to study," Nichols recalled. "I started to become serious and learned how to read music because Leonard said I had talent."[11] Nichols was but one of many painters, musicians, and writers who did not recognize their talents until Leonard did and then encouraged them to persevere. "I have this missionary feeling that I should influence people," Leonard said years later. "Nothing bothers me more than wasted talent. I believe people have the capacity to be the best they can."

Settled back at 39 Boswell Avenue, the Brooks had a visit from another war artist, the army's Molly Bobak, who had just given birth to her and husband Bruno's first child and needed a place to stay for a few days. Son Alex, named after A.Y. Jackson, was just three days old when they arrived. Molly described Reva as being "Mother Earth" during the stay, but that Leonard resented their presence. "He didn't like any intrusion," she said. "I don't blame him."[12]

Reva's maternal instincts must have been aroused once more by the presence in their home of a baby. She soon found herself pregnant a second time, but forced to spend days in bed against her will. "Whether the business will result in another Brooks to worry his way through the world or not remains to be seen during the next few months," Leonard reported to Earle Birney. Birney replied: "I hope that Reva is still Holding Her Own and without having to go back to bed. This baby better be good."[13]

Before returning to Northern Vocational, Leonard gave six weeks of art instruction in Toronto to a group of adults, including Mr. and Mrs. Charles Mustard, both Second World War veterans who had been apart for more than four years. "Leonard would do those most marvellous demonstrations of a still life," recalled Marie Mustard. "Zip, zip, zip, he'd produce the most wonderful

things in fifteen or twenty minutes."[14] Remarried to one of the Bermuda Trotts – they had settled on the island in 1685 – Marie Trott would become one of Leonard's major patrons after moving to Mexico.

Shorn of the beard he had sported in the navy and keeping just a moustache more acceptable to the classroom, Leonard soon became dissatisfied with teaching after the relative freedom of his war artist career. "The 5-day session ... actually uses so little of my real talent for teaching receptive and mature people instead of a lot of kids – and half-assed amateurs," he lamented.[15]

Unhappy at Northern Vocational, Leonard could not have been pleased with the Toronto art scene, either, because again he held his next one-man show of thirty works at the Zwicker gallery in Halifax in December. The *Halifax Herald* noted, "The current exhibition of paintings by Leonard Brooks ... affirms, as the previous exhibitions have, the gifts of this noted Canadian landscape painter."[16]

Aside from his appearance at the New York World's Fair in 1939, Leonard had received little recognition in the United States. Now he was asked by *Who's Who in American Art* to submit details of his career for a listing.[17] Under the heading of "Professional Classification," he checked off easel painter, etcher, and serigrapher. He listed exhibitions at Eaton's, Roberts, and the Art Gallery of Ontario.

By early February of 1947, Reva had suffered a severe cold for two weeks. "I think the kid angle has not survived," Leonard advised Earle Birney. "We'll be glad when the business clears up one way or another as it is nerve-wracking for her."[18] Sister Sophie was visiting on 3 March 1947 when Reva started to haemorrhage and have such pains that the first available doctor was summoned, Morris Selznick. He immediately diagnosed the problem as an ectopic pregnancy and cursed Reva's regular doctor for allowing it to advance this far. Sophie accompanied Reva in an ambulance to the Toronto Western Hospital. She underwent two-and-a-half hours of surgery as the dead foetus was removed from her fallopian tubes. Again she received massive blood transfusions. Selznick wanted to perform a hysterectomy, but realizing Reva's desire for motherhood reluctantly decided against it, although he held out very little hope for another pregnancy. "It's all over, and I'm very relieved and grateful to Doc Selznick," Leonard told Esther Birney in a letter.[19]

Selznick was known as "the doctor" to the artists. As such, he was often paid for his services with art works, and he ended up possessing a sizeable collection. Leonard, too, paid for the doctor's ministrations to Reva with a painting.

Once again, Reva's inability to have a normal pregnancy meant that Leonard did not have to limit future career decisions on the need to meet family obligations. He now desperately wanted to quit teaching for good when the

school year ended. As he waited each morning for the elevator to take him to his third-floor classroom, he would scratch a mark on the wall much as prisoners cross off the dates on a calendar to mark the days they have served on their sentence.

During an interview with the CBC in 1964, Leonard explained how he had felt:

I wanted to get away, strangely enough, from the winter. This was rather curious because at that time I was well known – at least before the war – for winter things. For a number of years I stood up to my neck in snow studying and painting in the tradition of many of the landscape painters, A.Y. Jackson and so on, and I think I was rather dubious about going back to Toronto after the war and taking up where I had left off. I didn't feel the same about those things. I felt that as far as my work was concerned I needed a complete break from what I had done before. I had painted in the war as a war artist. This had given me an opportunity to paint all day and everyday, everywhere. I had done this for several years with the navy and I wanted to go on doing that.

Leonard found himself in what Christine Boyanoski of the Art Gallery of Ontario has called the "forgotten" forties, sandwiched between the romantic naturalism of the Canadian Group of Painters formed in the Great Depression years and the emergence of the abstract Painters Eleven in the mid-1950s.[20] The art societies that were so important for the exposure of Toronto artists were losing their power and influence; yet the proliferation of private art galleries was still fifteen years away. Artists who wanted to experiment with abstract expressionism, frowned upon by the societies, would meet privately, as many did in the Gerrard Street home of Leonard's friend Albie Franck. From that point of view, Toronto was becoming more like arch-rival Montreal, where artists always eschewed societies in favour of autonomy.

"The war itself had a widespread impact on art," wrote Boyanoski. "When it finally ended, Canadian artists, like artists the world over, after a prolonged period of restricted movement were set free to tackle the complex issues and emotions of the day armed with various new approaches and techniques."[21]

Leonard was now convinced that he had no future as an artist in Canada and that no one outside the Toronto Board of Education wanted to hire him as an art teacher. His original idea was to return to Spain with Reva, as he had talked so much about the country to her. But there were post-war exchange restrictions that prevented anyone from taking more than $250 a year out of Canada.

Then W.J.B. Newcombe, a British Columbia artist and Royal Canadian Air Force gunner who had been shot down over Europe during the war, told

Leonard of a little Mexican art colony. "It's a marvellous little village and it doesn't cost anything to live," he said. "American GIs are going there. There's a little school where you can go down and study mural painting and frescos and lithography."

Newcombe, then forty, and his wife had just returned from a year in Mexico, most of it spent in the little village: San Miguel de Allende. Newcombe was anxious to find a place to rent in Toronto, so Leonard told him they should trade places. Newcombe could sub-let 39 Boswell Avenue if Leonard could get a grant from the Department of Veterans Affairs to study in San Miguel.

When Leonard told Alex Panton of Northern Vocational of his plans, Panton suggested that he take a one-year sabbatical instead of resigning. "If you leave this school, give up and go to Mexico, you'll be a bloody fool," he cautioned Leonard. "You'll lose your job here. Frankly, I think you'll fall flat on your face, dear boy."[22]

Leonard followed Panton's suggestion, which worked to his advantage. He was able to tell the Department of Veterans Affairs that he planned to use the knowledge gained in Mexico in his classes at Northern Vocational when he returned to Canada.

On 17 June 1947 the district board of Veterans Affairs approved an eleven-month course in San Miguel, eighty dollars a month plus forty dollars a month for tuition and sixty dollars for supplies. "He wishes to study lithography, fresco, and life drawing," Veterans Affairs counsellor W.J. Mackey said in his report.

The next day Leonard bought from a Northern Vocational colleague, Wilfred Victor Crich, a Rolleicord camera for Reva so that she could record his paintings in Mexico. The Brooks had never owned a camera and Reva said she had never taken any pictures before "except the occasional snap."[23] Cleeve Horne, best known for his portraits of former Prime Minister John Diefenbaker and other prominent Canadians, was also a fine photographer, and he told Reva how a camera worked but gave her no lessons.

Leonard said that had he been a good illustrator like some members of the Group of Seven, or Archie Arbuckle, who did many covers for *Maclean's* magazine, he would probably have stayed in Canada at this time, abandoning teaching to join one of the commercial art houses. "I couldn't do lettering," he said. "I didn't have the facility to do illustrations."

But he certainly could paint and was one of Toronto's rising artists in 1947. "You couldn't go into certain homes in Toronto without seeing a Brooks watercolour," said Esther Birney. "Watercolours are difficult to paint and Leonard was one of the few painters who could do them well."[24] Gavin

Henderson, who had promoted Leonard's career in the late 1930s when he was director of Eaton's Fine Art Gallery, agreed with Esther.[25]

Despite his misgivings, Alex Panton wrote a poem for Leonard entitled, "The End of the Rainbow Is Mexico":

> The migrant robin, southward bound,
> Forsakes the North for friendlier ground;
> Instinctively elects to go -
> To Mexico
> The rich suspend their vast affairs
> To winter in the tropic airs,
> And sign a lot of cheques to go -
> To Mexico
> But one needs not a banker's till
> Nor the robin's inborn skill,
> But only how to sketch to go -
> To Mexico
> And if, in Eaton's store, you face
> Brook's paintings of that fabled place,
> I'm sure you'll be the next to go
> To Mexico
> > With best wishes, Alex Panton

Panton was into recycling well before the term became popular as he reworked the poem and gave another version to York and Lela Wilson when they followed the Brooks to Mexico two years later.[26]

Leonard and Reva attended a series of farewell parties and bade goodbye to family and friends. No one accompanied them to Malton Airport on 16 July 1947 for the 7:00 a.m. Trans-Canada Air Lines flight to Chicago where they changed planes for Mexico.

"I think it would have been difficult [to leave Canada] if I had had a family and if I had had children and so on, but just the two of us, there wasn't much I could lose," said Leonard.[27]

Reva would say that there was not a morning when she woke up and did not grieve because she had been unable to bear Leonard five children.[28] "I don't think it disappointed Leonard as it might have a more ordinary man," Reva said.[29]

Had Reva known they were leaving her beloved Toronto for good, she probably would have refused to go. "I don't think that I wanted that much to leave Canada, but just for a visit that would be good to do," she recalled.[30]

As she sat beside Leonard on the plane, Reva clutched the Rolleicord camera that was to bring her international recognition and success surpassing, for a while, that of her husband. She would also find several substitutes for the children she was unable to bear.

~ 17 ~
We haven't made a mistake

When the Brooks disembarked at dusk at the concrete and stone Mexican railroad station and could see no lights anywhere nor any signs of civilization other than a black, 1927 Chevrolet taxi stationed nearby and four lifeless adobe huts, they questioned why they had left the comforts of Toronto the previous day. "What are we doing here?" Leonard asked. "It's complete nothingness."

They watched the red lights on the caboose sway into the gathering darkness as the train pulled out. The conductor had handed them their luggage, waved and then seemingly abandoned them at an unmanned station. They walked past two forlorn, dust-covered cacti and boarded the taxi, the only one in town; three tires were filled with air and the fourth with straw, rubber still being scarce in the aftermath of the Second World War. Lino, the driver who owned the taxi, had gone to the station on the offchance there might be arriving passengers. There was no telephone at the station to call San Miguel, two miles distant, for transportation; there were only ten telephones in the entire town itself.

Lino strapped their four suitcases onto the luggage rack while Leonard kept his painting gear and violin and Reva the bag containing her camera. Their doubts dissipated ten minutes later when they drove up hilly Canal Street – usually passengers were forced to walk a block because the taxi did not have enough power to ascend with both human cargo and luggage – and were met by a storybook, colonial town of 10,000: San Miguel de Allende, named after Ignacio Allende, the Mexican equivalent of Paul Revere. "We haven't made a mistake," beamed Leonard.

Twelve hours after leaving Toronto, an American Airlines propeller-driven DC-6 had deposited them in Monterrey, seventy-five miles south of the u.s. border. They had spent the night in town, where they were welcomed to Mexico by a group of wandering musicians – *mariachis* – who serenaded them at the

Esperanza cafe while they ate their first *tacos* and *enchiladas*. "From Bay and Temperance Streets to La Esperanza cafe in twelve hours is a jolt," Leonard commented, referring to an area in Toronto where he had once done some work.[1] *Esperanza* means "hope" in Spanish, and hope was what they had the next morning when they boarded the Nacionales de México Laredo-Mexico City passenger train for the final leg of their journey. Reva dressed up for the occasion, putting on a new felt hat adorned with a big red feather.

San Miguel de Allende in 1947 was just beginning to recover from decades of virtual abandonment, caused by the collapse of the silver industry. It had been settled in 1542, just twenty-four years after Spanish conquistador Hernán Cortés had landed in Mexico and defeated Moctezuma, the Aztec ruler. Franciscan friar Juan de San Miguel had moved his tiny Indian mission into Chichimeca territory at the foothills of the Guanajuato mountains, 6,400 feet above sea level in the Sierra Madre range. The new settlement became known as San Miguel de los Chichimecas. Friar Juan introduced the Indians to European techniques for weaving, a tradition passed on from generation to generation of artisans, who continue to practise their craft to this day.

The discovery of silver in nearby Zacatecas the following century prompted the establishment of Spanish military garrisons to protect the mining operations and guarantee safe travel for the mule trains carrying the metal to Mexico City, 160 miles southeast of San Miguel. Because of its proximity to the mining operations, San Miguel became the commercial and industrial centre of the region. The town was renamed San Miguel El Grande – St. Michael the Great – to reflect its new importance.

The workshops, tanneries, plantations, cattle, and industries of San Miguel made it a great commercial centre during the eighteenth century. Its serapes, blankets, woollen stuffs, cloaks, rugs, harnesses, machetes, knives, spurs, and stirrups became famous within and outside Mexico. The tallow produced by cattle was to be used widely on ships and for the illumination of churches, mansions and huts throughout New Spain.[2]

The wealthy Spaniards who owned the mines and the European aristocrats who followed the wealth to Mexico settled in San Miguel, furnishing their new mansions with art and furniture from Europe. The town was becoming a cultural centre, as it would again in the mid-twentieth century. The population of San Miguel in 1770 was estimated at 30,000, about the same as New York City, which had 33,000, according to the first u.s. census in 1790.

San Miguel's name changed again in the nineteenth century to honour its most famous native son, Ignacio Allende. Allende and two priests, Miguel Hidalgo and José María Morelos, were the Big Three of Mexico's War of

Independence. A one-time captain in the Spanish army, Allende had organized a secret society of Mexican-born Spaniards who plotted against colonial rule. The wife of the mayor of nearby Querétaro, where the society met, sent a messenger on 15 September 1810 to advise Allende that the Spaniards had learned of their conspiracy. Allende rode that night to nearby Dolores – later named Dolores Hidalgo – to inform the priest. The next morning, Hidalgo summoned the townspeople to arms with the cry of liberty: "Long live the Virgin of Guadalupe! Death to the Spaniards." Allende, Hidalgo and Morelos, who joined the fighting later, would be killed before independence was finally achieved in 1821, but 16 September would be celebrated as Mexico's Independence Day, especially in San Miguel.

Construction was begun on San Miguel's most recognizable building, a multi-spired church, known simply as La Parroquia, or the Parish Church. The architect was a humble man of pure Indian blood, Zeferino Gutiérrez, completely self-taught. He designed the church from postcards of European Gothic cathedrals, so the dimensions of La Parroquia are disproportionate. Construction was completed in the late 1880s, just as the silver was petering out and San Miguel was losing its main reason for being.

The Mexican government in 1926 declared San Miguel de Allende a national monument, saving some of the abandoned mansions from destruction.

The first American or Canadian to settle there was Martin Matt Beckmann of Delphas County, Ohio, who arrived in 1932, escaping the Great Depression. He founded a jewellery store that bears his name and is now run by his daughter.

Although Bill Newcombe was the first Canadian to live in San Miguel, many other Canadian artists had gone earlier to Mexico, starting in the 1930s. Gordon Webber went in 1935, Jack Humphrey in 1938, Stanley Cosgrove and Harry Mayerovitch in 1939 and Isabelle Chestnut Reid in 1942. Former war artist Jack Nichols went to Mexico City in 1947. Others would follow, many of them drawn to San Miguel by the presence of Leonard Brooks. Why the attraction?

First and foremost, Mexico offered Canadian artists an exemplar of a socially-orientated art. Second, Mexico was exotic. When travel abroad was restricted during the Great Depression and the Second World War, Canadian artists turned to Mexico, attracted by its colour, light, and ready-made subject matter, all of which were accessible on this continent. Finally, Mexico permitted the Canadian artist freedom from the status quo.

Mexican art was lauded for its democratic qualities during the 1930s and 1940s, at the same time that Canadian artists were encouraged to deal with contemporary social issues in their work. It was important for many artists to escape what they perceived as the confines of the conservative artistic community in Canada.[3]

Foreigners were also drawn to Mexico because of the respect shown artists and the encouragement offered by the government, a heritage of the 1910–17 revolution. Mexican artists – and those in other Latin American countries – were often social activists in the forefront of political change and whose opinions were sought on public issues.

While Leonard would agree with the highfalutin reasons for going to Mexico, his were more prosaic. It was close and cheap. The evening of their arrival in San Miguel, the Brooks took a room in the San Miguel Hotel. One of only three hotels at the time, it was a three-storey colonial building favoured by students for its low rates and proximity to the fine arts school. The Spartan rooms contained a dresser with a basin and a pitcher for water and two saggy beds. The communal bathroom down the narrow hallway boasted of hot water heated by a wood-burning stove. The rate for the room, fresh bedding daily, and three meals a day was forty-five dollars a month.[4]

After supper, the Brooks wandered out onto Calle del Correo, Post Office Street. Leonard described the scene:

We walked about in a trance that first twilight evening around the main plaza of the town, watching the grackles come noisily to roost in the thick, dark foliage of the laurel tree above our heads, while we listened to the *mariachis* strumming their guitars and singing plaintive Mexican *canciones*.

"It's all the way I knew it would be," I murmured to myself, while my mind flashed back to the months I had spent in Spain some 13 years before. "This is the way," I told Reva, "I wanted it to be for you." We left the circling crowd and ambled about the streets of the old colonial town with rapture. Every turn provided another stage set with superb lighting effects through the arches and on the shadowed walls with overhanging balconies. What theme here for a painter!

We were stopped by a woman who was selling roses. I bought a bunch of them for my wife at one cent each![5]

Daylight unveiled an awesome sight to the Brooks. The five motor cars registered in San Miguel were nowhere to be seen. Instead, burros clopped along the streets of cobblestones, many of which had been brought over as ballast in the holds of Spanish galleons taking back the riches of the New World. The men wore serapes against the crisp morning air, as they had done for centuries. The buildings the Brooks saw dated from the previous century and earlier. Looking up the mountain slopes on which San Miguel rested, they saw streets steeper than those of San Francisco.

After breakfast that first day, Leonard and Reva walked five blocks down to the Escuela Universitaria de Bellas Artes – the Fine Arts University School – where they met Stirling Dickinson, the second American to settle in San Miguel. As director of the school, Dickinson was the man to whom Leonard had written, asking to enrol. A tall, gangly, balding man, Dickinson was born in Chicago in 1909, the son of a wealthy lawyer, Francis Reynolds Dickinson.

If the fates had not led Dickinson to San Miguel in 1937, and, to a lesser extent, Leonard Brooks a decade later, the town would not have become such a celebrated art colony. A graduate of Princeton University and the Chicago Art Institute, Dickinson and a college friend, Heath Bowman, had decided to write an adventure book after touring Mexico in 1935 in a Model A Ford. While on their travels, they had met José Mojica, a Mexican opera singer and movie star who told them he was on his way to San Miguel de Allende, where he planned to buy a home. By the time they had finished the book, they learned Mojica was in Hollywood making a movie, so they wrote him a letter addressed to "José Mojica, MGM, Hollywood, California" asking if he would write a prologue. He did and the book, *Mexican Odyssey*, went into four printings.

After spending six months in South America the following year and writing another book, *Westward from Rio*, they decided to write a historical novel based on Mexico's War of Independence. Again they wrote to Mojica, asking him to recommend a town to use as a model for the book. Mojica replied that San Miguel met all their novelistic needs. Ten days after arriving, Dickinson paid two hundred and fifty pesos – about ninety dollars – for a former tannery property half-way up the foothill. After completion of the novel, *Death is Incidental: A Story of Revolution*, Bowman returned to the United States, but Dickinson remained behind.

Shortly after Dickinson arrived, a dapper, cultured Peruvian art lover and political figure named Felipe Cossio del Pomar showed up, attracted in part by the presence of Mojica and José (Pepe) Órtiz, Mexico's leading bullfighter, and his movie star wife, Lupita Gallardo. Cossio's sister was married to Juan Belmonte, Spain's leading bullfighter. A prominent member of APRA, the Alianza Popular Revolucionaria Americana party, Cossio sought exile in Mexico in 1937 after the military seized power in Peru. He was determined to open an art school in a former convent, a two-storey structure with a lush, inner courtyard with a central fountain, completed in 1765 and now occupied by the military. So he went to see President Lázaro Cárdenas, a former general. On 16 June 1937 Cossio took possession of the Royal Convent of the Conception, one of many Church properties seized by the government during

Stirling Dickinson, a native of Chicago who settled in San Miguel de Allende in 1937 and eventually ran three art schools, 1997.

COURTESY PHOTOGRAPHER
PETER OLWYLER

the 1910–17 revolution. "I don't know another case where a foreigner and political exile has a cavalry regiment kicked out of its quarters so a school can be established there," Cossio said.[6]

Cossio needed someone to run the school, so he offered the job to Dickinson, who prepared the first catalogue, extolling the sunshine, nearby thermal waters, Indian events, and the availability of fruits and vegetables. Students could obtain a Bachelor of Arts degree in three sessions and a Master of Arts, via the University of Guanajuato in the state capital. Dickinson shipped 5,000 catalogues in English to the United States and Canada and another 5,000 in Spanish to Latin America, as well as placing advertisements in the leading u.s. art magazines.

Since the former convent had not yet been rehabilitated for classroom use, the first students studied in a provisional building during the summer of 1938. Dickinson said there were only six or eight students that first year.[7] They found themselves in a virtually isolated town since the roads in and out were only passable by horse-drawn wagons and buggies. A donkey pulling a cart on rails brought passengers to and from the train station. There was no indoor plumbing and no restaurants.

The 118 students who attended the second summer class, now held in the former convent, provoked an outburst of anti-Americanism, a precursor of events to come. "The aggressive attitude of some residents who saw their tranquillity disturbed was evident," said Cossio. "I was obliged to ask the governor to send some police to protect students who were taking outdoor classes. Many times they were stoned."[8]

Once the United States entered the Second World War in 1941 following the Japanese attack on Pearl Harbor, Dickinson went to Washington to offer his services, but not before being named "adoptive son" of San Miguel by the municipal council. Nelson Rockefeller, then involved in naval intelligence, sent Dickinson back to Mexico to look for signs of Japanese or German activity. Accompanied by a Mexican friend and art teacher, Simón Ybarra, and a burro to carry their belongings, they walked the Pacific coastal area. They discovered that before Pearl Harbor a Japanese boat had docked in a tiny village in Michoacán state; the Japanese spent several days photographing the area. They also encountered a German citizen in what is now Zihuatanejo; whenever a boat docked, he would invite the passengers and crew to his home for a beer and pump them on what they had seen. The German was subsequently arrested and sent to a concentration camp. His mission concluded, Dickinson was assigned to the Office of Special Services (oss) the forerunner of the Central Intelligence Agency.

During Dickinson's absence, Cossio del Pomar purchased bullfighter Órtiz's ranch, Atascadero, on the hillside above San Miguel. By 1943, San Miguel had started to become a stopping-off point for international artists, drawn there by Cossio. They included Chilean poets Pablo Neruda and Gabriela Mistral, both future winners of the Nobel Prize for Literature. When the Peruvian government announced that exiles would be allowed to return home, Cossio accepted the offer. He sold his holdings in San Miguel to a Mexico City lawyer of Italian descent, Alfredo Campanella.

When Campanella discovered that he was the owner of an art school, as well as a ranch, he decided to continue to operate it, even though he had no particular interest in the arts and no pedagogical experience. What prompted his decision was a bill passed by the u.s. Congress: the GI Bill to finance the schooling of Second World War veterans. When the Veterans Affairs Administration on 18 February 1946 approved his Escuela Universitaria de Bellas Artes as a school for GI students, Campanella envisioned nothing but riches for himself.

The arrival of the GIs changed forever San Miguel de Allende and eventually led to the deportation at gunpoint of Leonard and Reva Brooks, Stirling Dickinson, and five others associated with the school.

I am beginning to feel the colour

Pressured by Alfredo Campanella, the new owner of the fine arts school, Stirling Dickinson oversold the qualifications of the teaching staff in the promotional literature he sent out. There were no leading Mexican artists on the faculty as claimed, nor, for that matter, outstanding teachers from anywhere. So when Dickinson met Leonard Brooks and learned he was an established artist and instructor, he visualized him teaching instead of studying. Leonard was initially reluctant, but eventually realized that the workload would be nothing like that at Northern Vocational and would not interfere with his own painting. So, after a few months of being a student, he joined the faculty. More importantly, he and Dickinson became close friends and travelling companions, a relationship that would have been precluded had Leonard been just a student.

The bond was strengthened when the Brooks became next-door neighbours. They were still staying at the hotel when they had a visitor, a twenty-one-year-old country girl named Marciana Méndez, who offered her services as a maid. Somehow they managed to communicate, the Brooks not speaking any Spanish nor Marciana any English. She returned the next day with Carmen Delgadillo, later co-owner of San Miguel's leading bookstore, El Colibrí, but then a municipal worker. She had been entrusted with finding a tenant for a furnished, two-hundred-year-old house owned by José Chávez Morado, a leading Mexican artist. The rent was the equivalent of ten dollars a month, so the Brooks quickly agreed to take the house.

La Rinconada – or "The Corner," as it was a corner house – was built on the foundations of the same hillside tannery property that Dickinson had purchased. Since one wall of the living room was the rocky side of a hill, the house became inundated during the rainy season. Water seeping from the hill flowed through the house out onto the street. That was the only running water in the house. Water for household purposes was hauled in pails from a spring across the street and poured into a cistern. There was no electricity, a gas lamp providing light. Because of the lack of refrigeration, food had to be purchased on a daily basis. Cooking was done over an open-air charcoal brazier. There was neither telephone nor radio. Despite the lack of amenities, the house was large and afforded Leonard ample space for painting. They had a live-in maid and a gardener, all on a Veterans Affairs stipend of less than one

Leonard and Reva climb the cobblestone street to their hillside rental home in San Miguel de Allende, Mexico, 1948.

hundred dollars a month. Looking back on the primitive life they led during the first couple of years in San Miguel, Leonard and Reva would say that this was the happiest time of their lives.

An American writer friend, MacKinley Helm, who did much to advance Leonard's career, probably summed up San Miguel best in his book, *Journeying Through Mexico*: "This is a place where, if it hits you right, you want to buy a house right away and stay a long time. If it doesn't hit you, you may find it dull. It has so few 'sights.' Its charm really consists in its hillside setting and views, its well-watered gardens, in the dependable sun, and the slow seeping of time in its plazas."[1]

The belief that she would probably never bear children still weighed on Reva. Never one to question the appropriateness of a request, she asked to be made a godmother. The Brooks had been in San Miguel less than a week when she met Lysia Brossard, the beautiful and very pregnant wife of New Jersey painter Ray Brossard. The following week, Leonard and Reva became godparents of Erica, born 29 July 1947. Reva never told Lysia of her own failed attempts at motherhood.

Leonard and Brossard shared a white-walled studio on the mezzanine of the art school. The pair used to put visitors through an initiation ceremony. Visitors had to close their eyes and draw a pig on the wall with a piece of charcoal. "It is surprising to see what even trained draftsmen do," reported one visitor. "Many of their pigs are square."[2]

Leonard was upbeat when he reported to Earle Birney on his life in Mexico:

The school is a freely run institution – I don't go to any "classes" but work on my own in one of the huge studios – in the former monastery. I do some lithography and a bit of fresco with a couple of the young teachers. There are life-classes to go to – but I prefer sketching in the streets and in the nearest market place.

A few serious students make life interesting about the school – but here are a collection of GI time-wasting boys – and a few females who dabble (quite well, too, some of them) and they are useful as they sell their paint and paper (generally lots of it untouched) when they leave for home.[3]

While Leonard painted, Reva was learning about photography. One of the GIS, a photographer named John Roberts, built a darkroom at the school and gave Reva lessons in developing and printing. "For someone like me who was so untechnical and unscientific, I was so anxious to get the results of what I had felt in front of the subject, that I learned everything necessary to get the images I strove for," she said. "I loved seeing those faces come out in the developer and have loved dark-room work ever since."[4]

Reva was also among the twenty-five students who took Dickinson's Spanish class. So anxious was she to learn the language that she pasted verbs on the wall above her bed. Reva finished first in the class and soon spoke fluent Spanish, an achievement that forever eluded Leonard.

The number of vehicles in San Miguel increased by one when Dickinson bought the first civilian post-war jeep to come off the production lines in Detroit. He became famous for his off-road excursions with the teachers, usually the Brooks and Brossards. While Leonard and Ray sketched, Reva would engage in conversation with the Indians they encountered and photograph them, clutching the twin-lens Rolleicord to her bosom as if it were a child.

The travels were also the source of ideas for skits that Leonard and Ray would write and perform at parties. Once in a hotel in Guadalajara, a paper-thin wall separated the Brossards from a pair of newly-weds. Lysia called in the others who listened while she took notes of gleeful remarks interspersed by the sound of lovemaking. A conversation between an older man and a young woman in a hotel room in the Pacific coast fishing village of Manzanillo was the basis of another skit. Eventually, the skits took on names, such as "Put the Blade in the Razor." That one involved a woman and her drunken husband who was trying to shave but had failed to put a blade in the razor.

Leonard and Reva toured backroad Mexico with Stirling Dickinson, right, in his jeep.
Leonard sketched while Reva took photographs, 1948.

Needing someone to bring out the boy in him, Leonard found the ideal person in Brossard. Ray was blond, boyishly handsome, extroverted, witty, charming, and talented as a painter and a musician. Brossard must have seemed to Leonard like an Evan Greene minus the perversity. "There wasn't anything he couldn't do," recalled Lysia, who said she eventually divorced him because of his attraction to other women.[5]

Once Dickinson and the Brooks unwittingly upstaged the governor of Oaxaca state in southern Mexico. The governor was to inaugurate a new road several hours after the San Miguel contingent was to pass by the site. When a jeep came into view, the waiting crowd assumed – incorrectly – it was the governor and set off fireworks. "The people looked a little chagrined that they had used up all the fireworks for a gringo and two Canadians, and the poor governor, when he arrived, didn't have any," recalled Dickinson.[6]

Another time Leonard was given a horse by a drunk and did not know how to get rid of man or beast. After travelling upriver in a dugout canoe with a guide, Reva and Dickinson had left Leonard alone sketching when the drunk appeared. Leonard gave the man a hurried sketch of the horse in the hope that

he would leave, but the gesture backfired. The man was so touched that he insisted Leonard accept the horse as a gift. Once Reva and Stirling returned, it was agreed that henceforth the drunk would be Leonard's protector. He tied the horse to a tree and got into the canoe with them.

Their guide eased the dugout onto shore a mile down river, telling the drunk they were going to pick up some coconuts. The guide helped the drunk out, pushed the boat from the shore and jumped back in. "We swung out, lightened by the loss of our surprised passenger, into the fast current," Leonard recounted the incident. "In a few seconds we were in midstream and we waved and shouted 'adios' to the confused and disappointed drunk."7

Leonard and Stirling wrote to Hiram Walker and Sons, the Walkerville, Ontario, distillery, after they opened a prized bottle of Canadian Club and found the contents had evaporated. They had been longing for a drink when they checked into a rustic hotel in the jungle. Canadian Club was then running an adventure series of ads in u.s. and Canadian publications, such as lassoing a condor in Peru or riding against Balkan lancers. The message was: "Invite this famous world-traveller to join you this evening." The letter that Leonard and Stirling wrote said in part, "Here we are in the jungle looking forward to a drink of Canadian Club and the corkage failed. We wanted to let you know." When they returned to San Miguel a month later, a case of Canadian Club was waiting for them at the train station.

While the trips were usually great fun, they also provided subjects for many of Reva's photos and Leonard's paintings. Leonard managed to get two paintings to Toronto for an October 1947 show of works by Canada's war artists at Eaton's gallery. When Leonard realized what was involved in legally shipping paintings out of Mexico, he asked an American colleague who was returning to the United States to ship them from there to Canada. Getting works back to Canada would always be a problem for Leonard and other Canadian artists based in Mexico.

As usual, Leonard received supportive reviews from the Toronto art critics. *The Toronto Telegram* said: "Leonard Brooks' outstanding contribution is *East End London, VE-Day*, and there is a delightful, warm scene, *San Miguel Valley*, fruit of his current year in Mexico."8 Andrew Bell, writing in the Christmas edition of *Canadian Art*, said: "During the past year Leonard Brooks has been in Mexico and his *San Miguel Valley* done there was fine – admirable colour, and though not a large picture, one of the more exciting in the [war artists] show."9

Leonard was obviously pleased with the way his career was developing in Mexico. "I wake up in the morning and know that during the day I will be

subjected to colour, character, something new and exciting in terms of form and colour," he told Earle Birney. "But it's coming through slowly. I am beginning to feel the colour and my drawing is improving every day." There was a worry, though: what was he going to do when the Veterans Affairs grant ended next 31 August. "Confidentially I think I'll try and wangle another year or two from the vets racket and go on living here."[10]

No one in San Miguel could anticipate the power of *Life* magazine, which would soon alter the dynamics of the nascent art colony.

~ *19* ~

I have sold quite a number of my photographs

Isaac, Stirling Dickinson's gardener, pounded frantically on the door of the Brooks' nearby house, asking to see Reva. He told her that his daughter-in-law, Elodia, urgently needed to speak to her. Never having been summoned before by anyone's hired help, Reva, partly out of curiosity, hurried down the street to Stirling's house. There, she met a distraught Indian woman who blurted out that her infant son had taken ill on the ranch where her husband worked and had died by the time she brought him to a doctor in San Miguel. He was the fifth of her seven children to die. "I don't have a picture of him," she sobbed. "Before we bury him, could you take one?"[1]

Reva's first thoughts must have been of the tragedy of giving birth and then losing a child, as compared to her own two failed pregnancies. "I couldn't bear to be with a dead child," she recalled. "We don't see dead children in Toronto."

But she was about to take the series of photographs that would catapult her into the international ranks of top photographers. Although she had less than a year's experience with her Rolleicord when she made the pictures, Reva was a natural, quickly mastering the three elements of photography: subject, exposure, and printing. She had taken rudimentary lessons in developing and printing, but the art of photography itself was completely self-taught during the months she had accompanied Leonard on his painting forays with Dickinson.

The twin-lens reflex camera was to Reva's liking. She looked down to focus, rather than through a viewfinder at eye level. She shortened the strap so that the camera would always rest at the level of her heart. "You must hold it over

your heart to feel connected to the subject," she explained.[2] "The minute I got the camera around my neck it was part of my body." That Reva became one with her camera was apparent to Canadian artist Sylvia Tait. She painted an eight-foot-high artistic cut-out of Reva, her camera a physical extension of her right hand.

Like fine art photographers, Reva would shoot only one or two frames, instead of shooting a roll and later choosing the best shot. She would always wait for "the decisive moment" to take that one shot, even if she had to repeatedly return to the subject.[3] She said she waited two years to take one shot of an Indian woman, Julieta, standing in a doorway, a photograph that would become one of her best known. Reva would not even focus her camera if she knew that the shot was not what she wanted. Whether or not this trait started with an understandable desire not to waste scarce film when the Brooks had limited resources in San Miguel, it served her well over the years.

That Reva preferred taking photos of children was also apparent and did not require any search for motives. "I suppose that some of my maternal feelings have been sublimated in the extreme pleasure I have of taking photographs of children and young people," she said.

When Elodia asked her to take the photo of her dead baby, Reva's first reaction was to refuse. Then she picked up in her arms one of Elodia's two surviving children, cradled it for an instant, and then walked to the open white casket placed on a table in one of Dickinson's rooms. She stared down at the dead, shiny eyes of the infant, a gold paper crown pressed down on his head, flies buzzing about. In his right hand was the picture of a heart with a cross on top. "You must brush away the flies," she told the mother. "Otherwise, I can't take the picture." Elodia shooed away the flies as Reva prepared her camera.

"I got right into it," she recalled. "Nothing fazed me at all. I just did everything." Using no flash, depending for illumination only on the noon-day sunlight streaming into the room, she took photos of the dead infant and those standing around the casket.

Protected by a handkerchief to prevent chafing, the grieving father placed the lidless casket on his head and, accompanied by mourners, Reva among them, walked through the streets of San Miguel to the cemetery on the outskirts of town.

Once she had developed the roll in her darkroom, Reva discovered the image of the mother on a crowded negative with the coffin in the foreground. She cropped out everything but Elodia, producing a dark print of a woman whose eyes showed intense pain and suffering but also dignity and the will to carry on. Reva would always be attracted to women with whom she felt an

affinity because of their suffering and triumph over adversity, as she herself had triumphed while growing up.

The series of photographs that Reva produced, "The Death of a Child," brought instant recognition in the United States. The photographs demonstrated that Reva had mastered within months twin skills that forever elude many photographers: She had a natural innate sense of composition and was also able to crop the image and find the right emotional tones in the printing process to make a memorable photograph. Her photos became noted for the darkness in the printing.

Reva's photograph of the grieving Elodia would appear in the New York Museum of Modern Art's "The Family of Man" exhibit, the most viewed photographic show in history. The San Francisco Museum of Art would select her as one of the top fifty women photographers of all time and use the photo of Elodia's dead baby to illustrate her works.

But more important, the series epitomized the type of photographs that became her trademark: "I'm not content with typifying anything in my photographs that doesn't deal with the deepest feelings to do with relationships between human beings, between a brother and his little baby brother or sister, or between a mother and child."[4] Reva said that Elodia was feeling what she herself felt.

"When we came to Mexico in July 1947, I was overwhelmed by the people, the culture, and the openness to the reality of life's problems, of poverty, illness, and *Death*," Reva recalled. "I found I was so moved by the candid expression of life on people's faces, that I tried to capture something in my camera."[5]

"Isn't it fantastic that I have sold quite a number of my photographs, and without ever dreaming that I was making them for anyone else than myself and my friends?" she told Earle Birney. A California magazine editor bought "The Death of a Child" series and told Reva she wanted to publish more in the future. "If that happens I won't envy Esther [Birney] any more the fact that she has a profession!" she said.[6]

Opposite page

1. The New York Museum of Modern Art acquired Confrontation, *a photo of the mother of the dead child which it published in* The Family of Man *in 1955.*

2. The New York Museum of Modern Art acquired the photo Doña Chencha, *mother of the Brooks' gardener.*

3. The San Francisco Museum of Art in 1975 selected Reva as one of the fifty top women photographer's of all time and published her photo Dead Child *in it's* Women of Photography.

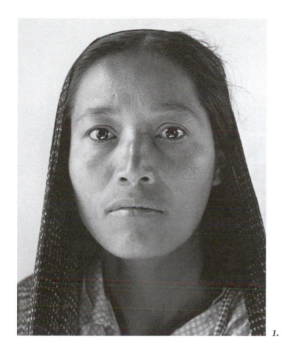

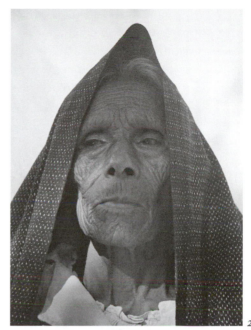

1.

2.

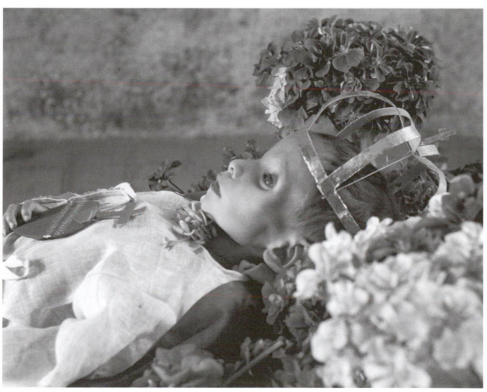

3.

While Leonard made a reputation as a landscape artist, Reva never took photographs of scenery, churches, or colonial architecture. "The picture had to have a human feeling and not just be staring at me," she said. Many artists were drawn to Mexico because of the social realism of its great muralists, but in the Brooks household, the one with the camera was probably more socially conscious than the one with the brush. Perhaps this was a heritage of Moritz Silverman of Slypia, Poland.

"I found photography as a medium for my emotions, but I could also say that photography found me," she once said.[7] There was no question but that there were now two artists in the Brooks' household.

Trouble in Paradise

~ 20 ~

I would rather have this letter than one from Picasso

The headline in the *Life* magazine article 5 January 1948 read:

GI PARADISE
Veterans go to Mexico to study art,
live cheaply and have a good time

More than 6,000 American veterans immediately applied to study at the fine arts school. This publicity given to San Miguel would eventually result in the closure of the school, a communist witchhunt and blacklistings of some in the United States.

Who could deny the appeal of San Miguel, given this description by *Life* magazine:

To GI students in u.s. colleges, crowding into Quonset huts and scrimping on their $65-a-month government subsistence, the Escuela Universitaria de Bellas Artes in Mexico would be paradise. The Escuela is a fine-arts school, accredited under the GI Bill of Rights, to which 50 u.s. veterans and their wives have come to study painting, ceramics, murals, sculpture, and languages. They find it very pleasant in the quiet little town of San Miguel de Allende, up in the mountains north of Mexico City. The air is crisp, the flowers are bright, the sun is warm, apartments are $10 a month, servants are $8 a month, good rum or brandy 65 cents a quart, cigarettes are 10 cents a package.

The three-page spread was mainly of photos. One showed Leonard Brooks playing his violin on a colonial terrace during a party. Another was of American students painting a nude model, who happened to be the wife of one of them as no Mexican woman would pose in the buff, but it was enough to draw the ire of local residents. Student Loretta Hardesty of Butte, Montana, was depicted painting in a cemetery, skulls and bones lying on the ground in a place Mexicans revere in their Day of the Dead ceremonies.

Previous page: Leonard waits outside Mexico City's Palace of Fine Arts with communist artist David Alfaro Siqueiros, who minutes later introduces him to Mexican President Miguel Alemán, 1949.
JUAN GUZMÁN – TIME MAGAZINE

"In the evenings, after work, all of them get together and drum up their own night life," the article said. "When the parties are too successful, the parish priest floods the village the next day with pamphlets sternly condemning the revelry as unseemly in San Miguel."

Given the cheapness of liquor and the lack of diversion in San Miguel, it was not surprising that partying was the major entertainment. Stirling Dickinson had a large, earthenware bowl at the entrance of his house where he asked his guests to empty their bottles, no matter what the liquor was, although it was usually rum. Drinks would be served in Mexican mugs, or *jarritas*. "If you drank two *jarritas*, you were really plastered," recalled one former GI student, San Miguel realtor Dotty Vidargas, but then Dorothy Birk of Chicago.[1] Another former GI, Bunny Baldwin, recalled that she and her teacher husband, Jack, also a veteran, once went to five parties in one day, starting at noon. That was the day they asked themselves whether it might not be wise to return to the States.

Recalled Jefferson Sulzer, a former GI later on the psychology faculty of Tulane University in New Orleans: "They were a wild bunch, as artists were in terms of hard-drinking and hard-partying, but by and large they were serious about trying to get a good education."[2]

New England painter Gordon Chabot described himself as one of the few abstemious students at the school. "Being a non-smoker and a non-drinker and seeing so much alcoholism down there and so much turmoil, it just rubbed me the wrong way," he said.[3]

The student population of San Miguel more than doubled within a year. Lysia Brossard, then the school's secretary, recalled she and Dickinson whittled the more than 6,000 applications down to one hundred, the number they thought the school – and the town – could absorb. "San Miguel was, until that moment, the most wonderfully quiet, beautiful town you've ever seen," she reminisced. "But when the students came, about ten percent – no more – were wild. They'd come from a war. They didn't know how to behave."[4]

One of the veterans who came to San Miguel under the GI Bill did so at Leonard's urging. While browsing through Dickinson's book collection one day, Leonard came upon *R.F.D.*, a 1938 non-fiction work about the vicissitudes, triumphs, heartbreaks and joys of the author's break from a big city literary life to run a farm in Ohio. The book – the title stood for Rural Free Delivery, a Great Depression era mail system – was a Book-of-the-Month-Club selection. On the spur of the moment, Leonard did something he had never done before nor would again: he wrote to the author. Charles Allen Smart, like Leonard, had been a lieutenant in the navy during the Second World War.

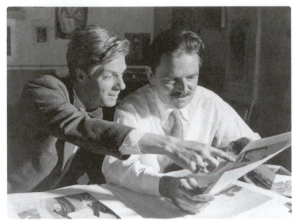

At Leonard's suggestion, Ameri-can writer Charles Allen Smart went to San Miguel in 1949 and eventually settled there.

Leonard and American ex-GI Eric Brossard held a joint show inaugurating the Mexican-American Institute of Cultural Relations in Mexico City, 1948.

"Leonard told me later that he never wrote fan letters, but felt a strange, not quite happy compulsion to write this one, and that he wrote it rather nervously, because the war had intervened and he felt that I might well have been killed in it." said Smart.[5]

Smart wrote back a letter of thanks in which he mentioned that he had been interested both in painting and in Mexico. Leonard suggested that Smart seek a leave of absence from his teaching position at Ohio University in Athens, Ohio, and attend the school under the GI Bill. Smart would not be the last person to follow Leonard Brooks to Mexico.

Meanwhile, Lysia Brossard's husband, Ray, and Leonard were putting on the first show in Mexico City by expatriate artists living in San Miguel. The show inaugurated the art gallery of the Mexican-American Institute of Cultural Relations at No. 63 Yucatán Street. When Leonard told Canadian ambassador Sydney Pierce about the show, the diplomat said his embassy would match anything the Americans did. An American cartoonist, Chuck Sharman, drove Leonard and Ray to Mexico City, where they stayed with Dorsey Fisher, the American embassy's first secretary, at his residence in the trendy Coyoacán district. Fisher gave a cocktail-buffet in their honour attended by some of Mexico's top artists, such as Juan O'Gorman and Carlos Mérida. Society columnist Virginia Snow commented in the *Mexico City Herald* about the guests of honour, "Neither one of the young painters looks like the popular conception of an artist."

This was heady stuff for Leonard. Feeling ignored by the Canadian art establishment, here he was, after less than ten months in Mexico, being feted in a country that venerated its artists. Leonard and Brossard were surprised at the publicity given the show. Their pictures with their respective ambassadors appeared in every daily newspaper and most magazines in Mexico City. One of the photos of Leonard and ambassador Pierce was distributed by the Canadian Press to its Canadian members. Leonard wrote: "When the crowds arrived that night and were ushered into the gallery where the Mexican, Canadian and American flags were displayed together on a dais as a symbol of the get-together, we felt we were really functioning in an international cultural interchange."[6]

Unlike in the United States and Canada, cultural reporting has always been a prized job for Latin American journalists, who see themselves as intellectual opinion makers. Leonard was now the recipient of favourable reviews by Mexico City's knowledgeable art critics. Antonio Rodríguez, writing in *El Nacional*, said of Leonard's works: "Brooks has interpreted the tremendous shock Nordic sensibilities have felt when coming in contact with certain realities of Mexican life. For instance, the philosophical attitude of our people toward death as seen in *San Miguel Graveyard*."[7] Luis Lara Pardo said in *Revista de Revistas*: "[Brooks] has painted Mexican types which, to our eyes, appear with novel strokes which we had not discovered."[8] Angel de las Barcenas, writing in Mexico City's *El Día*, said: "Leonard Brooks, in this exhibition of his works, shows himself principally as an excellent landscape painter who dominates figures and landscapes, with a marked impressionism in his paintings, which give life to the movement."[9]

Leonard's situation in San Miguel was now being clarified, as far as Northern Vocational and the Department of Veterans Affairs were concerned. Leonard and Reva were in Veracruz on a two-week painting and photography trip when the Toronto Board of Education sent a letter reminding him that his one-year sabbatical was coming to an end. While in Veracruz, Leonard was bitten by a mosquito and contracted yellow fever. By the time they returned to San Miguel, he was running a high fever and was delirious. When Reva read the letter, she replied over Leonard's signature that he was staying in Mexico. C.H.R. Fuller, business administrator of the Board of Education, replied: "This letter is to inform you that the Board of Education, at its meeting held on March 4th, accepted your resignation from your position as teacher at Northern Vocational School, to take effect June 30th, 1948."

Reva summoned their friend, Dr. Francisco (Paco) Olsina, to battle the yellow fever. Olsina had learned English while a doctor with the international

brigades during the Spanish Civil War. He had preceded the Brooks to San Miguel, following a tortuous journey from his native Spain to concentration camps in France and North Africa, where he learned to speak French, and exile in Cuba, Argentina, Bolivia and, finally, Mexico. Accompanied by his wife and infant daughter, he settled in San Miguel, Mexico being the only country that would allow him to practice medicine. Given his fluency in English and French, Olsina tended to the needs of San Miguel's foreign colony, charging the foreigners enough so that he could provide free services to his impoverished Mexican patients. The fact that Olsina was born in Barcelona, where Leonard spent much of his 1934 sojourn in Spain, solidified the friendship between the two men. Not having a car, the doctor lugged chunks of ice up the hill to the Brooks' home and applied them to Leonard until the fever broke and he regained full consciousness. Only years later did Olsina tell Leonard how serious his illness had been.[10]

When Reva told Leonard he had received the letter from the school board, he told her, "Tell them I can't return." "I already did," she replied.

To Leonard's surprise and delight, the Department of Veterans Affairs approved a one-year extension of his study grant, provided he commit himself to return to Canada to teach. "Otherwise, I must return all moneys they had spent," he told Earle Birney. "Rather ironic if there ain't no career there to continue – but I get their point."[11]

Leonard obviously felt he had a close call in terms of staying in Mexico, as expressed in another letter to Birney that summer. "Probably be one hell of an anti-climax after the excitement and vitality of Mexico ... I'm still tainted with Canadian pessimism where the Arts are concerned and must say frankly the only nostalgia for Canada is for its trees, fishing, winter and spring ... not for its welcoming arms which I've eluded for a time."[12]

The influx of GIS brought to San Miguel that year another person who would enter and alter Leonard's life: David Alfaro Siqueiros, one of Mexico's leading communists as well as a founder of the Mexican Mural Movement. Hardened by war, the GIS were not as passive as other students who had gone to the school. When they found there were no leading artists on the faculty, they complained to the Veterans Affairs section at the American embassy. Fearful of losing GI Bill status, owner Campanella hurriedly contracted Siqueiros to give a series of lectures and classes.

Siqueiros, who was forty-nine at the time, made a great impression on Leonard, with whom he had an instant rapport. "He is the most vital man I have ever met, and at the same time a very great creative artist in an international sense and I've absorbed much from him," Leonard wrote Birney. "He

Reva dances at a costume ball with Dr. Francisco Olsina, a medical doctor to the international brigades during the Spanish Civil War, who in exile settled in San Miguel.

dropped in here one morning and told me he'd like to do something for me ... write a few lines for me which might be useful ... I know he spent several hours thinking about my problems and it was indeed encouraging and flattering to have him go to this trouble entirely on his own ... Personally I would rather have this letter than one from Picasso ..." The letter from Siqueiros said in part:

Now then, there is no work in which there is not able to be found or in which there ought not to be found negative aspects. What are these in your work?

Excess of descriptivism; in consequence a certain amount of dispersion in the forms. Some persistence in what I call scenographic impressionism, very common in English and American artists and, therefore, a lack of formal synthesis. It would do your work a great deal of good, friend Leonard, to eliminate from it all the non-essentials, all the unimportant explanation in the integral body of your plastic discourse. Believe me that this would not weaken your realism, but on the contrary, would confirm it ...[13]

Earle and Esther Birney were not happy about Leonard's friendship with Siqueiros, whom they always felt had assassinated their idol, Russian revolutionary leader Leon Trotsky. "We told Leonard, 'You're harbouring a murderer with your friendship,' said Esther. He said, 'No, no. Siqueiros had nothing to do with Trotsky's assassination.' Earle would say, 'Oh, yes. He did.' He knew that he did. But it never affected Leonard's friendship with Siqueiros."[14]

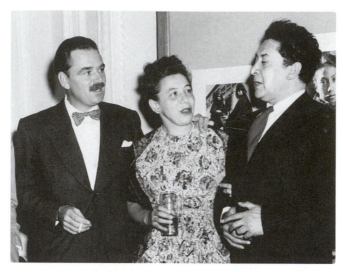

The Brooks with Mexican muralist David Alfaro Siqueiros, whose friendship caused them problems with American authorities.

Siqueiros' arch rival, Diego Rivera, and his wife, Frida Kahlo, had persuaded Mexican President Lázaro Cárdenas to grant Trotsky asylum. On 24 May 1940, more than twenty men led by a man in the uniform of a Mexican army major attacked Trotsky's residence. No one was killed or wounded, despite the firing of more than three hundred rounds of machine-gun fire and the explosion of two incendiary bombs. A search was launched for Siqueiros, believed to have been the man in the army uniform. Three months later, on 21 August, Trotsky died after being attacked by a Stalinist agent, Ramón Mercader, who was using the passport of a Canadian missing in Spain. Siqueiros was arrested but never prosecuted for the attempted assassination; he denied any role in the attack or Trotsky's death. Mercader served twenty years in prison.

The Brooks would withdraw from San Miguel's social life in later years, but in 1948 they were active participants. Annotations from a calendar show Leonard and Reva either hosted an event or were guests on all but two days in a typical two-week period. The "Siq" mentioned was Siqueiros and the Newtons were former Mexico City *Time* correspondent Don Newton and his wife. He was now trying his hand at fiction-writing in San Miguel:

Sun., 25 Oct.: Newtons for tea. To fiesta at San Juan de Dios. To Cucaracha [bar].

Tues., 26 Oct.: Siqueiros and wife arrived. Cocktail party at night.

Wed., 27 Oct.: To cocktail party at Armando García's with Siq.

Thurs., 28 Oct.: To Casa Artistas party with Siq.

Fri., 29 Oct.: To picnic, baseball and Stirling's with Siq. and Brossards.

Sat., 30 Oct.: To Guanajuato with Siq and party.

Sun., 31 Oct.: Return and Siq. and Newtons at our house.

Mon., 1 Nov.: To baseball game with Siq.

Tues., 2 Nov.: To Brossards for supper with Siq.

Thurs., 4 Nov.: To S[tirling] for supper.

Sat., 6 Nov.: To Newtons for tea.

Sun., 7 Nov.: [Birthday] party at night for Leonard.

Siqueiros' presence in San Miguel would soon have disastrous consequences for everyone associated with the fine arts school.

～ 21 ～

M̃ucho gusto, Señor Presidente

The issue that led to the closing of the art school in San Miguel was a mural by David Alfaro Siqueiros in the eighty-four-foot-long nuns' dining room, a project for which he enlisted the help of Leonard Brooks and other teachers as well as volunteer students. The idea for the mural came from Alfredo Campanella, who had been under mounting pressure from the GI students to improve the courses. Depicting the life of Ignacio Allende, the mural was to be the great achievement of the class of 1948-49. After Siqueiros' lectures had fired up the students, they prevailed upon him to do the mural. Siqueiros had admired the 5,555-square-foot room, just off the interior courtyard of the school, and visualized a mural that would cover every plane, including the floor and the vaulted ceiling. He intended the perspective of the mural to change as the viewer moved through the room. He agreed to do the project over five months for $1,500, the amount he normally received for two portraits. The cost of materials and for resurfacing the walls, ceiling, and floor was to be borne by Campanella.

The agreement stipulated that Siqueiros was to work on the mural for at least the first ten days of each month and that the work was to be completed in time for the Independence Day celebrations on 16 September.[1]

That Siqueiros and Campanella would come to an abrupt falling out over the mural was inevitable, given their disparate interests and backgrounds. A

short, stocky man with curly hair and a clipped moustache, Campanella looked like a well-to-do Mexico City businessman, a factory owner in his case. He boasted that his parents were Italian nobility.

When he was in residence at his Atascadero ranch in San Miguel, Campanella would dress in a Mexican *charro* – or cowboy – outfit and ride into town on a chestnut horse, which he tethered in the school's courtyard. Dismounting, he would ask, "Esteerling Deekenson ees here?" Students complained of the stench from horse droppings.

Born in the northern city of Chihuahua 29 December 1897, Siqueiros, a heavy-set man with tall, bushy hair and green eyes, was an authentic revolutionary. His paternal grandfather, Antonio Alfaro, was a legendary guerrilla fighter in the war against French occupation in the 1860s. His mother, Teresa, was the daughter of Felipe Siqueiros, an active Chihuahua state politician; he chose to use her surname, Siqueiros, rather than his father's more common name, Alfaro, as Spanish usage dictated.

Siqueiros' leftist politics were born in the 1910–17 Mexican Revolution in which he was a teenage participant. He once personally delivered a message to Pancho Villa, legendary commander of the revolutionary troops in northern Mexico. A captain in the Mexican army, Siqueiros rose to the rank of lieutenant colonel fighting for the Republican cause in the Spanish Civil War.

Before going to Spain, Siqueiros, who spoke fluent English, briefly taught art in New York in 1936. One of his students was abstract painter Jackson Pollock. Siqueiros' most visible work is the giant bas-relief and mosaic on the exterior of the administrative building of the National Autonomous University of Mexico, on which he worked from 1952 to 1956.

Siqueiros was arrested in 1960 and held for four years in Mexico City's infamous Lecumberri prison, where he continued painting. He was jailed for criticizing, while in Cuba, the anti-communist stance of Mexican President Adolfo López Mateos. He was banned from the United States from 1940 until his death in 1974, and also deported from Spain and Argentina. All told, he was imprisoned twenty-two times.

The mural project started smoothly as Siqueiros' twenty-four helpers came up with ideas for telling the story of Allende's life. Teachers and students worked on scaffolds under Siqueiros' direction, drawing the outlines of the elements to make up the mural. A bolt of lightning symbolizing the struggle for Mexican independence flashed across the ceiling. Kay Franger, who was a student assistant on the project, recalled work on the walls and ceiling as being so exhausting that by noon Siqueiros usually called everyone down from the scaffolding and asked them to sit in a circle around him. "He talked

THE SIQUSIROS MURAL

This sketch shows how the Siqueiros mural would have looked. This and other sketches in the biography were make by Leonard Brooks for a book of his, "In and Out of Mexico," that was never published.

about everything – art, colour and form in life – of their meaning and importance," she said. "He was also mischievous and fun. After holding us in thrall, he'd say, 'I'm too tired to go on in English, but if you want, I'll keep on in Spanish.'"[2]

Campanella became upset at the mounting costs of the supplies ordered by Siqueiros for this project. "The Mexican artists were experimenting with acrylics before acrylics came on the market," said Leonard. "We were making our own acrylics and Vinylite and using the plastic base, instead of fresco on the walls. Naturally, it was more expensive." When Campanella complained to Siqueiros, the artist said he could find funding from wealthy patrons to finish the project. But Campanella was reluctant to bring in outside funding, fearing this might endanger his income under the GI Bill. He decided to slow down the project and to skip the 16 September inauguration date by, among other things, not providing new material. As part of his strategy, he offered Siqueiros a new contract which the artist found insulting: while in San Miguel, he would not be allowed to do any painting of his own, even on Sundays. According to *Time* magazine, Siqueiros tore up the contract and threw Campanella down a flight of stairs at the government's National Institute of Fine Arts in Mexico City.[3] Leonard and the other teachers at the art school immediately walked out in support of Siqueiros.

Siqueiros sent a letter of protest on 6 July to Stirling Dickinson, GI student leaders, education secretary Gual Vidal and institute director Carlos Chávez, denying he had quit the mural project. "I did not abandon the work nor cancel the contract ... I only refuse to collaborate with Alfredo Campanella who happens to be director of the school by reason of a mercantile operation of hypothetical legality ... it could be that he is causing harm to the young foreign artists."[4]

Concomitant with but independent of the mural project, GI student leaders had organized a committee to present grievances to Campanella. Jefferson Sulzer, the Tulane professor who had worked on the mural, said the students met over several weeks to draw up their grievances. "This had nothing to do with Siqueiros," he said. "They were long-standing grievances that a lot of students had, like being unable to get the electrical wiring fixed in the studios."[5]

Flanked by two armed bodyguards, Campanella met with the student leaders, but cut off a reading of the list of grievances. "I decide what the school will do," he said. "You are the students. You do not make demands of me."[6] As a result, when the teachers boycotted the school in support of Siqueiros, the art students on 17 July voted 125 to 7 to join the boycott.

More than one hundred leading Mexican artists and filmmakers took out an advertisement in the newspaper *Novedades* declaring their support of the boycott and charging that the school had been awarding fraudulent Master's degrees. They asked that the school be reorganized under new management to comply with Mexican artistic standards. Among those signing the manifesto were artists such as Orozco, Rivera, his wife, Frida Kahlo, Doctor Atl and Rufino Tamayo, as well as filmmakers such as Emilio (El Indio) Fernández.

Campanella fought back five days later in a fullpage advertisement in all Mexico City's newspapers under the title: "Let's not play the publicity game of the slanderer, defamer and deceiver David Alfaro Siqueiros." He said that Siqueiros lacked the ability to prepare a budget and carry out a work of the magnitude of the mural. He said the cost of the mural threatened to reach 30,000 pesos ($2,400) for paint supplies alone. Campanella was obviously fearful of Siqueiros when he said, "Then came the challenging threat to take over my school by whatever means at his disposal since he operates through terror against those artists and authorities he wants to manage at his whim."

Once the art school was effectively closed down and the American embassy suspended payment of student grants under the GI Bill, the war veterans and the teachers found themselves in the same situation: no income and no school. So they decided to open a new school, to be housed in the building used provisionally in 1938 by Cossio del Pomar and Dickinson. The students and teachers joined forces to refurbish the building. Leonard wrote:

Former soldiers, marines and sailors organised workshifts, and the sound of sawing and hammering, the slap of the whitewash brush, and the work of the engineering and electrical parties soon made a noisy symphony of sound. Someone invented a combination seat and drawing board, and planks were cut to make up forty or fifty of these for the Life class room. Chairs and furniture were loaned and donated by the students

themselves and some of the townspeople and well-wishers in the American community offered to lend funds.[7]

All told, of the 135 students who lost their GI grants, 75 stayed in San Miguel and worked on the new school. The rest transferred to other accredited Mexican schools in Mexico City, Guadalajara, Morelia and Puebla.

Two days after his school was closed down, Campanella went to the American embassy with two of the students who refused to join the boycott, William Miller and Richard Midgett, with the intention of thwarting efforts to launch the new school. They denounced the teachers and students as rabble-rousing communists, according to Dickinson.[8] They were aided in their mission by the fact that one ex-GI had just killed another at a drunken party, bringing disrepute to the student body.

Alarmed about the threat to the new school, Dickinson, Leonard, and some of students went to Mexico City themselves to try and counter Campanella's campaign. They met in a coffee shop with Siqueiros, who suggested they take their case directly to Mexican President Miguel Alemán. The opportunity was there: Alemán was to inaugurate the biggest retrospective of the works of Diego Rivera at the Palace of Fine Arts. Siqueiros suggested a letter to the president, copies of which would be distributed to the guests and to the news media. "We must bring it to a head quickly," Siqueiros asserted. "We looked at each other," recalled Leonard. "It was the first time we had been asked to take part in Mexican-style tactics. Siqueiros saw the look of doubt which swept over our faces." "Believe me," said Siqueiros, "There is nothing to it. This is the way we do things here to get action. I will be there with the president and Rivera, and you will see how successful it will be."[9]

The San Miguel contingent met at the Monte Carlo hotel near the Palace of Fine Arts to draft the letter. Leonard's new friend, Charles Allen Smart, a professional writer, was instrumental in drafting the letter. Stirling Dickinson did the Spanish version. The letter, titled "A Good School, Not an Educational Racket," urged government certification of the new school and an investigation of Campanella's operation of his school. It was agreed that Leonard and student council president Bill Hammill would accompany Siqueiros to see the president.

Before the opening, the students and teachers gathered up copies of the letter and headed for the Palace of Fine Arts on broad Paseo de la Reforma. Among those who helped distribute the flyers was Arnold Belkin, a nineteen-year-old Canadian artist then studying in Mexico City. Belkin would be lionised as an artist in Mexico, where he lived until his death in 1992. Charles Allen Smart recalled the scene outside the palace. "There was a huge crowd of

all kinds of people, and I remember handing leaflets to ladies in diamonds, to barefoot Indians, and to some of the armed guards who came in with the President, before dumping the rest under a statue of a nude."[10]

As Leonard walked into the building with Siqueiros and Hammill, he asked if their presence might not upstage Rivera on one of the most important evenings of his career. Siqueiros laughed. "Of course it will," he said. "He's done it to me many times." Rivera once showed up at a Siqueiros opening with one of Mexico's leading movie actresses on his arm.

Siqueiros quickly joined President Alemán, who was talking to Rivera, and then signalled to Leonard and Hammill to come over. "Artists and students from San Miguel," Siqueiros announced, introducing Leonard and Hammill. "Here is the Canadian *maestro* Leonard Brooks, who wishes to present you with a letter." "*Mucho gusto, Señor Presidente*," said Leonard. Then Hammill pulled the letter quickly out of his coat pocket before the presidential body-guards could think he was drawing a gun and handed it to Alemán. The three-hundred-pound Rivera found himself pushed aside for a minute, obviously intrigued by the foreign intruders at his opening:

We spoke for a few seconds. The President told us he was very interested in San Miguel and our work and would be pleased to consider our letter. We thanked him, and feeling highly elated though perspiring and a bit shaky, found ourselves outside the sacred circle and lost once more in the mob, as a half-a-dozen more flashes illuminated the gathering. Siqueiros was grinning as we left, a big, "what did I tell you?" grin that made us want to laugh at our fears.[11]

Siqueiros telephoned Leonard the next day and told him to be at the office of Chávez, the fine arts institute director, at 10:00 a.m. President Alemán had already asked Chávez to immediately look into the case. They were told that three inspectors would be sent to San Miguel when the refurbishing of the new school had been completed.

The Escuela de Bellas Artes – the name was suggested by education secretary Gual Vidal – was duly approved by the inspectors and became part of the Mexican educational system. The Canadian government immediately followed suit, allowing Leonard to transfer there. Now the school just needed accreditation from the American embassy so the ex-GIs could enrol and resume receiving their cheques.

The American embassy's Veterans Affairs attaché, Nathaniel R. Patterson, had assured Dickinson that his office would accredit the school once the Mexican government had approved it. Apparently he was countermanded by

ambassador Walter Thurston, who agreed with Campanella that there were communists behind the new school.

Felipe Cossio del Pomar, back in exile in Mexico, blamed the closure of the school he had founded on the "unexpected bonanza" of the GI Bill and the hiring of Siqueiros. "Siqueiros, with his great intelligence, upon arriving in San Miguel realized that he could use the school for party propaganda."[12] But Philip Stein, a Hollywood set designer who went to San Miguel during a strike in 1948 and later became a Siqueiros biographer, said that the artist took pains not to get involved in political discussions with the students. "It was a no-no," he said.[13] Leonard recalled one student asked Siqueiros' wife, Angélica, if he would explain some of his political ideas. "His request was refused with the explanation that the *maestro* was there to talk about and teach painting, and nothing else," Leonard said.[14] Charles Allen Smart added, "there were probably half a dozen communists among the students" but few admitted it.[15]

A bi-weekly San Miguel newspaper, *Quijote*, attacked "communism in the art school," "drunken Americans" and even marriages of Catholic Americans and Catholic Mexicans. Signs reading "Catholic yes, communist no" were tacked on the doors of some homes in San Miguel. Rocks were thrown through the window of a female veteran, daughter of a U.S. admiral, and a bomb exploded against the home of John M. Johnson, a retired colonel and member of the student council.

The Mexico City newspaper *Excelsior* exacerbated the situation by publishing a story saying Siqueiros had planned to paint in the nude Mexico's patroness, the Virgin of Guadalupe, as part of the Allende mural.[16]

Veteran Marxist Earle Birney must have chortled when he received a letter from Leonard about the boycott of the school: "Some screw-ball students sabotaged us – and said we were all Reds – and turned the priests here against us."[17]

Dorsey Fisher, the first secretary and one of the few people in the American embassy supportive of the teachers and students, advised Leonard that a document was being passed around the building listing "Reds in San Miguel" and giving their background. "I would no doubt be amused and interested to learn that I had been a fighter pilot in the Spanish Civil war in 1937," said Leonard, who had left Spain three years earlier.[18]

As a last resort, Siqueiros agreed to Leonard's suggestion that he go to the embassy himself and try to convince the officers that there was nothing political behind the closure of one art school and the establishment of another one to replace it. Leonard made the appointment and accompanied Siqueiros. Before getting out of his car, Siqueiros removed his revolver from his pocket and placed it under the seat. "There are two places where I don't take this," he

explained. "One of them is the Palace of Fine Arts, and the other is to any embassy or government building. Anywhere else it can be a mighty useful thing to have around!"

Even if Siqueiros had brandished his revolver, he would not have moved the American diplomats during the two hours he was at the embassy. They delayed accreditation until the issue became academic when a new u.s. law prevented recognition of additional schools. The embassy contended the school was new, even though the teachers and student body were the same.

The new school opened 25 August 1949 with fewer than ten students in attendance; Alfredo Campanella's school closed for good; the mural extolling the life of Ignacio Allende that Campanella had ordered was never finished. Now Campanella plotted his revenge.

～ *22* ～

I no longer consider Leonard a Canadian painter

Having met Mexican President Miguel Alemán and helped to establish the new art school in San Miguel, Leonard Brooks returned triumphantly to Canada in September 1949 for a joint show with Reva. He could boast of having had his first one-man show in the United States earlier in the year; Reva accompanied him not just as a wife but also as an artist in her own right.

Leonard's only worry was the Veterans Affairs grant, now ending after two years. Canadian ambassador Sydney Pierce wrote to Ottawa urging that he be given a third year; teachers at the art school sent letters of support. Veterans Affairs insisted that Leonard already had enough training to enable him to secure "suitable employment" in Canada. Reva grumbled that Leonard kept her awake nights mumbling "suitable employment" in his sleep. Leonard told Earle Birney that even without the grant he planned to remain in San Miguel as he could live on the eighty dollars monthly he received for teaching three mornings a week. He also said he had sold $1,000 in paintings in Mexico, but he came close to duplicating that amount with sales in the United States.[1]

Leonard's American debut was at the Cowie Gallery at the Biltmore Hotel in Los Angeles. The one-man show was the brainchild of MacKinley Helm, a Pasadena, California, writer who had been instrumental in introducing Mexican art to the American public in the 1930s. At Helm's suggestion, Leonard

San Miguel Graveyard, *one of Leonard's first watercolours in San Miguel, late 1940s.*
COLLECTION ART GALLERY OF ONTARIO

had gone the previous year to California, where he showed one of his paintings, *Mexican Fiesta*, at an exhibition of the Pasadena Art Institute 14–31 September. While there, he was inducted into the California Watercolor Society, a recognition that pleased him since the Canadian watercolour society had denied him membership. At that time, Helm introduced Leonard to gallery owner Alexander S. Cowie, who arranged the show the following year. Cowie said of Leonard in a catalogue note: "Brooks has a fresh eye for scenes of churches, tiled adobe houses and spacious plazas which, invariably picturesque to Northern eyes, are all too often painted with a sentimental sweetness that belies their reality. One feels that the artist is delighted by what he sees, that he has an inexhaustible fund of compositions and never repeats himself; that each picture, in a word, is experience."

The *Los Angeles Times* review of 13 March said: "His warm and glowing watercolours of typical Mexican sights are vigorous and skilfully composed. They depict places where the artist has been living for the past two years, and will be found most enjoyable." Leonard sold ten works for prices ranging from seventy-five to one hundred dollars.

The Brooks were packing for the trip to Canada when a messenger arrived with a note from the Posada de San Francisco, a hotel where Leonard displayed his paintings. A Mexican guest had admired Leonard's watercolours and asked hotel owner Ramón Zavala about him. Leonard would have ignored the note except for the fact it came from an aide to General Ignacio Beteta, a former munitions minister. "Would you be kind enough to see the general and talk to him about painting?" Leonard agreed. The man who showed up at his studio looked more like an English squire than a Mexican general, ruddy complexion, blue eyes, reddish-blond moustache, tweed sport coat and snap-brim fedora.

They agreed to meet again that afternoon at El Chorro, a colourful square with concrete washtubs where native women did their wash. It was a favourite of painters. "The criticism I gave that afternoon was direct, if nothing else," said Leonard. "It was his tiny brush that did it. If there is anything a watercolour painter despises, it is those 'one-haired' limp brushes which so many amateurs seem to favour. 'With force,' I said. 'Don't paint like a *mujer vieja* – an old woman!'"

Rather than being offended by the remarks, Beteta, eleven years his senior, enjoyed Leonard's criticism and his enthusiasm. He gave Leonard his business card with his private telephone number, sealing a friendship that would last until Beteta's death forty years later. "Hang on to that," said Beteta's aide, an American named Martin Kauffman. "The general does not hand these out everywhere, and he wants me to tell you that if he can be of service to you any time ... "[2]

A year later, that business card would help assure the future of San Miguel as an art colony.

When Leonard stormed Toronto a few days after this encounter, he was just as blunt in his criticism of the Canadian art establishment. His message: Canadian talent was not appreciated at home and had to seek recognition elsewhere. The magazine *Saturday Night* said:

Painter Leonard Brooks, up from Mexico, hit the Canadian art world like a stiff sou'easter. Ostensibly, Brooks had returned to Canada to arrange exhibits of his paintings, but before his two-week stay was up some people were feeling their necks and wishing he hadn't made the trip. Others wondered whether he hadn't come home mainly to light a Fall bonfire under the lukewarm kettle of Canadian art.

Big, be-moustached 37-year-old Brooks' favourite theme was: "Why Canadian artists leave home." As he stepped off the train after a two-year absence, he took one fresh, grey-eyed glance at the Canadian art scene and, barely raising his soft voice, started discovering blight and famine all over the landscape.

Grumbled Brooks, "The state of the artist in Canada hasn't improved in twenty years. The artist doesn't matter a damn here. There is a complete indifference to any

contribution he might make to the national life. The tea-party artsy-craftsy attitude prevails all over."[3]

Leonard upset Lotta Dempsey of *The Globe and Mail* during a discussion on radio station CKEY with Art Gallery of Toronto director Martin Baldwin and novelist Frances Wees. Writing later in *The Globe and Mail*, she said: "That old Canadian inferiority complex reared its ugly head again recently on a highly stimulating discussion program ... we got as mad as heck at some of the things they had to say about lack of opportunity for young genius in these parts ... both artist Brooks and galleryman Baldwin were taking the tack, if we are not mistaken, that any big-time future for Canadian talent is by courtesy of the United States ... both Mr. Brooks and Mrs. Wees are, in their respective fields, top performers, and therefore among the few eligibles for top-notch fields like New York or Hollywood; or in the pages of circulation-heavy mags like *Life*, of which they spoke."

Leonard told *Canadian Art* magazine that he encountered "some resentment" from fellow artists because he felt so strongly about Canadian art and being a Canadian artist.[4] That resentment would increase over the years as Leonard began to prosper in Mexico. When told that Leonard retained his Canadian citizenship but had received Mexican residency papers, Archie Arbuckle said, "Well, that's being a Mexican, as far as I'm concerned. His whole life has been there, really."[5] Jean Horne, sculptor wife of Cleeve Horne, was blunter. "I no longer consider Leonard a Canadian painter," she said.[6] Cleeve Horne was especially upset that Leonard accepted the Veterans Affairs grant but never returned to Canada. "The whole theory is they give you money and you train outside of Canada if you want and come home with the wisdom you have and help the country," he said. "He was supposed to come back."[7]

Years later, Swiss-born Toronto gallery owner Walter Moos mused about such resentment. "The one thing that the Toronto so-called art establishment doesn't like very much is if somebody gets too successful, what I call the Toronto Syndrome," he said. "I don't know whether it is ingrained jealousy rather than being pleased, which would be the normal reaction of people."[8]

Herbert Whittaker, former drama critic of *The Globe and Mail* and author of a book on Canadian actors who achieved success in Hollywood and on Broadway, told the author that if he were writing a biography of Leonard Brooks, he would proceed from the perspective of the Canadian artist being forced into exile.[9]

"The expatriate part was something we had forced on us," Leonard told an interviewer many years later. "I tried awfully hard to teach in Canada, but there were few jobs. The pall of indifference that I have felt from Canada is, in a way, a very good thing because it enables us to go into the sunlight that exists outside

of Canada. If you're not around up there playing their game, you cannot be heard from again."[10]

One person who did not resent Leonard's life in Mexico was R. York Wilson, then known as Ron. A successful commercial artist who longed to paint full-time, Wilson was excited by the stories Leonard told during a luncheon at the Arts and Letters Club. As soon as the luncheon was over, Wilson called his wife, Lela, and told her, "Tonight I'm going to give you a sales talk on going to Mexico." "You don't need to," she replied. "I'm ready."[11] Two months later the Wilsons were in San Miguel, the first of many Canadian painters to follow Leonard to Mexico.

Where the Brooks received a warm welcome was at Eaton's Fine Art Gallery. "Eaton's are falling all over themselves to do our mutual photo and picture exhibition in a large way," Leonard told Earle Birney.[12] The joint show at Eaton's, "Two Years in Mexico," opened 20 September for ten days and moved to the Elsie Perrin Williams Gallery in London, Ontario, 14 October for a month. It was Leonard's eighth and last one-man show at Eaton's. As usual, the art critics praised his works.

The Globe and Mail's Pearl McCarthy wrote: "Leonard Brooks, working with convincing honesty, has obviously been seeking for years to work out an objective, rationally representative style which, at the same time, might not be lean in either aesthetic qualities or human sympathy. The paintings ... show that his last two years in Mexico, away from the daily grind of art teaching, have enabled him to realize that ambition as never before."

Nor was Reva ignored in this first show of her photographs, just two years into her career. Lotta Dempsey of *The Globe and Mail* wrote: "Mrs. B. became so interested in the unusual people of the distant Mexican villages – far from tourist centres – that she studied at the photographic school there and now has some of the most interesting studies that have been done of the inland country and its people."

The Toronto Telegram's Rose MacDonald said: "Mrs. Brooks, a truly perceptive young woman of Polish forebears, with a warm interest in the life going on about her, took up photography after going to Mexico. She has brought back with her a richly varied collection of photographs of the people, the very young and the very old, with whom she made friends, illustrating their folk cultures."

One of the people visiting the Eaton's show was the Group of Seven's Fred Varley, who was so captivated by Reva's photographs that he returned to the gallery to see them again. "He saw some of my photographs and he became angry with me," Reva recalled in a taped interview in 1969 with Varley's son, Peter. "He said I should devote my life to being a photographer, not to being a wife." Reva, who sounded wistful on the tape, must have been thinking

about "what might have been" in a photographic career that lasted, essential-ly, less than fifteen years.

~ *23* ~

*T*hey were a wicked pair together

The euphoria of the visit to Canada for Leonard and Reva soon gave way to the realization, once back in Mexico, that they had no steady source of income. His study grant had expired 31 August and the Department of Veterans Affairs still had not made a determination on its renewal. The decision by the American embassy to withhold accreditation of the new art school precluded the enrolment of GI students and meant Leonard would not be receiving the eighty dollars monthly he had counted on from teaching. Like the other teach-ers, he would be working for virtually nothing. For income tax purposes, he claimed a total income for 1949 of $1,080, the lowest amount since he and Reva had married in 1935. To save rent money, the Brooks gave up their lease on La Rinconada and house-sat with Charles Allen Smart and his wife, Peggy, at 35 Sollano Street. That was the home of John M. Johnson, the retired colonel who decided to take his wife on an extended trip following the bombing incident during the boycott of Alfredo Campanella's school.

Leonard and Reva received some much needed moral support at this time from an unlikely source, Marciana, the maid. "Don't worry, *señor* Brooks," she told Leonard. "We can always live on *tortillas* and beans. They don't cost much money."[1] Leonard was so moved by the concern of this bare-foot young woman that he would often recall her words during difficult times.

Marciana even brought in money for the Brooks. They returned from a trip to Mexico City to find a cheque for fifty dollars waiting for them. "I sold one of your paintings to two Americans," a pleased Marciana announced. Leonard wondered how this could be since his studio was locked. Marciana explained that when the pair had appeared at the door saying they wanted to buy a paint-ing, she had taken one of Leonard's discarded sketches out of the trash bin, smoothed it out and offered it for sale.

Leonard and Reva were living at Sollano Street when York and Lela Wilson arrived for a six-month stay, the first of many they would make to San Miguel over the next thirty-five years. Of the three closest friends Leonard would have

during his lifetime – Earle Birney, Charles Allen Smart, and York Wilson – York was the most important, if not the most intimate, because he was the only painter among them. "They were like brothers," said Lela Wilson.[2] Wilson's background was not dissimilar to that of Leonard, who was four years his junior. Like Leonard's parents, York's were English immigrants. His father was a lifelong postman, providing the family with a less than middle-class lifestyle, as had Herb Brooks on his railway salary. Whereas the Brooks family was culturally bereft, the Wilson family was definitely not. An aunt who was the mother of famed conductor Leopold Stokowski had raised York's mother, Maude. Maude brought her love of music to her marriage with William Wilson and imparted it to her son. York would recall that he spent his first earnings as a twelve-year-old on two classical records.

Like Leonard, Wilson was a high-school dropout, quitting at age sixteen at his parents' suggestion because family finances were strapped. He had briefly studied art at Oakwood Collegiate in North Toronto before being asked to leave because the school found his behaviour unsettling. His sense of humour and comic antics were presumably too much for the teachers.

While Leonard opted for Europe as an impoverished artist, York, still a teenager, left for the United States. He was soon working for the Meinzinger Studio in Detroit for fifty dollars a week, an enormous sum for 1927. The start of the Great Depression two years later left him unemployed, so he returned to Canada to live once again with his parents, but he brought back a skill in illustrating and lettering that would eventually make him a sought-after commercial artist.

Wilson was working at Ronalds Advertising Agency, where he did many *Maclean's* and *Liberty* magazine covers, when he met Leonard in 1939. He was also painting and selling some of his own works, so Leonard encouraged his admittance to the Ontario Society of Artists, where he soon became president. "He was a very successful commercial artist who always managed to make a very good living, more than most," said Leonard. "He was a brilliant artist who could do anything." When Wilson heard Leonard's enthusiastic description of San Miguel, the timing could not have been better. At age forty-one, he was already wondering if he could drop his lucrative commercial work and live on the sales of his paintings. Mexico thus became "the major catalyst of his career."[3] The commercial artist was plain Ron Wilson; the painter became R. York Wilson.

The Wilsons must have been impressed by their welcome to San Miguel. Thanks to the Brooks, they were greeted by mayor Julian Malo and serenaded by a group of *mariachis*, the traditional Mexican musicians. For forty dollars a month they rented a house with a swimming pool on Recreo Street and settled in.

The Brooks arranged with mayor Julian Malo for a musical reception when
they arrived in San Miguel in 1949. Leonard is to York's left.
COURTESY OF LELA WILSON

Wilson soon got into the Mexican mood, falling in love with bullfighting.
He and Leonard would follow the local circuit, from San Miguel to Celaya to
Querétaro to Comonfort, wherever there was a Sunday *corrida*. Sometimes
after a few drinks of rum the two would jump into the ring and challenge the
bull themselves, according to Lela Wilson.[4] York had inherited and enlarged
on his father's droll sense of humour to such an extent he would have been a
good stand-up comic. An extrovert, more than anyone else he brought out the
boy in Leonard and led him to do things he might not have done otherwise.
"They were a wicked pair together," recalled Helen Watson, widow of Syd
Watson, director of the Ontario College of Art. "But they had fun together."[5]
"They were each other's Mutt and Jeff, Abbott and Costello," said Toronto
writer Scott Symons. "They played off each other with vehement wild
humour."[6] Long-time San Miguel resident Jim Hawkins likened their zany
antics to something out of the "Saturday Night Live" television show.[7] A
favourite skit involved a one-armed flute player who was asked for a light and
how he managed to play and light a match at the same time. "We'd go to a
party and York would say something funny and I'd pick it up," Leonard
recalled. "We were like a couple of vaudeville hams." As an example of
Wilson's wit, Leonard recalled the time they painted with Toronto's Syd
Hallam. Hallam complained, "God there's a strange smell around this place.

It's bothering me." Wilson replied, "Why don't you move back a little bit from your painting." Said Leonard, "He was the funniest man I'd ever met."

American academic and writer Edmund Fuller said one of the two or three funniest evenings of his life occurred in Paris when Leonard and York were improvising during a dinner at the home of Canada's ambassador to UNESCO, Léo Roy. The pair started to joke in various English accents. "They could do all of them with great perfection," said Fuller. "But the thing that was so funny was not that they could mimic the sounds of those regional dialects but they had remarkable penetration into the psychology of the people who spoke those dialects. They would go on improvising in an amazingly creative and hilarious way."[8]

Lela Wilson told of a bibulous dinner at their Toronto home after which either Leonard or York grabbed a manuscript that Earle Birney was carrying and threw it into the blazing fireplace. Wilson then thought he should sacrifice some of his art, too, so he added one of his paintings to the fire. The best that Leonard could do to keep pace was take off his tie and toss it in.

If they felt their humour was worth the effort, they would dedicate not only their creativity but their time. They once spent two days doing some fifty drawings in the style of artists like Picasso and Dufy as a surprise gift for Charles Allen Smart.

Within weeks of Wilson's arrival in San Miguel, Leonard involved him in a Mexican art exhibit followed by some typical Mexican revelry, a harbinger of future outings together. The exhibition was sponsored by the newspaper *Excelsior* and held 10–23 December 1949 in Chapultepec Park in Mexico City. The two Canadians were among the few foreigners whose works were accepted for the exhibition, entitled, "Mexico City Interpreted by Its Artists."

While in Mexico City to make arrangements for the exhibition, they decided to visit Plaza Garibaldi, the tough, bawdy, gaudy night-club and dance-hall area and locale of wandering *mariachi* players whose play-for-pay songs draw eager crowds. "The real Mexico," as Leonard boasted to Wilson. They left most of their money in their hotel room, hidden in their paint boxes, and headed for Plaza Garibaldi and its various delights. After an evening of drinking and dancing, they returned to their hotel at 4:00 a.m. with a couple of the ladies of the night who shortly thereafter slipped out of the room and disappeared. "Jesus, I think they've taken us," said Leonard. Their paint boxes had been emptied of money. They still had enough in their pockets for bus fare back to San Miguel. Hungover, they stopped and sketched on the way back so they would have something to show for their time away. "We had some nice sketches out of it," recalled Leonard.

An oft-repeated story was how they were in a house of ill repute in the nearby town of Celaya when the police raided the establishment. The two of them

ran down the hallway in opposite directions and managed to get out onto the street without being detained. Once the story was told during dinner while Reva was in the kitchen. When she appeared, the conversation abruptly changed. Accounts of other escapades abounded.

Jack Baldwin, a fellow teacher and painter, told his wife, Bunny, about how boisterous Leonard and Wilson were on painting expeditions. "He said they both made so much noise and they grunted and squealed and carried on while they were painting furiously," said Bunny. "They were a good pair."[9]

Mainly when the two men were together, they endlessly talked art, critiqued each other's work and argued. One of the arguments centred on whether an artist could take the least promising subject matter and produce a worthwhile painting. They decided to put themselves to the test, driving a predetermined distance and painting whatever they found on the right-hand side of the car. Leonard explained what happened:

We stopped on the dot of mileage 14,286.4 and found ourselves staring at a desolate, dried field with three cactus plants as large as small trees, and a stone wall.

"Quite inspiring," muttered Wilson to himself, while I tried to look nonchalant and unperturbed by the desolation.

We spent most of the morning staring, turning over rocks, and trying to visualize what could be made from such unlikely beginnings. If a painter had to be in love with his subject to do anything worthwhile, we would have been finished.

We had agreed that after we had made our notes, absorbed our material, we would have two weeks in which to complete our paintings. Then we would meet and exchange notes on our production. Wilson made some careful drawings of cactus forms and I finally, in desperation, did a literal watercolour, putting in everything I could see for future reference.

We drove back to our studios feeling rather foolish and thinking that we could have at least picked a more intriguing mileage with potential picture-making material.[10]

They each did about a dozen paintings of that scene, all of which were sold. One of Leonard's became part of the permanent collection of the Carpenter Galleries at Dartmouth College, Hanover, New Hampshire.

There was a friendly rivalry between the two men, what Rumanian-born sculptor Sorel Etrog termed a "constructive rivalry" that challenged both of them. "The challenge was very positive, sort of creating demands on one another." He saw in their funny antics a removal of their protective Canadian mask and an unleashing of their creativity. "All this childish fun, this employment of the absurd, allowed their imagination its utmost freedom."[11]

Over the years, they influenced the way each other painted. Although Leonard had experimented with abstract expressionism as early as 1954, he called it "a smear of ugly nothingness ... dabbling, daubing, negative crap ..."[12] It was Wilson who pressured Leonard into giving his abstracts a fair trial. When he did, Reva was delighted. "I like my husband's paintings more as he becomes more and more intensely abstract, and to me it's more spiritual, it's more meaningful, it's more philosophical ... he started out by being a landscape painter and what you might call an expressionist painter of nature, and very fine and so on, but they never were as moving to me as some of the ones that he does now when he is in these moments and moods of tension, where he has to release something, and eventually it's released in an abstract way and it's very meaningful."[13]

Wilson would follow Leonard's lead in collage. "All our life we influenced each other," said Leonard.

Whenever Wilson left San Miguel to return to Toronto, Leonard would complain he had no one with whom to talk art, even though he lived in an art colony. No one else filled the role that York had played.

The arrival of the Wilsons and the presence of Charles Allen Smart in San Miguel at the same time gave Leonard a level of social satisfaction he had seldom enjoyed. All that was to be threatened in 1950, a pivotal year for both the Brooks and San Miguel.

~ 24 ~

Vámonos! Now!

Alfredo Campanella had achieved a partial victory in his fight against the new art school in San Miguel. He had conspired with the American embassy to prevent GI Bill accreditation for the school, thus denying it tuition from former u.s. servicemen. Now he set out to close it down and drive out the teachers who had defied him. He was aided in his endeavours by the town priest and the presence of a Hollywood film crew.

Fresh from the seminary, Father José Mercadillo arrived in San Miguel in 1937, the same year as Stirling Dickinson. The son of a poor family, he became as conservative as his San Miguel parishioners – and he also managed to accumulate considerable wealth. He was violently anti-American, as were most of his parishioners, yet he liked the artists because he was a good amateur painter himself.

After the fight with Siqueiros and the opening of the new art school, Campanella found an ally in Mercadillo. Both now had the same goal: drive out the Americans – no distinction was made between Americans and Canadians – who had taken up residence in San Miguel. Campanella sent letters to American universities denouncing Dickinson and the teachers as communists and deriding their new school. He also recruited to his cause friendly journalists, obviously for a monetary consideration. Mercadillo used the pulpit to attack the American colony in his Sunday homily. He went as far as to threaten the Americans where it would really hurt: he urged their maids to quit working for them. That reportedly drew a rebuke from the bishop. Mercadillo told mayor Julian Malo at a municipal meeting 30 April 1950, "I regret very much that these bad elements, determined to make San Miguel a focus of communist propaganda and a nest of card players and repugnant homosexuals, distort the healthy and patriotic intentions of the government."[1]

Columnist Roberto Furia of the Mexico City newspaper *Excelsior* commiserated with the "decent people" of San Miguel, writing that "there are many communists" in the town, all, he said, friends of Siqueiros.[2]

Not that American communists were unknown in San Miguel. One couple who owned a rental home stopped off en route to Mexico City to visit their tenants. They asked their passenger to wait for them in the park. The passenger was Gus Hall, future chairman of the American Communist Party. "I'm sure an FBI informer was sitting right next to him in the park and another followed this couple down by our house to see where they were going," said former GI Bunny Baldwin, who lived next door to the couple's San Miguel house.[3] As the Cold War between the United States and the Soviet Union deepened, the FBI opened files on many American citizens – as well as some foreigners – it viewed as communists or sympathisers. Baldwin later received a copy of her FBI file under the u.s. Freedom of Information Act, thirty-five pages, almost all on her life in San Miguel.

Because of its colonial architecture and few anachronistic overhead wires, San Miguel had often been the location for Mexican movies set in the eighteenth and nineteenth centuries. Then Hollywood moved in. For more than a month, the crew of "The Brave Bulls" starring Mel Ferrer shot scenes in the local bullring and other locations. The cast and crew monopolized the Cucaracha bar, the favourite drinking spot for foreigners and the only one that admitted women, and replaced the departed GI students as targets of opprobrium. Encouraged by Campanella, the Mexico City newspaper *Ultimas Noticias* published prominently on page two an article on the controversial

presence of the filmmakers. Under the headline "Paradise of the Depraved," the story said:

According to credible reports received by this reporter, it can now be made public that there are shameful goings-on that demand the immediate action by the authorities. People who were recently in San Miguel de Allende, Guanajuato, for the filming of "The Brave Bulls" assure us that this beautiful town has become the paradise of shameful acts by numerous individuals, all of them Americans.[4]

The account said that among the hundreds of people brought in from Hollywood were men who could be seen embracing and holding hands in public.

If the locals did not like filmmakers, their presence was a welcome diversion for the foreign community. When Canadian university students Kay Sillers and Marg Short arrived in San Miguel that summer to study at the school, drawn by Stirling Dickinson's advertisement in *Canadian Art* magazine and Leonard's presence, Reva took them immediately to the Plaza de Toros to see the filming.

Attractive young ladies, Kay and Marg were soon involved in a social activity that always drew the wrath of Father Mercadillo and many *Sanmigueleños*: they dated Mexicans. During the four years the former GIS studied in San Miguel, many of the men dated – and some married – Mexicans, as did one of the handful of female students, Dotty Birk, who married Pepe Vidargas. "Mexican men resented the GIS who dated local girls," said Casimira (Cassie) Bowman, who married GI painter Kent Bowman and remained in San Miguel with him.[5] Kay and Marg were courted by two of San Miguel's most eligible bachelors, Dr. Felipe Dobarganes and his best friend, a law student. They took the girls to the Fronton Club in Querétaro in Felipe's red convertible, one of the few cars in town, and Felipe even hired *mariachis* to serenade Kay under the window of their hotel. "The Mexican girls hissed at us all the time," recalled Sillers, now Kay McKeen of Pompano Beach, Florida. "They didn't like us at all."[6]

Dotty Vidargas, who with her husband runs a real estate firm and interior decoration store, recalled that local residents were at first delighted when the ex-GIS departed. "Townspeople said, 'The gringos have gone. Good.' They were happy about that. Then they realized there was no money coming in. There was a lot of anti-American sentiment in 1950."[7]

Campanella also took advantage of Mexican law to harass the teachers with unfounded charges. "Two or three times a month we were asked down to see the public prosecutor who by law had to ask for our appearance to present to us verbally the accusations against us submitted by *señor* Campanella," wrote Leonard.[8]

Dressed like a Mexican, Leonard teaches one of his students, Canadian Kay Sillers, shortly before he and other teachers are deported in 1950.
COURTESY KAY MCKEEN, NEÉ SILLERS

Although Leonard had only six students in his class, they were not up to the standard of the former GIs. "The students here give me a pain in the ass – mostly retired school teachers with a complex that they know all about it," he wrote to Charles Allen Smart, who had returned to Ohio. "Sometimes I think the teaching racket stinks and doesn't do much good anyway. I'm really happy getting away from this nonsense for a time."[9]

The Brooks were scheduled to visit the Smarts in Chillicothe, Ohio, so Leonard and Smart could go over a joint book project on which they were working. Smart would present the problems of an amateur painter and Leonard would respond and do the illustrations. The book was written, but no publisher would accept it. However, the experience helped Leonard when he wrote the first of his published art books.

Increasingly Leonard was looking towards writing to supplement his painting sales. With Smart as a consultant, he submitted to *Atlantic Monthly* magazine a 4,700-word article entitled "The Neighbour You Take for Granted" on the differences between American and Canadian cultures. Leonard was writing about himself and his frustrations:

It is true that many of us in Canada believe that it saves a lot of trouble if we say little when we should often be a bit noisier about things. Speaking up, making a noise, or

taking a really honest look at ourselves is not easy for us. We find it much easier to hide behind what we like to consider our ingrained "English reserve" which is supposed to have come over from the Old Country during the last century. Making a noise can too easily be construed by others as being a nuisance and most of us would rather be found dead than be accused of *that*.[10]

The editor liked the article but asked Leonard to make a series of changes that he felt unable to accept, so it was never used. "Damn if I can seem to do it the way they want and it is here untouched on my desk," Leonard told Earle Birney.[11]

The Department of Veterans Affairs finally renewed Leonard's grant through 31 August 1950. The guaranteed income enabled the Brooks to rent a house of their own for eighteen dollars a month. Leonard signed a commitment with the Department to return to Canada and apply his new knowledge in a teaching post. "I too realize that I cannot stay here much longer without becoming an expatriate," he wrote. "I have an itch to see spring and snow and Canadian things again and feel I can really tackle them afresh after this last three years of steady experiment and work."[12]

Leonard would look back on the 1950s as the decade he broke into the u.s. market. Taking over fifty paintings with them for exhibit and sale, he and Reva travelled north by train in March to visit the Smarts and lecture to art students at Ohio University in Athens. Smart had arranged the lectures, the first of many that Leonard, the high-school dropout, would give at a university. Smart also invited two hundred friends and neighbours to a private showing of Leonard's paintings at his home and was astonished at the number of works sold. A formal show opened 28 March at the gallery in the Chubb Memorial Library at the university.

Leonard's wish to see some snow was granted when the Brooks and the Smarts were snowed in for a week at the Smarts' farm house. After they were dug out, the Brooks headed for Boston, where Leonard had his second important American one-man show, this time at the Childs Gallery, 169 Newbury Street. Thirty paintings were hung for the 15 April opening.

As he had done a year earlier at the Cowie Gallery in Los Angeles, MacKinley Helm had arranged the show. This time he also wrote the catalogue note:

Leonard Brooks has entered into the life of Mexico as few foreign painters seem to have done in my time. I do not know any foreigner who has painted Mexico as the Mexicans paint it ... But Brooks has looked at Mexico more deeply than many. He has seen the ostensibly colourful theatrical setting, the picturesque ballet backdrop, into the palpable and tragic stillness of both life and landscape. What he is producing,

with an ever-increasing economy of his delightful means, seems to me to be informed with its own kind of validity.

The prestigious *Christian Science Monitor* said of the show: "Mr. Brooks seems to translate the picturesque and the primitive into paint with a judicious selection of telling detail, and with a conscious effort to express the intrinsic character of outlying villages and lesser-known pueblos. The style of painting does not correspond with any of the pronounced tendencies of modern idiom. It is a brand of present-day naturalism, simplified by an abbreviated use of the brush, and heightened with an emphasis upon qualifying details."[13]

Leonard must have been pleased with the comparison that critic Lawrence Dame of the *Boston Sunday Herald* made with his idol, Frank Brangwyn. "He uses watercolor, often with broad, sweeping wet strokes, and while some of his smaller pieces seem tentative, his larger ones have the brilliance of Venetian works by the great contemporary English master, Frank Brangwyn. There is a powerful talent here mixed with a sensitive spirit."[14]

Always anxious to keep Leonard's name before the Toronto art establishment, Reva wrote to Rose MacDonald of *The Toronto Telegram*, apprising her of the Childs Gallery show and getting in a dig at Leonard's Canadian colleagues. "Leonard is getting 'out in the world' and it is a good feeling to be standing up to a greater competition," said Reva.[15]

While not showing in Toronto, he did on the West Coast. Earle and Esther Birney helped arrange one-man shows at the Vancouver Art Gallery 20 June–9 July and later at the Arts Centre Gallery in Victoria. Thirty paintings, all done in Mexico, were displayed in Vancouver and those not sold moved on to Victoria. Leonard was not on hand for the openings.

Critic Mildred Valley Thornton of the *The Vancouver Sun* wrote of the Vancouver Art Gallery show: "*Tejuantepec Women* is a small vivid oil, so lifelike that the figures almost walk out of the picture. In *Peregrination* there is a poignant quality. The utter loneliness of the landscape accentuates the human tragedy of exodus. *Night Fiesta* is a joyful painting, full of the gaiety, action and careless abandon of a primitive people gone merrymaking."[16]

Leonard was pleased with the success of the Vancouver show. "I had two wires from the Vancouver Art Gallery selling four things, one large and three smaller [ones] of women and San Miguel streets," he wrote Charles Allen Smart. "It is apparently being well received."[17]

Leonard was so encouraged by his sales in Canada, the United States, and Mexico that he told Stirling Dickinson he would not teach after the end of the summer session because he and Reva were returning to Canada. This decision

was also in response to Leonard's commitment to the Department of Veterans Affairs. He wrote to York Wilson in August, "I hope to get a car and make a trip to Vancouver and then come on down here for several winter months to clear up things before the final return to Canada."[18] Neither Leonard, nor Reva, who was then teaching intermediate Spanish at the school, nor the other teachers would finish the summer session.

At 11:00 a.m. on Saturday, 12 August, 1950, three armed government agents showed up at the art school and ordered Dickinson and the teachers to accompany them: "*Vámonos!* Now!" Alfredo Campanella finally had his revenge. Given the anti-Americanism current in San Miguel, he was able to bribe officials of the Interior Ministry to deport the school's foreign faculty. Dickinson said he understood Campanella paid between $8,000 and $10,000 in bribes.[19]

~ 25 ~
You can go back anytime

The Canadian embassy immediately filed a protest with the Mexican government over the deportation of Leonard and Reva Brooks, but the American embassy did nothing for the six Americans involved. Besides the Brooks, those deported were Stirling Dickinson, painting instructors Jack Baldwin and James Pinto, as well as Pinto's wife, Rushka, and crafts instructors Howard Jackson and Ruby Martin. They were presumably communists or sympathisers who got what they deserved for consorting with the likes of painter David Alfaro Siqueiros.

The New York Times, in an article from its Mexico City correspondent, said:

Officials of the Veterans Administration in the United States Embassy here said the Mexican Interior Ministry which had ordered the deportation of the eight art teachers had learned that with their students they had been actively supporting opposition by Señor Siqueiros to United States military intervention in Korea and were also helping the communist painter's circulation in Mexico of the Stockholm "peace" proposal.[1]

The Korean War had erupted 25 June 1950 when the North invaded the South. Although Siqueiros backed the peace proposal by a mainly European leftist movement named Partisans for Peace, none of the teachers supported

him overtly in this endeavour. The fact that the *Times* quoted an official of the Veterans Administration indicated the source of the story was Veterans Affairs attaché Nathaniel R. Patterson, firm supporter of Alfredo Campanella. The *Times'* version of the deportation was reprinted in Toronto by *The Globe and Mail* under the headline, "Claim Deported Artists Showed Red Leanings."

When Dickinson arrived at the school that morning, he noticed three well-dressed men feigning to read newspapers as they leaned against lampposts in the plaza next to the building. He did not need his wartime espionage experience to tell him something untoward was about to happen. "I smelled a rat, but I didn't think there was any point of starting a fuss here in San Miguel," he recalled.[2] When the agents walked into the school after Dickinson's arrival, only Leonard was not there; he was out sketching. The agents told Dickinson that all foreign teachers had to take the afternoon train to the border and re-enter Mexico from Laredo, Texas, with work papers, since they had been working illegally on tourist cards. They assured him that everybody would be back within a week.

"We couldn't find out where you were sketching, but we've got to hurry and do something," an upset and excited Reva told Leonard when he finally showed up at the school. "They say we've all got to go up to the border – and we'll be back with our new papers in two days." The other teachers had returned home to pack a few things for the trip, but the Brooks now did not have time to do so. Fortunately, they had their passports at the school. "But we don't *want* new papers," Leonard protested. "We'll be leaving in a few days for Canada, and there's no point in going all the way to Laredo now – it sounds screwy to me." "That's what I told them," Reva said. "But they keep saying that it will only complicate matters for the others to go without us."[3]

The Brooks took a taxi to the train station where the other teachers, except for the Pintos, were already waiting. Leonard saw the agents for the first time. One of them had lost a leg and used crutches. The agents smiled at them, pleased that Reva had convinced Leonard to come along. Then Leonard lost his temper and refused to leave.

"I'm sorry, but my husband has decided he is not going," said Reva, who usually did the talking to Mexicans because of her fluency in Spanish.

"But it is impossible," said the one-legged man, adding that Leonard's name was on the order and he had to board the train, which was now pulling into the station.

"I would like to see this order you are talking about," replied Leonard.

When the Pintos arrived and realized that Leonard had decided not to leave, they joined him. Rushka Pinto grasped a pole and refused to let go. The

overweight agent whom the teachers nicknamed Pudgy then pulled his gun out of a shoulder holster and stuck it in Leonard's ribs. "We are not getting on that train," stated Leonard, who realized that the agents' comportment belied their claim that the teachers were to receive working papers. With the train now behind schedule, Pudgy told the station agent to let it depart as incredulous passengers stared out the windows at the confrontation.

Mayor Julian Malo, always sympathetic to the teachers, arrived and promised to try and get the order stayed. But soon two taxis pulled into the station, disgorging One-leg, who had gone to the army barracks and now returned with eight soldiers in full battledress. They escorted the teachers to the barracks next to Campanella's shuttered school.

There, a three-car caravan was formed, Leonard and Reva sharing the back seat of the lead car with a soldier and One-leg in the front seat with the driver. They headed for the railroad junction of Escobedo, where they would be put aboard a mixed freight-passenger train at 3:30 a.m. The crowning insult came as the caravan pulled out of the barracks and passed the school. Campanella and several colleagues stood on the sidewalk and watched, smiles on their faces. When Reva protested that they were leaving their belongings behind, the agent told her, "This is what you get for your husband's temper. You will never get anything ... nothing!"[4]

The caravan arrived in the late afternoon in Escobedo, an army captain and his squad lined up on the platform of the train station as a welcoming committee. When Leonard and Reva wandered past the end of the platform, a soldier pulled his bayonet from its scabbard and waved them back. Since the train was not due for another ten hours, the Brooks complained to the major, who had accompaied them from San Miguel and, after consultation with the pudgy agent, the teachers were allowed to wait in a room above the station. Leonard whispered to the old man who led them upstairs that he would like a bottle of rum. "We heard what we thought was an American voice raised in anger," said Leonard.[5] It was Bob Benjamin, the *Time* magazine correspondent in Mexico City. Prevented from talking to the teachers, Benjamin hollowed out a bun and stuffed in a note saying, "Help will be on the way." Then he asked the old man to deliver the bun in a paper bag with the rum. But the man got cold feet and removed the note. The captain suspected something and burst into the room demanding the bag. Once on the train, the teachers tried to find a fellow passenger who would take a note to American authorities explaining what was happening to them. They were laughed at. "Haven't you heard the revolution is over?" one man asked them.

When they arrived late Sunday in Nuevo Laredo on the u.s.–Mexican border, One-leg took the group to the Regent Hotel. He curled up in a red leather

chair in the lobby, ready to stop anyone who tried to slip out during the night. The next morning, One-leg, Pudgy, and the third agent escorted the eight to a photographer to have pictures taken; then they walked the short distance to the Mexican Customs and Immigration Building.

Leonard was the first person called in. He was given six sheets of paper to read and asked to sign them all. "I read what I could of the paragraphs of close, Spanish type," said Leonard. "It seemed legitimate enough, as far as I could understand. An account of the immigration laws, a description of myself, other data. I signed one or two, then read on more closely – just in case, yet feeling foolishly in my distrust. Then I saw it! Tucked away neatly in small type between the third and fourth copies, the words seemed to enlarge and jump out at me. '*DEPORTADO*,' I read."[6] Leonard said he muttered *gracias* to the official, left the papers and rushed out to where the others were waiting. "There is something wrong, Stirling," he said. "We've had it ... it says '*deportado*.'" Dickinson had a different version of what happened. He said that Leonard had rushed out gleefully waving papers he thought were working papers, not understanding the "deported" stamp because of his imperfect knowledge of Spanish. "Leonard, may I see them, please," Dickinson recalled asking.[7]

The teachers now realized they had been tricked, that there never had been any intention of giving them working papers. Before they could be called in, Reva, Dickinson, and the Pintos slipped out of the building and headed for the American consular office. When Rafael Arredondo Coss, the head of the immigration office, realized they were missing, he called the consulate, assuming correctly the four were there. "Papers or no papers, signed or not signed, you are all going. Now!" Arredondo Coss yelled over the phone.

Leonard, Baldwin, Martin, and Jackson were escorted across the International Bridge and turned over to u.s. immigration officials. But Leonard was not admitted to the United States because Reva had his passport, so he was returned to the Mexican immigration office, to the dismay of Arredondo Coss. Leonard was locked in an office pending the return of Reva, who was escorted back by immigration agents sent to the consulate. Two hours after being turned back at the border, Leonard rejoined his colleagues in the United States.

Now officially deportees, barred forever from Mexico under article 33 of the constitution, they registered at the Hamilton Hotel to ponder their next move. The newest hotel in Laredo, the Hamilton was the only one in town with air conditioning. When Leonard opened the door to his room the next morning, he saw two men slowly pacing up and down the hall. They were eventually relieved by other men, leading Leonard and his colleagues to assume they were agents from the Federal Bureau of Investigation (FBI) who had them under surveillance.

Probably to their disappointment, they discovered that they were not the targets of the FBI Mrs. Helen R. Sobell was. Her husband, Morton, had been accused of passing atomic secrets to the Soviet Union while a naval employee at a General Electric plant in Schenectady, New York. Sobell, recruited by Julius Rosenberg, later executed alongside his wife for treason, had fled with his family to Mexico and had been deported at the same time as the teachers. He was being held in the Webb County jail awaiting extradition to New York.

Except for Dickinson, the teachers could not afford to remain at the Hamilton Hotel, so rooms were taken at a boarding house along the bank of the Rio Grande. They had kitchen privileges, so to save money they prepared communal meals, usually salads eaten on the balcony. They kept one room at the Hamilton, that of the Brooks, as their headquarters and refuge from the heat, which topped 100 degrees Fahrenheit on many days during their stay.

Back in Mexico City, the deportations were page-one news in the newspapers, which wholly supported the government action. *Novedades'* headline said, "Six painting instructors who entered the country as tourists/had high paying jobs in San Miguel de Allende."[8] The teachers wished that had been so. *El Universal Gráfico* said editorially: "A group of foreign pseudo artists, mainly American, turned San Miguel into a centre of vice through numerous homosexual acts and every other type of public and immoral behaviour."[9] *Novedades* added editorially, "As for the agitators, especially those of the so-called left, they were used to opposing the positions adopted by our government in international matters."

The day the teachers arrived in Laredo, Leonard received a telegram from Siqueiros:

INTERIOR MINISTER ORDERED THE ACT OF DEPORTATION BE SUSPENDED IMMEDIATELY AFTER HEARING PROTEST OF ARTISTS STOP YOU SHOULD GO IMMEDIATELY TO MEXICAN IMMIGRATION AUTHORITIES AND DEMAND ACTION ON SUSPENSION STOP IN CASE SAID AUTHORITIES DO NOT YET HAVE SAID ORDER IN THEIR POWER TELEGRAPH IMMEDIATELY TO INTERIOR MINISTER AND TO ME STOP WE CONTINUE WORKING FOR YOU STOP SIQUEIROS.

The telegram was premature. The interior minister, Adolfo Ruiz Cortines, was the second most powerful man in Mexico, since his cabinet post was the traditional stepping stone to the presidency. However, he must have had second thoughts about returning to Mexico foreign teachers accused of being communists because American and Mexican police were then discussing a joint plan against supporters of the Soviet Union. "According to extra-official but reliable sources," said the newspaper *Excelsior*, "the Federal Judicial Police, the

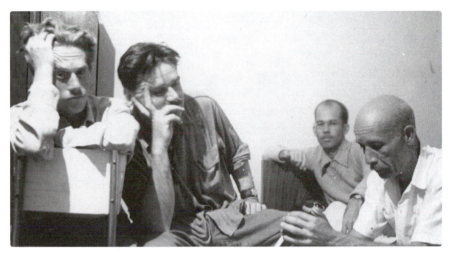

Looking dejected, (left to right) Jack Baldwin, Leonard, Stirling Dickinson, and Howard Jackson wait in the Brooks' room in Laredo, Texas, after being deported from Mexico, 1950.
COURTESY DONALD PATTERSON

Federal Security Directorate and the main police forces in the Republic have drawn up a plan with the FBI to combat Red elements in the democratic countries."[10]

Stirling Dickinson called Felipe Cossio del Pomar, the founder of the art school, to see if he could use his influence on the government. Dickinson managed to get the American embassy to arrange for security at their homes – including the Brooks' – to prevent looting. Fernando Gamboa, the new director of the National Institute of Fine Arts, came out in defence of the teachers. "These artists weren't even treated as well as many criminals," he said.[11]

Boredom set in. The same pocket books were being re-read. Trips to the movies, as much to cool down in the air-conditioned theatres as to see the film, were curtailed to save money. Jack Baldwin and Jimmy Pinto splurged and bought a set of children's watercolours and some cheap paper and tried to paint, but Baldwin was soon talking of hitchhiking home to California.

The local newspaper, *The Laredo Times*, published daily stories on the two groups of famous deportees, the Sobells and the teachers. It carried a report that Rushka Pinto had been roughed up at the Nuevo Laredo immigration office. That brought an angry denial from immigration chief Arredondo Coss. "On the contrary," he said, "one of them tried to get tough with us," an obvious reference to Leonard.[12]

Canada's ambassador to Mexico, Paul Charles Hébert, called the Brooks to offer his moral support and to tell them the embassy was doing all it could to help.

On the fifth day, Leonard found General Ignacio Beteta's business card and prepared a telegram asking his help. Beteta's brother, Ramón, was the current finance minister. Western Union delivered an immediate reply to Leonard: HAVE TALKED PERSONALLY TO MINISTER OF INTERIOR WHO OFFERS TO DICTATE IMMEDIATELY ORDERS PERMITTING RETURN TO SAN MIGUEL STOP ONLY REMAINS TO REGULARIZE YOUR SITUATION STOP CORDIALLY GENERAL IGNACIO BETETA. Then the general had his aide Martin Kauffman telephone to assure them they should not worry and to ask them if they needed money.

There was obvious friction between Leonard and Stirling Dickinson over who was doing the most to get everybody back to San Miguel. Leonard wrote on Hamilton Hotel letterhead to Charles Allen Smart: "It has been interesting to see the attitudes and changes of the 8 of us as the days went on and no sign of rescue from Stirling's friends – Gamboa, Pomar, etc. Siqueiros' wire showed he took up arms for us at once ... I wired [Beteta] and he immediately saw the secretary of government – and demanded recall – In other words – Siqueiros and a general saved our necks not any of the S[tirling] crowd."[13]

The fact that Dickinson's parents could support his activities also bothered Leonard, who preferred self-made men to those with inherited wealth. Leonard told Smart that Rushka Pinto had blown up and told off Dickinson, apparently over the teachers' precarious financial state compared to his own. Leonard wrote: "He's lost no matter what, his loyalties gone this time by acting in a most selfish manner – when his parents phoned and asked if he needed money he told them 'no' – etc., while most of us were getting ready to live on do-nuts and Baldwin was preparing to hitchhike home. It's all rather nasty but I feel far away from it all and only look forward to getting out of the stew completely."[14]

The teachers were having coffee in a restaurant on Saturday, 19 August, when a reporter from the Associated Press burst in with the news that the Mexican consul had received a telephone call from the interior minister's office. "You can go back anytime," he said.[15]

Since the Brooks planned to return to Canada and Leonard would not be teaching any more, they went to the immigration office in Nuevo Laredo the

following Monday and received new tourist cards. They caught the next train and were back in San Miguel ten days after being seized by the immigration agents. On the way home, they detoured by the office of mayor Julian Malo to tell him they had returned. He apologized for the deportation, saying he had been helpless to prevent it. As the Brooks left his office, they passed Alfredo Campanella's brother-in-law, who had taught guitar at the closed school. He gave them a dirty look. "There would be no celebration and fiesta for him this night, as there had been at their ranch up the hill the day we were taken for a ride to Escobedo," wrote Leonard.[16] There was joy, however, at the Brooks' home where Marciana, the maid, told them she lit candles every day on their behalf. The other teachers were issued working papers and returned to San Miguel a day after the Brooks.

Those familiar with the deportation believed that Leonard's friendship with Siqueiros and Beteta was key to the return of the artists to San Miguel. They would agree with Reva, who wrote to Earle and Esther Birney about the deportation: "Finally a General Beteta (who is our personal friend thru his love of Leonard's work) gets the Ministry of the Interior to revoke the deportation."[17] Had the Brooks and their colleagues not returned, San Miguel would not have become such an important art colony. Half a century later, internationally known cellist Gilberto Munguía said, "Leonard was responsible for bringing people to San Miguel. Other painters came. Then he got involved with music. All that cultural activity was what made San Miguel what it is today, the big centre for arts in Mexico. When he arrived in San Miguel, it was a sleepy little town where magic was about to happen. Leonard brought the magic."[18] The Rev. Richard C. (Cass) Nevius, former minister of St. Paul's Episcopal Church in San Miguel, would say that judging Leonard's importance to the town "is like asking a theist about the importance of God to the creation of the universe."[19]

~ 26 ~
Darling, I am dying

The deportation of the Brooks, Stirling Dickinson, and the others in 1950 coincided with the birth that year of McCarthyism in the United States. Senator Joseph R. McCarthy began his investigations into communist subversion in the federal government and contributed a word to the lexicon: McCarthyism – the practice of making accusations of disloyalty, especially of pro-communist

activity, in many instances unsupported by proof or based on slight, doubtful, or irrelevant evidence.[1] The anti-communist fervour that swept Washington ensnared many of those who participated in the boycott of the Escuela Universitaria de Bellas Artes and its aftermath, including Leonard and Reva Brooks. The first victim was Dorsey Fisher, first secretary at the American embassy in Mexico City and a fervent supporter of the San Miguel art colony.

Dorsey Gassaway Fisher had a name that could have come from a 1930's F. Scott Fitzgerald novel, and he had the education, poise, and appearance to go along with it. Born in 1907 in Fort Leavenworth, Kansas, he joined the u.s. Foreign Service at twenty-two after graduating from Harvard University. He was appointed to the Mexico post in 1946 after assignments in Havana, San Salvador, and London. Tall, blond, suave and impeccably dressed, Fisher soon became a popular figure in Mexico's art circles. He hosted Leonard and Ray Brossard when they had their joint show at the Mexican-American Institute of Cultural Relations; he warned Leonard that the embassy had a file stating he had been a pilot in the Spanish Civil War; he was the only ranking officer who objected to allegations that the teachers who boycotted the school in support of communist painter David Alfaro Siqueiros were communists themselves.

Senator McCarthy had announced the launch of his witchhunt in a speech on 9 February in Wheeling, West Virginia, telling the audience: "I have here in my hand a list of 205 – a list of names that were made known to the Secretary of State as being members of the Communist Party and who nevertheless are still working and shaping policy in the State Department." As it turned out, no such list existed, but that did not stop McCarthy from leading a senate investigation that ruined hundreds of careers.

Under the circumstances, it was inevitable that Fisher would be brought to Washington in the fall of 1950 and questioned by a State Department intelligence officer about his relationship with teachers who had supported a known communist, Siqueiros. After receiving a security clearance, Fisher was appointed first secretary and counsellor at the embassy in Madrid on 7 November 1950. He requested that John Elmendorf, director of the Mexican-American Institute of Cultural Relations, be assigned to the embassy as cultural affairs officer. A Quaker and Second World War pacifist, not only did Elmendorf not receive the posting but the State Department removed him from the cultural institute, which it funded, according to his widow Mary.[2]

After his Madrid posting, Fisher was named counsellor of the embassy in Jeddah, Saudi Arabia, but he never got there. He was questioned on the same allegations of disloyalty in March 1953; he thought he had been cleared and received his inoculations and booked passage by ship for the Middle East.

*Dorsey Fisher,
American diplomat
who was a victim of
the McCarthy era,
in part because of
his defence of the
San Miguel artists,
1948.*

COURTESY OF MR. AND MRS.
FRANK TREMAINE

The magazine *Collier's*, which published a report in its 9 July 1954 issue on the hounding of foreign service officers, told what happened next:

Four hours before his ship was to weigh anchor in New York, Fisher received a frantic phone call from Washington, explaining that there had been a mistake and that he hadn't been cleared after all. He was told to sit and await clearance.

Six nerve-wracking weeks later, Fisher was called back to Washington.

"I saw Robert Blank" (a pseudonym for a security officer) "for several hours. We went over the whole business again. Blank explained, and I know honestly, that cases under recent procedure are being decided very predominantly against the officers concerned, so that I could make up my mind to resign or let the case go through the full process and end in dismissal."

Fisher resigned. The quotation above is from his diary; afflicted with a long-time cardiac condition, he died of a heart attack a few months later. Today his friends are convinced that the security ordeal killed him. That can never be proved one way or the other; the important fact is that people believed it and were afraid.

One of those friends convinced that the McCarthy witchhunt killed Fisher was Lysia Brossard Whiteaker, who had been very close to him in Mexico City. "He was warned [in Washington] that he was either one or the other – a communist or gay – or both: a communist, because he loved all artistic people, or a homosexual, because he had never married. He was declining in

health when he came to Mexico on a visit. He said to me, 'Darling, I am dying. I wanted to come and say good-bye to my friends. I broke my heart.' Within a month or two we heard that he had died of the broken heart."[3]

Fisher was taken by ambulance to Washington's Bethesda Hospital on 11 January 1954. He died the following morning of a massive coronary thrombosis. He was forty-six.

Fisher's fate was obviously sealed by his bachelor status and the reputations of the friends he kept. He had resigned from the Foreign Service in June 1953. Kay Tremaine, whose husband, Frank, was the United Press (UP) bureau manager in Mexico City when Fisher was posted there, said, "We were shocked to learn he had a heart attack right after, caused by a former UP employee of Frank's exposing him for being gay."[4] During the 1950s, Cold War thinking prejudged homosexuals as being communists, at least in Washington.[5]

If Fisher had possessed the legal arsenal at the disposal of Stirling Dickinson, his case might have turned out differently. Dickinson was the next target. On 29 August 1957, the *New York Herald Tribune* carried a story that began:

MORE THAN 100 EXPATRIATE REDS

IN MEXICO VIEWED AS PERIL TO U.S

By Bert Quint

Mexico City – Two of Mexico's most picturesque colonial communities – Cuernavaca and San Miguel de Allende – have become the headquarters of some of America's richest and most active Communists.

The real leaders of the group, Embassy sources say, are [Albert] Matz, [Maurice] Halperin, and a so-called "mystery man" named Sterling [*sic*] Dickinson, according to United States sources, is an important leader, "A new man to us."

Time magazine, in its edition of 9 September, picked up the story under the headline "Red Haven": "A gathering place for the colony reportedly is the spacious home of Sterling [*sic*] Dickinson, U.S.-born director of art-conscious San Miguel de Allende's biggest art school. A resident of Mexico for 20-odd years, he keeps open house for communists and fellow travellers."

Leonard and Reva were among those who sent telegrams to U.S. ambassador Robert C. Hill. Theirs said:

WE ARE SHOCKED BY BERT QUINTS COMPLETELY FALSE STATEMENTS ABOUT STIRLING DICKINSON AND SAN MIGUEL IN THE NEW YORK HERALD TRIBUNE AUGUST 30 AND BY EQUALLY FALSE STATEMENTS IN TIME SEPTEMBER 9 STOP AS CANADIANS WHO HAVE KNOWN HIM FOR MORE THAN TEN YEARS WE KNOW

WITHOUT DOUBT WHATSOEVER THAT THESE LIBELOUS STATEMENTS ARE COMPLETELY UNTRUE STOP WOULD APPRECIATE YOUR INTERVENTION ON BEHALF OF ALL OF US IN SAN MIGUEL.

Even Father José Mercadillo, who had railed from the pulpit against the Americans in San Miguel, sent a telegram of support to the ambassador. The Mexico City newspaper *Novedades*, no friend of the foreign community, said the *Herald Tribune* and *Time* stories were correct except in their reference to Dickinson. "Dickinson is very beloved and respected not only by Mexicans but Americans and Canadians, having arrived here in 1937," it said.[6]

The issue was deemed important enough to reach the desk of Secretary of State John Foster Dulles, who agreed that ambassador Hill could receive Dickinson but should not admit that the news story originated with the embassy. Dulles wired: SUGGEST STATEMENT THIS FACT WITHOUT ELABORATION ANY INFO ACTUALLY SUPPLIED QUINT.[7]

Consul Walter L. Nelson prepared a memo on the case 10 September for ambassador Hill. He went into the closure of the Escuela Universitaria de Bellas Artes: "The students were accused of habitual drunkenness, homosexual activities, dope users, non-attendance of classes, communistic influence, and finally culminating in one veteran student murdering another student following an all-night drinking party. Shortly thereafter a student and faculty revolt against the owners, headed by Alfredo [*sic*] Siqueiros, famous Mexican communist and painter, and Sterling [*sic*] Dickinson stopped all classes at that institution."[8]

The issue might have sputtered on for a few weeks and died had it not been for the intervention of Wilson & McIlvaine, the Chicago law firm where Dickinson's father was a partner. The firm sent a letter dated 30 October to Roy E. Larsen, president of Time, Inc. The letter said: "Mr. Dickinson does not intend to press you with legal action seeking large or punitive damages unless it becomes necessary to do so to clear his name. He cannot, however, disregard what you have already printed and will take any steps necessary to set the record straight."

Harold Medina Jr. of *Time* made a report to Larsen, naming as "probable Communists" Leonard Brooks, Dr. Francisco Olsina, James Pinto, Jack Baldwin, and Howard Jackson. All had been deported except Olsina, the Spanish Republican. He would subsequently be denied entry to the United States as guest lecturer at Bradford College in Haverhill, Massachusetts; he finally obtained a visa after six months.

Time realized that Wilson & McIlvaine would not have taken on a libel case – their speciality was estate planning – unless they believed strongly that an injustice had been committed. So, in its issue of 17 February 1958, the magazine

carried a note: "*Time* erred. There is no support for any assertion of connection between Mr. Dickinson, his school or his town and Mexico's colony of wealthy Communist expatriates."

The *Herald Tribune* sent to Mexico one of its top reporters, Joe Hyams, to interview Dickinson and do a rectifying article. "Right in the middle of the interview he just told me to tell him what I wanted him to write and he'd write it," recalled Stirling.[9] The newspaper put in a paragraph apologizing for the allegations and he was satisfied.

But there was a final chapter. Dickinson went to Washington with one of the lawyers from Wilson & McIlvaine and convinced the House Un-American Activities Committee to read into the Congressional Record a statement that one Stirling Dickinson was not, and had never been, a communist.

The Brooks' turn was yet to come.

~

Disappointments and
Difficult Decisions

~ 27 ~

Our existence is idyllic at the moment

For Leonard and Reva Brooks, the aftermath of the deportation brought an end to their travels with Stirling Dickinson. A combination of factors prompted the distancing of the Brooks from Dickinson. Their differences in Laredo might have affected their relationship. Then, when Leonard stopped teaching, he lost the daily contact with Dickinson, which obviously inhibited invitations to travel. Although they remained friends, the warmth and intimacy were gone. The big loser was Reva, for arguably her best work was done in the 1947–50 period when the Brooks travelled with Dickinson in his jeep and she would wander off with her Rolleicord while Leonard sketched. "At the beginning, going on trips with Stirling was excellent for both of us as he looked after a great deal of the planning and practical matters," Reva said later.[1] But the next few years were to mark the apex of her photographic career.

When Dickinson and company returned from Laredo, twenty-four hours after the Brooks, a large crowd awaited them at the train station; consideration had even been given to ringing the bells of the parish church to honour their return.

Not everyone in San Miguel welcomed home the group. They were already on their way back when the Mexico City newspaper *Excelsior* published a letter to the editor from Juan Pérez, who lived at No. 1 San Francisco Street in San Miguel. "It's a lie," he wrote, "that the people of San Miguel de Allende are upset about the deportation ... I hope the American authorities won't allow the return of those whom our authorities, who maintain a titanic fight against the Russian Bear, have thrown out because they had little regard for our laws."[2]

Leonard, never known to back down from a fight, had feared reprisals from Alfredo Campanella. "I confess I'd be rather frightened to live in S.M. for I know Campanella will really be rabid if, after paying bribers – thugs, etc. we all turn up and continue working," he told Charles Allen Smart. "He's shown his teeth – and I don't like the sight."[3] But there was nothing to fear from Campanella. Overburdened by debts, he was forced to sell his holdings in San Miguel and return in disgrace to Mexico City.

Nor did the new art school continue. Back in exile in Mexico, Felipe Cossio del Pomar wanted to duplicate his original success with the Escuela Universitaria

Previous page: Manzanillo Morning, *Mexico, watercolour, 1951.*

de Bellas Artes by opening another art school in San Miguel. This time he joined forces with Enrique Fernández, former governor of Guanajuato, the state in which San Miguel is located. They purchased and renovated the ruined eighteenth century Renaissance palace and gardens that had belonged to the Count of Canal, one of the European noblemen who had come to San Miguel during the silver boom. Their Instituto Allende would boast huge grounds, its own hotel, and a series of cottages. Fernández came with his American wife, Nell, a stunning beauty from Arkansas who vied with Reva to be the First Lady of the growing art colony.

Cossio del Pomar had invited Dickinson to join the venture as director, so Stirling asked the Mexican government permission to close his school. All the teachers except Leonard moved to the Instituto. Reva replaced him on the faculty, teaching photography for a term. Cossio del Pomar would soon split with Fernández over, among other things, the landscaping of the school grounds.

Even before its official opening, the Instituto held an exposition 13 September–3 October 1950 of the works of artists resident in San Miguel. Leonard was one of twenty-three painters represented and Reva one of five photographers. Several months later Reva held her first one-woman show at the British Council in Mexico City.

The trauma of having a gun stuck in his ribs made Leonard leery of Mexican police, as evidenced by an incident that occurred shortly after the Brooks returned to San Miguel. Leonard had taken his car for repairs to the nearby town of Querétero. While waiting for the work to be completed, Leonard set up his easel in the main square.

Leaning his stool against a lamppost, he started to sketch, ignoring a tap on his shoulder. Finally he turned around and was surprised to see a policeman, whose presence he nervously ignored. *"No, señor, por favor,"* the officer pleaded, telling Leonard the police chief wanted to see him. When Leonard reached for his back pocket where he kept his school ID, the policeman blanched. *"No, no, señor,*

A leery Leonard ignores a policeman's attempt to tell him he was leaning against a freshly painted lamppost,

pistola, no!" As was his wont, Leonard became aggressive once in the police station. "If you will just calm down," sighed the police chief. "I only want to let you know your shirt is dirty." Leonard had been leaning against a freshly painted lamppost. "I turned and stumbled my way out, trying to preserve some dignity," he recalled.[4]

Leonard must have felt optimistic about the future, even though his income was limited to the sale of his paintings. The Veterans' grant had ended after three years. He no longer taught, not that the sporadic payments from the art school the past year had amounted to much. "Our existence is idyllic at the moment," Leonard told Earle Birney. "Four servants, a huge, beautiful house, music, hard work and little money. Somehow it doesn't seem to matter too much down here."[5]

Leonard had enough money saved to buy a new car, a green 1951 Ford station wagon, when they went to Toronto that fall. Possibly because of the notoriety of the deportation, Leonard found that galleries in Toronto wanted his work and several people approached Reva with commissions for portraits of their children. He headed north to Haliburton, Ontario, to do some fall paintings to meet the demand. Always prolific, he told Charles Allen Smart he did two oils and two watercolours one day in the cold. "It's been getting chilly – cold and it seems like old times to be out sketching in it again," he wrote.[6]

The publicity given the deportation in the Canadian news media caused some of Leonard's fellow painters to wonder what he had been up to in Mexico. "Where there's smoke, there's fire," words Leonard recalled being muttered at the Arts and Letters Club. He said he heard that some people were asking if he had "gotten into drugs" in Mexico.

When they went to North Bay to visit Leonard's parents, they were questioned about the deportation by the local newspaper, the *The North Bay Nugget*. The newspaper reported, "It was a misunderstanding. That is how Leonard and Reva Brooks today summed up the deportation of themselves along with six United States art instructors from Mexico during August this summer."[7]

Despite the fact that Reva's photographic career was rooted in Mexico, she longed to return permanently to Toronto and her family. Back in San Miguel from the trip to Canada, she became upset at a suggestion from Lela Wilson that the Brooks planned to remain in Mexico. "I don't agree with what you wrote about life in Mexico being 'too easy' and that 'one does not make the progress one should,' etc. etc.," she said in a testy letter to Lela. "That might be true for some people, but as far as I am concerned it has been the liberation of Leonard's creative energies, which always seemed to have had a hard time in

Canada being liberated! However, Canada is our country and we love it and intend to settle down there when the time comes."[8]

Someone who wanted to enjoy Mexico while Leonard was still there was Fred Varley. "I'm green with envy!" he wrote. "It seems that wherever I go I bump into someone who has either been to Mexico or who is going to Mexico, and asks me why I don't go."[9] The next month he wrote again: "I'm coming to Mexico as soon as I can gather up the necessary dollars – in a month or six weeks." That alarmed Leonard, who feared that Varley, at sixty-nine and knowing no Spanish, would get into too much trouble in the *cantinas,* or local bars. "Reva, I think we must try to keep Fred from coming down to San Miguel," Leonard said. "A man's *cantina* at the best of times is a dangerous place where people get hurt very quickly." Leonard wrote to Varley and told him he did not think it would be a good idea to come at that time. He also contacted art patron Charles S. Band and told him to dissuade Varley from coming. Varley abandoned his travel plans.

Leonard must have been thinking about events earlier in the year in the *taurino* – or bullfighters' – *cantina,* a popular downtown all-male drinking spot. The *cantina* was one of the locales for the shooting of "The Brave Bulls." Soon after the filming ended, a drama unfolded in the *cantina* that would have been unbelievable in a movie. Leonard and Reva were in San Miguel's only movie house, Cine los Aldama, sitting on a backless wooden bench watching a scratchy American gangster film when shots rang out. They initially thought the shots came from the soundtrack, but they had originated in the *cantina* around the corner on Reloj Street. As was his custom, a local judge had stopped off on the way home for a shot of tequila. The man standing next to him was a drunken ranch owner who invited the judge to have a drink. Since it would have been an insult to refuse, the judge accepted, and then had to reciprocate. When the judge started to leave after buying the rancher a drink, the man pulled back his coat and patted a .45 on his stomach and said, "Have another one." After a few more rounds, the judge decided he would risk a departure. He always carried a small pistol, so when the rancher carried out his threat and pulled his gun, so did the judge, and they fired simultaneously. The rancher was killed and the judge wounded. Hearing the shots, another patron thought he was the target, so he emptied his pistol, killing another five people and wounding six.[10] The shooting was even too much for San Miguel, so the police closed down the *cantina*.

The departure of the GIs and their replacement by art students attracted to the Instituto Allende changed San Miguel forever. "Most of the people had come to San Miguel in the post-war as people went to Paris post-World War I," said Carl Migdail, a foreign correspondent based in Mexico City at the time. "It became an

artists' community with really no rigid rules."[11] Now the students were younger and not united by wartime experiences. Migdail said 1950–51 was a watershed for San Miguel. It was as well for the Brooks. "They kept to themselves," recalled Migdail, who would visit the Brooks when he went to San Miguel. The Brooks developed a small network of friends – Canadian and American – who entertained each other and played music together. Increasingly the Brooks withdrew from the broader social life of San Miguel. Leonard enjoyed small groups and good conversation over a wide range of subjects, but the more gregarious Reva probably would have preferred to go out on the town.

Now they made plans for their most ambitious trip to date. They would drive to California and leave paintings in Los Angeles, then to Vancouver to visit the Birneys and sound out the University of British Columbia about teaching prospects, and then continue to Toronto. It would be a traumatic trip.

~ 28 ~
*M*y girl, you've got it

Reva's growing reputation as a photographer would force the Brooks in 1951 to take a couple of decisions that would put their marriage to the test and affect both their careers. The pivotal event occurred in California, a way stop on the drive to Canada. Leonard and Reva loaded their Ford station wagon with nearly one hundred art works, his painting gear, her portfolio and cameras, plus camping equipment. They left 1 June on a trip that would last more than five months and cover more than ten thousand miles.

Their travels with Stirling Dickinson prepared them for roughing it on the road. Wherever they could find a campground or a suitable place to park, they stopped, cooked over a propane stove – Leonard was especially good at preparing breakfast – and spent the night in sleeping bags in a tent. They drove north to Durango, where the actor John Wayne had a movie site where many of his westerns were filmed, and then down the coastal range of mountains to Mazatlán on the Pacific. They crossed the border from Nogales, Mexico, to Nogales, Arizona, and then to Tucson, San Diego, and finally Los Angeles, arriving after six days on the road. Leonard did all the driving as Reva did not know how, although she expressed a lifelong interest in learning.

Leonard left paintings with Alexander S. Cowie of the Cowie Gallery in Los Angeles. Either Cowie or Leonard's friend, MacKinley Helm, introduced the Brooks to members of California's burgeoning photographic movement, including Minor White. The meeting with White paid dividends for Reva. He used her photograph of *Doña* Chencha, the mother of their gardener at La Rinconada, on the cover of the third issue of his new quarterly photography magazine, *Aperture*. After looking at Reva's prints, White was probably the person who told her they should stop off in Carmel to meet Edward Weston, then the leading American photographer, and gave her a letter of introduction. They camped at the Gaviota Camping Park west of Santa Barbara and at the Big Sur Redwoods Park on Highway 1 before going on 16 June to visit Weston, obviously with a bit of trepidation. Reva had already been anointed by painter David Alfaro Siqueiros, who wrote of her work:

Inspired by a tender love of our country, for the people of Mexico and things Mexican, [Reva Brooks] has travelled through the whole Republic, camera in hand, giving us photography of great worth for its technical as well as for its human values, direct human emotion without any supersensitive or cowardly concealment and a technical sense of resolute photographic objectivity. In other words, with her camera she has produced photography and not photographic painting ... and photography of this kind is an aid to painting, while pictorial photography is prejudicial to photography. Thus, this photographer from Canada combines the qualities which, in my opinion, are fundamental in any photographic worth.[1]

So aggressive about promoting Leonard's career, Reva was reluctant to do likewise with her own. She did not want to bother Weston, then sixty-five and suffering from Parkinson's disease, but Leonard insisted. "Reva, please do it," he implored. "I'm sure he'll receive us." Leonard prevailed and they drove to the Weston compound on Wildcat Hill overlooking the Pacific Ocean. There they found Weston and two of his four sons, Chandler, the eldest, and Brett, the second oldest, in the modest clapboard pine house he had built.

Weston had lived twice in Mexico in the 1920s with former disciple and lover, the Italo-American photographer Tina Modotti, so they talked about many of the friends they had in common, such as Siqueiros, Diego Rivera, and the husband and wife photographic team of Manuel and Lola Alvarez Bravo.

Finally, Weston asked in a barely audible voice, "Where are your prints, girl?" Reva opened her portfolio and one by one laid out the photos before Weston. "My girl, you've got it," he exclaimed as he patted her on the back.[2] He told her it was a good thing that she had discovered her own way to photograph,

uninfluenced by other photographers. Leonard, who was seldom in awe of anyone, said it was as if he had met Picasso and the Spanish artist had said to him, "Leonard ..."

Weston would have appreciated Reva's subject matter because, like her, he was obsessed by the faces of those he photographed. Perhaps he saw in Reva something of Tina Modotti, who spent nearly ten years in Mexico where she was known for her photographs of the poor and of members of the labour movement.

Because of the Parkinson's disease, Weston had stopped taking photographs several years earlier and now limited his activities to his darkroom, where he needed help with the equipment. For most of his career, he had young female photographers apprenticing with him and, increasingly, working with him in the darkroom. His current assistant, Dody Warren, was about to leave him.

Now Weston would have made the following offer to the Brooks: "You can live on the property. Reva, I'll be your mentor, guide you in your photography and critique your works. You'll work with me in the darkroom. Leonard, there's an important group of artists working in Big Sur. I'll introduce you to them and see that you're accepted."

Reva had already experienced a decrease in her photographic output because of the end of the travels with Stirling Dickinson. She would have realized that future contact with the subjects she sought would be limited. So here was an opportunity to refocus her nascent career under the guidance of the leading photographer in the United States. She must have felt blessed, as were the predecessors chosen by Weston to work with him.

The Brooks hit it off with Brett – he was Leonard's age and a fine photographer himself – and moved in with him for a few days as they debated his father's offer. Neither Leonard nor Reva would ever discuss with others what transpired, but they obviously had a heated exchange. Reva wanted to stay in Carmel; Leonard did not. If she stayed, it would be on her own.

Leonard won out.

Always an individualist, Leonard rejected the idea of associating himself with any California painting movement. He would say he did not want to stay in Carmel because he did not find the atmosphere of Big Sur conducive to his work.[3] But he must have been influenced as well by the secondary role he would have played. Less than four years after picking up her first camera, Reva was receiving international recognition of a type that had eluded Leonard after more than twenty-five years of work. For Leonard, apprenticeship was important; Reva achieved her prominence without any. As well, Leonard came from a generation of men who felt duty-bound to support their wives and did not

Edward Weston, then the leading photographer in the United States, encouraged Reva in 1951 to become his apprentice in Big Sur, California, where she photographed him.

want them to work, as evidenced by the fact he had Reva quit her job in Toronto as soon as he started teaching. "You never had to make a living from your work because I made the living," he told her once in the author's presence.

This must also have been a difficult period for Reva, a woman who came of age in the 1930s when a wife's career, if she had one, was always subordinate to that of her husband. She had been too successful too fast. She was very conscious of Leonard's ambivalence when she was praised for her photography. He was very proud of her achievements, yet frustrated that his own work was not receiving the same recognition. "I was being recognized to the ultimate degree," Reva later recalled. "He was not in his own field. It used to bother him. It was harder for him to come through and be his own unique self."[4] Reva came close to saying "rivalry," the source of much friction between married artists. Abe Rothstein, who would represent Leonard at his Horizon Gallery in Rockport, Massachusetts, said that "there was no question" but that Reva subordinated her career to his. "They would have torn each other apart otherwise," he said. [5]

Reva now realized that she had already found her voice in her photography, while Leonard was still striving for his, and that she would be recognized as the leading artist in the family were they to accept Weston's offer.[6] She was obviously torn between pursuing her career or risking her relationship with

Leonard as her fame increased. "I must say that was always a rather touchy matter," she said.[7] So she turned down the offer, realizing that she would have to fit in her photography as best she could. She explained this in a later filmed interview:

I'm a photographer because of the way my life is with my husband, because by travelling with him and coming to Mexico, and having the camera and life opening up, it's really made it possible for me to have a career in photography ... I wanted very much to go out in the world with my photography, and then I realized that all the success in the world would never make up for my intensely satisfying personal life that we had together. And at that time [1951] I decided that if I was any good as a photographer I would do it within the context of the important part of my life, which was my life with my husband.[8]

British-born painter Joy Laville, who played the cello in Leonard's pickup chamber music quartet, observed how Reva tried to find the time for her photography. She recalled many occasions when Leonard would summon Reva from her darkroom to fan away smoke from a defective fireplace that was bothering the players. "It was almost a weekly occurrence," she said.[9] Other times Reva would opt to remain in San Miguel and work in the darkroom rather than accompany Leonard to the coast for a sketching vacation.

Leonard would say later that a decision was made not to commercialize Reva's work. "You could have moved in and taken portraits of people," he said to Reva in the author's presence. "That wasn't your field. We did not commercialize you so you'd be free to take photos without the pressure of having to sell them." Reva agreed. They would say that she limited her sales to significant buyers. The non-commercialization of her work appealed to the socialist in Reva, who felt that art should be available to all, not only to those with the money to purchase it. "I just felt that being unduly ambitious to make a commercial mark wouldn't help my photographs at all," she said.[10] Whatever the reasons, one fact remained clear: the Brooks certainly could have used income from the sale of Reva's prints at this time.

Did Leonard consider photography as important as painting? "To record something doesn't necessarily make art," he once said. "Art begins when we create a new reality."[11]

Reva took Weston's photograph and he, in turn, gave them a Mexican photo, one he had taken of Nahui Olin, a painter and mistress of Dr. Atl, a well-known painter. Both were Mexicans who adopted Aztec names. The Olin photo would hang in the entrance of the Brooks' home. Before they departed after a week with the Westons, Edward recommended to Reva that she see

Edward Steichen of the New York Museum of Modern Art, the leading authority on photography in the United States. She would take his advice.

They bid their farewells to the Westons – Brett would later visit them in San Miguel – and headed for Vancouver.

Asked years later if she had abandoned photography for Leonard, she replied, "I gave up being celebrated in photography." Did this affect her deeply? "Very," she said. [12]

~ *29* ~

Mexican or American citizenship

After their experience with the Westons in Big Sur, Leonard and Reva were looking forward to spending three weeks in Vancouver with their best friends, Earle and Esther Birney, whom they had not seen in four years. The Brooks arrived 25 June, stopping off in San Francisco, where Leonard visited Gump's Inc., an elegant art gallery at 250 Post Street. Gump's took his paintings on consignment.

No longer receiving a Veteran's grant, Leonard was now actively seeking a teaching post in Canada. Birney, who taught English literature at the University of British Columbia, introduced Leonard to his colleagues, but there was no Fine Arts Department at that time that could hire him. However, he and Reva were offered contracts to teach summer courses at the university the following year.

Leonard had two shows in Vancouver, the first in the family room of the Birneys' home at 4590 West Third Street and the second with the same paintings at the university. *The Province* art critic who signed Palette wrote: "There is variety in his work, always a quick energy and keen awareness, ranging in expression from joy to tragedy or dramatic overtones. The painting is spontaneous and direct, but has been preceded by reflection as to the essential meaning of the theme in relation to both art and life."

Although he was 2,500 miles away, Leonard could not resist the temptation to get off a barb aimed at the art establishment back in Toronto. "I can get ahead further if I take out Mexican or American citizenship, but I want to be part of Canada," he told an interviewer. "Canadian artists are fine creative people with a very high standard, but we also have an inferiority complex about ourselves. There are too many regional squabbles for one thing and we're just

cutting our own throats. Our weakness is we allow ourselves to be swamped with so-called American culture."[1]

Leonard told Mildred Valley Thornton of the *The Vancouver Sun* that Canada could learn a lot from Mexico about how to deal with her artists. "[Mexicans] well know that but for the genius of their artists the world would have little knowledge of their country," Leonard said. "Canada is slowly becoming aware of her artists, most of whom must expend their best physical and mental energies at other occupations to gain a few precious hours for painting. To say we are a young country is merely an excuse for lack of vision and initiative. There is no reason why art should not flourish in Canada the same as in Mexico, and with exactly the same results." "Like so many others," Thornton said, "he has found in a foreign land the freedom and self-expression denied by his own country. The spontaneous, zestful quality of his work is glowing evidence of this fact."[2]

Reva got into the act, too, in an interview with Betty Marsh on the "Morning Visit" radio program. Marsh asked if she and Leonard "didn't have a hankering" to remain in Canada. "Of course we have," Reva replied. "We are Canadians, and no matter how much we travel, we want to keep our roots here. But it's still very difficult for a painter to exist in Canada. He has to devote most of his time to teaching, or some other job, in order to make enough money to go on painting."[3]

Leonard was not to make much money in Vancouver, then or later. Esther Birney always attributed Leonard's lack of commercial success there to the opposition of hometown painter Jack Shadbolt. "Shadbolt was the king of the castle and was not friendly to Leonard," she said. "Shadbolt rejected him. You could not break into Vancouver's art scene without Shadbolt's support. He didn't encourage anyone coming in."[4] "I knew that something had gone awry," recalled Leonard. "But that's being an expatriate. I desperately tried to become part of Vancouver."

Shadbolt's and Leonard's backgrounds were very similar, even to having Leonard as a second name. Jack Leonard Shadbolt was born in Shoeburyness, England, in 1909 and emigrated to Canada with his parents in 1912, a year before the Brooks. His father, a sign writer, and his mother, a dressmaker, settled briefly in Nelson, British Columbia, before making Victoria home. Like Leonard, Shadbolt taught at the high school level before joining the faculty of the Vancouver School of Art in 1938, remaining until retirement in 1966. A prolific painter like Leonard, Shadbolt had one-man shows or participated in group exhibitions virtually every year from 1932 into the 1990s. Leonard first met Shadbolt in 1941 at the Kingston conference, but Shadbolt later did not recall the meeting. Shadbolt said he did not "remember seeing anything" from

Leonard's shows after he had left Canada. [5] Yet, like so many Canadian painters, he went to see Leonard in San Miguel, showing up with his wife, Doris, on New Year's Eve in 1963. "I find it very astonishing that an intellect like Leonard Brooks would hang out in a little town like San Miguel all his lifetime," Shadbolt told Latvian-born Vancouver painter H. Eberhard (Ebe) Kuckein.[6] Doris Shadbolt was the biographer of Emily Carr, who had greatly influenced Jack's career. She was for many years a Canada Council representative in Vancouver, making the Shadbolts a truly power couple in the city's art world.

Leonard left his unsold paintings – about sixty works – with the Birneys, who offered to try and sell them. Earle took out a $4,000 insurance policy on them, paid by Leonard.

Reva wrote ahead to Toronto's *Globe and Mail*, giving an overly enthusiastic view of Leonard's shows. As a result, the newspaper published an article saying: "Leonard Brooks, the artist, who has done such fine work during his years in Mexico, and who has been holding a much applauded show at the University of British Columbia, will arrive back in Toronto within the next week. West Coast art lovers have found his pictures particularly to their liking, and his clever wife, photographer Reva Brooks, has also found an excellent clientele there, we hear."[7]

Leonard now set his sights on a teaching post in Toronto, which delighted Reva, as she would now be able to return home. Both would be disappointed.

~ 30 ~

I wanted to destroy all those memories

Nothing went right for the Brooks in Toronto. Reva started haemorrhaging during the ten-day drive from Vancouver. Trying to ignore the pain, she accompanied Leonard to the apartment at 39 Boswell Avenue that they had sublet to painter Bill Newcombe and his wife four years earlier. If Leonard was to teach in Toronto as he hoped, they would repossess the apartment. They were aghast at the disorder they found.

"Boswell Ave. was sheer hell ... with a mess such as you cannot conceive, short of a bombing ... cupboards filthy, junk, studio left full of crates, his discarded stuff," Leonard told Earle Birney. "But today the place is empty almost and the worst over ... We blew up and told him [Newcombe] off but its [*sic*]

been very upsetting for Reva."[1] The raucous parties hosted by the Newcombes caused much of the damage. Former war artist Aba Bayefsky, who attended many of the parties, recalled, "Bill was unpredictable and there was a fair amount of drinking."[2]

Against that background, Reva was sent to the Toronto General Hospital by her gynaecologist, Morris Selznick, when the haemorrhaging did not subside. On 1 August 1951 he performed the hysterectomy he had reluctantly postponed four years earlier after Reva's second ectopic pregnancy. "I'm sitting in Room 705 and Reva is recovering from the operation this morning," Leonard told Birney. "Selznick did a good job and she found it less weakening than the ectopic last time."[3]

While Reva was still in the hospital, Leonard did something for which she never forgave him. He returned to 39 Boswell and, in a fit of rage, burned all of the diaries he had kept since age sixteen – he missed one, written when he was in Spain in 1934 – and all his wartime correspondence with Reva.[4] He also destroyed many of his paintings, but he did not have the heart to destroy his collection of three hundred books, many purchased when he was a teenager. So he sold them for nine dollars to Morris of the Forum, a second-hand book dealer. The piano that Reva played was ruined and had to be discarded. Some bits of furniture and a radio he salvaged and stored in the basement of the house of his sister-in-law, Sophie Sherman, where he and Reva were staying on Warwick Street.

Bill Newcombe was a bit player in the Brooks' lives, but without his actions, their careers might have taken a different turn. He was a catalyst. The Brooks went to San Miguel in 1947 because of Newcombe; their decision to settle permanently there in 1951 was influenced in great part by Newcombe's trashing of 39 Boswell.

Leonard said later that he was destroying the past in order to start life anew once back in Mexico. "I wanted to destroy all those memories," he said. He realized that he would never be faced with the financial burden of fatherhood. Nor was there much hope of obtaining the teaching job that would keep him in Canada and meet his commitment to the Department of Veterans Affairs. He did not want to return to the Toronto high school system that he had left four years earlier. Instead, he sought a university or college position that would allow him more time for his own painting. But his chances of a faculty post at the University of Toronto were practically nil, given the fact he had not graduated from high school, let alone had a Master's degree or Ph.D. Nor was there an opening at the Ontario College of Art.

Leonard expressed his feelings in a letter to Birney: "It is, after our good time with you and Vancouver, like suddenly being plunged into a swamp to be

here and the Great Panic I always feel here when I see how ugly, how difficult it is for a man to be an artist, or to breathe good fresh air – sweeps over me no matter what I do. It is important that I have folded up the rather tattered tent I had here and plan on getting the hell out – no matter where."[5]

But Reva did not share Leonard's desire to return to Mexico. They had agreed before leaving San Miguel that they would settle in Canada and occasionally visit Mexico. Reva had always felt they would return to Canada, preferably Toronto. Having had to forfeit her apprenticeship with Edward Weston, she must have been resolved to stay in Toronto. Reva indicated in later years that she and Leonard had an explosive fight over the issue and that he had given her an ultimatum: return to Mexico with him or the marriage was over.[6] Again, Reva put her love and loyalty ahead of any personal wishes.

Leonard taught for five weeks that summer of 1951 at the Doon School of Art in the village of Doon, near Kitchener, Ontario. Founded three years earlier, the school recruited many top artists as teachers, some during summer vacation from their regular high school jobs or positions at the Ontario College of Art. Fred Varley taught with Leonard that summer. Doon director Ross Hamilton asked Leonard to return the following summer, but he eventually chose to teach instead at the University of British Columbia. The decision not to return to Doon was costly in a way. Leonard had left three paintings which he had traded for other artists' works: two by A.Y. Jackson and one by Tom Thomson; these he used in his class. When he returned to Doon the following year to retrieve them, Hamilton told him there was no record of them.

While Leonard taught at Doon, Reva returned to Sophie's house, where she was given the room of Sophie's one-year-old daughter, Nancy. Sophie marvelled at the fact that Reva, too weak to navigate the stairs on foot, would descend and ascend the steps on her buttocks, lifting herself up and down with her arms. The knowledge that motherhood was being denied her must have been doubly painful for Reva to accept while she was occupying the bedroom of an infant niece. "The doctor said I didn't know how lucky I was," Reva wrote to the Birneys. "A few years ago this type of thing kept the patient in bed 10 days, two weeks in the hospital and months as a convalescent, and here I am up and around in two weeks."[7]

After the hysterectomy, it would always be difficult for Reva when women around her became pregnant. Painter Sylvia Tait recalled the day Reva dropped by to see her in San Miguel and learned that she was expecting her second child. "I saw her face crumble after the congratulatory hug and I felt her personal pain so acutely," Tait said. "She left almost immediately."[8]

Leonard, who was never as enthusiastic about having a family as was Reva, found solace, if any was needed, in his paintings, "my children," as he called them. Reva found two outlets for her maternal instincts: her husband and her photos. "Reva was the mother," said sister Sylvia Marks of Reva's marriage. "She decided everything."[9] Once, when Reva suffered a kidney infection and was half-delirious, she asked that Leonard not accompany her to the hospital. "Don't let that baby I created come with me," she implored.[10] Another time, she said, "Don't you think I'm lucky, if I didn't have the five children that I wanted, that Leonard has turned out, you know, he's such a terrific everything?"[11] Niece Nancy Sherman, who lived with the Brooks in San Miguel on several lengthy visits and knew their relationship far better than most, said, "Leonard has been her work of art and is in some ways very fortunate to have that unquestioned support."[12]

Reva recognized that she concentrated on young people and mothers in her photography as a substitute for not having children. She said in one interview that she put her "soul" into her photography. "So if you detect a lot of that in my work, then that's why it's there, because it was taking the place of the children I didn't have."[13] She would also use sexual terms in referring to photography, once saying, "Negatives are like one's womb," meaning the source of creation.[14]

Once, when the author was present, Reva was lamenting about not having five children. "If we had five children or three or two you wouldn't have become a photographer," Leonard said. "We'd have stayed in Toronto and I'd have stayed at Northern Vocational and hated it. We would not have had the life we've had." Leonard's friend Clyde Gilmour was correct when he said that the childless status of the Brooks freed Leonard to become the artist he wanted to be.[15]

Yet, of the two of them, it was Leonard who had the gift with children, the clown who found a hundred ways to amuse them and make them laugh and love him. Reva was the no-nonsense, humourless disciplinarian, the person who preferred to buy a book rather than a toy for a child.

As they prepared to return and settle permanently in San Miguel, Leonard probably compared how he was treated in both countries, how he was accorded the honorific title of *maestro* in Mexico. A measure of his prestige had come earlier in the year when the new Instituto Allende decided to award scholarships for American and Canadian artists, one for each country, although the United States had ten times the population of Canada. That was due entirely to Leonard's position in the San Miguel art colony. While in Vancouver and Toronto, he promoted the scholarships. Canadian recipients would include Jack Bechtel, Marcel Braitstein, Robert Hedrick, Stanley Lewis, Hitoshi Mishi, Robert Murray, Toni Onley, and Ron Spickett.

Leonard and Reva left Toronto on 11 September, driving to Boston for a call at the Childs Gallery, and then on to Dartmouth College in Hanover, New Hampshire, where friends Edwin and Mary Scheier taught pottery. There they made arrangements for a joint show opening 1 December.

Arriving in New York, they followed Edward Weston's suggestion and sought out Edward Steichen of the Museum of Modern Art. They told Steichen's secretary they had come at Weston's insistence. As director of the museum's department of photography from 1947 to 1962, Steichen could bestow no greater honour on a photographer than choosing his or her works for the museum's permanent collection. The Weston name served as an *entrée* for the Brooks. Reva showed Steichen her portfolio and he selected for the collection an eight-by-ten-inch gelatin silver print, untitled, of a Mexican woman. It was of Elodia, the mother of the dead infant in the series that Reva did in 1948. The picture would later be named *Confrontation*.

Since the Brooks were not staying over in New York, Steichen had handed them a cheque immediately. As they floated out of the museum, cheque in hand, they debated whether they should keep and frame it or spend the money. They opted for the latter and bought a set of cutlery before continuing south.

They had questioned the wisdom of making their next stop, at Lexington, Kentucky, thinking they were heading for hillbilly country. They went there at the suggestion of an ex-GI who had studied in San Miguel in 1948, Van Deren Coke. Coke offered to arrange a show for Leonard at the Creative Art Gallery, owned by his wife. But he later was more important for Reva when he became one of the top photography critics in the United States, eventually becoming the director of the photography department of the San Francisco Museum of Art. Coke took Leonard to the University of Kentucky, whose art department head, Donald L. Weismann, wrote the note on the invitation to the 1 November opening: "In all the watercolours of Leonard Brooks, no matter if the subject is northern snow or tropical jungle, one feels the activity of a delighted eye and a sure hand. There is a casualness in Mr. Brooks' paintings, an informally pleasant manner with which he adroitly catches the light and colour of particular places at particular times."

Soon after their return to San Miguel 12 November, the Brooks ratified their expatriate status by buying their first home. Realtor Dotty Vidargas told them she had found a bargain for them. For just $2,000 they could become owners of a 250-year-old colonial house at No. 11 Pila Seca Street, just steps from the town centre. More than forty years later, the house, then owned by others, sold for $350,000 and became a bed and breakfast inn. The Brooks had to make numerous repairs and build a studio, but they were pleased with their purchase. "The fact we are

just staying in our 'own' place with our own things around us, not in suitcases, pleases us, and we gloat in the fact of our own kitchen, fireplace, etc., without having to pay $100 a month rent,"[16] Leonard wrote.

As this decisive year in the Brooks' lives drew to a close, Leonard, in a letter to Birney, stated his philosophy of doing things his own way, ignoring current trends and tastes in art:

I am gradually evolving my own style, I think, but it is being hammered out painfully over the years, and if I had it my way, the stylization would not be too obvious but a natural following up of what I am trying to say. I don't want to have a style that will force me to go around looking for material or subject that will fit into it. I have seen at least 30 or more brilliant and sensational ways of piling on paint even this year. The very latest and most fashionable New York-accepted ways. Most of them are not too hard to imitate – in fact, are damned easy, and would bring ohs and ahs from the chichi boys. I think painting is concerned with something much more than farting about with little sensations in new and fancier dress.

I'm all for we Canadians buying Canadian, but I certainly do not agree that I have to paint Algonquin Park or the Rockies to produce a good thing. In the ordinary sales mart of pictures-over-the-fireplace to match the drapes, I can understand someone wanting a decoration recollection of something they know, expressed in rather obvious terms. But generally, people with taste beyond this feel and know a good painting when they see it, and will buy it if they can.[17]

On the road returning to Mexico, the Brooks had written a letter to Edward Weston. A "Dear Mr. Weston" letter, signed by both but in Reva's handwriting, it read: "We have been many miles and many places since we last saw you and we are now in Ohio on our way back to Mexico and 'home.' Just wanted to let you know that while in New York we saw Edward Steichen, and he bought one of my photographs for the permanent collection of the Museum of Modern Art. We told him of our visit with you last June. Also have met many people who were glad to get news of you. We look forward to seeing you again next May or June when we will be going up the West Coast. We will never forget our fine visit with you."[18]

There was no mention of Weston's offer of an apprenticeship for Reva.

A Writer Takes the Stage

~ 31 ~
The two are friendly rivals

The rebirth that Leonard had contemplated when he destroyed his papers in Toronto now meant he had no income from teaching and would have to live on sales of his paintings and, he hoped, his writing. Reva had to become an aggressive marketer of his paintings, even if she often had to set aside her photography. She used to go down to the Posada de San Francisco, then the leading hotel in San Miguel, and collar arriving guests. She would show them Leonard's paintings on display in the hotel and invite the person to the studio for a private viewing. Leonard would bring out a selection of paintings and then discreetly withdraw while Reva did the bargaining. This aggressiveness and *chutzpah* rankled some of the other painters and their wives.[1] However, most of the other painters also taught so they were not as totally dependent on sales as was Leonard.

As in Toronto, Reva planned social occasions with a view to sales. The invitation list for dinner would include a mix of friends and potential buyers. A visit to the studio would be obligatory. "She was incredible," said Lysia Brossard Whiteaker, whose first husband, Ray, was Leonard's studio-mate at the school. "It wasn't something I liked about her, believe me, but she worked, always entertaining as many names as she could. That was to promote his work."[2] "She was an amazing supporter," said Helen Watson, who visited the Brooks in San Miguel with her husband, Syd, director of the Ontario College of Art. "Mind you, she alienated people because of her support."[3] Toronto artists Cleeve and Jean Horne were in the Brooks' home in San Miguel when a potential buyer dropped by. The Hornes offered to leave the room, but Reva insisted they stay. "We were both embarrassed by the sales pitch Reva was giving," said Jean Horne.[4] When Betty Anne Affleck of Montreal, a retired university professor, went to San Miguel with her wealthy friend Loni Campbell, Reva thought it was Affleck who had the money and acted accordingly. "I was welcomed with open arms, but Loni was treated like my maid," Affleck recalled. "Loni was not offered anything to eat or drink and was not invited to Leonard's studio as I was."[5]

Previous page: Leonard, captured by Reva in a Hemingwayesque pose, once envisioned a career like that of the American writer.

There was no question now but that Reva's main role was creating an atmosphere in which Leonard could best work and promoting him and his works. "It's almost a privilege to share his life and to help in every way you can," she told an interviewer. "To be a helpmate to a man you love and respect and admire, I think it is most satisfying."[6] Looking back years later, Reva would write, "All artists fret and suffer about what they consider 'not being recognized.' Their wives, whom they make suffer, have an interminable task of bolstering up their confidence and ego."[7]

Yet niece Nancy Sherman, who observed them together more than did anyone else, felt the need for recognition for Leonard came from Reva, not Leonard himself. "I don't think he was looking for recognition," she said. "I think this very volatile, emotional personality is driven to express himself. It's his therapy. He doesn't do it for anybody else."[8]

Whatever the reason, the Brooks' homes would be adorned with Leonard's works. Seldom if ever were there any of Reva's photographs on the walls. If anyone wanted to see her works, she would bring out her portfolio.

Hoping to increase sales in Vancouver and compensate the Birneys for their time and effort, Leonard offered them a twenty-five percent commission on the paintings now back in their family room. Given their friendship, the Birneys were reluctant to accept anything, as indicated in a letter from Earle to Leonard. "Your pictures are priced so low I don't think 25% commission is fair. To keep it on a business basis, let's say ten percent, and I'll worry about how to collect it."[9] Leonard replied, "If you won't take 25% make it 15% and call it a deal – at least."[10]

The Birneys submitted some of Leonard's Mexican works to Vancouver Art Gallery's 1951 "Buy a Canadian Painting" show. Earle reported that a Mrs. Dick Sandwell had gone to the show intending to buy only a Canadian scene but bought Leonard's *Shrine at Atotonilco* for the marked price of sixty dollars, saying she could not resist it. "Her remark, by the way, is typical and underlines a lesson I learned from this show – Vancouver buyers (perhaps all Canadians) are not yet adjusted to the idea that Canadian painters can go outside the country and paint successfully or significantly."[11]

Birney had touched on a fact of life that inhibited the sale in Canada of Leonard's Mexican landscapes: Canadians wanted Canadian scenes, as opposed to American buyers, who were not as nationalistic. Once Leonard got into collage and abstract expressionism, his Mexican base was no longer such an impediment to Canadian sales.

Leonard was about to make a big commitment to improve those sales. He finally agreed to have his first art dealer in Toronto. York Wilson, who had been

represented at the Roberts Gallery for several years, convinced Leonard that it was in his best interest to join him there. When Roberts' Jack Wildridge and his wife, Jennie, visited the Wilsons in San Miguel, York set up a meeting with Leonard. There are two versions of what happened. Lela Wilson said everything went fine until Wildridge brought up the question of representation, whereupon Leonard bolted from his studio with Wildridge in hot pursuit, shouting, "Leonard, Leonard, I want to talk to you."[12] Jennie Wildridge said chasing after Leonard did not sound like something her late husband would do.[13] However, Leonard so abhorred anything involving the sales side that he would have been capable of running out. Leonard himself said they met in the park and came to an agreement. Whichever version is correct, the two men shook hands – no contract was ever signed – and Wildridge took back some works to initiate the new commercial relationship at Roberts, now located at 659 Yonge Street.

MacKinley Helm, who brought Leonard's paintings to the attention of American collectors in Los Angeles and Boston, tried to do the same with his writings. He introduced the Brooks to his friend Charles Morton, associate editor of *Atlantic Monthly*. Both Brooks made submissions to the magazine, Leonard two articles on being an artist and Reva some of her Mexican photographs. Neither made a sale, but Morton sent an encouraging letter to Reva: "I find that your photographs are unforgettable. The triptych about the dead child is so vividly in my mind that it's almost as if it were on my wall. I have never seen any photographs that impressed me so deeply, and I am sure you will find many others who feel the same way, as your shows go on."[14]

Morton recommended Reva's work to *Coronet* magazine, whose picture editor, Carl Bakal, wrote to her on 13 January 1953: "Mr. Charles Morton of the *Atlantic Monthly* spoke with Mr. Fritz Bamberger, our editor, about your photographic work. His high praise for it makes us extremely eager to see some samples of your pictures. Mr. Morton mentioned in particular the sequence with the death and funeral of a little Mexican child." Reva submitted a series of photographs, but they were not accepted. "We are afraid that your pictures of Mexico, although excellent individually, still do not add up to a picture story for us," Bakal wrote back.[15]

Perhaps Leonard was encouraged by Morton's letter to embark on a more ambitious writing project. He wrote and illustrated "In and Out of Mexico," a ninety-two-page account of the Brooks' first four years in San Miguel, highlighted by the closing of the art school in 1949 and the deportation and return of the teachers the following year. The title referred to the deportation and return. Canadian writer Fredelle Maynard shopped it to Penguin Books in

Toronto, while MacKinley Helm submitted a manuscript to *Atlantic Monthly*. The piece was never published, in part because it was too short for a book and too long for a magazine.

The person key to the teachers' return, General Ignacio Beteta, had recognized Leonard's role in marshalling support for their cause. Alone among the deportees, Leonard was invited to Mexico City for a dinner hosted by Beteta in a hotel in the upscale Polanco district to celebrate their reincorporation into Mexico's art world.

Now, whenever Beteta learned that Leonard was going to be in Mexico City, he would telephone him. One such call introduced Leonard to the power and privileges of the ruling class in Mexico. Beteta asked Leonard to join him on a sketching trip to the colonial silver town of Taxco, 111 miles southwest of Mexico City. At 1:30 a.m. a three-car caravan accompanied by motorcycle outriders and with sirens blaring swerved into narrow García de Lorca Street, just to pick up an expatriate Canadian painter at his hotel. When Leonard got into Beteta's limousine, he discovered the general had brought along three beautiful young women from his office, one of whom actually painted, and quite well. Once in Taxco, Beteta ordered all the guests in one wing of the hotel removed so that his party could have rooms with the best view.

In early May 1952 the Brooks retraced the route they had taken the previous year to Vancouver. They stopped in Santa Barbara, California, where MacKinley Helm had arranged a show of Leonard's paintings at the Santa Barbara Museum of Art, and then continued on to Big Sur, where once again they met with Edward Weston and son Brett. This time the Westons suggested the Brooks meet a neighbour in Carmel, Ansel Adams, one of the first photographers to capture the spirit of the west with his pictures of mountains and coastlines. A native of San Francisco and sixteen years Weston's junior, Adams would eventually surpass him in the galaxy of American photographers. They met twice with Adams, on 29 May and 7 June. "This gal has an amazing sense of composition," Adams said after looking at Reva's portfolio.[16] He bought one of Reva's prints and, like Weston, encouraged her to associate herself with the California photographic movement. Marion Carnahan, Adams' secretary, wrote to Reva, "Your print of the Mexican woman is a very fine one and I'm delighted Ansel has purchased it for his collection."[17]

The Brooks reached Vancouver on 15 June for a ten-week stay with the Birneys, during which time both Leonard and Reva taught summer extension courses at the University of British Columbia.

The Vancouver press treated Leonard and Reva like visiting stars. The *News-Herald* devoted the top quarter of a page to three photos of the Brooks.

Leonard, familiar cigarette smouldering beneath his moustache, is shown in one photo kneeling on the ground while giving painting tips to two students. The caption of a grimacing Reva said, "Photographer Brooks claimed there was only one camera in the world which really and truly upset her and that was the one taking her picture." It showed this time. The third photo was of Leonard and Reva and their combined classes as photographers took pictures of the painters and their works. "The two are friendly rivals when it comes to their respective arts," wrote a perceptive reporter.[18] Said *The Province* critic who signed Palette: "Exhibits of contour-free line drawings from models, and also some lively watercolours made from memory, indicate influence of the vitality and intense purpose characteristic of Leonard Brooks in charge of this class."[19]

Leonard's presence helped generate sales of his paintings in the Birney's makeshift family-room gallery. "Did we mention that we spent the summer in Vancouver where we were teaching at the University?" Leonard asked dealer Jack Wildridge. "I didn't have a formal exhibition there, but sold a number of things and found a great deal of interest."[20]

Besides income from teaching and sales, Leonard picked up another $876 by cashing in his superannuation benefits accumulated during his years at Northern Vocational in Toronto. The Brooks needed the funds as they completed repairs and renovations on their house on Pila Seca Street in San Miguel.

Leonard had inherited his love of gardening from his father and was enjoying his new garden. He told Earle Birney, "I get up and go out and water the garden and my square of lawn I grew personally ... and pick weeds! I nourish radishes with loving care, watch a seed pop up out of the ground as though it were a child ... and I know each plant and bush intimately. I suppose it is owning the bit of land that does it. "[21] Increasingly, Leonard would find subject matter in his own garden. He would do flower series without ever having to leave his property.

Despite Leonard's contentment, Reva still wanted to get back to Toronto and Canada. She wrote to the Wilsons, "Altho' we have a modest place here now, we by no means expect to spend most of our time here. We still want to settle somewhere in Canada and be able to come down here when we feel like it. The trouble is that it is almost impossible for us to be anywhere in Canada unless Leonard can be assured of some kind of income so we can pay the high expense of living."[22]

*L*eonard is a world-class watercolourist

The Brooks had a triumphant return to Toronto in 1954 when Leonard had his first one-man show at the Roberts Gallery 4–17 June. "Every time Leonard Brooks and his camera-artist wife Reva return here the artistic atmosphere of the city is freshened," gushed art critic Rose MacDonald in *The Toronto Telegram*.[1] There were eighty-five by-invitation-only guests at the cocktail party opening night, including A.Y. Jackson of the Group of Seven and fellow artists Cleeve and Jean Horne, Yvonne Housser and Isabel McLaughlin. Reva's brothers George and David brought the liquor – twelve quarts of rye at $3.25 each – plus a two-dollar liquor licence and $3.75 for the rental of glasses. David set up the bar and served as bartender. Leonard also paid for twenty-dollar advertisements in *The Globe and Mail* and *The Toronto Telegram*. Leonard was pleased with the sales, including several Ducos – literally painted with automobile enamel – that brought three hundred dollars each.

The reviews could not have been more encouraging. Wrote Pearl McCarthy of *The Globe and Mail*: "Leonard Brooks' exhibition at the Roberts Gallery is one of the most heartening shows put up by a single artist in a long time. He has avoided being trapped by his own or anybody else's mannerisms, on the whole, and has continuously sought an engagement between his own feelings and what natural sights the world has to present for our endless wonder."[2]

The *Telegram's* Rose MacDonald was struck by Leonard's paintings of cacti, obviously those painted after he and York Wilson had driven out into the country and stopped at a predetermined odometer reading and painted whatever they found. She wrote: "Brooks has taken the cactus, so commonly used these days as a symbol of Mexico that it has found cartoon level. He, for one, has restored its value. There are at least three paintings based on cacti in the present exhibition, one dominantly green, another grey-black as at night, and another luminous with pale amber light."

MacDonald noted that very few of the paintings were watercolours, which was ironic because that very year art critic and historian Paul Duval included one of Leonard's paintings, *Morning, Veracruz*, in his new book on watercolour. "I reproduced him in my 1954 *Canadian Watercolour Painting* book because he's a brilliant watercolour painter," Duval told the author. "No one ever had a natural style of painting in watercolours more than he did. He was just born to the media. He's a world-class watercolourist."[3]

Now Leonard was also dabbling with abstract expressionism, which he had previously abhorred. Although Leonard would say his move into abstract expressionism initially came in the early 1960s, California painter Rico Lebrun had got him involved a decade earlier. The new Instituto Allende had brought Lebrun to San Miguel as a star teacher. A native of Italy who had moved to the United States in the 1930s, Lebrun was not himself an abstract expressionist, but he urged Leonard to experiment. "Lebrun came to me once and said, 'Free yourself for a while and try it,'" Leonard recalled. "I said, 'I'll see what happens.'"

Lebrun was awed by Leonard's output when they went on sketching trips together. Robert Maxwell, who went to San Miguel on an art scholarship in 1950 and founded Casa Maxwell, the town's largest arts and crafts store, recalled the reaction of painters the first time they sketched with Leonard. "They'd be waiting for him to have breakfast at 9:00 a.m. in the hotel lobby and he'd come back with a couple of watercolours already done," Maxwell recalled. "He'd probably been up since 5:00 a.m. He was a very fast worker, very prolific and very good. He'd awe everybody."[4] Maxwell recalled a caricature that Lebrun made of Leonard after one trip. It showed a frenetic, paint-splattered Leonard, squeezing a tube of paint while he painted, a brush coming out of one ear, another sticking in his hair and one coming out of his rear end. Leonard, who would do similar sketches to mark special occasions, probably loved it.

Lebrun was the guest of honour at a luncheon that passed into San Miguel lore because Reva crashed it. The hosts did not like Reva, so the Brooks were not invited, but they showed up anyway. One of the hosts, looking down from a second-floor landing, shouted, "You people are not invited." Mortified, Leonard left, but Reva was not to be deterred. Having no place to sit, she found a chair, brought it to the table and sat down, according to one of the guests present.[5]

Reva also crashed the reception for Barbara Fernández, the daughter of the owner of the Instituto Allende, when she married Dr. Felipe Dobarganes. Some five hundred people – the virtual who's who of San Miguel – were invited to the wedding in the Parroquia, the parish church, and the reception afterwards, but not Leonard and Reva. "I didn't like Reva so I didn't invite her," recalled the mother of the bride, Nell Fernández. "But I'm a very good friend of hers now."[6] Since the wedding was the social event of the year, Reva had checked with friends when no invitation was forthcoming. "Reva was just fit to be tied," said Bunny Baldwin, who, with painter husband, Jack, was invited. "She came over to our house one morning and happened to see the

John (Jack) Baldwin and wife Bunny, both former GIS, met and married in San Miguel, where he taught at the art school.
COURTESY BUNNY BALDWIN

invitation and asked us about it." When the Baldwins were walking into the Instituto Allende for the reception, Reva appeared out of nowhere, slipped her arm through Jack's and said, "I'm going in with you." And she did, much to the annoyance of Bunny. "I had never seen such unmitigated nerve," said Bunny.[7] Barbara Dobarganes recalled that a wedding present had arrived from the Brooks, one of Leonard's watercolours.[8]

Before returning to Canada, Leonard was involved in a publishing project with a former president of Paraguay, Natalicio González. Leonard had done twelve sketches in a series on *Posadas*, the Mexican fiestas celebrated for nine days before Christmas which relive the journey the Virgin Mary and Joseph made from Nazareth to Bethlehem. Impressed by the sketches he chanced to see, González published a limited edition of 2,000 copies as a package. They were snapped up. Wrote Charles Allen Smart: "In moving from Canada to Mexico, he took a great leap forward in his work and produced a large body of Mexican landscapes, fiesta scenes, and so forth – including a series reproduced in colour in a small portfolio called The Posadas of San Miguel – that, without his ever painting a political cartoon, made him one of the leading foreign painters in Mexico."[9]

Many of those Mexican works were with the Brooks when they drove to Toronto via Texas where Leonard gave the first of many workshops in the United States. He was a guest instructor at the San Antonio Art League at the Witte Memorial Museum, where he probably met Helen Lapham, a painter and former

beauty queen from Houston who was so captivated by the handsome instructor that she followed him to San Miguel to get to know him better. Leonard was one of three judges at the twenty-fourth annual Local Artists Exhibition 18 April–9 May at the museum. He and Reva also had a joint show there.

The biggest problem for Canadian artists living in Mexico was always how to get their works back to Canada for exhibition. Many artists employed brokers to handle the paperwork and do the shipping and customs clearance in Canada. But Leonard felt this was an unnecessary expenditure, so he always transported his paintings himself or, if people were travelling to Toronto, he would ask them if they would mind dropping off a few works at the Roberts Gallery. He seldom received a negative reply. Occasionally paintings would go astray, as did one roll that ended up at Georgian Bay instead of Toronto.[10]

Once Leonard was stopped by u.s. Customs in Laredo, Texas, en route to Canada and asked to unpack his paintings. Leonard explained that he was going to use them as teaching tools at a workshop in the state. The customs agent took note of how many paintings there were and told Leonard he would have to account for them when he returned to Mexico. Leonard left the paintings in the United States and Canada as planned, bought some canvases and, with his usual speed, did some fast paintings, which he showed at the border. He repainted over the canvases when he returned to San Miguel.

Once back from Canada following the show at the Roberts Gallery, Reva learned that Edward Steichen of the New York Museum of Modern Art had selected her photo of the grieving mother – *Confrontation* – to appear in his *The Family of Man* book of photographs, a high point in her career. The book turned out to be the best-selling photographic book of all time.

When Steichen announced plans for the project, the news shot through the photographic community, not only in the United States but worldwide. The photographers were not to be paid for their works, but they would have them showcased as never before. "*The Family of Man* is planned as an exhibition of photography portraying the universal elements and emotions and the oneness of human beings throughout the world," Steichen said. "It is probably the most ambitious and challenging project photography has ever faced and one for which, I believe, the art of photography is uniquely qualified."[11] By the 10 April 1954 deadline for submissions, Steichen had received more than two million prints. Reva had submitted eleven, of which the selection committee chose one, *Doña Chencha*, the former gardener's mother, as it pared the number down to 10,000. But when it came down to the final choice, Steichen opted for *Confrontation*, which he had purchased from Reva three years earlier. Reva

was in select company, one of 273 photographers from sixty-eight countries who had 503 photographs reproduced. The greats of world photography were included: Ansel Adams, Henri Cartier-Bresson and Robert Capa of Magnum, and Alfred Eisenstaedt, Cornell Capa, Gordon Parks, Margaret Bourke-White, David Duncan and Carl Mydans of *Life* magazine, Richard Avedon of *Harper's Bazaar* and Civil War photographer Matthew Brady. Poet Carl Sandburg wrote the prologue which ended with the phrase, "A camera testament, a drama of the grand canyon of humanity, an epic woven of fun, mystery and holiness – here is the Family of Man."

Publicity surrounding *The Family of Man* was so great that advance orders were placed even before the book was published. Harvey Breit, of *The New York Times Book Review*, appeared bewildered in his "In and Out of Books" column. "That book of photographs folks have been looking at and buying hasn't even been published, yet *The Family of Man* ... has not only jumped publication date; it made the best seller list last week. Don't ask us why. Since we can't explain it, we feel duty-bound to report it, because it is a sort of phenomenon. Sold: 130,000 copies. On the presses: 130,000. Honestly, we ourselves don't dig it."[12]

A travelling exhibit of the photographs toured the world for several years, increasing interest in the book. Because of "unprecedented" sales, Steichen wrote Reva 15 June 1956 that she was being paid twenty-five dollars for the use of her photo.

There was a curious footnote that year. James Bagby, Ph.D., Committee on Research in Juvenile Delinquency, New York, wrote Reva: "One of your photographs which appeared in the remarkable collection entitled *The Family of Man* published by the Museum of Modern Art was used in a social psychological study which I conducted for Princeton University last year."[13] He asked Reva permission to reprint the photo in a scientific report.

Leonard and Reva must have looked back on 1954 as the most successful of their twenty years together. While in Toronto, he was confident enough about the future to trade in his 1951 Ford plus $1,995 for a used 1953 Dodge station wagon in excellent condition. But little could they anticipate that Leonard would have a bitter falling out with Jack Wildridge of the Roberts Gallery and that he would not have another one-man show in Toronto for fifteen years. His reputation would suffer as nearly a generation of Toronto art lovers came of age hearing little about Leonard Brooks. Fortunately for Leonard, the following year he launched a parallel career that helped bring to the Brooks the financial security for which they longed.

Oh, I could handle the bed part

The letter that would change Leonard's life was found lying on the snow in front of the house of Sophie Sherman, Reva's sister, in Toronto. It was from Reinhold Publishing Corporation in New York, asking Leonard to stop off and visit next time he was in the city. Reinhold was interested in a proposal Leonard had made for an art book, not a how-to-paint book but one aimed at professionals and advanced amateurs. Since he and Reva thought they were going to be in Toronto in March of 1955, Leonard had given Sophie's address on Warwick Street as the return address on his proposal. The postman found the soggy letter – who had dropped it, no one knew – and gave it to Sophie, who mailed it to San Miguel.

Leonard and Reva did not get back to Canada until the fall, so it was not until 3 November en route home when they stopped off in New York. On that day Leonard signed "a fine contract" for a book – *Watercolor: A Challenge* – and walked out of Reinhold's offices at 430 Park Avenue with a $2,000 advance.[1] He was pleased that Reinhold thought so highly of the project that it planned to have the printing plates made in Holland for maximum reproductive quality. He eventually wrote eight highly acclaimed art books which earned him more than $40,000, established his reputation in the United States and made him a sought-after lecturer.

"My teaching really is in my books," Leonard explained. "I decided it would be a very nice way to teach, working in my own studio without having to go to an art school ... I sold my first book by writing to the publisher and saying I thought they were underestimating the intelligence of the people who were getting books on painting, that they were too simple, and that there were many, many people out there who wanted something a little more intelligent addressed to them."[2]

"Leonard's writings seem to set him apart from other Canadian artists," said Joan Murray, then the executive director of the McLaughlin gallery in Oshawa, Ontario. "Those books are absolutely out of the norm; they're so well written they're really fun. It's very unusual for an artist to be that versatile."[3]

Leonard was emboldened to write Reinhold because the *Atlantic Monthly* had finally bought one of his articles. Entitled "You Too Can Paint," it was a satire on amateur painters in San Miguel and was published in June 1955, although it had been accepted the previous year. The article was prompted by

an incident in San Miguel's town square where Leonard was painting. A "sweet-faced lady *turista*" said to him, "Charming, such a charming hobby – so creative, and doesn't do anyone a bit of harm. My husband George is doing one just like it down the street. What, if I may ask, do you do for a living?" *Atlantic Monthly* paid Leonard $125 for the article. "I thought if I could break into the *Atlantic Monthly*, I couldn't do much better for myself," he recalled. "That was the test."

Leonard also started an eight-year relationship with the Ford Motor Company. He had sold six sketches and a brief text for an article entitled "New Vistas in British Columbia," published in the June 1953 issue of *Ford Times*, and seven sketches for an article entitled "The Low Road to Mexico," published in the December issue. Now Ford was interested in Leonard writing as well as sketching for its upscale *Lincoln-Mercury Times*. The *Ford Times* was a small magazine, just five by seven inches, while the *Lincoln-Mercury Times* was a regular size, eight-and-a-half by ten-and-a-half inches.

Leonard reported to Earle Birney that he and Reva had made two trips, one to Veracruz on the Gulf coast and the other south through Chiapas to Guatemala, taking notes and sketching. "If they take the [manuscript] on the Chiapas trip they are now considering and some more paintings, I'll be set up for a time, and can smack into my own work which is getting very exciting for me," Leonard said. Here, he confirmed that he had been experimenting with abstract expressionism. "I have been moving into more abstract and experimental stuff of late ... for example have four large canvases on the go based on the music of Vivaldi's 'The Four Seasons.' I am painting them without benefit of subject as such, trying to put down with form and colour the feeling of my memories of all the seasons I have lived and painted in Canada over the years."[4]

Leonard would earn more than $10,000 for work on the Ford magazines, which were distributed at Ford dealerships in the United States and Canada. Ford bought forty-one watercolours for $100 to $150 each and paid Leonard ten cents per word for the text. The company also paid expenses for hotel and meals plus seven cents a mile for the use of his car. More importantly, both Leonard and Reva did their own work on trips that were paid for in full by Ford. Leonard had only one minor reservation about his relationship with Ford: since he was pre-selling his work, people might think he had become an illustrator and was doing commercial art rather than serious art. "These aren't great works of art," Leonard told the author as he flipped through issues of the Ford magazines, "but looking at them now, they're affable."

Writing was always easier for Leonard than painting, obviously because it did not take such an emotional toll on him. But he wrote as he painted, quickly.

Leonard's friend Charles Allen Smart was a slow, plodding writer, who used to chide him about writing fast. "Good books cannot be ripped off – even by you," Smart told him.[5] Through his readings, Leonard had developed a vocabulary that surprised him at times, as it did those aware of his limited formal education. He enriched his vocabulary through his artist's eye. Much of his interesting phraseology appeared not in his published writings but in jottings in his diaries and journals, such as:

"I have little interest in walking the narrow shoreline of repetition and problems already solved."
"... blow clouds of scudding grey and raw across normally blue skies."
"... sadness of cloaked figure going aboard plane."
"... a spasm of visitors ..."
"... time catching all of us in his net ..."
"... the usual hovering bird of disappointment ..."
"... a fat motherly miracle looks after us ..."
"... jet planes doing a Jackson Pollock across the sky ..."
"A faraway hen pierces the quiet stillness like a stiletto."

Leonard also preferred the immediate financial rewards of writing, the advance before anything was put down on paper, compared to the complicated logistics of marketing paintings and paying commissions to a dealer. "You can't walk out in the street and sell a painting," he would say. "But you can walk out and sell an article if it's well written."

Leonard had a visitor that year with a growing reputation as a writer, Earle Birney. Birney would eventually win two Governor General awards, publish some twenty volumes of poetry, two novels, and a memoir. He had agreed to write an article for Canadian Pacific Airlines in exchange for a free air passage to Mexico City.

Birney was in San Miguel for all of two days when Leonard took him on the first of what were to be a series of adventures – many fuelled by rum – over the next two months. Reva being absent, Leonard received an invitation to visit Helen Lapham, the American painter who had beseeched her husband to rent a house in San Miguel after becoming smitten with Leonard while attending one of his workshops in San Antonio. He asked if he could bring along Birney. After a few rums, Birney started arguing with the hostess about Americans and walked out of the house. A man with a penchant for climbing trees, on that hot summer night he scaled one in the Lapham garden and refused to come down. Leonard and Helen were having a drink when Birney,

covered in slime and wearing only his underpants, burst into the room. "Where's the bathroom?" he shouted. "I've got to wash up."[6] He had decided to cool off by bathing in what he thought was a rather small swimming pool. It was a large concrete tank for storing rainwater and washhouse overflow.

Leonard conceded in later years that "I got myself involved" with Lapham. A stunning brunette, she was the third of four wives of John Lapham, a wealthy polo player who owned a 3,000-acre ranch in Center Point, Texas. She married Lapham in the late 1940s or early 1950s and had two children, Stanley and Biddy. By the time Leonard came upon the scene, the marriage must have been troubled because she and Lapham divorced shortly thereafter. She had been married to a general when she met Lapham and married a retired army officer after divorcing him. Lapham's next wife, Ella Maie, also met Leonard and promoted his workshops in Texas.

As she had done with regard to Helga Overoff in London during the Second World War, Reva learned of his affair with Helen. She would also be told about a weekend Leonard and Earle were now to spend with two young ladies in the Pacific coast resort of Manzanillo. Claire Watson, whose father, William, ran an art gallery in Montreal, visited Mexico with a friend, Frances Booth. Before they left, Montreal painter Fred Taylor had suggested they visit the Brooks in San Miguel. Birney took an instant liking to Frances and she to him. As Birney was a houseguest of the Brooks and needed more privacy, he suggested that he and Leonard drive to Manzanillo with the ladies. Someone took a photo of Leonard, dressed in bathing trunks, boyishly flexing his muscles and showing off for the girls, who were out of camera range.

As soon as Reva learned about the trip, she wrote to Claire Watson, with copies to Earle and Esther Birney. Leonard appeared as a naïve victim of Birney's lechery, which was hardly the case. The letter said:

When Leonard returned from Manzanillo and told me you had both been along, I was so surprised that I didn't quite realize it for a few days. Not surprised that they would have wanted to take you both to see Manzanillo, but absolutely stunned and amazed that no one mentioned it to me that Friday night when we were together. Since Leonard has never done this sort of thing before to me, I just came to the conclusion that he didn't tell me before he left because he was put suddenly into a difficult situation because of Earle's sudden attachment for Frances, and he thought perhaps I wouldn't understand or that I would disapprove. Since I have known that Earle was a "free" man in this regard for many years, nothing in regard to him would shock me, but I was deeply hurt that I wasn't treated at least as a friend and told that my husband, our old friend and our two new friends were going on a trip together. Since I wouldn't have been able to

go at that time, and have always been so sure of Leonard's love and friendship for me, I would have considered it natural for him to go along with the three of you. At the very least it was most inconsiderate and thoughtless of them to put you both in such a compromising situation; as for me it shook the very high regard I have always had for Leonard's good qualities of frankness and consideration and loyalty. I resented intensely being treated this way when I was doing everything in my power to be friendly and helpful with Earle and you and Frances. Leonard wants me to overlook the whole thing, but I felt it only fair to myself to let you know all my feelings about it.[7]

Claire Watson recalled that she and Reva exchanged several letters over the incident. She said she had counselled Leonard to tell Reva about the trip, which he apparently did. "I remember Leonard saying, 'What if Reva hears about this?'"[8]

For his part, Birney wrote about the trip in a poem dedicated to Leonard, telling how the girls were pale and frightened as Leonard took the sharp, mountain curves in his '53 Dodge. The car stalled and had to be towed. Birney rose early the first day to see the sunrise, only to find that Leonard was already working on his fourth watercolour.

On another occasion, drinking in a *cantina* in the red-light district of Morelia, Leonard and Earle came close to being shot when a drunken rancher burst through the door with his pistol drawn, "shouting for *Yanquis* to shoot." He was seeking to avenge the death of his younger brother who had just been killed trying to cross the Rio Grande into Texas. When he spotted Leonard and Earle, he thought he had found his Yankees. "No, no, they're Canadians," shouted the bartender, just in time.[9]

"In those days, like most veterans who'd survived bombs, we thought we were invulnerable," said Leonard. "We'd go into places and talk to local guys. We thought no one could push us around, but we were completely wrong. Once we were nearly shanghaied. Earle got into an argument which got pretty edgy. I got him by the scruff of the neck and said, 'Let's go!'"[10]

No slouch himself as a charming ladies man, Leonard was frankly in awe of Birney's sexual prowess. "Earle Birney was the greatest lover I've ever known," he said. During a half-hour drive through the mountains near Patzcuaro, Leonard, to pass time, asked Earle to list all the women he had bedded. He had not finished the list by the time they arrived at their destination. Earle had brought down correspondence from the women in his life, past and present, which he duly answered. Once Leonard discussed Earle's womanizing with Esther Birney. "Oh, I could handle the bed part," Leonard told Esther. "It's the phoning I couldn't cope with."[11]

Wailan Low, Birney's third wife and forty-five years his junior, said this period in Mexico was one of the happiest in Earle's life. "Probably one of his most productive periods, probably one of Leonard's too," she said. "He told me things Reva wasn't supposed to know about. They went on the road, they got drunk, they met up with girls on the way."[12]

Wailan said that Earle used to call Leonard a man's man. "Earle is a very difficult person, highly charged – lots of energy – great creative intelligence," she said. "That's where he and Leonard fed off each other because they were two of a kind. I think Leonard's the same way, sparks of temperament and yet gentleness and generosity. They were very alike, irascible, a world unto themselves. There really wasn't any room for anybody else. It was a circle, just the two of them."

Besides Manzanillo, Morelia, and Patzcuaro, they went to Actopán, Guanajuato, Irapuato, Pachuca, Pozo Rico, and Querétaro. They were fundamentally working trips, Leonard sketching and Birney jotting in his notebook. Earle was so charmed by San Miguel that he paid $450 for a lot next to a vacant one the Brooks owned on Quebrada Street where he planned to build a house.[13] Earle credited the visit to Mexico with giving him the confidence to travel the world reading his poetry. He said in his poem to the Brooks:

> You've written almost as many [books], with your middle hand
> (the left's on your violin)
> books both beautiful and honest guides to artists.
> But you've had to live and deal outside Canada to do it.
> We've all remained Canadian wherever we've lived
> because we were born that way
> and we're also internationalists
> because we were made to create.

PATZCUARO –

Back in Canada, Birney wrote about the Brooks in the 15 October issue of *Saturday Night* magazine:

Creative types in Canada are grown largely for export. I don't mean what they create, but they themselves. We rear actors for London and Hollywood, singers for New York; we ship writers anywhere that will take them. I'm speaking, of course, of the Number One Hard varieties, not the seed-crop who, by getting themselves labelled teachers, continue to be locally consumed.

In the last decade we've even found a market for some of our visual artists, our painters, sculptors and the like, a genus formerly thought to be too indigenous for exile. And most seem to be coming to a little town in Mexico where I have been living this summer, San Miguel de Allende, in the high hills of Guanajuato.

The Brookses are not only the Canadians of longest residence here, and pioneer supporters of the Institute in its less palmy days, they are also symbolic figures, conspicuous examples of the successfully exported Canadian artist.

～ *34* ～
I resent spending money needlessly

Leonard felt so encouraged by his financial prospects from painting, writing, and teaching that he consulted a tax expert in Canada, now that he anticipated a taxable income. He wrote to Philip T. Clark, a government lawyer whose wife, Paraskeva, was a painter, so artists tended to seek him out for advice. "Since I have thrown over my security of a teaching job and business contacts in Canada to engage in this task of being a full-time painter, things have not been easy, but somehow we have been able to make progress in our work, and to live reasonably," Leonard wrote. "I know you understand me when I talk about the struggle to be a productive creative artist, but I am wondering how I would be understood in the world of business and taxes? There is nothing I would like better than to pay a huge income tax, and I always hope that some day financial success will come my way!"[1] Clark replied that Leonard, as a permanent resident of Mexico, owed taxes to that country, not Canada.

Like many Latin American countries, Mexico pampered its artists and other creative people. In lieu of income tax, artists could annually offer a painting to

the government, sending a photo of the work and a letter with the dimensions and characteristics. A committee then decided if the work was worthy of acceptance. Leonard just once submitted a painting, acquired by the Mexican Museum of Modern Art.

Leonard and Reva came of age during the Great Depression, an event that would forever mark them. While many people of their generation shrugged off the years of hardship, the Brooks could not. His early artist years in Toronto and his year in Europe, especially, scarred Leonard. "All those years of penury put their mark on me and I never really learned how to relax and let myself forget what it means to have no money, no means of living without worrying about things, what they cost, what is needed to feel secure," he wrote.[2] Once he achieved financial success undreamed of by aspiring artists – he estimated his estate in 1998 at more than $5 million[3] – he still could not bring himself to spend money. "I resent spending money needlessly – can't pay $100 for a meal like some of my friends, etc.," he wrote to the former Canadian auditor general, Maxwell Henderson, a good friend.[4] "Money never mattered much to him," said brother Bert. "He never did things *for* money."[5] For decades, the Brooks limited their travel to places where they could stay free with friends. Sometimes the friends willingly gave up their bed and even their home so Leonard and Reva could move in for a few days. It became a joke among friends and relatives that there was never a fight over the bill when they lunched or dined in a restaurant with the Brooks: Leonard never made a move to pay. However, there were two things on which the Brooks freely spent, besides their professional supplies and equipment: books and music. There was no limit there.

When Leonard decided to give up the secure paycheque from Northern Vocational for the uncertain life of an artist in Mexico, he was risking a diet of *tortillas*, in place of potatoes. Yet, it was a good gamble. During the first nine years in Mexico, his income totalled just $16,338. Had he remained at Northern Vocational, he would have earned more, but the cost of living would have been higher and the standard of living lower. No maids or gardeners.

Leonard had faithfully submitted income tax returns after going to Mexico in 1947, when he declared an income of $1,800, most of it earned in Canada before they left. His 1948 income $1,220; his 1949 income dropped to $1,080; in 1950 he made $1,865; he jumped to $2,345 in 1951 but dropped to $1,225 in 1952; he made $1,860 in 1953, $2,138 in 1954, and $3,304 in 1955.

Whether or not Leonard paid income tax was an issue that rankled some of his painting peers in Toronto, such as Franklin (Archie) Arbuckle. "I don't know how much tax he paid," Arbuckle said. "I've heard he didn't pay any."[6]

Now Leonard concentrated on writing *Watercolor: A Challenge* – he had already chosen the title before starting – and selecting the paintings to be reproduced. All the works, two hundred reproductions and sketches and sixteen pages of colour, were his own, except a York Wilson cactus, one of the series done from their painting trip. "I ... preferred to use my own paintings throughout for demonstrations, not to show how it should be done, but because I have felt that I know and can explain my own children – with all their weaknesses – better than the offspring of others," he wrote in the introduction.7 Reva made photographs of the paintings for reproduction in the book, a rare talent that made her popular among other San Miguel painters who wanted to record their works. "I have been so busy making photos of L.'s paintings and charts that I haven't yet printed up orders for my own photos," she told Fred Taylor.8 A better typist than Leonard, Reva also prepared the final manuscript.

Like Leonard, Reva felt that success with the art book would give him the financial security to paint more freely. "After all, having no children, and if this art book is successful, he should be able to dedicate himself to going as far in his painting as he can," she told Earle Birney.9

Leonard, in the acknowledgement page, thanked both Birney and Charles Allen Smart "for their advice and encouragement" given to him when he was writing the book.

Although Reva chided Claire Watson for going to Manzanillo with Leonard, Earle and Frances Booth, all seemed more or less forgiven when the Brooks went to Canada in 1955. Either that or it was Reva, the business manager, rather than Reva, the aggrieved wife, who wrote to Fred Taylor. "Thanks for sending Claire Watson to see us – we enjoyed meeting her very much, and she is all and more of the nice things you said she was. That sounds complicated, but you know what I mean! With her attitude and inquiring sympathetic mind to art and artists, her gallery should have a fine future both for her and Canadian artists."10 The Watsons took on Leonard as one of those Canadian artists and probably helped Reva to arrange a show at Eaton's in Montreal. "Claire is doing so much to help us and we certainly hope her efforts will be rewarding," Reva wrote to Birney.11

Reva's show was held on the ninth floor foyer of Eaton's store on St. Catherine Street 5–15 September. The Brooks were houseguests of Fred Taylor and accompanied him to the opening. "Small crowd – Mexican consul – old friends," Leonard wrote to Birney. He reported that "everyone was impressed with Reva's show" at Eaton's."12 *The Gazette* of Montreal said: "Reva Brooks knows what makes a good picture, is sound in her types and admirable in her

Above: Leonard's only sibling, Herbert (Bert) Brooks, nine years his junior.

COURTESY BERT BROOKS

Leonard's father, Herb, visited San Miguel in the early 1950s.

spontaneous arrangements. There is no sense of posing – her types appear to have been encountered in casual wanderings."[13]

Claire's father, William, bought four hundred dollars-worth of watercolours for resale at the Watson Art Galleries, 1434 Sherbrooke Street West, and Leonard left eleven caseins there on consignment. "[Claire] said she and her father liked the paintings immensely and they feel sure they will be able to sell easily the ones taken on consignment as well as the others," Leonard told Birney.[14] By the end of the year, the gallery had sold five of the caseins.

The Brooks had been back in San Miguel for a week when Leonard's father, Herb, died in his sleep, 23 November 1955, at age seventy-five. After retirement, Herb had gone to San Miguel twice on his railway pass, the first time alone and the second time with Nell. The friction was such between Reva and her mother-in-law that Nell insisted after a couple of days that they return to Canada. When Herb came down alone, Leonard was surprised at his first sight of his father in San Miguel: he found the dapper Herb sitting on the terrace of the San Francisco hotel chatting with some women. On the trip through the United States, Herb had befriended a black master sergeant from the u.s. Army. When they got south of the Mason-Dixon line, the sergeant

bade his farewell to Herb, explaining he now had to move to a black car as the one they were at the time in had become whites-only. "I never felt so ashamed in my life of being a white man," Herb said later.[15] The incident reinforced Leonard's belief that it was Nell, not Herb, who was opposed to having a Jewish daughter-in-law.

Upon learning of his father's death, Leonard immediately returned alone to Toronto, catching a 1:00 a.m. flight via Chicago. The funeral was held in Hamilton, where the senior Brooks had moved after Herb's retirement. Leonard paid for the funeral, which cost $556 and included the hearse, flower car and seven-passenger sedan for Nell, brother Bert, and himself. He told Earle Birney that the advance for his book allowed him to cover the expenses. Birney wrote back: "Believe me you are very very much in my thoughts, old man; I know how much you loved your father, and what a shock his sudden death must have been."[16]

~ *35* ~

*O*verboilings

When Montreal poet Eldon Grier and his painter-wife Sylvia Tait first met the Brooks in 1956, they fell in love with their house at No. 11 Pila Seca and made an offer Leonard and Reva could not refuse: $12,000 and they could continue living there for another year. Since the Brooks had only paid $2,000 for the house and put in maybe another $1,000 in repairs and renovations, they did not hesitate in closing the deal. They had found Pila Seca inconvenient – the bedrooms were separate from the main house, which created problems on rainy nights – so now they planned to use some of the profit to design and build a dream house on their lot on nearby Quebrada Street and save the rest for a trip to Europe. "It was too much to turn down," Leonard told Earle Birney.[1]

Grier, whose family's fortune came from timber, first went to Mexico in 1945 not as a poet but as a painter and ended up working with Diego Rivera on a mural in the National Palace. He had returned to Mexico ten years later with Sylvia, whom he had recently married, and spent six months in San Miguel, he writing poetry while she painted. They met the Brooks and were invited for dinner literally on their last day before returning to Montreal for the birth of

their first child. Maybe they had not looked up the Brooks earlier because of the reception they had received from Leonard's war artist colleague Michael Forster, who had followed him to San Miguel. When they recognized Forster, they introduced themselves as Canadians. "Don't talk to me," he shouted at them. "I've come here to get away from Canadians."[2]

Although Grier did not need to earn a living, Leonard must have felt he had served his apprenticeship with Rivera. The two men took an immediate liking to each other. However, Leonard could not resist making cutting gibes at the tall, thin, gentle poet, trying to provoke him. Despite his pacific nature, Grier was once moved to challenge Leonard to a fight in a *cantina* in a Mexican mining town. "I don't know what started us arguing, but suddenly Leonard started bossing me around," recalled Grier. "I told him to shut up. He started yelling at me and I started yelling back."[3] Grier stood up and the Mexican patrons who had heard the angry shouts moved back their tables in anticipation of a fight between the two foreigners. Realizing how ridiculous the situation was, they backed off. "Leonard was so energetic and so full of life," said Grier. "I was a very peaceful sort of man."

Grier was the person who identified Leonard as an existentialist, someone who believes that there are no social or physical limitations to one's freedom, that what one does and thinks defines who he or she is. "I'm an existentialist in spite of myself, from my early days on, and I count each day as a miracle – I really do – and always did," Leonard once told an interviewer.[4]

One of those freedoms that Leonard exercised was to give vent to his emotions. He had what he termed "overboilings" on a trip he made to Guatemala with Grier, Swiss painter Roget von Gunten and American Don Grey. Since Leonard had driven the roads of southern Mexico before, Grier let him take the wheel of his new Pontiac station wagon. Angry over something, Leonard drove the car at almost suicidal speeds on the two-lane highway. "He was going eighty-five miles per hour on these narrow roads, trees on both sides and animals wandering about,"[5] Grier recalled. He urged Leonard to stop, but he refused to do so until they came to that day's destination, where Eldon took back the keys.

Sylvia Tait surmised that Leonard was probing her husband's "female side" with his provocative remarks.[6] Whatever the reason, Leonard would later needle another wealthy Montrealer, Fred Taylor, with almost tragic results.

Although some members of the art establishment thought Leonard had abandoned Canada, he was now invited to join The Canadian Group of Painters. The Group of Seven, which gave its last joint show two years earlier, had founded the new group in 1933. Each year new artists exhibited at the group's shows and some were invited to become members. They included Jack

Bush, Charles Comfort, Isabel McLaughlin, Pete Haworth, and Will Ogilvie. "The main [accomplishment] was that the Group was the first in Canada dedicated to the modern movement," said Joan Murray, chronicler of the group.[7] But by 1956, when Leonard joined, the group had peaked and he dropped out seven years later. "I had hoped that I would have been able to continue to exhibit and participate from time to time in the Group activities," he wrote in his letter of resignation, "but I regret that distance makes this impossible for the time being." Leonard exhibited at least once with the group. From several paintings the Roberts Gallery offered the group at Leonard's request, the organizers selected *Night Ruins* for a show in Vancouver. Membership dues were five dollars a year and the group took a fifteen percent commission on any sales it generated.

No sooner had Leonard joined the Canadian Group of Painters than he received a letter from painter Alan Collier, treasurer of the Ontario Society of Artists (o.s.a.), demanding payment of fifty dollars he owed in back dues. Leonard was so upset that he wrote a letter to the o.s.a. threatening resignation on the grounds it did little for members like him who lived abroad. That prompted a reply from fellow member York Wilson: "... the letter received by the o.s.a. from yourself (while justified, admittedly) was very disturbing to guys like Cleeve [Horne] and me, and somehow we'll have to arrange that a compromise is reached so that you don't leave us. It's a matter, however, that can be discussed easier when we see you again, and we can all hit the roof together and cool down with rye or tequila – but you can't quit. It ain't fair after getting us in."[8]

Leonard participated in an exhibit entitled "Canadian Artists Abroad" assembled by his friend Claire Bice, curator of the Art Gallery and Museum, London, Ontario, and circulated by the National Gallery of Canada. Alan Jarvis, director of the National Gallery, wrote: "The present exhibition deals particularly with some individual artists in whose works changes have taken place, brought about or encouraged by periods of residence in other countries. Often during these excursions, different surroundings, the impact of another culture, and further acquaintance with French, British or Mexican art will induce major changes in the artist's personal outlook or technique."[9]

Poet Miriam Waddington, a good friend of both Reva and Esther Birney, was someone who did not think that living in Mexico had improved Leonard's work. Not noted for diplomacy, she wrote the Brooks from Montreal where she was on the McGill University faculty: "I used to like Leonard's work so well – its autumnal moodiness – and somehow I could not find any feeling in these crepe paper flowers on the altar that spoke to me; the colours of Mexico in the hands of a non-native also repel me – I am sorry, and this doubtless will reveal

more about the eyes of the beholder than the painter. I can only sum up by saying that I don't think artists should leave their country of birth – ridiculous as this dictum sounds."[10]

Reva's work, meanwhile, appeared in two American publications. *u.s. Camera's* 1957 annual reproduced two of her photos, *Young Mother* and *Grieving Mother*, the latter another image of Elodia from the 1948 series on the dead child. "I respond most strongly to situations that give me an insight into the effect surroundings have on an individual," the annual quoted her as saying. The *Louisville Courier-Journal* magazine published a photo of a child bricklayer in an article pegged on the "Creative Photography 1956" exhibit at the Art Gallery of the University of Kentucky. *Camera* editor Thomas V. Miller Jr wrote: "The direction Reva Brooks has taken is to have identified herself in sympathy with the Mexican-Indian people. She extracts the mood from them that indicates complete candidness without making you feel that she is concerned with the quaint or sociological implications of people."[11]

Reva also signed with the Gamma picture agency in New York and made her portfolio available for sale. Besides getting her picture assignments, Gamma would give her a minimum of thirty-five dollars for any of her existing photos that were reproduced. Since the agency mainly dealt with news pictures and Reva was remote from Mexico City, the country's major news centre, the arrangement was more a source of prestige than income.

Leonard always envied those who had advanced degrees. "Rue my lack of education, ability and unsuccess at times to a hypersensitive degree," he told his diary.[12] Now he was about to enter within the ivy-covered walls of one of the oldest universities in the United States as a visiting professor.

～ *36* ～
Professor Brooks – not that by God

After successfully launching his writing career, Leonard Brooks, the high-school dropout, now had an opportunity to teach art at the college level as visiting professor at Wells College in Aurora, New York, thanks to Miss America. It was not lost on Leonard that it was an American institution that hired him, rather than the University of Toronto, McGill University or the University of British Columbia, where he had made overtures.

The invitation came from Louis Jefferson Long, president of Wells College, an all-girls school founded in 1852 by Henry Wells, who made his fortune as the Wells in Wells Fargo of American stagecoach fame. He had met the Brooks at the summer cottage of John and Naomi Adaskin on Lake Vernon, near Huntsville, Ontario, where they were all houseguests. There with them were John's fellow musician brothers, Murray and Harry. Adaskin had met Jeff Long at the 1955 Miss America pageant in Atlantic City, New Jersey, where both were judges. During a weekend of fishing, drinking and talk, mainly about music, Long learned of Leonard's teaching activities. When Long had to fill a teaching spot for the fall term, he wired Leonard an offer: $3,000 for twelve hours a week, 17 September to 19 January.

Leonard was in a quandary. He was interested in the offer, but he was still residing in Mexico on a tourist card. The Mexican government had shortened the validity of such cards from six to just three months, so given the deportation, Leonard did not want to risk another run-in with the immigration authorities by not being able to renew the document in time. He now consulted an immigration lawyer about changing his status to that of resident, which would mean he could no longer bring a Canadian vehicle into Mexico. He toyed with the idea of remaining a tourist and having Reva become a resident so that he could legally remain in Mexico as her spouse. In the end, both became residents.

Before accepting the offer from Wells, Leonard consulted Earle Birney. "Lots of time to fish, paint, or take trips to New York," he told Birney.[1] Earle replied: "It's reasonably good pay, though if it's 12 hrs a week you'll find you won't have much time for jaunts to New York, etc."[2] Leonard accepted the offer anyway.

Leonard was in high spirits as he headed north alone by road to Aurora. He wrote to Reva from the Buenas Noches Motel in George West, Texas:

Dearest Reva:

Off with a bang! – A rainstorm stopped all traffic – 100 miles or so on – 150 miles – the car came to a full stop – chug-chug – deserted country – as I drove toward Beeville. No go – blamed gasoline pump – dial marked half full – flagged down car – and deaf and dumb people – wrote notes – please send tow truck ... a car's personal innards are more fascinating to me every time I see – or pay for a new tube or vital organ. I'm enjoying it all – even breakdowns. I'm finally on my way – and any experience is refreshing – and doesn't bother me a whit. So don't you worry about me.[3]

Leonard was delighted with the facilities when he arrived in Aurora 14 September. He was given the downstairs apartment in an old, white, lakeside

clapboard house on the 365-acre campus alongside Cayuga Lake, one of the Finger Lakes in upstate New York. "How I love the life of change and ironical circumstance! I thrive on it – and need it. I have a thousand new ideas – feel alive," he told Reva.[4] One of the ironies was to don a black gown and mortar board, loaned him by Jeff Long, and take part in the convocation at the college. "I looked quite dignified in the procession somehow – though the mortar board felt funny, I must say, on my fat face. Quite a thrill though (confidentially) for me – to be part of the academic parade."[5]

After the convocation, Leonard drove to New York City for a week of work with Reinhold on the layout of *Watercolor: A Challenge*. He brought back the proofs and was very pleased with what he read. "Did I write that – I say to myself – It reads and all sounds to me – at this far remove – so direct and to the point – I don't realize I dreamed it all up! It has to be a success for not many have said it more directly."[6]

His own manuscript was not the only one that Leonard worked on while at Wells. He also reviewed the manuscript for Charles Allen Smart's *At Home in Mexico* during a visit the Smarts made to Aurora. Leonard prepared fifty-four sketches for the book. He had his reservations about some of the tales Smart recounted. "Allen has cast it – verbatim – from our journeys and conversations of trips, etc. and I'm afraid he'll have to cut down on some of the Brooksian adventures recounted or I'll be in a small blaze reflected from Allen's perceptive accounts," Leonard said in a letter to Fred Taylor.[7]

Leonard taught three Creative Art classes with twenty students in each. He confided to his diary that he was told the class he taught at night was getting rave reviews. Earle Birney gave Leonard advice on how to handle his classes to which he replied: "Thanks for the advice on freshmen, etc. Lots of pretty knees ... (they all wear shorts to class and smoke like fiends) but there's nothing like being set aside all alone with the pretty young lasses in my studio building to put me on my best decorum. I'm so proper with my little nest here ... I really feel like the visiting professor I'm supposed to be - a spell of this kind is good for me - and I'm sorting myself, ideas, and painting out ..."[8]

Like his father, Leonard had an ability to make friends, shy and introspective though he was. He mentioned this to Reva in a letter. "The remarkable facility I have for getting along with people most of the time – (Don't laugh!) is a valuable asset around here – or anywhere else. 'How to Make Enemies and Influence Friends' by L.B. seems to me one way of putting it," he said.[9]

Besides teaching his class, he addressed Rotary Club members at the Episcopalian church: "... rambling discourse on Mexico with watercolours and

they enjoyed it."[10] He also gave a talk on Abstract Canadian Painting for the Smithsonian Traveling Show at Wells College. He did not abandon his music at Wells, playing the violin with the girls orchestra. He also traded a water-colour for Sunday violin lessons from a music professor.

A weekend trip to Toronto depressed Leonard and convinced him – if he needed any convincing – that he and Reva had no future there. As he reported to her:

I don't know exactly why I'm depressed by it all – but it seems further and further removed from our way of living – the rush – the horror of the suburbs – and traffic – the business with the family. Maybe we're *nuts* but I think they are all off the beam ... the cosy bourgeois happiness of all of them – troubles me greatly.

I get nervous, tense, and want to rush off and get boiled. I guess I really know I haven't been able to run away from it all – even now – and never can – nor will – and yet I can't be part of it either – ever – a goddamned fish neither in or out of the water – be somewhere in between – dunked and revived from time to time long enough to nurture the pleasant illusion of having perhaps progressed. We could *never* live in Toronto again. It would be an impossibility.[11]

Reva planned to join Leonard in Aurora after overseeing the plans for the house that they were building on Quebrada Street. She was to travel there by train, a four-day trip from San Miguel, so Leonard gave her some tips that would have gone against her nature had she accepted them. "Go in to the bar [car] and get yourself a drink and flirt with a good-looking young man or chat with lady travellers." He gave another bit of advice Reva was never able to follow: "[You] have to learn to relax and take it easy at times – as well as going at it hard – I get carried away with myself – but manage to rest – or sleep and recover from it." Leonard always took a nap after lunch and slept well at night. Reva was a restless sleeper and would often get up during the night to write letters or notes to herself.

Reva ended up delaying her trip by two weeks because she was confined to bed with thrombosis in a blood vessel in one of her legs. As she would often do, she kept the news from Leonard so as not to upset him. She also received a pledge from friends in San Miguel not to mention the thrombosis to him once he was back.

Shortly after Reva's arrival, the Brooks had a joint show at Wells College of seventy-five paintings and thirty-nine photographs. Leonard sold six hundred dollars-worth and Reva an unmentioned amount. "I don't go pursuing photos," Reva told a reporter from *The Post-Standard* of Syracuse.

Scene on Quebrada Street, painted from the doorway of the Brooks' home, on canvas glued to masonite, casein plus varnish, 1960s.
COLLECTION MARTHA HYDER

"When I see something that moves me, I just stand around until I can get it."[12]

Leonard, who failed to obtain faculty positions in Canada, was now offered a permanent appointment at Wells College by president Long. Despite the positive experience, one semester was enough to convince Leonard that a full-time teaching career at the college level was not for him. "I wouldn't be a full professor here for *nada*," he told Charles Allen Smart, who was on the faculty of Ohio University. "The academic run – but not Professor Brooks – not *that* by God."[13] Leonard now knew his destiny lay with his painting, subsidized by his writing, when necessary.

We have a real hit on our hands

The success of *Watercolor: A Challenge* and the other art books he would write was a mixed blessing for Leonard Brooks. He was now achieving recognition as a writer and teacher, rather than as a painter. Especially in the United States, more people would know him through his books than through his paintings. Leonard enjoyed writing, but as he continued to produce books, Reva felt that this was hurting his painting career.

Reinhold Publishing was delighted at the reception given *Watercolor* when it came out in April 1957. William W. Atkin, Reinhold's Editor of Art Books, wrote Leonard, "The more people see this book, the more convinced I become that we have a real hit on our hands ... I talked last week with Ernest Watson, the man who used to be the Editor of *American Artist*, and he told me he thought it was the best book on the subject he had ever seen and it was a thrilling book."[1]

Watercolor sold 2,400 copies the first three months, an outstanding figure for such a publication, but even more impressive considering that the $12.50 cover price was higher than usual for a Reinhold art book. At ten percent of the retail price, Leonard's royalties on the initial sales came to $3,000. The book would go into multiple editions over the years.

"I have had excellent reviews all over the u.s. and Canada a bit," Leonard reported to Earle Birney.[2] *American Artist*, then the leading art magazine in the United States, praised Brooks, the artist, as much as it did Brooks, the writer: "The 200 reproductions, sketches and sixteen full-colour pages make an impressive record of the work of the artist, giving the book the dual purpose of art book and guide." The review of the *Hamilton* (Ontario) *Spectator* had similar dual praise: "Leonard Brooks, one of Canada's foremost watercolourists, had a book published recently, which clearly proves that the artistry of his pen equals the artistry of his brush."[3] Leonard's writing was also praised by Alan Jarvis, director of the National Gallery (1955–59), in the summer issue of *Canadian Art*: "At a time when the painting-for-pleasure movement is threatening to engulf the professional art world and when do-it-yourself books are almost as numerous as the painters themselves, Leonard Brooks' book comes as a breath of fresh air. First of all, Brooks' book is articulate, intelligible and literate."[4]

Leonard detested the phrase "how-to" when applied to his books, but it inevitably came up in some reviews, although always in a flattering way. The

prestigious *Christian Science Monitor*, for instance, said: "It is far above the ordinary how-to-do-it manual. Leonard Brooks, a leading Canadian artist, also shows up as a magnificent teacher."[5]

There was one sour note that detracted from the symphony of praise. Leonard had carried through with his threat to resign from the Ontario Society of Artists after being dunned for back dues. The biographical note on the dust jacket of *Watercolor* contained mention of Leonard's O.S.A. membership. As soon as Leonard saw the note, he wrote a letter to R. Austin, O.S.A. secretary: "The paper jacket was printed from some old biographical notes of mine which they had, and I see that they listed the O.S.A. as one of the Societies in which I have membership. Since this paper jacket was not given to me for checking, I could not correct this error, but I have written to the publishers to have it omitted in later editions."[6]

An unusual assignment now came Reva's way, possibly via the Gamma agency in New York. *The Daily Mirror* in London wanted photographs of the new-born child of Princess Ira, the wife of Prince Alfonso de Hohenlohe, the first Volkswagen concessionaire in Mexico. Ira von Fuerstenberg's marriage at age fifteen to the prince had been one of the big society weddings of 1955 in Europe. Reva was assigned to take photographs of Christofo Victorio Humberto Egon Hohenlohe-Langenburg, aged nine months. Leonard accompanied her to Mexico City for the photo shoot at the couple's high-walled, pink-stucco mansion outside the city. She mailed fourteen eight-by-ten-inch photos. *The Daily Mirror* used two of them for which Reva was paid seventy-five dollars.

Reva felt let down by the *Atlantic Monthly*, which had been considering using four of her photographs. She lost out to another Canadian photographer, Ottawa's Yousuf Karsh. Charles Morton, the associate editor, wrote a "Dear Reva" letter in which he said, "I am sorry to be bringing you, after all these months, a negative word on our plan to use four of your wonderful photographs in the *Atlantic*. But the theme of the sequence which I had picked out caused some difficulties of opinion here, and the whole matter was settled by a decision to produce four portraits by Karsh with a text by him for each of them."[7] Reva replied, saying she too was sorry. "I am still hoping that some day I will have a large group of my photos published as a book, which I would entitle, 'Some Faces of Mexico.' From most people's reaction to them I am convinced that it would be a successful venture."[8]

Another book by a local author was soon on sale, but it did not receive the rave reviews in San Miguel that *Watercolor* did. Charles Allen Smart's *At Home in Mexico* was criticized for some of the things he wrote about San

Miguel residents. Leonard was pleased with newspaper reviews making reference to his sketches in the book. "I've had some nice mentions in N.Y. Times and Tribune, etc. on the illustrations," he said.[9]

Smart had written in the book about Lucy Loosebones, the Brooks' dachshund, a dog that received the love that only a childless couple can give to a pet. Leonard had included in the book a sketch of Lucy, a bone lying in front of her. Shortly after the Brooks had moved into their new home at No. 109 Quebrada Street on 6 September 1957, a very gracious and beautiful woman appeared at the door. "Does Lucy Loosebones live here?" asked Hollywood and Broadway actress Helen Hayes, who had driven to San Miguel from her home in Cuernavaca.[10] She met Lucy and left with four of Reva's photos, *Sara, Dos Músicos, Atrio,* and *Boy Listening,* plus Leonard's watercolour book. The Brooks showed her around San Miguel. "A most sensitive and lovely woman who responded keenly to our work," Reva told Lela and York Wilson.

A few days later a big gruff man stormed into the house. He was not interested in seeing Lucy Loosebones. Movie director John Huston demanded to see Reva's photos. When Reva displayed the photos, he quickly selected eleven, but she put aside two prints that she had committed to someone else. "You can't have these," Reva told the director, who won Academy Awards as best director and for best screenplay for the 1948 classic, "The Treasure of the Sierra Madre," which was set in the very mountain range in which San Miguel was located. "My girl," he replied, "I'm taking these."[11] He bought them, along with two of Leonard's paintings.

As he started his second art book, *Oil Painting: Traditional and New,* Leonard admitted to his diary that his thoughts were now almost exclusively on writing. "It is no wonder I have done little or no painting of consequence," he wrote.[12] Despite his misgivings about his recent work, he still planned to take twenty-one paintings to Toronto for a May 1958 one-man show at the Roberts Gallery. "It will be interesting to see what happens to this set – they should sell – if not in popular ideas of the moment."[13] What happened was that Jack Wildridge, the Roberts' owner, would not accept the paintings.

There is no record of either subject matter or of style of the paintings, except that Leonard and Wildridge argued heatedly. Leonard was so upset that when he reached Bay Street, several blocks from the gallery, he broke down in tears, either from rage or frustration. As he recalled in his diary, "the sobbing on Bay Street – the incredible blow of being subject to such horror."[14] Asked years later about the incident, Leonard said he could not recall what happened, which probably meant it was too painful to dredge up again. Leonard, who always dreaded going to Toronto, had looked forward to this trip, coming after the

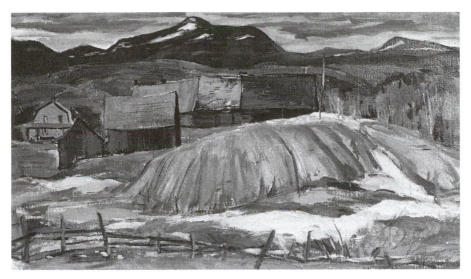

Leonard would do landscapes on his trips back to Canada, such as this oil painted in Quebec, 1958.

COLLECTION ALLISON BRIGDEN

successful publication of his watercolour book. "So this time I go to Toronto – not unsung – and not broke – a fine feeling of independence," he had told his diary.[15]

Possibly Wildridge was upset because Leonard had no Canadian paintings to offer, just Mexican subject matter. "Anything that Leonard did that wasn't Canadian, nobody was that interested in," said Brooks' friend Jean Townsend-Field, who with her husband opened the Upstairs Gallery in Toronto in 1958.[16] The first statement of account shows that all five of Leonard's paintings that Roberts sold in 1952 – the first year he was associated with the gallery – were of Canadian themes, as were all but two of fifteen sold the following year, the others being Mexican. Not only did Wildridge not accept the twenty-one paintings Leonard now brought up, but he returned the twenty-five he already had at the gallery; eleven of those were Mexican. Wildridge wrote a formal "Dear Mr. Brooks" letter on 7 May, advising Leonard that all the paintings – he listed them – had been removed and that the Roberts Gallery now held none of his works.

Leonard would have nothing further to do with Wildridge, so Reva intervened and "rescued" her husband, as he put it in his diary.[17] She convinced Wildridge to take seven paintings, none from the lot Leonard had brought up.

Leonard and Reva had told friends of the planned May one-man show at Roberts, so now they had to do some explaining. "Complications with

Roberts – which I shall tell you about anon – and I'm not going to show as intended," Leonard told Fred Taylor.[18] But Reva followed up with a letter downplaying the incident. "The Roberts Gallery affair was nothing at all – Leonard did not feel like a full-fledged show and wanted to just leave a group, to which they agreed," she told Taylor.[19] To Esther Birney, she said, "He never did want a 'real' exhibition at this time."[20]

This would not be the last falling out between Leonard and Jack Wildridge.

Leonard now had a problem of what to do with some forty paintings the Roberts Gallery did not want. He could not ship them to the Watson gallery in Montreal because he had just learned from Claire Watson that it had closed down. Exacerbating the situation was the fact Esther and Earle Birney were leaving Vancouver for Toronto and they had another forty of Leonard's paintings on hand for sale. Leonard told Birney to destroy the works rather than ship them to Toronto, which Earle refused to do. "As for destroying any of them, nuts," Birney replied. "I hasten to add, of course, that I believe the artist has the fundamental right to destroy his own work, but in this case I would demand that you personally view each picture you have had destructive designs on and do the job yourself, which would give you a chance for sober second thoughts."[21]

A solution was found. The Brooks' friend, Naomi Adaskin, would display the paintings in the Adaskins' Lyndhurst Road home in Toronto and receive a commission of twenty percent on sales. Naomi immediately contacted an acquaintance, Jack Spitzer, a partner in the Toronto advertising agency of Spitzer, Mills & Bates Limited. He bought six of the works and became one of Leonard's major collectors and a person who tried to promote him in Canada. When Naomi's husband, John, became seriously ill, Leonard told her to give one of his paintings to the attending physician, Dr. McTavish, in lieu of payment.

Very conscious of the power of the media, Naomi also contacted Lotta Dempsey of *The Toronto Star* and sold her on doing a story about someone who accidentally turns her home into an art gallery to help a friend. That, of course, led to a critique of Leonard's works. Dempsey wrote:

To this private eye view the other day, Leonard Brooks' work of late has reached a new richness of strength and vividness, without in any way losing the old delicacy of conception and response to beauty of a given moment. His versatility is astounding, with the sensitive artist's chameleon-adaption to each new mood and locale, without any dilution of a strong inner core of individuality.

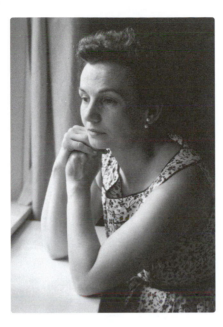

Pianist Naomi Adaskin sold Leonard's paintings from her Toronto home after the Roberts Gallery pared down its holdings of his works.

Whether this is the effect of Mexico these past several years, overlaid on the Canadian experience of the painter, or simply the maturing of a great talent, is an intriguing conjecture.[22]

Hollywood returned to San Miguel in December of 1958 for several weeks of filming of "The Wonderful Country" starring Robert Mitchum and Julie London. Once again the streets of San Miguel were filled with crew members and the Cucaracha bar became a fixture for Mitchum, Jack Oakie, and others.

Director Robert Parrish hired as extras many members of the foreign community, including Leonard Brooks and Eldon Grier, who were given the roles of turn-of-the-century American senators. Leonard was given a brief speaking part, toasting Mexican actor Pedro Armendáriz, who played a Mexican governor.

Their makeup was so effective that Grier said his young son, Brock, did not recognize him. Leonard and Eldon were in costume one day when a half-hour break in shooting was called. They strolled up the street and were near the entrance to the town when they saw a familiar car approaching. It was that of Fred Taylor, whose arrival for the winter with wife Nova had been expected any day. The two men stepped into the street and flagged down the car. Disguising his voice and shielding his face, Leonard told Fred that a civic committee in old dress was waiting in the centre of town to give them an official welcome to San Miguel. There is no record of the disappointment that Fred, a very

Leonard and poet Eldon Grier had roles as turn-of-the-century u.s. senators in the 1959 Robert Mitchum western "The Wonderful Country," partially filmed in San Miguel.

proud but gullible man, must have felt when he realized the welcoming committee was a film crew and that the men who stopped him were Leonard and Eldon. The leg-pull was but a harbinger of things to come.

After another day's shooting, Leonard and Eldon took some of their new movie friends to La Turca's, the local brothel at No. 19 Organos Street. La Turca (The Turk) was an exotic woman with bright red hair who kept a pet goat tethered to the bar. A religious woman, she hung on the walls of the rooms used by her girls pictures of the Virgin of Guadalupe, Mexico's patron saint, with lighted votive candles. The mayor advised one British veteran of the Korean War that he had better leave town after La Turca reported that he had committed the unpardonable sin of blowing out a candle.[23]

Leonard and Eldon were to have met their wives downtown, but when they did not show up Reva and Sylvia went to the Griers' home for coffee. Maybe Reva guessed where Leonard and Eldon had gone, because she opened up with Sylvia in a way she never did with her sisters and seldom with her close friends. She told of her longing to have had children and how she thought of this every day. "Reva said that Leonard's flings and affairs were terribly troubling to her," recalled Sylvia. "'But he always comes back to me, so I can live with that,' she said." Sylvia added: "It hung on Reva's shoulders all her life. I'm sure they were meaningless to Leonard. He had this energy, very manly, and he'd take off and feel it was okay."[24]

The one person with a fly-on-the-wall view of the Brooks was their niece, Nancy Sherman, who as a teenager lived with them twice for long periods in San Miguel. "I think Reva understood Leonard's psyche," she said. "They became such a part of each other's life that even when he started to consider other options, I think she had already forged that bond so strong that he could not conceive of a change."[25]

~ *38* ~
*H*enry Miller went mad about my watercolours

En route to Vancouver in 1959, the Brooks again travelled through California, where Leonard met someone who was almost a mirror image. He was Leonard's height, five-foot-eight, came from a poor immigrant family, was self-educated, shy with women but exuded great sex appeal. Although he was twenty years older, he had been penniless in Paris during the 1930s as was Leonard in London. He was also a writer and a painter, but in that order. He was bald, whereas Leonard always had a mane of flowing hair. As Earle Birney considered Leonard to be a man's man, Henry Miller, possibly the most controversial American writer of the twentieth century, must have had the same opinion, because the two men immediately bonded. Few writers have had their books banned in their home countries. American readers had to violate the law and smuggle in European editions of *Tropic of Cancer* and *Tropic of Capricorn*, the autobiographical novels written in Paris in the 1930s that chronicled Miller's sex life.

The Brooks had driven to California in their Volkswagen van with playwright Martin Flavin and wife, Connie, as passengers. They drove through Death Valley, where they camped out, and then on to the luxury resort of Pebble Beach, south of San Francisco, where the Flavins lived. Leonard and Reva were houseguests of the Flavins, but managed to go to nearby Carmel to visit Brett Weston – his father had died the previous year – and to meet the writer-painter Emil White, a close friend of Henry Miller.

But it was not White who put the Brooks in contact with Miller. The Flavins made arrangements for them to visit a Protestant minister who played the violin so that Leonard could get in some playing time. The minister, in turn, introduced them to Nancy and Sam Hopkins, also violinists, who lived on

Partington Ridge in Big Sur, just above Henry Miller's cabin. After several days of playing, the Hopkins gave Leonard a letter of introduction to Miller.

The Brooks were reluctant to bother Miller, who usually had a guard posted near his cabin to fend off the curious and only allow access to those with appointments. A gardener told the Brooks that Miller was not there but would return any minute. Leonard was anxious to get back on the road and was leaving when Miller arrived, pulling a child's wagon loaded with groceries. "Who are you?"[1] asked Miller. When told Leonard was a painter and Reva a photographer from Mexico, he invited them in and broke out a bottle of gin. "You're a watercolour painter," Miller said. "That's my love." Leonard went to the van and got a copy of his watercolour book for Miller, who in turn gave the Brooks copies of his books, dedicated to them, plus one of his watercolours. A painting of a woman, it would forever after hang in the entrance of the Brooks' residence. Reva took a photograph of Miller that was shown in many of her exhibits.

Over drinks of gin, the two men discussed philosophy, about which they were in complete agreement. Looking back years later on their meeting, Leonard recalled the conversation. "We agreed that great men have a psyche and realize that the only thing that really matters is themselves. If you don't have that conviction in yourself, you can't succeed. You have to believe that you're in charge of your own destiny. You try to reach this through your work. You have to find a pathway to yourself." That Leonard followed that credo in his art and relations with others is beyond dispute. He would readily admit that his actions and those of other artists might be perceived as selfish – there was no shortage of critics on this point – but he believed that mankind was bettered in the long run because the artist gave his creative best.[2]

Miller, who would marry five times, was then without a love interest in his life, so he asked the Brooks to stay with him for a few days. "I'm on my own here," Miller said. "He just begged us to stay," recalled Reva. But the Brooks turned down his invitation. Then Miller suggested he might go down to San Miguel to visit them. Leonard forgot his sketchbook at Miller's cabin, but Henry found it and mailed it to San Miguel with a note asking, "When am I going to see you again?"[3]

From Santa Barbara, Leonard dropped a note to Earle Birney. "We got here last night and now live the life of luxury on millionaires' row again after a hectic and busy session from camping in Death Valley, Grand Canyon ... excellent San Francisco week with friends ... and a stay at Big Sur with painters and writers where we camped in a forest (only travellers in the immense camp) slept high on the Sur again in luxury and ate beans en route by the tremendous crags and surf. A good spell with Henry Miller too, who went mad about my

Leonard and novelist Henry Miller found many common interests when the Brooks met him in 1959 at his home in Big Sur, California. This photo by Reva appeared in many of her exhibitions.

watercolours – he loves to paint – we had quite a time and he took one of my things and loaded me down with copies of his books ... and apologetically presented me with one of his paintings. Discover my books everywhere and lots of people seem to know my work in the States even if they don't give a damn about me in Canada."[4]

Leonard participated in a joint show at the Vancouver Art Gallery. The art critic Palette wrote in *The Province*: "Among the best of Leonard Brooks' paintings are *Deserted Mining Village, Burned Church at Tabasco* with a Utrillo-like touching his handling of the remaining white tower of the edifice, a colourful fantastic *Tropico* and numerous scenes of fiestas, full of moving characterful crowds."[5]

The Brooks then drove cross-country to Toronto, where Leonard saw Jack Wildridge at the Roberts Gallery. Relations were still strained, because, once back in San Miguel, Leonard wrote in his diary, "Roberts – thinking about my reception angers me this morning – the little stinker! Canada certainly doesn't encourage me – to go – and I'm out of the clutches of such – thank God."[6] While he indicated that relations were severed, Wildridge still carried some of his paintings.

Given her experience as his West Coast saleslady, Esther Birney must have come to realize the difficulties faced by expatriate Canadian painters like Leonard. She expressed her thoughts in a letter to Reva: "When I first knew you in Toronto [Leonard] was one of Canada's top artists who sold fairly steadily and was 'in.' Do you know what I mean by 'in'? I mean accepted and acknowledged as among the top professional painters. Had he remained in Canada I am convinced he would have maintained his position but because he went to Mexico the gap caused by his going closed over – someone else took his place and only if he had become a successful Mexican painter, a Diego Rivera or Orozco, could he have kept his name before the Canadian public."[7]

If Leonard was not satisfied with his painting, he was delighted with the look of his oil painting book. When he had received the galleys for the book, he told his diary, "and a good thing too – for the 'Art World' – and Canada has left me high and dry – and never a word – or important purchase."[8] When he saw a copy, he celebrated with a bottle of Seagram's V.O.[9] The reviews once again were good. Former National Gallery director Alan Jarvis reviewed the book for the *Montreal Star*. "[Brooks] ranges, with deliberate eclecticism in his demonstrations, across the whole gamut of styles from photographic realism to complete abstraction or non-objective painting."[10]

Ken Saltmarche, future director of the Art Gallery of Windsor, wrote in *The Windsor Star*:

This is a 'how to' book with a significant difference. Like his 'Watercolor: A Challenge' of two years ago, it deals at length with methods and materials and provides all manner of useful hints and guidance for the beginning painter. But it also includes, as most books of its kind do not, much of the Why and the *Purpose* of painting; it directs the beginner's attention to the ends rather than the means; and, more than any other book of its type that I have seen, it stimulates creative thought by the very enthusiasm with which its author, however unknowingly, has presented his ideas.[11]

But writing still kept Leonard away from painting. Now he planned two more art books, both small. One was on casein and the other on wash drawing. Both were published in 1961. "I could have sat down and written twenty-five books on how-to because my mind would click like that," he once explained. "It became easy, like the violinist who has been trained to play all the scales without thinking."

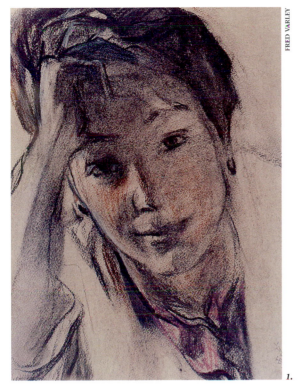

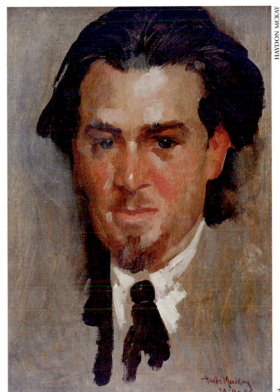

1.

2.

1. When the Group of Seven's Fred Varley stayed with Reva during the Second World War, he did a charcoal sketch of her on brown paper.

2. British portrait painter Haydon McKay did an oil of Leonard in London in 1933 and presented it as a gift to his impoverished Canadian colleague.

3. Leonard had money for only two inks, brown and blue, when he did this sketch, Book Stalls in the Rain, *in Paris in 1934.*

3.

4. *Leonard's best known work as a war artist was this 1944 watercolour,* Potato Peelers, *which typified his search for the unglamorous side of war.*

5. *One of twelve water-colours from a limited edition of 2,000 copies of* Posadas, *the Mexican fiestas celebrated for nine days before Christmas. A former president of Paraguay, Natalicio González, so liked the paintings that in 1953 he put together the edition, which immediately sold out.*

4.

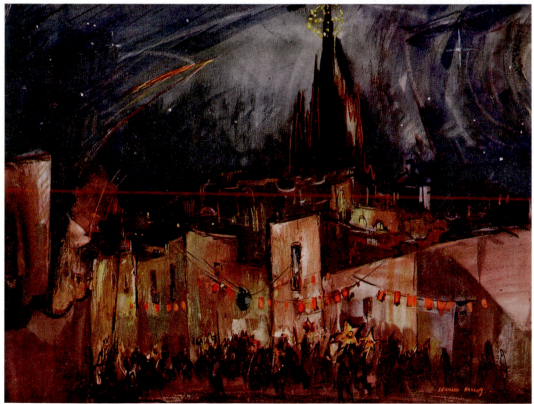

5.

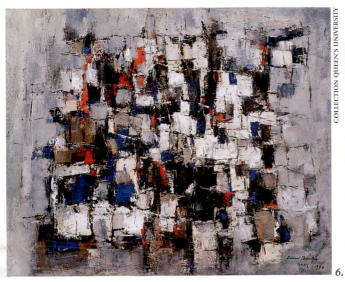

6.

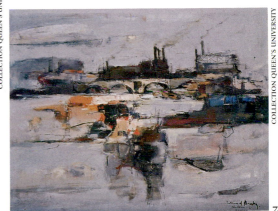

7.

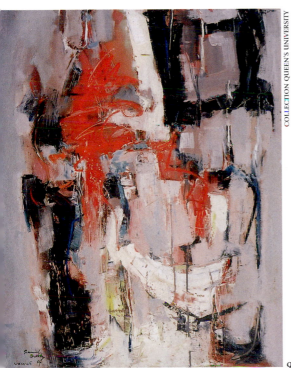

9.

8.

6. Urban Scene, *oil on canvas, 33 by 27 inches, 1960.*

7. Thames River, *oil on canvas, 31³/4 by 35 inches, 1961.*

8. Costa Brava, *oil on canvas, 29 by 35 inches, 1961.*

9. Venetian Mood, *oil on canvas, 31 by 40 inches, 1962.*

11.

10.

10. Spring Moon, *collage acrylic, 66 by 46 inches, 1975.*

11. Autumn Moon, *collage acrylic, 50 by 39³/₄ inches, 1980.*

12. Tuscany, *an 8 by 10 feet tapestry, one of nineteen Leonard had transposed from his paintings, 1976.*

12.

13.

14.

13. Elora, *watercolour, 1979.*

14. Evening in San Miguel, *watercolour, 28 by 22 inches, 1980.*

15. Cat and Garden, *oil, 48 by 47 inches, 1980.*

15.

16.

1

18.

19.

16. Greek Harbour, *collage acrylic, 41 by 36 inches, 1980.*

17. Morning Glories, *collage acrylic, 39 inches by 27 inches, 1984.*

18. First Rain, *a 30 by 45 inches collage acrylic of the fish pond on the Brooks' property where Leonard found the subject matter for many of his paintings, 1984.*

19. Amaryllis and Cat, *collage acrylic, 36 by 30 inches, reproduced in Milan by the New York Graphics Society, making Leonard its only Canadian artist in a list that included Leonardo da Vinci, 1984.*

20.

21.

FESTIVAL DE SAN MIGUEL DE ALLENDE

GILBERTO MUNGUIA, DIRECTOR

DICIEMBRE
1 9 9 4

22.

23.

20. Iris and Pond, *collage acrylic triptych, 60 by 32 inches, reproduced by the New York Graphic Society, 1985.*

21. Time Pendulum, *collage acrylic, 60 by 40 inches, 1985.*

22. Artist and Flowers, *collage acrylic, 1987.*

23. *American-born cellist Gilberto Munguía, a musician of international reputation, used a painting from his collection done by Leonard as a poster for the music festival he hosted in San Miguel.*

24.

25.

24. Requiem for Ken Harvey, *collage acrylic, 35 by 28 ¹/₂ inches, 1990.*

25. In Memoriam for Gunther Gerzso, *after awakening from a dream about his recently deceased painting colleague, Leonard went to the studio and felt guided by Gerzso as he did this 32 by 27 inches acrylic on masonite, 2000.*

26. Decline and Fall of the Roman Empire, *oil on canvas, completed shortly before Leonard's 1998 opening at the Edward Day Gallery in Toronto.*

26.

Emotional Strains

∼ 39 ∼

He so violently gives vent to all his feelings

Dinner at No. 109 Quebrada Street ran longer than usual the evening of 13 May 1960 as the Brooks entertained York and Lela Wilson. After the meal, the two men lingered at the table drinking rum and talking art. Since Lela was a social drinker and Reva seldom touched alcohol, both wives were anxious for the evening to end. Reva's signal that guests should withdraw was to remove ashtrays and any other objects in use. Lela kept referring to the hour. Since her husband was ignoring her entreaties, Lela finally decided to join in the conversation, so she made a comment about painting. "You have no right to talk about art," Leonard, fuelled by rum, screamed at her. Shocked, Lela broke into tears. Reva consoled her and soon both couples were embracing and crying. "I just had to let loose," Leonard told his diary.[1]

Over a thirty-year period, this was the first of four emotional blow-ups by Leonard directed at Lela, the wife of one of his best friends. The second time occurred when Lela mentioned Leonard was writing more than painting, the third time when she suggested he exhibit with the Royal Canadian Academy to bring his name to the fore, and the final recorded instance – in a crowded restaurant in 1991 – when she asked him not to smoke. On these occasions, Leonard shouted obscenities and stomped off.

After Lela once complained about Leonard's behaviour, Reva explained, "He is an angel when he feels free to pursue his struggles with painting, play his violin, write, etc., and live a quiet, domestic life – even then, under the best of conditions, he builds up pressure and his eruptions, as you have seen, these seem almost physically and psychologically necessary to his nature from time to time."[2] Reva was never surprised by Leonard's "nasty self" outbursts since she was usually their target. An innocent word might trigger an explosion, but the underlying cause always lay elsewhere, maybe even unknown to Leonard himself. Reva tried to explain this behaviour to herself: "This particular pattern of periodic bursting forth by taking some remark as a personal insult and injury must have very deep roots and needs. When it's over it's usually not mentioned again, and if I criticize him for it, he tells me

Previous page: Collage acrylic on masonite, 1960s.

the trouble is that I take those things too seriously, that I believe everything he says, which I should not do when he's in certain moods."[3]

This had not been a good year for Leonard. Book sales were fine, but painting sales were down, due in part to the fact he was not producing as many new works because of the demands of writing. His relationship with Toronto dealer Jack Wildridge was tenuous at best, so he found what he called irony in the fact that York Wilson had recently sold $15,000 in paintings at a Roberts show. "Roberts won't even take any of my last work to show," he complained to his studio journal. "[York] is outgoing – extrovert in company – still full of fun ... while I grow more misanthropic."[4] Leonard conceded that he had cut himself off from the artistic "boom" in Canada while Wilson had profited financially from it.

Leonard was especially upset at the National Gallery of Canada, which had never purchased any of his paintings, even though Alan Jarvis, while its director, had praised his watercolour book. The only works it held were some silk screens Leonard donated to the war effort in 1943 and for which he received royalties on copies sold. "Why should I take it as a personal insult when someone like Toni Onley tells me the National Gallery just bought one of his things?" he asked. That must have galled Leonard because Onley had gone to San Miguel in 1958 on one of the Instituto Allende scholarships Leonard had organized with director Stirling Dickinson. Leonard visualized a letter from the National Gallery: "Dear Mr Brooks: The National Gallery would like to buy your large canvas of 'Flowers' at the Adaskins," or, "Could we prevail upon you to accept our 'artist in residence' year on the West Coast," or, "Just a nice big plain old surprise – like a prize for not ever winning a prize – or award anywhere."[5]

Used to criticizing his fellow Canadians for having an inferiority complex, Leonard now questioned his own feelings. "I think I may have developed an inferiority complex about my work lately – because of the lack of contact – and so-called 'success' – but this must be a common complaint of most painters when their ego gets slapped about a bit with the years," he wrote.[6]

Now he was about to have five emotional eruptions in little over a month, probably the most he ever had in such a short period of time. Just three days before the dinner with the Wilsons, the Brooks had been invited to a party at the home of Lillian Birkenstein, a San Miguel resident. A female guest asked Leonard if he would donate one of his art books to the local library, which was run by the foreign community. Had she asked for a painting instead, Leonard's reaction might have been different, because he wanted to be recognized as a painter, not as a writer of art books. He "blew up" at the woman and stormed out. "Too much rum," was his explanation.[7]

On 2 June, the Brooks were invited to a dinner at the home of Fred Taylor where Leonard had an "almost frightening" eruption. No mention is made of what triggered his reaction, but it was probably Taylor, who had an uncanny knack for unknowingly upsetting Leonard. "Drinks caused it," Leonard said.[8]

Later that month, the Brooks drove to Mexico City where Leonard had a painting, *Composición*, in a show at the Palace of Fine Arts. He said he went "berserk" at the reception, but gave no details. That the incident was dramatic is indicated by the fact Leonard underlined "berserk" in his diary entry.[9] Two nights later he had another "scene" at a post-show dinner.[10]

Years later Reva, in the occasional diary she kept, would describe one of Leonard's prolonged outbursts:

Today, for nearly 3 hours in the middle of the day, Leonard talked, had a veritable explosion, an irresistible letting go which has shaken me profoundly. Nothing against me – on the contrary, he expressed his appreciation, love and tenderness for me. But all his frustrations and hurts came bursting forth. This, after a morning of beautiful work he had done. It was almost like an attack, an eruption, of alternate despair and exhalation. He says he sometimes looks at the window and wants to jump out, first throwing his paintings and end it all. He so violently gives vent to all his feelings – his deep hurt all his life of not being recognized, appreciated in Canada, lack of a really understanding, sensitive dealer on the highest plane there.[11]

Nor did Reva just confine her feelings about Leonard's behaviour to her diary or personal correspondence. She went public during a filmed interview with Amaranth Productions of Toronto: "His recurrent unhappiness, depression and despair come from the struggle to try and find his real self in his art. I know that this has been the thorniest part and aspect of our lives together. The most difficult and painful part has been, and still is, going through those periods of his frustrations, his moodiness, his anger, his irritability, and his inevitable explosions of emotions."[12]

Sometimes the blowups appeared humorous in retrospect, such as the time Leonard removed his dentures and threw them against the bathroom wall to make a point. "Broke 3 or 4 of them – and had to take them to the dentist's for re-doing – an expensive penalty for getting out of control."[13]

Niece Nancy Sherman was one of the few family members to witness an outburst. "I've heard shouting and yelling and seen things being thrown, but this did not mean much to Leonard," she said. "It was just another way of blowing off steam, like another painting or playing his music. It was an artistic luxury."[14]

There is no indication that Leonard had such emotional outpourings before going to Mexico, nor in the first years there, although the Brooks' friend, Miriam Waddington, a social worker and noted poet, saw signs when she knew him in Canada. "I could see the depression and melancholy in Leonard, a person who held a lot underneath," she recalled. "Maybe it was just hostility and anger."[15] When Reva was not the target, the emotional storms always occurred at social functions after Leonard had taken a few drinks. The early parties where he performed skits with Ray Brossard or York Wilson were enjoyable for Leonard. But when Reva, outgoing and social, later dragged him to dinners and parties against his will, he would often go off in a corner by himself, as he became easily bored. Charles Allen Smart gave an explanation of Leonard's social behaviour in his book on San Miguel:

When his home life or the company at a party seems dull to him; or when someone he is thrown with seems false and pretentious; or when some Mexican, Canadian or American legal restriction seems stupid or unjust; or when some painter or critic seems petty or dishonest; Leonard is apt to go off in a boyish fit of the sulks or into a more respectable explosion of rage.[16]

There was one person in front of whom Leonard always tried to control his temper: New York travel writer Kate Simon. The first sight that she had of him was of his backside as he pranced up the stairs at No. 109 Quebrada Street. Even in his eighties, Leonard never dragged himself up the stairs as many people do. He always went up blithely. That December day in 1960 when Reva opened the door to Simon, he went up faster than usual. He did not want to be inveigled into a conversation with a stranger.

Over the years, Kate arguably became the most important female in Leonard's life, after Reva. When a widowed friend in San Miguel started dating again in his eighties, Leonard wondered aloud with whom he might have a relationship should Reva predecease him. The answer became whom he *would have had*, as No. 1 on his list was Kate Simon, who had died six years earlier. No. 2 was Esther Birney.[17] Reva, who was present during the rumination, agreed with his choices. Close friends, Kate and Reva had much in common, including Jewish-Polish parentage and the fact both left home at age fifteen.

Her marriage to New York publisher Bob Simon coming apart, Kate was doing research for a book the day she came knocking at the Brooks' door. Once Leonard was lured down from the second floor to meet her, the chemistry between the two of them was instantaneous. It soon became apparent that they had many shared interests: she was a writer who had dabbled in

New York travel writer Kate Simon, left, and Carmen Masip, director of the cultural centre in San Miguel.

painting and was knowledgeable about music. Her travel books were not guide books, just as Leonard's art books were not how-to books. Kate's books were part history, part observation, part essay, like her classic account of how to eat a mango: naked in a bathtub. She was also charming, interesting, amusing, a miniature Katherine Hepburn look-alike. One of Leonard's aspirations was to illustrate one of her books.[18]

"He was enchanted by Kate," said painter Joy Laville. "He was like a little boy when she was there."[19] "Kate Simon made Leonard scintillate," said Letitia Echlin, who, with her physician husband, Frank, bought a home in San Miguel in 1970 and wintered there.[20]

At one New Year's Eve masquerade party hosted by the Echlins in San Miguel, Leonard came in drag as Madame X. Kate described him: "L.B. grotesque balloon breasts 'red paint' on cheeks and lips and eyelashes. Gray mop head – knot at top. Mini skirt, panty hose. Leading Victorian blonde girl to sell her, as pimp. Vulgar, bumping, high female Cockney voice. Liked role, kept stroking panty-hose, liked feel legs good-looking. Not so much disguise as wish to be female. But vulgar, sexy, earthy and terrible caricature. [Reva] hated it, felt vaguely that this portrait of her – wheedler, seller."[21]

Once Kate was at the Brooks when the subject of sex came up. "Well, if sex is going to continue, then men are simply going to have to come up with better equipment," she said.[22] Leonard, the man who said he painted with his penis, was speechless for one of the few times in his life.

When visitors started to admire the Brooks paintings in her Gramercy Park apartment in lower Manhattan, Kate offered to promote Leonard's works.

Within two months, she had sold fifteen small paintings out of her apartment, joining Esther Birney and Naomi Adaskin as unofficial dealers. She eventually also agreed to accept a commission.

∼ *40* ∼

There would have been no music without Leonard

Leonard Brooks and fellow painters Roget von Gunten and Joy Laville were practising for a chamber music concert scheduled for 22 November 1960, the feast day of Santa Cecilia, the patron saint of music, when they were approached by several Mexican *mariachi* musicians who were intrigued by the Bach, Mozart, and Haydn works they heard. "Where can our sons learn to play that kind of music?" asked bass player Andrés López. The answer they received would eventually lead to international recognition of San Miguel as a music centre and to Leonard becoming the music man for a generation of young Mexican musicians. "Send the kids over to my studio on Saturday morning," Leonard told López.

The Brooks had received the seventy-seventh telephone in San Miguel, and 77 became one of the town's best known numbers, not because it was easy to remember but because of its ubiquity. Leonard posted messages throughout the town: "Anyone interested in playing chamber music, please contact Leonard Brooks. Phone 77." Over the years, some of the top musicians in the United States and Canada would make their way to the Brooks' home to play chamber music with Leonard.

When the professionals were not available, Leonard had to make do with local talent, like Laville and von Gunten. Born on the Isle of Wight, Laville was a Second World War bride who was taken to the interior of British Columbia by her husband, Kenneth Rowe, a former member of the Royal Canadian Air Force. Recognizing the marriage was a mistake, she took her then five-year-old son, Trevor, and, penniless, headed for San Miguel to be an artist. She played the cello. Swiss-born von Gunten went to Mexico as a youth in the mid-1950s and eventually made it his home. After living some time in San Miguel, where he also played chess with Leonard, he moved to the outskirts of Mexico City and became identified as a Mexican painter. He played the flute.

Father José Mercadillo, the priest who had railed against the foreigners a decade earlier, asked Leonard if he would give a concert to commemorate Santa Cecilia in a small theatre he had built behind the parish church. The group was described on the program as the "famous *Conjunto Allende*," a name thought up on the spur of the moment by Leonard.

The following Saturday morning bass player López appeared at No. 109 Quebrada Street with his son, Rodolfo. On subsequent Saturdays other boys appeared. A *mariachi* player named Anselmo Aguascalientes brought his son, Daniel, followed by brothers José Luis, Gregorio, Rafael, Mario, and Enrique. The students were poor, sons of bricklayers and other labourers. Many showed up barefoot and dirty, since running water was a luxury not enjoyed by their parents. Before sending them into the house, Reva and the maid would de-louse and scrub the boys in outdoor concrete tubs used to wash clothes. "As time went on, I found it impossible to teach Mozart without becoming involved in the social structure," Leonard recounted.[1] The Brooks bought shoes for the shoeless and medicine for the ailing. Some they took to the dentist. They bought one boy with poor eyesight three pairs of glasses over the years. When the Brooks went to Canada, they collected duffel bags full of used cloth-ing from relatives and friends for the students. The Brooks created an orches-tra fund – Reva was in charge – to accept donations. Neighbours, friends, houseguests, and visitors would contribute. Professional musicians like Toronto's Ettore Mazzoleni gave sheet music.

Daniel Aguascalientes was Leonard's star pupil. One day he asked Reva, "Does Mr. Mozart come here to visit you?"[2] As adults, the Aguascalientes brothers played with the Guanajuato Symphony before Daniel formed his own band with his brothers: two violins, a bass, a guitar, and an accordion. The band tours the United States and Mexico and appears often on Mexican television, playing everything from classical to popular to international music.

"*Señor* Brooks was always strict," recalled Daniel. "Now that I'm an adult, I see that I learned a lot from him when I was young. He was very demanding, very energetic. He recognized that my brother José Luis and I had talent and he wanted us very quickly to play music that's not easy to do on a violin. He used to invite us to listen to records. 'You and José Luis have to play like this man.'"[3]

"There were problems because he didn't speak Spanish very well," said brother Rafael, "But we understood him not through words but through music. He would play and say, 'Listen well,' and we'd try to imitate him."[4]

What Gregorio Aguascalientes learned from Leonard was, "You have to see everything with enthusiasm, that you have to see things positively."[5]

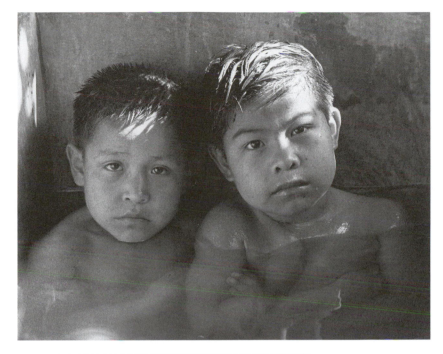

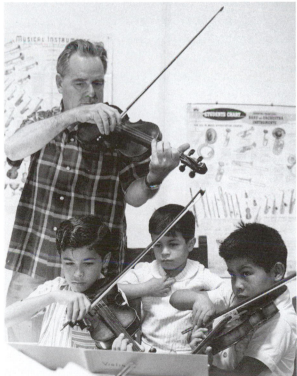

Above: When Leonard gave classes at home, the students were bathed first. This photograph by Reva, Daniel Aguascalientes at right, was shown in her exhibitions.

Left: For twenty-five years Leonard headed the music department at the Fine Arts school in San Miguel. Student at right is future bandleader Daniel Aguascalientes.

Their father, Anselmo, once asked Leonard to pay him for allowing his sons to play a concert at the Angel Peralta Theatre in San Miguel. "If that's how you feel, that's fine," Leonard told him. "Please return the instruments and don't bother to send your children here again." The boys played and not another word was ever said about payment.

Others besides the Aguascalientes brothers went on to become professionals, including Rodolfo López, concertmaster of the orchestra of the National Autonomous University of Mexico.

Canadian painter Mai Onnu, then a next-door neighbour, said Leonard and Reva became surrogate parents for the children.[6] Foreign correspondent Carl Migdail, a close friend and a frequent visitor to San Miguel, said, "Leonard felt this was an outlet for his non-fatherhood."[7]

Reva, too, enjoyed the children, sometimes fifteen or twenty children crowded into their home. They also provided her with subjects for her photography, now that she was not travelling as often to interior towns. She did some of her best work and would have one show just on musical themes, including photographs of students being scrubbed.

Finding violins for the students was always a problem. Helen Watson, whose late husband, Syd, was principal of the Ontario College of Art, recalled going up and down Church Street in Toronto with Leonard looking for violins in pawnshops. She remembered being at a party at the Brooks in San Miguel when one of the students appeared at the door. "Leonard left the party and gave him his lesson and then came back," she said. "He came back glowing. You realized how much it meant to him. He loved those little kids."[8]

One of the first professionals to dial 77 was California band leader and viola player Ken Harvey, who answered Leonard's plea in 1957; he always played Saturday nights with the Brooks pickup quartet when he was in San Miguel. Harvey was one of the GIs who studied in Mexico in 1948, but being a musician, he had gone to the Mexico City College. A short, roly-poly, bald-headed man, Harvey had teaching experience, so he was the ideal person to help Leonard when he and his family vacationed in San Miguel. More importantly, he would bring sheet music, strings, and other paraphernalia from his own orchestra. His two daughters, Hiliry and Mindy, who were the same age as some of the Mexican students, participated and added an international flavour to the classes. Once Harvey brought down music for a march entitled "True Blue" and shocked the students. Joy Laville, who occasionally sat in and played with the students, recalled what happened. "The end of this piece finished dah-dah-dah-dah. Those notes mean in Mexico, 'screw your mother, you so-and-so.' When they got to that part, the poor little kids, their faces went wooden."[9]

After one class, Harvey turned on his tape recorder as he and Leonard relaxed over a drink at No. 109 Quebrada Street. "Those kids were waiting for us," Leonard said on the tape. "When they saw us, they rushed to get their instruments. I wouldn't let those little kids down for anything."

For many years, Ken Harvey and his orchestra played six nights a week at the Sacramento Inn, then the largest hotel in the California state capital. During one visit to Sacramento, Leonard joined the band and played his violin and sang. When Ronald Reagan was governor of California, Harvey's orchestra played every Friday night for the future president and his wife, Nancy.

The first year Leonard taught in his home, Stanley Fletcher, classical pianist, composer, and music professor at the University of Illinois arrived on a sabbatical. "The first time I walked into Leonard's living room I found myself deep into his project to build a musical life in the town," he recalled. "There was Leonard with three native musicians avidly initiating them into the mysteries of playing baroque ensemble, the sort of thing I had been doing weekly for a few years with my children and their friends. It was apparent that he needed help, struggling to be first violin, conductor, and instrumental and musical coach all at the same time. I was at the piano before a few minutes had passed, and one strong strand of the winter's web of life and a strong first bond to Leonard and the town [were formed]."[10]

One day Leonard received a visit from Mexico's minister of culture, Celestino Gorostiza, and a delegation from Mexico City's National Institute of Fine Arts, the government body that oversaw the country's artistic and cultural life. The institute had taken over the former convent that had housed the Escuela Universitaria de Bellas Artes and was turning it into one of its cultural centres, known as Bellas Artes, or Fine Arts schools. The delegation wanted to recruit Leonard as the founding director of the music department. "I told them I wasn't a professional music teacher," recalled Leonard. "But you have all the students," Gorostiza replied. Leonard agreed to accept the post under three conditions: that he donate his time, that the lessons be free, and that Bellas Artes give him the musical instruments he needed. "Don't worry," he was told. "They'll be waiting for you next week at the Conservatory of Music in Mexico City." Leonard went to Mexico City and returned with six violins, four violas, a cello and music stands. A truck brought the piano, one of the finest Steinways in Mexico.

The opening of Bellas Artes came at the right time because Leonard had not anticipated the popularity of his Saturday morning classes, which had begun eighteen months earlier. "I had ten and fifteen kids knocking on the door and coming in back here, and my painting career was beginning to suffer a little,

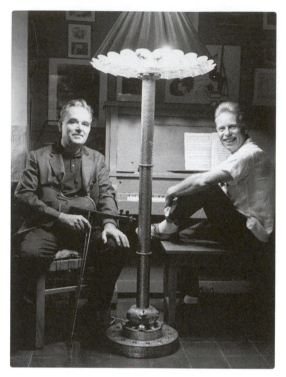

Leonard and American composer and pianist Stanley Fletcher, who helped him teach the violin to young Mexicans, 1960s.

and I just couldn't keep it up by myself," he later recalled.[11] Now, he hoped to recruit teachers to help share the load. Although he would eventually have seven teachers, he had to depend on friends, new and old, like Fletcher, to help him during the first few years.

The evening Itzvan Anhalt, composer and former head of the music department at Queen's University in Kingston, Ontario, met Leonard, he was pressed into service as a pianist with the student orchestra Leonard had formed. He remembered very well the Christmas night concert in 1963 because Leonard, conducting, did not want the evening to end, even though the audience at the Instituto Allende was getting restless. When Leonard finally lowered his baton, the hungry audience rushed to the buffet tables, leaving nothing for the poor orchestra members who had been looking forward to a meal.[12]

When Naomi Adaskin, also a pianist, went to San Miguel for a visit, Leonard met her at the bus depot and took her straight to his class, not even giving her time to change and freshen up. "It really was an achievement, taking these boys off the street, literally, and teaching them the real basis of violin," she said.[13] Travel writer Kate Simon would also sit in on piano.

One Saturday night, a blonde seventeen-year-old whom Leonard, in his diary, called "the guitar girl" showed up to play with his quartet.[14] The girl was Canadian classical guitarist Liona Boyd, who accompanied her teacher-father on his sabbatical leave. That night, she played the Haydn guitar quartet, sight-reading the music. "It was nerve-wracking," she said.[15] Leonard and his colleagues played until 1:30 a.m. "I remember with great affection the many evenings spent enjoying the music created by Leonard's chamber music ensemble," she recalled.[16] Reva obtained permission for Liona to practise in the afternoons at Bellas Artes when the building closed for the siesta period.

Another person who played in Leonard's quartet was jazz great Bobby Haggart, who wintered for ten years in San Miguel. A man accustomed to playing with the likes of Louis Armstrong, Duke Ellington, and Charlie Parker, Haggart filled in on the cello parts using the double bass, playing the parts up an octave.[17]

American composer Warren Benson chose San Miguel in 1962 as the place to finish writing his "Symphony for Drums and Wind Orchestra." He had given strict instructions he was not to be disturbed. Within minutes of completing the work, Reva arrived bearing a collage that Leonard had made to commemorate the occasion. "How thrilled I was and touched to have a work of Leonard's created especially to celebrate the conclusion of my work," said Benson.[18] Two years later he dedicated "Recuerdo," a solo work for oboe/English horn and wind ensemble, to Leonard and Reva.

After writing his symphony, Benson had to go to Detroit where his father was hospitalized. At the same time, the tourist papers for his 1957 Plymouth had to be renewed for another six months, so Leonard offered to go to the border with Benson's wife, Pat, then thirty-seven years old, and her young children. Mrs. Benson was denied re-entry on the grounds she was a member of an international car theft ring. Leonard was the knight to the rescue. Benson recalled the story as told by his wife:

Quietly asking Pat how much money she had in pesos, Leonard took a handful of her money very discreetly and engaged the customs officer in quiet conversation to the effect he was an "innocent gentleman" of some few more years than the lady. He was only trying to return to his home in Mexico where he was a respected resident with this charming young lady, and her children, to ease the pains of his older years, and with a few winks of the eye and the knowing raising of his eyebrows to the Chief of the Customs Service, he casually opened the drawer of the man's desk, dropped the pesos in it, closed the drawer and suggested that surely this distinguished Mexican officer could understand the needs of his fellow man! That did it! Pat was now viewed in a completely different light, and Leonard's "savoir faire" as a Don Juan carried the day.[19]

Leonard spent twenty-five years as head of the music department at the cultural centre. During that time, he taught music to hundreds of young Mexicans, aged seven to seventeen, most of whom he recruited himself, going door-to-door in the poorest sections of San Miguel where few foreigners ever set foot. The most promising students would be invited over on Saturday nights to play in his quartet.

"Leonard did a fantastic job getting the students from the poor classes," said Carmen Masip, director of the centre during most of Leonard's time there. "He was responsible for everything that happened because there would have been no music without Leonard. He created the whole thing."[20]

Leonard always showed more affinity for musicians than he did for fellow painters. Hiliry Harvey recalled her father saying Leonard would not allow just any painter to come into his house, but he would invite in almost all musicians. "He's much more open when it comes to being a musician than he is as an artist,"[21] said Hiliry, who played the cello many times with Leonard. Vancouver artist Will Allister, who lived for several years in San Miguel, used to attend the concerts given by Leonard's young protegés. "They were marvellous," he said. "I saw that Leonard enjoyed the musical side of his life much more than the artistic side."[22]

Leonard had just accepted the post at the cultural centre when he ruminated in his diary that music might have been his main pursuit had he a better grasp of theory. "Theory of music ... how little I know of it and what work and study could be put in on it ... perhaps if I could start all over again ... this would be my pursuit."[23]

~ *41* ~

I am not and have never been a communist

Musician Stanley Fletcher and his wife drove Leonard and Reva to Tampico on Mexico's gulf coast for the Brooks' 17 February 1961 departure for Europe on the Holland America Line's *Kloosterdyk*, a four-year-old freighter. They paid $632 and joined twelve other passengers on board. Leonard had long wanted to take Reva to the Europe of his youth and of his Second World War artist days. When they bid goodbye to the Fletchers and the *Kloosterdyk* lifted anchor, it looked like the long-awaited dream was about to come true. Instead, four days later the trip turned into a nightmare.

When the freighter docked at Port Arthur, Texas, its first port of call, an agent from the Immigration and Naturalization Service (INS) first stamped the Brooks' passports and then returned later – after checking their names against the black book of undesirables – to advise them they were not allowed to go ashore. The ghost of the 1949 boycott of the fine arts school had visited them. Since the boycott and deportation, they had entered the United States by road at least once a year with no problem. When they reached New Orleans, Leonard was allowed to disembark, but not Reva.

The INS advised her: "You are temporarily excluded from admission to the United States under Section 235 of the Immigration and Nationality Act."[1] Section 235 excludes "aliens who are members of or affiliated with the Communist Party of the United States" or knowingly distribute and circulate material urging the overthrow of the government or teaching opposition to all organized government.

Reva immediately wrote back:

On my way to Europe with my husband, Leonard Brooks, on the Holland America line ship "Kloosterdyk," on Tuesday, February 21, 1961, 4:30 a.m. we had our passports stamped by the United States Immigration Officer at Port Arthur, Texas, along with the rest of the passengers. About an hour later at 5:30 a.m. after we had returned to the ship we were awakened by a knock at the door and were advised that the Immigration Officer wanted to see us again. He told us that our name was on his list and that we could not go ashore, and he crossed out and wrote "canceled" on the stamp he had put in our passports.

That same day, in the late afternoon, a U.S. officer came from Houston and advised us that only I was on the list and asked me to sign a paper. We were shocked and sure it was some kind of mistake, and the officer took a signed statement by both of us, and told us that I could make an individual statement in the next stop at New Orleans where someone in the U.S. office there would see me and take the statement. On arriving in New Orleans, Friday, February 24th, my husband phoned the U.S. Immigration Office and he was told that "nothing could be done ... it was out of their hands."

I am not and have never been a communist. I would appreciate knowing of what I am accused and why I am on the U.S.A. list.

The Brooks sent a telegram to Stirling Dickinson who replied, "It would appear that this incident is something caused by a left-over list of bygone days which should have been put in the wastebasket years ago."[2]

Dickinson was right. The source of the blacklisting was indeed the 1949-50 communist scare involving Siqueiros. According to the Brooks' file obtained

from the Federal Bureau of Investigation under the u.s. Freedom of Information Act, someone who had lived in San Miguel denounced them in 1951 in San Antonio, Texas. The report is heavily blacked out. It said in part, referring to the informant:

[The] subjects, who are Canadian citizens and man and wife, have aroused his suspicions and he believed they were engaging in Communist activities in San Miguel de Allende ... REVA is the name of Mrs. BROOKS, the wife of LEONARD BROOKS. (Blacked out) further said that LEONARD BROOKS is a painter and that his wife REVA is a free-lance photographer. (Blacked out) believes that both the subjects are from the Province of Ontario, Canada, since they drive a 2-door Ford Sedan with Ontario license plates. (Blacked out) advised that he knew very little about LEONARD BROOKS but that his wife, REVA, takes an active part in pro-Communist activities, such as making speeches at Communist-inspired pro-peace rallies, using the theme of "Keep UN Troops Out of Korea." According to (blacked out) REVA BROOKS has attended pro-Communist meetings held at Umaran #12 in San Miguel de Allende. (Blacked out) stated that he did not know whether the subjects are, or had ever been, card-carrying members of the Communist Party of any country.

The informant's physical description of the Brooks was neither flattering nor accurate:

Name:	LEONARD BROOKS
Age:	40
Height:	5′ 7″
Weight:	160
Build:	Stocky
Hair:	Brownish red
Peculiarities:	Wears small moustache; has slight paunch
Name:	REVA BROOKS
Age:	40-42
Weight:	140
Hair:	Gray
Eyes:	Blue
Peculiarities:	Has large nose; has a "waddling" walk

As for the alleged meetings at No. 12 Umarán Street, neither the Brooks, Dickinson nor other old-timers in San Miguel could recall who lived at that address in 1949–50. Ironically, Alfredo Campanella died while the Brooks were on their trip.

Immediately after the *Kloosterdyk* docked in Antwerp 13 March, the Brooks went to Paris, where Reva saw vice-consul James T. Doyle at the American embassy. He wrote her 19 July: "I regret that, as of this date, we have not received a reply to our letter to Washington regarding your case. I am writing again today to ask the Department if our inquiry can be concluded as soon as possible."[3]

York and Lela Wilson were waiting for the Brooks in Paris. Wilson drove them to a Renault dealership where they bought, for $1,000, a new car that they would sell back 5,000 miles later for $611. Leonard was anxious to take Reva to Spain, where they met Felipe Cossio del Pomar, the founder of the original fine arts school in San Miguel. Together they drove to the ranch of his brother-in-law, Juan Belmonte, the legendary bullfighter, whom Reva photographed. Then they toured the Costa del Sol for a month, leaving Barcelona for the last.

Leonard knew the return to Barcelona would be emotional. It was. He parked the car in front of 114 Paseo de Gràcia and told Reva he had to be alone while he returned to the home of the Hopf family where he had held his second exhibition in 1934. "I left Reva down in my car and walked up and knocked on the door," he recalled. "I came down crying as I could see myself there." Neighbours knew nothing of the Hopfs; a check with the British consulate indicated the family had not survived the civil war.

The Wilsons helped them find an apartment in Paris at 79 rue de Patay that belonged to a Belgian painter, Luc Peire. This was the city where Leonard was to first paint the collages with which he would become identified in his latter years as he had been with watercolours in his early years. "My first collage experiments were made in 1961 in Paris," he wrote years later. "From this time I have developed an acrylic collage medium that has become my favourite form of expression and is as natural to me as a painting device as oil painting or watercolour that I still love to do."[4]

Maybe Lela Wilson was paying back Leonard for his outbursts against her when she wrote about the same period in her biography of York:

During the Brooks' temporary residence in Paris, we noticed how Leonard studied York's paintings. Sometimes while we were visiting with them, he unconsciously turned his back to us to look at York's works. York knew that Leonard had been suffering from depression, as abstraction was becoming more and more dominant in the art world, and Leonard had no feeling for abstraction. During the Paris trip he began gathering all sorts of materials to make collages. This progressed nicely and he did many good things. Later when we were back in Canada, we were sometimes amused when we mistook Leonard's work for York's. York was pleased that Leonard had got over his depression, and was painting his own fine abstractions.[5]

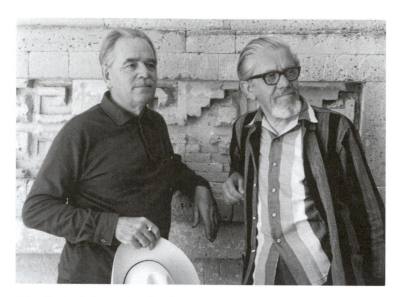

Friendly rivals, Leonard and York Wilson influenced each other, Leonard to experiment with abstract expressionism, York to try collages.

Leonard would say later that Wilson influenced him in abstract expressionism while he influenced York in collage. Leonard's easy mastery of collage drew the attention of Dr. Herta Wescher, who had written a 418-page book entitled *Collage*. She promised Leonard she would include him in the next edition, but she died shortly afterward.

Reva's growing international recognition as a photographer preceded her to France. Two years earlier, the magazine *Réalité* had published several of her photographs. Upon learning of an exhibition at the Salon International du Portrait Photographique at the Bibliothèque Nationale, Reva entered some of her photographs. That exposure led in turn to an invitation by the Photo-Ciné Club du Val de Bièvres in Paris to submit works for "The Great Photographers of our Time" to be held in the town hall of Versailles in 1962. "We consider the presence of your work indispensable," the invitation said. "We should be particularly pleased if you would send us some of your admirable portraits of Mexican women." Reva sent eighteen photos, including *Doña Chencha*, and exhibited alongside the likes of Ansel Adams, Man Ray, Margaret Bourke-White, Carl Mydans, and Brassaï, the Hungarian photographer born Gyula Halasz.

Albert Plécy, writing in *Gens et Images* in Paris, said of Reva: "The most remarked about entry in the exhibition 'Great Photographers of our Time' has certainly been that of Reva Brooks. The sadness so close to despair has never

been shown with such intensity ... The human value of this photographic witnessing is overwhelming."[6]

While Reva enjoyed success with the photographs she had taken in Mexico, she confessed difficulty with her subject matter in Europe. "I go out looking at people every day with my camera and find it infinitely more difficult to capture my kind of thing here than in Mexico," she noted. "The people here are good-looking in a more ordinary, European way and poverty has made them look rather miserable and hard-bitten, but I keep looking and trying."[7] A photo she took of a French mother and child, *Train to Calais*, would be one of the few new ones included in her future exhibits. She also took a series of photos of English men and women that were lost for more than thirty-five years and never exhibited.

The Brooks met many of the Canadian painters based in Paris. But the artist with whom they developed the closest rapport was Marcelle Ferron, the diminutive Montreal artist who had left a husband and daughter behind in Canada and was then living with Dr. Guy Trédez, a physician and artist himself. She recalled seeing Leonard sitting beside a window and staring out. "I said to myself, 'That man is certainly very *bon.*' I think it's very important that people are *bon*. After that, suddenly, he starts to laugh. A mixture of nostalgia, a kind of melancholy. *Très poétique*. For me, he was a poet."[8] They traded paintings, Ferron's hanging in the Brooks' downstairs hallway.

Leonard did not have an exhibition while in Paris, but Reva reported to Fred Taylor that "everyone is trying to persuade us to stay here for six months or a year" as they felt Leonard should continue working in France and eventually having a show there. "But L. does not want to do so at this time," she said.[9]

The Wilsons, who were by then familiar with Europe, and the Brooks drove in two cars through France, Switzerland, and Italy, Leonard and York sketching along the way. At one point, Wilson groused that he was always picking up the check for both couples whenever they stopped to eat. "I thought you were the father," replied Reva.[10]

The visit to Venice, where they spent ten days, was a highlight for Leonard because there was a travelling exhibit of New York's Guggenheim Museum. "Guggenheim show excellent ... early [Georges] Braque in grays and greens ... collage show good."[11] He walked miles along the canals and did up to nine watercolours a day. "Venice portfolio should be vital and good," he said.[12]

Another time, the Brooks went by themselves through Belgium, Germany, and Holland, visiting galleries and museums. Like so many Second World War veterans, Leonard felt uneasy in Germany. "General feeling of being in Germany strange. To walk streets where only a short number of years ago we would have been 'caught and cooked,'" he wrote.[13]

As much as the Brooks enjoyed their months in Europe, the spectre of Reva's blacklisting in the United States haunted them. If she were now refused entry to the United States by land, the Brooks' way of life would be drastically changed. Reva would be unable to accompany Leonard when he taught in the United States nor would he want to drive to Toronto with his paintings if Reva were not along. On 7 September Reva received a letter from the u.s. Department of State saying she should contact the embassy in Mexico City upon her return.

Leonard celebrated his fiftieth birthday in Paris. Reva gave him a self-winding wristwatch. York Wilson gave him a painting. Coincidentally, a royalty cheque for $2,326 from sales of his art books arrived from Reinhold Publishing in New York.

The Brooks left the Gare du Nord for Calais and the Dover ferry on 18 November. Leonard returned to London and revisited the haunts of 1933–4 and 1944–5. As he did in Barcelona, he told Reva he had to go by himself the first couple of times. "I was just crying," he later recalled. "I couldn't stand it. Here was where Cynthia [Bowen] had been. I went to these places, the bars, all had been changed."[14]

Leonard took Reva to meet Aunt Daisy, Uncle Frank, and cousin Donald, discussing with the latter the "Brooks disease" of boredom and introversion.[15] He wrote to Earle Birney that he had inquired about Helga Overoff, his wartime lover, but no one had news of her.[16]

The Brooks boarded the freighter *Princess Irene* along with sixty other passengers on 23 December. Probably suffering a letdown as the European sojourn ended, Leonard felt "depressed ... and more anti-social than ever." He was upset at the "synthetic" New Year's Eve revelry on board ship. Reading a biography of Robert Browning, he expressed his displeasure upon learning the nineteenth century British poet had gone to Italy on his parents' money and not penniless as he himself had done in 1933 when he went to Europe with Evan Greene. He had learned of Greene's death while in Paris.

The European trip marked a turning point for both Leonard and Reva in their respective careers. Leonard now seriously committed himself to abstract expressionism. "That's why I went to Paris in 1961 and worked with and met all the great experimental painters," he recalled. "Some of my best work is from that period." Reva was delighted. "I like my husband's paintings more as he becomes more and more intensely abstract, and to me it's more spiritual, it's more meaningful, it's more philosophical," she would say.[17] Reva was not as happy with her photography. She must have realized that her special rapport with her subjects was limited to Mexican natives and was not applicable to

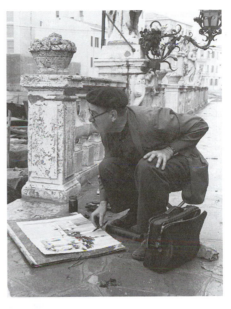

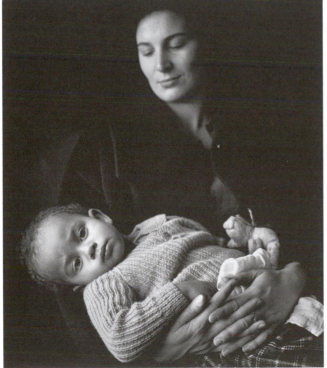

Above left: Paris, *pen and ink sketch, 1961.*

Above right: Leonard sketches in Paris, 1961.

Left: Train to Calais, *one of Reva's best known later photographs, 1961.*

sophisticated Europeans. Looking back on the 1961 trip, she later wrote, "Before that I seemed to have been able to take all our troubles and difficulties in my stride with hopefulness, humour, and courage."[18]

When the freighter made a stop in Miami, the u.s. immigration agent ignored the "canceled" stamp in Reva's passport and allowed her to disembark. "Go on ashore, spend all your money," he told them.[19] Reva broke into tears. The nightmare was coming to an end. But there was still another chapter to come.

When the Brooks flew to San Antonio, Texas, in early 1966, they were met by agents from the INS who told them they were undesirables who had to return on the next flight to Mexico. Leonard pulled from his pocket a letter from the dean of the art department at the University of Texas in Austin, where he was scheduled to deliver a series of lectures. Taken aback, the agents allowed them to remain in the United States for two weeks, provided they check in regularly with the INS. So successful were the lectures in Texas that the dean offered Leonard a teaching position, which he turned down. When they returned to Mexico, they went to the American embassy, where they were assured there was no longer any dossier on file. That was the last the Brooks were to hear of the black list, seventeen years after the closure of the fine arts school.

~ 42 ~

Then they started to do tourist crap

Discouraged about sales in Canada, Leonard now endorsed the idea of a co-operative art gallery in San Miguel where he could sell his new, experimental works in abstract expressionism and collage. The idea for a gallery grew out of a regular meeting of painters in the home of Harold Black, a New York artist, where they would critique each others' works. When he studied in San Miguel, Canadian artist Toni Onley used to participate in these sessions. "He was the one who usually slept through everyone else's and woke up when his were being critiqued," recalled playwright Lois Hobart, then Black's wife.[1] Eventually talk got around to forming a co-operative gallery. Leonard was invited to become a founding partner. Besides Black and Leonard, the other partners were American painter and teacher Fred Samuelson, Diederich Kortlang, a *mastershuler* from Germany who fled Cuba in 1960 with his Cuban

wife, Frederica, and two women painters, Margaret Schmidt, whose husband, Norman, was a leftist refugee writer from Hollywood, and Lucille Wilkinson. Each partner invested five hundred dollars.

Despite being an art colony, San Miguel in 1962 had no art gallery as such. For thirteen years, Jim Hawkins ran El Colibrí, a book and art supply store where artists would often leave paintings for sale. Hawkins, married to Carmen Masip, director of Bellas Artes, had sold eleven watercolours and twenty-two oils of Leonard's the previous year.

Leonard's decision to join the gallery coincided with two other decisions. He decided to write another art book and to find a studio away from home, as his friend Fred Varley had done in Vancouver. Leonard had received a letter from a painter in Atlanta, Georgia, by the name of Bucca who had purchased his watercolour and oil books. Bucca wanted to know if Leonard planned a book on abstract art. "Shall I try another book on problems of abstract thinking and art?" he asked himself.[2] The answer was yes. He made a proposal to Reinhold Publishing: "This is not just an art appreciation book, but a practical painter's discussion of thinking, and techniques associated with the field."[3] The result was his fifth art book, *Painting and Understanding Abstract Art*, which sold better than Reinhold had anticipated, particularly to professional painters.[4]

The place Leonard found for his studio was on the second floor of a colonial building overlooking the *Jardín*, or town square, a ten-minute walk from Quebrada Street. The rent was eighty pesos a month, less than seven dollars. The room next to Leonard's was vacant, so he suggested to Joy Laville that she make it her studio. "We had a great time there," she recalled. "Leonard would make us mid-morning beef tea on an oil stove." She recalled looking out the window and seeing Leonard walking up the street, "his eyes down, hoping not to make eye contact with anyone."[5] He did not want to be distracted or get involved in unnecessary conversation, a trait that many in town would interpret as aloofness or being standoffish.

Laville would keep the adjoining studio for seven years, until she left San Miguel to marry Jorge Ibargüengoitia, one of Mexico's leading novelists.[6] Joy was so poor when she arrived in San Miguel that Reva once gave her three dresses – and returned the following day to take back one of them.[7]

Asked why he no longer wanted to use the studio he and Reva had designed at No. 109 Quebrada Street, Leonard would say he needed more privacy. Whatever the reason, Reva never felt quite at ease having Leonard paint elsewhere in town. She eventually convinced him that they should buy a big lot and build a house and a detached studio so he could have his privacy without leaving home.

Joy Laville, British-born war bride whose art studio was next to Leonard's, 1997.
COURTESY JOHN VIRTUE

The partners in the gallery scouted several possible sites and chose one in a colonial building across the *Jardín* from Leonard's studio. To save money, the artists and their wives helped in the clean up and painting. "It looks like a Fifth Avenue gallery – beautiful lights – walls, etc.," Leonard reported to Earle Birney.[8] Kortlang carved the wooden sign that would hang outside the gallery for more than thirty years: Galería San Miguel. The opening 17 November was such an important event that it attracted more than four hundred people and was broadcast live on local radio station XESQ; Father José Mercadillo blessed the gallery. The partners set a maximum price of one hundred and fifty dollars and a minimum of twenty-five and kept a commission of $33^1/_3$ percent. Non-partners could submit works for a fee of fifty pesos, about four dollars.

The gallery made a modest, and sometimes substantial, profit right from opening day. But within two months Leonard was complaining about the quality of works being accepted from outside painters and was threatening to pull out. He and Reva felt that inferior paintings detracted from his own works. "It started off being a serious gallery with just serious painters," he said. "We had a couple of shows with very good painters, then they started to do tourist crap. I put money into it on condition it be a serious gallery." One of the artists whose works Leonard thought should not have been accepted was Will Allister. Leonard considered Allister a novelist, not a painter.

Allister, his wife, Mona, and daughters Dorrie, then eleven, and Ada, seven, had moved the previous year to San Miguel where Will wanted to write his second novel. His first novel was based on his experiences during the Second World War when, as a young Canadian soldier, he was captured at the fall of

Hong Kong Christmas Day 1941 and imprisoned for three years and eight months in a Japanese slave labour camp. A commercial artist back in Canada, Allister would save motor oil drippings and other liquids he then mixed to make paints for works he surreptitiously did as a prisoner. It took him ten years to write the novel, *A Handful of Rice*, while working as an executive for a Montreal advertising agency.

On weekends, Allister took a break from writing and started to experiment with painting. At the end of a year, he had about fifty works. "They weren't too good, but they were all different, experimental," he said. All ten paintings he submitted to a Galería San Miguel show sold on opening day. "'This is the kind of stuff we've been looking for,' people told me. Unfortunately, I outsold all the pros, the seasoned artists and teachers," Allister said.

Allister discovered that Leonard had wanted the gallery to reject his paintings. "Leonard, who had a quick temper, sounded off, and I was told he was attacking me because of my style and my whole approach," recalled Will. "I think he felt that I was pandering to the public. He was sore as a boil."⁹ Allister learned that Fred Samuelson and Diederich Kortlang had come to his defence and won the battle against Leonard and some of the other partners. Sylvia Samuelson, then Fred's wife, confirmed the incident. "We used to sell Will's works like hotcakes," she said.¹⁰

Leonard resigned at a board meeting 9 December. "Glad to be out of this as it is on a very shaky foundation artistically," he wrote in his diary. The partners bought him out for $557, but he continued to show at the gallery for another four years.

Will Allister finished the novel he came to San Miguel to write, *Time to Unmask the Clown*, but it was never published. He eventually became a full-time painter. "Leonard couldn't hate me because I thought his paintings were wonderful," he said. "I was one of his biggest fans."¹¹

"As soon as I recognize the professional talent in someone, I am in awe," said Leonard in what could have been a reference to Allister. "But we can lose patience when somebody paints for six months and suddenly has an exhibition."

Faced with multi-talented people in San Miguel, Leonard seemed to pigeon-hole them according to what they professed to be when he met them. Will Allister would forever be a writer. Jazzman Bobby Haggart would forever be a musician, even though he was also a professional painter. Only once did Leonard comment on one of Haggart's works. At a party, Leonard paused in front of a painting Haggart had done of colourful clothes at the public laundry in San Miguel. Leonard pointed to the right lower part of the painting and

said, "If you just had a little line pointing up this way, I see that the painting needs that."[12] Haggart did not put in the line.

The Allisters, now residents of Delta, British Columbia, also ran afoul of Leonard because of the Canadian Broadcasting Corporation(CBC). The CBC's Harry J. Boyle wrote Leonard in 1963 to say that ever since a visit to San Miguel he had dreamed of doing a television documentary. "I do hope most sincerely that we can work out an arrangement to have you both as central figures," he said.[13] When producer Jack Zolov and cameraman Hans Michel met the Allisters, the focus of the documentary changed. They decided a film about a family with two young girls would make better television fare than one about the childless Brooks. "I don't think Leonard and Reva liked that," said Mona Allister. They did not. "I'm awfully browned off at the Allisters – and others," Leonard told Earle Birney.[14]

Mona said the CBC wanted to involve Reva in one scene with her at the market. "Just be very relaxed and chat the way you would on a regular market day," the cameraman told them. "We were walking along and Reva is pinching my arm and kept saying, 'You're being relaxed, aren't you? It seems to me we're being relaxed.' And she kept pinching me," recalled Mona.[15]

The Allisters, left to right, Mona, Dorrie, Ada and painter Will, became subjects of a CBC film.

COURTESY OF WILL AND MONA ALLISTER

What new worlds do you want to conquer?

No artist in Mexico can be considered accepted by the art establishment until he, or she, has had a one-person show at the ornate Palace of Fine Arts on broad Paseo de la Reforma in Mexico City. That honour was bestowed on Leonard Brooks in 1965. The National Institute of Fine Arts had for months been after Leonard for a show in the Sala Internacional, but he had been delaying his decision. When he finally agreed, he could not accept the proposed date – June – because he was committed to return to teach in Texas, an easy source of income and an opportunity to stock up on art supplies not available in Mexico.

Leonard was artist-in-residence at the Hill Country Arts Foundation in Ingram, Texas. He received $1,000 for teaching and made another $1,400 in sales of his paintings and art books. That Texas also recognised his worth is evident from a note in a social column in the *Houston Chronicle*, which reported: "Artist Leonard Brooks and his famous photographer wife Reva departed for Mexico via New Orleans in their VW van."[1]

When the fine arts institute, supported by the Canadian embassy, proposed 29 October as the opening date, Leonard accepted, only to subsequently receive a request from David Carter, director of the Montreal Museum of Fine Arts, for an exhibition there 28 October. Leonard said "no" to Montreal and never was able to arrange another date. He obviously was interested, if for no other reason than to show up the Toronto art establishment. He opted for Mexico because of the honour being bestowed upon him, especially since he was a foreigner. "It is some kind of accomplishment – and is clear and rewarding to be asked by the Bellas Artes to have the show," Leonard told York Wilson.[2] He enlarged on his reasoning in a diary notation: "The Canadian scene always rough on me somehow without aid or hope when I needed it – disdainful when I did not need it – well, here I go – a Canadian having an exhibition with Canadian ambassador sponsoring it at Bellas Artes. Will it only provide some of them with a chance to disregard me and my work again?"[3]

The ups and downs of the emotional rollercoaster that was Leonard's life can be appreciated by the fact that, in the midst of his acceptance as a ranking artist in a country that venerated its artists, he suddenly found himself in a depression of suicidal proportions. He often made allusion in his diaries to suicide, but seldom as blatantly as he now did. "The dullness inside myself aggravated with bickerings with Reva annoy me ... the hopes and plans – dust

– and lethargy takes over so that I want to do nothing – and doing nothing is a misery and adds to hopelessness ... I can imagine Hemingway feeling this way before he shot himself. It is not a matter of 'being unhappy' – it is just the feeling of *being* becomes intolerable."4 Ernest Hemingway, whose literary path Leonard once fantasized about following, had committed suicide four years earlier.

Yet, just four days later, Leonard reported his "glooms dispelled" after an evening of drinking rum and talking things over with his studio mate, Joy Laville. They were always supportive of each other. Whenever Joy was down, Leonard would cheer her up with macho encouragement: "Keep your pecker up."5

Laville also had some advice for Reva, who was suffering from a bout of dizziness, possibly brought on by anxiety over the upcoming show at the Palace of Fine Arts and Leonard's depression. "You've taken a lot of blows lately. You shouldn't perhaps bottle things up so," Joy wrote. "A bit of shouting with rage and kicking inanimate objects is an excellent release. I am quite serious. And for severe depression there's nothing like kicking an animate object. Now I'm not serious."6

Both Brooks had reason to be depressed because of the murder of an American couple who lived across from them on Quebrada Street. Leonard was called at 5:00 a.m. by their maid and found Ashmead (Scotty) Scott, a former scriptwriter for the Red Skelton show, and his British-born actress wife, Tig, shot. She was dead and he would die two days later. Police later arrested a man with a long police record, Jesús (El Negro) Larios López, who said he had entered the house thinking no one was home and shot the Scotts with a .22 calibre revolver when they surprised him. Leonard slept with a loaded shotgun beside his bed until Larios López was arrested.

Leonard showed in the same fine arts palace where he had helped deliver a protest letter to President Alemán in 1949 at a retrospective of Diego Rivera. Although Leonard was invited by the Mexican government, the show itself was co-sponsored by the Canadian embassy, under ambassador Herbert F. (Temp) Feaver. Leonard hung ten oils and twenty-two collages. There were 479 people at the opening, many of them Mexican artists. Afterwards, Feaver hosted a dinner for sixty government officials, diplomats, and other dignitaries. "I feel that the Instituto Nacional de Bellas Artes did something quite remarkable in their outgoing sponsorship for me as a Canadian painter – an honour that very few foreign artists have been privileged to have," Leonard wrote to the ambassador.7 Reva reported on the show to York and Lela Wilson: "Everything about the exhibition turned out very well and that whole evening is like a dream – a very exciting and pleasant one."8 She also had former *Time* correspondent Bob

Benjamin, who now ran his own public relations firm in Mexico City, send a press release on the show to the Canadian Press news agency in Toronto.

Jorge Juan Crespo de la Serna, probably Mexico's leading art critic, said in the newspaper *Novedades*: "This capacity for deep personal reflection reveals itself in what he is painting today; and in what he has been painting now for several years, during which I have followed his work with extreme interest. He is a superb colourist and a consummate master of his craft. He is a painter, an excellent painter."

The fact that two-thirds of the works at the show were collages and one-third oils and none watercolours indicated the new direction of Leonard's art since returning from Europe. The man who had made watercolour his own medium found himself in an unusual position: "Watercolours – so long since I've done one."[9] Leonard was increasingly being identified with collage.

Now that he was concentrating on collages, Leonard felt that he was reaching a new level in his work. "This new work must get to the right people," he said.[10] He had people in mind like Ellie Martin, an art collector, music lover, and wife of a wealthy Chicago architect, Albert R. Martin. She bought one of his collages and had a room done over to match it. Once when she visited Leonard's studio, he commented on her black and purple dress designed by Sweden's Mary Meckko. "That would look great in a collage." Ellie picked up Leonard's scissors, went into a corner and snipped off a bit of material that ended up in a painting.[11] She would eventually own more than twenty of Leonard's works.

The first months back in Mexico from their European trip, Leonard was selling five and six collages a month. "Collage seems to be the media which appeals to the buyer of my work more than oil," he noted.[12] As he did with Martin's dress, Leonard put diverse material in his collages, old newspapers, posters, sheet music, letters, account ledgers, egg cartons, all usually found out in the

SAN MIGUEL
DE ALLENDE –

street. "I was once walking down the street with Leonard when he suddenly ran out into the street," Will Allister recalled. "He had seen old coloured papers. 'I need these for a collage,' he said. He explained, 'These have been discoloured by time and they won't fade any more. So this colour is perfect because I can put it right on the painting and nothing will happen to it.'"[13] A buyer complained to the Roberts Gallery that his collage smelled of rotten fish. He was right. The fish net that Leonard had incorporated in the collage let off an odour. Leonard suggested the collage be sprayed.

Toronto advertising executive Jack Spitzer, who first bought works rejected by the Roberts Gallery, became Leonard's biggest Canadian collector. "Fortunately or unfortunately, depending on one's viewpoint, my collection is limited as to artists, namely Leonard Brooks," he told Leonard.[14] He would rival Ellie Martin in the number of paintings purchased.

Someone who now showed curiosity about Leonard's evolving style was Jack Wildridge of the Roberts Gallery. He wrote to Leonard saying that Albert Franck was enthusiastic about his recent work and asked to see some of the paintings.[15] Leonard would later leave "ten small collages" at Roberts. "Still dislike Wildridge attitude but hope he sells all," he said. "Too cautious and business-like for my liking, I'm afraid."[16] Leonard was ambivalent about whether to aggressively seek another Toronto dealer or try to rekindle his relationship with Roberts, who still had some Brooks paintings on hand. "There seems to be a resentment – about anyone who becomes independent – and gets out of the rut – and away on their own,"[17] he told York Wilson, who enjoyed good relations with Wildridge.

Reva touched on the subject of Toronto sales in a letter to Naomi Adaskin, who was probably selling more of Leonard's works out of her home than Wildridge was out of the gallery. "We certainly have not had good luck with galleries, and Toronto now to us seems to be the source of the least support and income in Canada," she said. "We are partly to blame by not being there and not keeping up with some gallery or other, but L. feels more than ever that his 'home town' never has been and is not aware of his worth."[18]

Leonard had tried to use his Toronto background in 1963 to get represented in New York by Martha Jackson, then one of the most prominent dealers in the United States and a promoter of abstract art. American painter Lynne Aultberg, whom Leonard met in San Miguel, told him Jackson was investing in a Toronto gallery and suggested he see her. When Leonard met Jackson at her gallery at 32 East 69th Street, he was interested in New York, not Toronto. Jackson, a parrot perched on her shoulder, was interested in Leonard in other ways and made a pass at him in the elevator to her gallery. Nothing came of

the trip. Jackson drowned several years later in the swimming pool of her Brentwood, California, home.

Leonard did not have to seek out the prestigious Horizon Gallery in upscale Rockport, Massachusetts. Gallery owner Abe Rothstein and his wife, Harriet, visited Leonard in his studio and left with twenty paintings, the first of many they would sell over the next decade. They put on a by-appointment-only show 3 April 1965:

> Horizon Gallery
> Presents the work of Leonard Brooks
> San Miquel [*sic*] D'Allende [*sic*], Mexico
> World Renowned Contemporary Artist and Author
> A superb collection of
> PAINTINGS, COLLAGE and DRAWINGS
> A personal selection brought from a recent visit to Mexico
> April 3 through 15 by appointment.

"He did very well with us," said Rothstein. "We did the best with him of all the painters that we took on as clients. He was the best." He did not feel the same way about Reva, who acted as Leonard's agent. "I found her a bothersome woman. I don't want to sound like an anti-feminist, but she was impossible in certain ways. I felt she was a hindrance to him."[19]

From the 1960s onwards, Leonard would sell more works to American than Canadian collectors. "About three hundred of my best paintings are not in Canada at all. They're in the United States," he said. Many of the American collectors would go to his studio to view and select paintings.

Reva's aggressiveness on Leonard's behalf now rubbed someone else the wrong way, causing a split in San Miguel's artistic community. After John L. Brown, cultural attaché at the American embassy, had given a talk in San Miguel, Reva allegedly spirited him away before he had a chance to meet American artists. Rushka Pinto, wife of painter Jimmy Pinto, was so angry she wrote Reva 31 March 1965, not believing she could keep her temper under control during a telephone call. "After what happened during Dr. Brown's visit here, I think that it is much better if we leave things quiet for a while. I am still too upset to talk things over, can say something that I might be sorry for later." Reva replied, also by mail: "Your letter has me completely mystified. How can such misunderstanding arise? Whatever you imagine I may have done to 'upset' you, I have certainly done unwittingly, and am indeed sorry." Brown visited Leonard's studio twice, but Reva insisted he had done so only after first meeting the Pintos.

Artist and craft-store owner Robert Maxwell, a friend of both Leonard and Jimmy, said he subsequently opted for the Pintos' social functions.[20]

Reva became famous for her single-minded determination, oblivious at times to outside distractions. As well as helping run the co-operative gallery, Sylvia Samuelson, who was a nurse, tended to the needs of San Miguel's artists. Will Allister had just lowered his pants to get an injection when Reva telephoned Sylvia. "How are you? What's going on?" Reva asked. "At the moment," replied Sylvia, "I have Will Allister in my living room and he's just taken down his pants for me." "Oh, how nice," answered Reva. "Now, about the tea ..."[21]

Nor could many people think as fast on their feet as Reva. Once, when her son had a fever, Joy Laville went to the Brooks to use the telephone to call a doctor. Since the Brooks were hosting a dinner that night, Reva said to Joy, "Oh, you received my telepathic invitation."[22]

Leonard now had behind him the most prestigious exhibition of his life and the publication of his fifth art book, *Painting and Understanding Abstract Art*, which came out earlier in the year. Writing in *The Gazette* of Montreal, critic Rea Montbizon said: "Among his friends one often hears expressions of regret about Leonard Brooks' apparent neglect of his painting, placing it, as one hears, behind writing, playing the violin and teaching, in that order. But by his present volume the artist's friends should feel reassured. 'Painting and Understanding Abstract Art' is well stocked with the author's own works. It contains 26 colour illustrations and countless black and whites, from formal painting to collage, from sketch to vignette."[23]

Reva was one of those who felt Leonard was neglecting his painting. But she put a spin on his books in a letter to York and Lela Wilson: "Writing seems to clear the way for L. to go on searching deeper in his painting, and the royalties are sufficient to live on here so that he never needs to feel any pressures except his own inner ones in regard to his struggles in the studio. More and more he eliminates everything from his life which does not contribute to his main job of painting – everything has to fit in with that."[24]

Earle Birney wrote, "A beautiful, impressive and most helpful book. Congratulations once again on a fine job. Water, Oil, Casein, Wash, Abstract – what's next? What new worlds do you want to conquer?"[25]

PART NINE

New Directions

\mathcal{I} *don't blame him for getting fed up*

While Leonard basked in the reception of his latest art book, Reva was becoming frustrated in her role as manager of of his artistic works, as opposed to his writing. She obviously had unrealistic expectations of his successful show at the Palace of Fine Arts; given the interest, she thought that he would be taken on by some major Mexican galleries. "I tried to do everything in bringing that about, and the failure has been bitter for me," she said.[1] Although Reva talked to Mexico City gallery owners at the show, none offered to represent Leonard. She then approached Inez Amor, who owned the Galería de Arte Mexicano, considered to be Mexico's leading gallery. To Reva's chagrin and disappointment, Amor turned down Leonard and, to make matters worse, agreed to represent Joy Laville.

Then Jack Wildridge of the Roberts Gallery on 13 April 1966 said he was not enthusiastic about Leonard's collages after all and suggested he take them back or have them sent to Naomi Adaskin. Wildridge told Leonard that he did not want to judge Leonard on those works but would like to see some of his larger works before making a final decision. Wildridge stressed that he wanted to keep open the possibility of doing business.

On 20 April Leonard wrote in his diary: "Miserable letter from Roberts' Wildridge sending cheque but snide remarks returning other small things back to Adaskins – as if I cared – as usual the Torontonian end is always a negative one." Two days later he replied to Wildridge: "I would appreciate it very much if you would be good enough to deliver my paintings to Mrs. John Adaskin at 60 Lyndhurst Avenue." Wildridge confirmed on 29 April that the paintings had been delivered and that Roberts did not hold any of his works.

The stormy fourteen-year relationship between Leonard and the Roberts Gallery had come to an end and he no longer had representation in Toronto, aside from Naomi Adaskin's sales out of her home.

Esther Birney visited Toronto during the summer and came to the conclusion that Leonard should return to Canada if he wished to save his reputation there as an artist. "I am very troubled with you about Leonard's position in

Previous page: Leonard holds Chiquita Burrita, the second of two dachshunds the Brooks pampered.

*Jack Wildridge,
owner of the Roberts
Gallery and Leonard's
longtime dealer in
Toronto who twice
broke with his client.*

JOHN WOOD – THE GLOBE
AND MAIL

Toronto," she wrote to Reva. "I don't know the solution but I feel instinctive-
ly that it means his and your presence to start the ball rolling again. Those that
know L. and his work are staunch, enthusiastic, and appreciative. But newer
faces and canvases more and more claim the limelight. Add to all this that the
whole art picture is confused and meretricious and you have a messy situation.
L. has, besides his art, a great personality and this is missing from the art scene
in Canada."[2]

Leonard wrote in his diary 7 May: "Reva is still upset about Inez Amor
brush-off – and another damn Roberts Gallery letter. How I should know bet-
ter than to get hurt by these things at this late stage of my life and work. Carry
on! That's the cry and do my work for myself – and handle it for myself."

Then on 22 June Reva's father died in Toronto. Reva now longed for per-
sonal contact with her family and was shattered when niece Nancy Sherman
failed to arrive on a 7 July Canadian Pacific Airlines flight that she and Leonard
had gone to Mexico City to meet. The flight had been cancelled due to
mechanical problems. Nancy would come several weeks later.

This series of setbacks drove Reva into a self-admitted state of depression.
Leonard dealt with his depressions through his blowups, by burying himself
in his painting or by playing his violin. He also had his own checklist of things
to do to counteract the "glooms," as he called depression: "Sitting quietly and
counting one's blessings, good health, eyesight. Able to walk, etc. Listening to
music – reading a book – looking back over one's accomplishments – with a
fresh eye – and comforting oneself with past deeds – meeting a kindred soul
occasionally with the same problems – getting a bit drunk – and hoping to

recover and break the 'spell' of 'melancholy.'"³ Reva had no such outlets, not even her photography at this point, so on 8 July she started writing her thoughts in a journal for the first time since she was sixteen, hoping this would help her heal herself:

I have always been ambitious for the best from and for him, and have felt unhappy when it was not happening. This has been a touchy and even dangerous element in our marriage, which I now realize has a great deal to do with my present mental state.

The reason I want to write everything down as clearly as I possibly can is not to say what is right or wrong, who or what is to blame – but it is to try and get myself out of this horrible state I am in.

So I have to admit I feel devastated (a strong word, but my emotions are strong) because he is not being recognized and appreciated in the way he should be. I feel this ambitious need for him because I know how hurt he has been by the disinterest in Canada. And it is partly my maternal protective instinct – actually, it is all too complicated for me to figure out. It is nearly 2:00 a.m. and I want so much to sink into a deep sleep – I wonder if this writing will really be of help.

I must clarify my situation about my photography and become completely absorbed in it. I know I can do more good work.

Reva wrote 13 July that Leonard "blew up" at her the previous night, "and I don't blame him for getting fed up with my depressed state." She said that her father's death had released "all the mixed-up feelings of my life."

Ironically, in the midst of Reva's depression, Leonard now wrote in his diary, "Learning to enjoy every minute again."⁴

There was another death during the year that especially grieved Leonard: Lucy Loosebones, his beloved dachshund, died at age ten. Leonard gave Lucy sleeping pills and chloroformed her when it became apparent she was ravaged by cancer. He wrapped her body in a blanket, placed it in one of his violin cases, and buried her next to her father, Poco Más, in Stirling Dickinson's garden. For days, Leonard expected to find her in the house. He told his diary, "Miss Lucy here and there in house and I know what 'heart ache' means when I look at the couch where she loved to sit – for so long – or when I have my 'naps' without her."⁵ Friends and relatives were advised of the death and many wrote notes of condolences. Esther Birney said, "My heart aches when I think of her life drawing to its end. I think of her always as some loving, darting, little black sonata by Mozart in doggie terms."⁶ "We were sorry to hear about Lucy," wrote sister-in-law Sylvia Marks. "I didn't even know she was sick."⁷ The Harveys wrote from Sacramento, "We were so sorry to hear about Lucy. Such a

shame. We'll miss her next time we come down."[8] Author Alan Marcus, who wrote *Of Streets & Stars*, gave the Brooks an "excellent book" entitled *Man Meets Dog* by Konrad Lorenz to help them cope.

Two years after the death of Lucy Loosebones, when they were up in McAllen, Texas, Leonard bought another dachshund, a black and tan pup that he named Chiquita Burrita because she looked like a little donkey. She was so small he was able to slip her into his coat pocket and smuggle her into Mexico. When Chiquita died unexpectedly nine years later, probably of a snake or scorpion bite, he buried her in his garden. An unbeliever, Leonard placed a replica of St. Francis of Assisi, the patron saint of animals, over the grave of Chiquita Burrita.

Years later, when Reva was looking at a picture of Leonard holding up Chiquita Burrita, she said, "Look at Leonard and that damn dog. It should have been our baby."[9]

~ 45 ~

Born physically from his mother and continually reborn by me

When Leonard and Reva Brooks boarded the Italian freighter *Morosini* in Veracruz 27 April 1967 for a trip to Greece, they were convinced they had solved the problem of exhibiting in Toronto. As soon as Arnold Mazelow of the Mazelow Gallery had heard rumours of Leonard's break with the Roberts Gallery, he wrote to Reva.[1] She wrote back, encouraging Mazelow to meet them during a planned trip to San Miguel, but making no mention of Roberts.[2] Reva might have been leaving the door open for reconciliation with Jack Wildridge, but not Leonard. "Mazelow Gallery in Toronto interested in showing work eventually – now Roberts is off our list so definitely forever," Leonard wrote in his diary.[3] But he was wrong on both counts.

When Mazelow saw the Brooks three months before their trip to Greece, it was agreed Leonard would give him some works to show in his gallery. Mazelow and his wife, Helene, had met Leonard in 1965 when they were buying paintings for the Sears Price Collection, Sears being the department store and Price being actor and art expert Vincent Price. Mazelow had purchased $1,000 worth of Leonard's paintings for showing and selling at the galleries in the Sears stores.

Although the arrangement with Mazelow should have lifted her spirits, Reva was depressed on the eve of the departure for Greece. Probably fearing any mention of her emotional state would undermine her role as the strong, wise, older sister, Reva never told her siblings of her depression. But now she confided in Esther Birney, a trained social worker who had professional experience dealing with depression. Esther gave advice to Reva in a letter dated 11 May:

I have thought a lot since I got your letter and I have come to a couple of tentative conclusions: first travel isn't all it's cracked up to be and second when we carry anyone else's burdens as well as our own we're heading for trouble. Part of your sadness and depression will be alleviated by returning to your own familiar surroundings, the other difficulty will probably continue until you can make some basic changes in some of your attitudes. Some residue of unease will remain forever and you must learn to live with it. Meanwhile watch your dreams for clues to what is pressing but censored in your conscious life. What a social worker paragraph that was!

Esther recommended that the Brooks move to Vancouver since a return to Toronto might be viewed as a defeat for Leonard. She also correctly stated that a Vancouver base would make it easier for Leonard to seek and service outlets in San Francisco and Los Angeles, cities where he was already known.[4]

The Brooks found the *Morosini* to be a "ratty" ship and Captain Linazzo "a character from movies," but the food was good and Leonard managed to paint on board. When the ship docked in Houston, Texas, the Brooks feared a repeat of their 1961 problems with the INS. But this time they were able to disembark. Reva would write later to Lela and York Wilson: "This trip is so much more satisfying for me without that bothersome cloud [U.S. blacklisting] which hung over me the last time we were in Europe. I realize now it should not have bothered me so much and spoiled part of my trip then, but to me it was a nasty blow which fortunately they realized was a mistake."[5]

As Gibraltar came into view, Leonard was so pleased with his output during the month-long trip – "nearly 50 collages and drawings" – that he gave a watercolour to Captain Linazzo. The Brooks changed ships at the Italian port of Genoa and on 12 June arrived at the Greek port of Piraeus, where they stayed at the Solomov Hotel for $4.50 a night. Greece had been under military rule since 21 April when Premier Panayotis Kanellopoulos was overthrown in a military coup. Earle Birney told the Brooks he could not have visited Greece under a right-wing military dictatorship, but the Brooks, who shared his view on such matters, had already purchased their tickets.

Canadian ambassador Temp Feaver, who had co-sponsored Leonard's show at the Palace of Fine Arts two years earlier, sent a car for them and the Brooks dined at the embassy residence.

After a week, they left Piraeus for Rhodes and booked into the Palace Hotel, where Leonard found space where he thought he could work. Leonard reported "Reva on edge ... out of touch with friends and family but seems to function well."[6] There was no question but that Reva's state of mind was affected by Leonard's decision to write a sixth art book. A contract from Reinhold Publishing caught up with them in Rhodes. "It's an insurance against future nuisances of galleries – sales, etc.," he told Earle Birney.[7] Reva felt that his art books catalogued him as a writer instead of a painter. Reva later wrote, "A serious situation is that I feel so uninterested in his projected book – more than I *hate* the idea of him doing it. When I indicated this early this year, it brought about a very painful situation, and I had to back down."[8] Leonard had said at the time, "R[eva] discouraging and must fight this off as it does not help me in spite of her good intentions for ideal artist's life."[9]

The Brooks were able to stay at the Athens School of Fine Arts in Rhodes. Leonard, to whom young children would always be attracted, was moved when a little boy and girl presented him with a bright yellow flower they found growing in the rubble of a bombed-out mosque he was sketching. Reva studied Italian during the month they were in Rhodes.

They returned to Athens for a day to get permission from the Board of Arts to stay for thirty days at an artist's chalet maintained by the government in Hydra. Just eleven miles long and four miles wide, Hydra, like San Miguel, was sought out by painters, writers, and actors. Writer Henry Miller had spent time there. Canadian poet/song writer/singer Leonard Cohen owned a home there. There was no vehicular traffic on the island because the streets were too hilly for cars or trucks.

On board the ship *Sophie* en route to Piraeus, Reva felt so depressed that she picked up a notebook and started another diary to record her feelings:

I try to be strong and by writing out my feelings as simply and openly as possible I hope it will help me to overcome my worries and depressed states. It is worse at night when I awaken and my mind buzzes with all the regrets, frustrations, guilts of things done or not done to do with all aspects of my life. Why must I be so tortured by all the things, so much so as to interfere with my sleep, my daily activities?[10]

Reva's depression worsened when the Brooks received news that Arnold Mazelow had suffered a fatal heart attack 3 May at the age of forty.[11] The Brooks

were already grieving the loss of two close friends, Charles Allen Smart and Léo Roy, who had died earlier in the year, Roy drowning in a boating accident in Quebec. She wrote in her diary:

How can I find the way to get over having these sinking, melancholy feelings, that terrible sensation in the pit of my stomach on awakening every morning too early? Sometimes I take a Valium 5 which helps for a while, but I must find a real way out. I try to think of all the good things – that we are alive, in good health, free to travel and do our work. But I am tormented by thinking of all the familiar disappointments which L. has borne with his struggles in his painting, both to produce it, and to have it adequately appreciated (he has to 'go it alone' always) by some *good* gallery dealer. And now after finally getting around to making an agreement with Arnold Mazelow to be L.'s dealer, to find that he has died of [a] heart attack.

Reva added a note at the bottom of the page: "Born physically from his mother and continually being reborn by me – agony of pain and birth."[12]

Reva was apparently self-medicating herself as there is no evidence of professional supervision of her use of Valium, which might have exacerbated her mental state, rather than improving it.

Now Leonard joined Reva in being depressed; she revealed in her diary that her ability to photograph was affected when she worried about him:

My nature is that I feel that my responsibilities as a wife, a helpmate, have to be fulfilled before I can feel at peace to go forth with my camera and search for subjects ... But I am always supremely sure of *what* I am searching for of the expression of humanity in my photography ... Just now asleep, half asleep in the afternoon, an *involuntary* spasm assails me in my diaphragm – a horrible, death-like feeling ... When upset this way, and feeling intensely nervous, my sense of timing and technical control in photography are affected adversely.[13]

Two days after Reva's entry on Leonard's low spirits, he had bounced back. "Hydra finished – but good stay after 30 days of work and inviting friends," he wrote. The next day he added, "Big parcel of collages – and work – wrapped up." Then the following day, a note from Delos, "Wonderful ruins, deserted ... phallic image intriguing old ladies."[14]

As she had during the 1961 trip to France, Reva found the faces in Greece not conducive to photography: "I have to admit I find it difficult to work if I don't have peace of mind, and a most serious detail is that I do not find the faces here inspiring to photograph in the manner which I love."[15]

While Reva was agonizing, Leonard was in unusually good spirits and touched on his own mental state. "Curiously in good humour – and not worried about work at moment," he wrote in his diary. "Moods a matter of mental discipline and health." Another entry read, "A mad morning! *Five* collages including a large one. Falling over myself – and excitement – almost too much for me."[16]

Reva appeared to be coming out of her depression when Leonard's actions drove her back. The occasion was a visit to the Brooks by a certain Madame Sofia of Marianulu, who was "profoundly moved" by Leonard's paintings. After she left, Leonard got into his cups and became emotional about Canada. "Toronto, lack of any interest in him there, he never wants to return, to not bury him there when he dies, etc." she wrote in her diary. "In short, all the things which I can't bear to hear and drives me to the edge."[17]

Given his enthusiasm, Leonard was always able to bridge language barriers with fellow painters and musicians. He did so now with leading Greek painter Jannis Spyropoulos, who was his age. Spyropoulos and his wife, Zoe, got together with the Brooks three or four times over a ten-day period, including an invitation by the Greeks for a lobster dinner at a countryside hotel. Given the parity of ages, Reva not surprisingly compared the success of Leonard and Spy, as he was called. "Jannis is a good example of the internationally successful painters whose work is bought by collectors and shown in many different countries," she said. "Leonard is as good a painter, and in his best work, even better, but his output and progress has been uneven and varied. The contradictions between his background and evolution as a person is reflected in his work."[18]

The Brooks left Greece 24 October for the trip to Italy, checking into a hotel in Genoa. When they weighed themselves, they found that Reva had lost twenty pounds and Leonard ten since leaving Mexico six months earlier. Reva's loss was probably related to her depressed state while Leonard burned up calories as he painted and probably forgot to eat.

Esther Birney had anticipated that Reva's current depression might be related to her photography. She told her, "I think that it is most important for you to move out of the introspective mood into which you have fallen. I can recommend nothing better than work – your own preferably. In fact I wonder if you are depressed because you have neglected your own work. Have you much to show for your trip? Along with your depression and perhaps arising out of it seem to be feelings of guilt and self-reproach."[19]

Esther was close to the mark in her diagnosis. Four days out of Veracruz aboard the Italian freighter *L. Mocenigo* on the return home, Reva wrote:

This year has been the most distressing one of my life because of my continuous state of depression of mind and spirit, interfering with the full appreciation of the trip and with my work ... I feel sad not to have been able to do more and better photography – I realize a professional ruthlessly overcomes and surmounts every obstacle to get what he wants. I have always said that a photographer should do good work within the limitations of his or her life. Now I find it difficult to do so as a woman, a wife, a traveller, a sightseer. I want to be free to do the kind of work I most love, close-ups of people's *feelings* ... For me, I should get into my photography, which I love, as long as I am free to do the kind of subjects I want. If possible, I would like to emerge every day with no responsibility than to make the best photographs of which I'm capable. Have all the material details of living, travelling, etc. looked after.[20]

When the Brooks arrived at No. 109 Quebrada Street, neighbour Mai Onnu came out to greet them. She recalled Reva dragging her camera equipment into the house as if it were a burden she was anxious to drop.[21] Although Reva would take her equipment on future trips, her productive photographic career was obviously now over.

~ 46 ~
You live in Leonardbrooksland

During the 1960s, when Leonard's deteriorating relations with Jack Wildridge led to his break with the Roberts Gallery, Toronto was undergoing a surge of interest in the arts, marked by the opening of new art galleries. The city that just a few years earlier had only three galleries, now counted more than fifty. Swiss-born Walter Moos, who had opened his first gallery in Toronto in 1959, believed that the international competition for the design of the new Toronto City Hall was the catalyst for a cultural awakening. He said it was, in his opinion, one of the three great architectural achievements of the decade, ranking alongside the Museum of Anthropology in Mexico City and the Shrine of the Book in Jerusalem.[1] The Mazelow Gallery at 3463 Yonge Street was one of those new galleries.

When Reva wrote a condolence letter to Helene Mazelow, she indicated that Leonard wanted to show at the Mazelow Gallery despite the death of her Arnold. "Arnold had asked [Leonard] to put aside his best work for him

(which he had already begun to do) so he can continue to do this as he promised, and later on he can get them up to you, when you wish," Reva said.[2] Helene replied, "I am at a slight disadvantage because I have not seen Leonard's new work as Arnold did. How lovely it would be if you could send me just a few slides or photographs so I could be in touch mentally with what he is doing now."[3]

The first opportunity Reva had to send photographs to Helene was in December, after returning from Greece, but she did not do so because York Wilson had advised that Wildridge would be coming to San Miguel and wanted to see Leonard. "I think Leonard will fare much better with Roberts than Mazelow," Wilson said.[4]

Leonard met with Wildridge 11 February 1968, but no agreement was reached at that time on a renewal of representation. The Brooks still wanted to see Helene. Less than a month later, Reva again wrote her. "I'm sorry that I have not as yet sent to you slides and photographs of the paintings which you requested in your letter ... It would be such a fine thing if you could possibly arrange to get down here for a few days – is this at all possible?"[5]

When Mazelow could not get to San Miguel, the Brooks opted to return to the Roberts Gallery. Reva reported to Esther Birney: "Jack Wildridge of Roberts was down here and was so keen about L's work that he went out of character, became most enthusiastic, and with great aggressiveness tried to overcome L's indifference and lack of co-operation (a form of self-protection on L's part). So it looks as if there will be a showing in Toronto after all and I hope they will look after representing L's paintings in a thorough manner so we can devote ourselves more and more to work."[6]

Reva advised Helene Mazelow of their decision. "But we do want you to know that we appreciate the interest and our all too brief contact with you and Arnold," she said.[7] If Leonard and Reva had been influenced in their decision not to deal with the Mazelow Gallery because a woman now ran it, they were misled about the origin of the gallery. Arnold had been a clothing salesman travelling throughout Ontario while Helene had run the Helene Arthur's Studio since 1955 with several partners. Arnold wanted to get off the road, so he and Helene opened the Mazelow Gallery in 1966. Arnold was the salesman while Helene had the eye for art, including that of Harold Town, whom she promoted in the 1950s.

Art patron and advertising executive Jack Spitzer had not known of the rapprochement with Roberts when he laid out a plan to promote the Brooks across Canada:

A Leonard Brooks show at the Roberts Gallery is just another show by just another artist – no matter how well it is done, etc. There will be a few puffs in the papers, perhaps a feature – and that's that.

I believe Brooks (plural) are more important and their background and experience provide more to build on.

1. You are an outstanding artist and have proved it.
2. You have some very successful books to your credit – with another one coming.
3. You were official navy artist for some years.
4. You studied in Canada at O[ntario]. A[rt]. C[ollege]. (Did you teach also?)
5. I believe your stuff is hanging in some important museum art galleries.
6. You have, as an avocation, given unstintingly of your time to develop little Mexican children musically. There is a real public interest story on this – supported wonderfully by some of Reva's photographs.
7. Reva is a photographer of international repute.
8. Already there is a precedent – Sponsored by the Canadian and Mexican governments you have had a successful show in Mexico City.

Now – Why don't you talk to the Canadian ambassador and the Canadian man in the Mexican State Department about co-sponsoring a show in the new Art Centre in Ottawa. Then you move it to Toronto – possibly in the o.a.c. gallery ... it could be a rehearsal for New York or London, etc. Why settle for less?[8]

Spitzer anticipated a joint show with Reva, lectures by Leonard, and a program on the cbc. He was too late with his suggestions.

Leonard did not have time to start preparing works for his return to the Roberts Gallery. Feeling ill on an April evening, he went to bed, broke out in a sweat and staggered to the bathroom, where he vomited. Dr. Paco Olsina diagnosed a bleeding ulcer and had Leonard transported to the American-British Cowdry Hospital, the medical facility in Mexico City that usually looked after English-speaking foreigners. Dr. David Brucilovsky confirmed a duodenal ulcer and some hernia problems. Leonard was given blood transfusions and kept in the hospital for three weeks. "Result of tensions, work, general upset about things this last while ... and I suppose over the years – for this painting business is a tense one and these days so much of it is disturbing," he told musician Stanley Fletcher.[9]

When Leonard returned home, Olsina converted his bedroom at No. 109 Quebrada Street into a hospital room, complete with intravenous stand for drip-feeding. Lying in bed upstairs, Leonard was serenaded one evening by cellist George Sopkin of the Fine Arts Quartet of Chicago and a pickup group he had formed for the occasion. Sopkin was there because Leonard had

suggested to Ellie Martin in 1965 that she get the quartet – she lived in Chicago – to play in San Miguel. She contacted the u.s. State Department and San Miguel was added to a Fine Arts Quartet tour. Sopkin would return to inaugurate a prestigious, annual international music festival in the town. "L. was floating on clouds upstairs listening, and I'm sure it helped his recovery," Reva told York and Lela Wilson."[10]

That September, Leonard loaded more than seventy paintings in a new Rambler station wagon he had purchased for $3,720 and he and Reva drove to Toronto. While there, a Toronto doctor pronounced him recovered from the bleeding ulcer but recommended he cut down on cigarettes and alcohol.

Now that Leonard had a Toronto gallery again, he thought he should spend more time in Canada, so Reva's brother, David Silverman, offered him ten acres of his 150-acre farm at Elora, sixty-five miles west of Toronto on the Irvine River. Leonard liked the idea, as did Reva, who would be closer to the Toronto family she so dearly missed. "I feel the need of some roots in Canada for the future and here is the chance to do it," Leonard told Earle Birney.[11] Toronto architect Steven Irwin, who had remodelled the Silvermans' 140-year-old stone farmhouse, did several draft sketches of a studio with living facilities where the Brooks could stay for half the year. The construction would cost $15,000. Appealing as it was, Leonard decided against it six months later. "The 'affluent society' is a bit frightening – and where I could fit into it if I do come north again," he wrote in his diary.[12] In lieu of payment, Leonard gave Irwin a watercolour that he liked so much that he later bought a collage.

The Brooks' possible return to Canada, even on a limited basis, pleased Esther Birney, who thought this would be good for both Leonard and Reva. "... my reading tells me the really good people are rarely recognized in their own time and painting more than any other art seems to be victimized by fashion and by exploiting gallery-owners," she told Reva. "However, we can only live in our own times and Leonard has to do his best with things as they are."[13]

Reva reported to Esther that she was relieved that Leonard was back at the Roberts Gallery and hoped this would be a long-term arrangement. "Leonard is feeling and looking better than ever and is working well – nearly a year since his serious illness of internal haemorrhage and no recurrence of ulcer – actually it seems to have served almost as a 'beneficial' illness," she said. When she mentioned that the Brooks would be remaining in San Miguel year-round after all, she noted, "As someone said to Leonard: 'You don't live in San Miguel, you live in Leonardbrooksland.'"[14]

One of those puff pieces to which Jack Spitzer referred appeared in the January 1969 issue of *Toronto Life*. Written by Shelagh Horne, an article entitled "Toronto's Mexico Colonialists" was an incisive look at the life of the Brooks in San Miguel:

The dean is Toronto artist, writer and musician Leonard Brooks ... Brooks can now look back and declare that he has made as big an impact on the Mexican cultural scene as he has on the Canadian one – or possibly bigger. He created a chamber music group that led to the formation of the world-famous music school at the Bellas Artes. Among the 50 musicians enrolled at the school are many of the promising young Mexicans Brooks introduced to stringed instruments.

Leonard was very pleased with his students when they played in the patio of the fine arts school for Mexican President Gustavo Díaz Ordaz, who was in San Miguel in January for the opening of a public works project.

Jack Wildridge placed advertisements for Leonard's 14 April show in *The New York Times*, as well as in the Toronto newspapers, and sent out 2,800 invitations. Among those at the preview were Helene Mazelow, who bore no grudge about not getting Leonard for her gallery, the Group of Seven's A.J. Casson, Fred Varley's son, Peter, former National Gallery director Alan Jarvis, and Horizon Gallery owner Abe Rothstein, who flew up from Massachusetts. Future Governor General Jules Léger, then the under secretary of state for External Affairs, sent a "best wishes" telegram from Ottawa. From San Miguel came one in Spanish from Will and Mona Allister, "FELICITACIONES COMPADRE MUCHO EXITO," "Congratulations *compadre* great success." Allister obviously harboured no hard feelings from Leonard's denigration of his work.

Without mentioning the fifteen-year gap between shows, Jack Wildridge said in the catalogue notes that Torontonians might remember Leonard's appearances at earlier exhibitions. He said Leonard's works had matured in the interim.

Writing in *The Globe and Mail*, Kay Kritzwiser said:

The painter's eye of Leonard Brooks, whose blazingly vigorous collages are at the Roberts Gallery, has become so keen that he can pounce on a cloth scrap and use it with the cunning of a squirt of oil paint.

In the 70 paintings which attracted a preview crowd of almost 800, Brooks has truly made his collage technique an extension of his palette.

He has been experimenting with collage for the past 10 years. He can mix a shred of corrugated paper, a wisp of tissue, a label from a sauce bottle with a sweep of oil or acrylic, and there it is: a kind of visual journal of his life in Mexico.[15]

Of the seventy paintings, forty were sold opening night and another fifteen within days. Leonard ended up celebrating at composer Harry Somers' home with painter Harold Town until 5:30 a.m. "... fun as in the old days," he told his diary.[16]

After a fifteen-year absence from the Toronto art scene, Leonard Brooks was back.

~ 47 ~
You have so much to be talked about

When Reva Brooks returned from Toronto, she realized that the triumphant show at the Roberts Gallery was due in great part to the sacrifices she had made to her photographic career. She soon found herself back in a state of deep depression and again she turned to a notebook to express her feelings:

Now on our return from Toronto, I have been having these distressing feelings again of depression and deep dissatisfaction with some of my attitudes and actions and must do everything I can to reveal them to myself and try to correct them.

Some of the most distressing times we have spent both in Mexico and Canada, especially Toronto, have been to do with this lack in our lives of a dealer to look after showing the paintings. We have had to spend too much time ourselves in this regard, and I have taken it upon myself to do much in every way – contacts, showing, arranging, etc. etc. I could not seem to devote myself to my own work while this situation existed ... I've got to come to grips with myself and start my work again in photography.[1]

Reva expressed her regret that Leonard had been "bogged down" for so many years doing watercolours, although she conceded they were "brilliant." "But basically he had, he has the real 'goods' and thank God it has been able to emerge and will continue to emerge." She continued:

What I can't get used to and is upsetting, is the choleric temper flare-up which occurs every so often, directed towards me or whoever. It usually happens after drinking. Someone makes a remark which he construes as an insult and away he goes, eyes flashing, nose flaring, ranting about a remark which he usually magnifies beyond anything. This happened once in Toronto at [the CBC's] Rita and Bob Allen's house in a

conversation with Spencer Clark of the Guild of All Arts at the dinner table. Leonard in a touchy, nervous mood reacted violently to some remark about 'smug' – a violent outburst, diatribe, injured feelings, a great emotional explosive release which seems to have to run its course, no matter how anyone tries to reason with him. It has been directed at me many times throughout the years, usually in the evening while we are eating. Even if there wasn't a reason for his anger, his need for explosion would have to create one.

Reva revealed that on a stopover in New York Leonard had another flare-up, this time at the home of Letitia and Frank Echlin at 164 East 74th Street. Canadian-born, Echlin for twenty-five years was the head of neurosurgery at the Lennox Hill Hospital. He was one of the specialists summoned to Dallas after the shooting of President John F. Kennedy in 1963. The target of Leonard's anger was the Echlins' daughter, Johanna, known as Joey, then a university student.

"Leonard had a reaction I'd never seen before," Joey recalled. "He got very upset and went running out of the house, yelling. What he was yelling, I don't know but he was very emotional." Joey said she had argued with Leonard about happiness, love, and passion; he had insisted one had to have a creative activity in order to be happy. A psychotherapist by training, she later looked at the incident from a professional viewpoint: "I was wondering about Leonard's frustrations in his own relationships, in his own love life, in their lack of children, etc. He would have to defend the passionate outlets that he did have. I understood that I had touched a very sensitive chord that he had to defend very strongly, which brought on his emotional outburst. Such as the choice of his wife; she's a fairly aggressive lady."[2]

Upon her return to San Miguel, Reva felt unwell physically as well as emotionally. She soon discovered why: like Leonard, she now suffered from an ulcer, although it was not serious enough to require hospitalization. The depression and worry were obviously taking their toll on her.

Reva agreed with advertising executive Jack Spitzer that as good as sales were at the Roberts' show, publicity had been lacking. Publicity was not Jack Wildridge's strong point, nor was it Leonard's. "All the important things were good, but we didn't do anything about getting publicity," Reva told Esther Birney. "It would have been gratifying, but there needs to be a launch, and we didn't get [to Toronto] much before the opening. Several television interviews and a review – but word of mouth by discerning people on excellence and quality made up for it."[3]

"In my judgement your publicity should have started sooner and should have been deeper and wider," Spitzer told Leonard. "You, Brooks, don't seem to realize it, but take it from an old publicity man, you have so much to be talked about. From now on, don't be so bloody bashful. Talk about your Mexican music for the little ones. Talk about your artist friends all over the world, and what they say about your paintings. Talk about your writing, etc., etc."[4]

Leonard anticipated publicity in Toronto when he received a letter from the Canada Council, sent on the eve of his fifty-eighth birthday. It read:

Dear Mr. Brooks:

We, of the Canada Council, take great pleasure and pride in writing to inform you that you have been chosen as the recipient of this year's highest award in the Arts: The Batik Banner of Honour. We are doubly pleased that this award should coincide with your natal day.

While the choice was a difficult one, for there were many fine candidates in every field of creative artistic endeavour, in contention, we are happy to say that the committee has made you the final choice by a wide margin. You may appreciate the magnitude of our decision by the fact that such illustrious Canadian names as Harold Town, for creative writing; Chicho Vallee, musicologist; Don Messer, violinist; Honest Ed, patron of the arts; Charles Goldhammer, artist, were submitted for our consideration. Our congratulations to you.

Speaking personally I would like to add my own congratulations to you and your dear wife, Niva, upon receipt of this coveted award. I can safely say that I have always been one of your most ardent boosters and, when you are next in Canada, I would like to commission you to do my portrait, to be hung in the Council boardroom. I trust that you will be able to work this into your very busy schedule as I understand that you are going to write a book about art or sculpture.

Our warmest best wishes to you as one of Canada's up and coming young artists.

Yours artistically

Gordon Sinclair

Chairman, Canada Council

Well before Leonard reached the end of the letter, he realized it was a hoax, probably perpetrated by his good friend York Wilson, who somehow had obtained Canada Council letterhead. Leonard never mentioned the letter to anyone. The chairman at the time was Jean Martineau, not Toronto journalist Gordon Sinclair.

A letter that did please Leonard was one containing the news that his sixth art book, *Painter's Workshop*, had been selected Art Book of the Month and

2,500 copies were ordered. "Trying to imagine 2,500 books piled up at one time," he wrote in his diary.[5] Leonard was especially proud of *Painter's Workshop* because he had convinced the publisher to put inside the back cover an envelope containing a year's study plan for the serious reader.

There was a copy of *Painter's Workshop* lying on a table when artist Fred Taylor dropped by the Brooks for a visit. Taylor ignored the book. "Book on table – large as life – chat and small talk – without glancing over it,"[6] Leonard noted, saying he was "annoyed" with Fred.

Leonard would soon have reason to feel more than annoyed with Fred Taylor.

No Joking Matter

Fred was not a man who would weave or avoid a punch

Those who knew artist Fred Taylor best inevitably used the same three words to describe him: a perfect gentleman. Frederick Bourchier Taylor would not have wanted it any other way, nor would his upbringing have permitted him to comport himself otherwise. There was one man who knew how to pierce the genteel armour of Fred Taylor: Leonard Brooks. For Leonard, Fred enjoyed all the advantages denied him: family wealth, respectability, refined upbringing, university education, and even a scholarship to study abroad. "Most people have to struggle to overcome, compared to Fred, who had everything presented to him on a platter," Leonard said. "He could do anything he wanted to do." Yet the envy was mutual. Fred wished he could have experienced Leonard's carefree bohemian days and enjoyed life the way Brooks seemed to do. Taylor once lamented, "A candid real friend, an astute observer, said to me, 'The moment you realize that you are enjoying yourself you feel guilty.' This is true, and very hard to overcome."[1]

The money that permitted Taylor's privileged upbringing in Ottawa's then exclusive Sandy Hill came from his mother's side of the family. His maternal grandfather, Charles Magee, an entrepreneur who founded the Bank of Ottawa, could have retired in his early thirties but branched out with other investment opportunities. The Taylors were descended from a military family – Bourchier – that boasted generals and admirals going back to the Norman Conquest of England in 1066. Fred's father, Plunket, married Florence Magee and went to work for the Bank of Ottawa, a job arranged by his father-in-law.

Frederick Bourchier Taylor was born in Ottawa 27 July 1906, almost six years after his brother, Edward Plunket Taylor, better known as E.P. The elder brother used the family's controlling interest in the Brading Brewery as the springboard to become one of Canada's wealthiest men and a horse breeder whose "Northern Dancer" won the 1964 Kentucky Derby. As president of the Argus Corporation, E.P. controlled, among other companies, Dominion Stores, Massey-Ferguson, Hollinger Consolidated Mines, Canadian Breweries, and the Dominion Tar & Chemical Co.

Previous page: A sketch by Leonard.

Not surprisingly, given the family's military background, Fred recalled a life at home where everyone obeyed the rules. "My paternal grandparents, particularly my grandmother, were terribly proud of their family. Their guiding precepts were: public opinion – you must keep your nose clean at all times and be the pillar of society; respectability and security; and the church. My father's guiding principles were community service, public opinion, respectability, and financial security. It didn't matter whether you were wealthy or not, you must not only be a good citizen, you must not have anything said about you. What people said was of terrific importance."[2]

Both Leonard and Fred spent childhood years in England during the Great War. Since Nell knew few people in Canada, Corporal Herb Brooks took his wife and young son back to England in 1916; Plunket Taylor, a colonel and second-in-command of the 77th Battalion, took his wife and sons with him because that was a right then enjoyed by officers. Fred and Leonard lived for a while within miles of each other in Enfield, where Plunket left his family with friends while seeking living accommodation. Both boys returned to Canada speaking with a British accent, for which they were teased and called sissies. Faced with beatings in the schoolyard, Leonard sought solace in painting and music. Fred chose to challenge his tormentors by beating them in sports.[3] He became a football player, international competitive skier and, at six-foot-two, intercollegiate heavyweight boxing champion of Canada while an architectural student at McGill University. Taylor had a lifelong trait of never giving in to adversity, the exception being his last conscious act. Harry Mayerovitch, later a Montreal architect, painter, photographer and writer, recalled witnessing Fred's loss of his heavyweight title in a fight at the McGill Union against University of Toronto boxer Harry Hills. "I have never seen a man take so much punishment; it was almost suicidal," he said. "Fred was not a man who would weave or avoid a punch. He never retreated. He would take everything head on and return in kind. That was his nature, all his life. He never avoided anything."[4]

Taylor graduated as an architect from McGill in 1930, winning the Lieutenant Governor's medal for top achievement in the "professional practice" of architecture. As well, he won a $1,500 scholarship to study at the Sorbonne in Paris. He also studied etching at the London Central School of Arts and Crafts and at the Byam-Shaw School in England, overlapping at one point with Leonard in London, although the two young men did not meet there. During the 1934 Easter break, Fred captained a team in a skiing competition in Italy while Leonard was trying to get together boat and train fare to go to Spain.

Taylor made three major decisions in 1936: he married his first cousin, Miriam Magee, who also was studying at the Byam-Shaw School, he became

interested in communism and he started painting in oils. On the one hand, he was striving to maintain the family posture by marrying one of its members; on the other, he was rejecting his family's entrepreneurial interests, especially those of his brother. Having business acumen, E.P. was clearly his father's favourite. Many years later, the author had occasion to take to San Miguel a pair of shoes that Fred had specially made in the United States. "The only exercise I can get now is walking," he said, explaining the need for good shoes. He then patted his knees and said, "I ruined these in sports trying to show my father I was as good as Edward."

"Fred Taylor never let on or wanted to be reminded of being E.P.'s younger brother," said Walter Klinkhoff, Fred's Montreal art dealer. "It was best not to mention E.P. to Fred ... Fred was in my estimation one of the best etchers and print makers Canada ever had and he was also a fine painter. E.P., the great business tycoon, may one day only be remembered as being Fred's brother."[5]

"I think his brother was far too well known a figure for Fred," said Noreen Taylor, wife of E.P.'s son, Charles, who was very close to his uncle. "He felt that the world did not give him the respect and attention he deserved and the world, of course, reflected the family, the approbation that was freely given his brother as a man of business."[6]

Fred's marriage to Miriam was one and the same as his embrace of communism since the couple shared common political beliefs. The catalyst was the start of the Spanish Civil War, the same year as their wedding in London. The Taylors were active in raising money to aid embattled Republicans supported by Russia. Fred was a friend of Norman Bethune, the Canadian doctor and Communist Party member who pioneered battlefield blood transfusions during the war.

The newlyweds returned to Canada in 1937 and Fred set himself up in Montreal at 4136 Dorchester Street as a portrait painter. The following year he and Miriam joined the communist movement where they participated in behind-the-scenes activities with like-minded intellectuals in Montreal. Merrily Weisbord, in a 1983 book on Canadian communists, placed the Taylors in an elite, secret cell – Section 13 – organized by Fred Rose, a communist Member of Parliament later found guilty and imprisoned for giving official secrets to a foreign power.[7] One of the subjects of a Taylor oil was Tim Buck, leader of the Canadian Communist Party.

By 1940, Fred was on the faculty of his alma mater, teaching drawing to architectural students. He had also achieved his ambition of going into the factories and other places in Quebec and painting workers involved in the war effort.

*Fred Taylor, photographed in 1964 by his son Jeremy, profes-
sional photographer whose first teacher was Reva.*
PHOTOGRAPHER JEREMY TAYLOR

After Plunket Taylor's death in 1944, Fred no longer had any financial worries. "I was left with a private income that allowed me greater freedom," he said.[8] As welcome as the guaranteed income was, Fred had problems in the offing. Miriam left him in 1951 and later married Gordon Lunan, a reporter for the Canadian Wartime Information Board who had spent five years in prison for spying for Russia. Lunan was fingered by Igor Gouzenko, a Russian embassy cipher clerk in Ottawa who in 1945 defected after copying over one hundred documents showing the West's wartime ally had been spying on them. The year after the breakup of his marriage, Fred would be diagnosed with arthritis. He was forty-five.

A 1954 trip to San Miguel to visit the Brooks led to his meeting Nova Hecht, daughter of American painter Zoltan Hecht and a painter herself. They were married the following year and visited San Miguel regularly until deciding to settle there in 1959. The deciding factor behind the move was the realization that the warm, dry mountain air eased the arthritic pain in Fred's hands that had been inhibiting his painting. He became so relatively pain free that he was able to take up sculpting.

For the previous quarter of a century Leonard and Fred had been friends, keeping in touch by mail if unable to meet personally. But the social intimacy of a small town like San Miguel proved their undoing.

How's the hunting, Fred?

Unlike Leonard Brooks, Fred Taylor suppressed his emotions. If he had an acceptable outlet for his anger, it was sports. But as his arthritis worsened, even this was denied him, until he discovered shooting and hunting, thanks to Leonard. During his visits to San Miguel, Taylor had learned that Leonard, Stirling Dickinson, Jimmy Pinto, and Jim Hawkins were avid hunters, although Leonard said for him the outings just represented an opportunity to get together with the boy and see the countryside.

Now, as he planned to settle in San Miguel, Fred asked Leonard's advice on what type of gun and ammunition to buy. "I have a Remington 'Wingmaster' five-shot repeater – standard, I think," replied Leonard. "I think you can get it in a 12 gauge – mine is 16. I would bring in some Super Express No. 4 and 6 shot."[1] Fred did not buy a Remington but on impulse for fifty dollars purchased a second-hand Stevens five-shot, 12-gauge shotgun with which he did some target practice. He reported the results to Leonard: "I set up a big old carton and fired a few rounds at 40 yards and a few more at 25 yards. The gun seems accurate and very powerful. There won't be much more than feathers left of anything in the direct line of fire at 25 yards and the spread of shot at 40 isn't as great as I figure I'll need to wing something at greater distances. Anyway, at age 52 I've now fired a shot gun!"[2]

Although Fred was not close to his brother, he obviously told Edward of his new interest in shooting and hunting. E.P. Taylor was not only a hunter but was one-third owner of a private hunting preserve, the Two Island Club at Lac Edouard, 190 miles northeast of Montreal. He told Fred to use the club. "Believe it or not – I've shot two ducks! And wounded a couple of others," Fred enthusiastically reported to Leonard from the club. "One was a fine fat Black one and we had it for dinner last evening and it *was* good!"[3] On his next four outings, he bagged a duck on the wing each time. "The fourth time I was with a retired British Army general and another man of long and wide shooting experience," he told Leonard, as if seeking his approval. "Only one shot was fired, mine, and it was after they'd both passed up the passing bird and they'd advised me it was out of range. The general sportingly called out, 'Good shot!' The other fellow later said, 'That must be a pretty good gun you have.'"[4]

Besides the shotgun, the items the Taylors packed for their move to San Miguel included the tools of Fred's profession, for he planned one final

building project: a dream house. He found a property at No. 49 Sollano Street, in the colonial heart of San Miguel, cleared off the ruins on the site and designed a house that followed the contours of the sloping property, with floors at different levels. On the sunny, second level he built his-and-her studios for himself and Nova. The large, landscaped garden in the rear contained an area for the bird dog Fred bought to take hunting. Fred and Nova moved into the house with its red brick, *bóveda* ceiling in April of 1960 and started their painting and the social activities so dear to most San Miguel residents.

The clinical neatness of Fred's studio was subject of comment, but he would be the first to admit it was so. "I abhor clutter and like to keep the floor as clean as I can," he conceded. Sylvia Samuelson, owner of the Galería San Miguel, likened Fred's studio to a surgical operating room. "Everything was perfect," she said. "I don't think he ever dribbled one drop"[5] When Fred taught Eldon Grier how to etch, he said Taylor had him wear "a sort of surgeon's gown" before they entered his Montreal studio. "He was very immaculate in everything," Grier said.[6]

Bob Maxwell, the artist and store owner, dropped by the Taylor house one day and found Fred wearing not a surgeon's gown but an apron. "He was polishing his hunting boots," said Maxwell. "I asked if he'd just come back from hunting." 'No, Bob,' he said. 'We're just going out.' This was the way Fred was."[7]

Taylor took his hunting very seriously, buying all the literature he could find on the subject and consulting fellow hunters in San Miguel. Jimmy Pinto, art teacher at the Instituto Allende and known as the best shot in town, took Fred under his wing. But soon the student was as good as the teacher. Jim Hawkins, who called Fred "a good shot, a natural sportsman," had an explanation for his prowess. "A friend of mine named Norman Schmidt had a theory about artists. We were always wondering why the artists we knew were good shots," he said. "Norman thought it was because artists had a sense of faith and co-ordination which would tend to make them good shots."[8]

Taylor started a collection of shotguns, buying a Drilling over-and-under, a Czech-made Bernal, a Fox double-barrel and his pride and joy, an Italian-made Franchi, which then cost about $1,000. "At least three times a week as the sun cools Taylor will change clothes, grab one of his six shotguns, push his favourite dog into his station wagon and drive out into the countryside to hunt for rabbits, quail, ducks, and doves," said one newspaper account.[9]

While hunting was Taylor's release, painting was his vocation, and as with his hunting, he sought out his peers for advice, guidance, criticism, and recognition. He turned to Leonard and York Wilson, both of whom were then

involved in abstract expressionism. "He was a good etcher and silkscreen man," said Leonard. "York and I tried to help him get beyond being literal, but he never could break away from his architectural thinking, which was his strength. He couldn't understand what abstract painting was about." "They thought he was a dodo. They made it quite clear and Fred was terribly hurt,"[10] said Letitia Echlin, a San Miguel winter resident who had been the bridesmaid at Fred's first wedding. "It's not that he wouldn't experiment, he couldn't," said Fen, Fred's third wife. "He painted very well what he saw, but he saw what was there. There's a certain creativity that an artist might have or might not have, and he didn't have it."[11]

"Leonard couldn't stand Fred Taylor's painting," said Will Allister, whose own works did not meet with Leonard's approval either. "Fred had a real complex about not being accepted anywhere, being looked down on, this contemptuous attitude people had towards him."[12]

Yet Taylor never wavered in his admiration and respect for Leonard Brooks, the painter, even if he found fault in Leonard Brooks, the man. Leonard, five years his junior, was already a father figure among younger artists in San Miguel, and, like them, Fred longed for his approval, just as he did from his own father, Plunket. "What a prolific worker he is!" Fred told Toronto artist Yvonne Housser. "He turns out so much and did a tremendous body of work in Europe and what I have seen of it I consider to be very, very good. He is a master of collage, colour, texture, and design and, I would say, almost great – I would leave out the adjective but for his intolerance in respect of lesser talents and lack of outward or apparent humility – though I believe he is inwardly actually quite humble."[13] Taylor's reference to "lesser talents" was obviously to himself. He made a plaintive plea for Leonard's friendship in a letter he wrote to the Wilsons: "I need not say that Leonard is a very good painter – maybe he could be described as a great painter, but I would not say so for greatness, I believe, surely implies greatness as a man and that implies a great capacity for friendship – including sharing with friends."[14]

For this tall, handsome, charming man who could trace his roots back nine hundred years to the battlefields of England, his nemesis became two men from the wrong side of the tracks, culturally speaking. At one point, the innocent gibes of Leonard Brooks and York Wilson stopped being funny for Fred, even if they did not realize it. "Fred Taylor was a very modest man apt to belittle himself," said Taylor's Montreal dealer, Walter Klinkhoff. "This way he was a perfect target for overbearing rival artists."[15] E.P.'s son, Charles, who was often closer to his uncle than to his own father, said that Leonard and York used to "bully" Fred, figuratively, if not literally, for the powerfully built Fred

Reva and Toronto sculptor Fred Powell, a man with a biting wit.

towered over both men.[16] "Leonard and York used to poke at him, try to get him going," said Eldon Grier, whose friendship with Fred dated back to the 1940s.[17] Helen Watson, widow of Syd Watson, principal of the Ontario College of Art, said Leonard and York were "naughty" with Fred. "They would sort of think, 'Let's gang up on Fred,' and would do it. Fred was rather a gullible man and he wouldn't quite know what was happening."[18] The two were sometimes joined by Toronto sculptor Fred Powell. "They played cruel jokes on him," said Lupe Powell, Fred's widow. "I didn't approve of it."[19]

On the evening of 31 July 1962, Earle Birney gave a poetry reading at the cultural centre at the fine arts school. As they left the building after the reading, Fred Taylor slipped his arm through Leonard's, a common sign of male friendship in Latin America that he had picked up in his three years in Mexico. Will Allister, walking behind them, overheard Leonard ask Fred, "How's the hunting, Fred?" "In Fred's mind, this question must have seemed to him like, 'they see me as a hunter and not an artist,' for he threw Leonard's arm away from him and walked off in a huff," said Allister.[20] Leonard noted the incident in his diary: "Fred Taylor crying when I asked innocently 'How's the hunting, Fred?' Inward hurt because 'That's all I ever asked him.'"[21]

Jim Hawkins, whose wife ran the cultural centre, recalled another incident in the 1960s when he was seated beside Fred at a theatre production. The Brooks took their places several rows in front of Fred. Leonard turned and, in

a loud voice, asked, "Heh, Fred, how's the shooting?" Fred said nothing, but at intermission he approached the Brooks and told Leonard he was being mean. "I didn't understand it, why he was so angry," said Hawkins, who asked Fred what the trouble was. "He always asks me about hunting," Fred replied. "He should ask me about my painting."[22]

On 4 December 1969, Leonard and Reva ran into Fred on the street. Again Leonard asked, "How's your hunting?" This time Fred broke into tears and sobbed, "You never ask about my painting."[23] Despite the incident, the two men agreed to go quail hunting five days later with Fred Bernstein, a Hamilton, Ontario, businessman and amateur sculptor then living in San Miguel. Taking Leonard's car, they drove seven miles north in late afternoon towards Atotonilco, a favourite place for painting because of its colonial church. Bernstein had never hunted before, so Fred had loaned him a shotgun. On the way, they stopped and Taylor set up a target so that Bernstein could get in some practice before the hunting started. Then he showed Bernstein how to lead a bird in flight, anticipating where the bird will be when the shot hits it. Returning to the car, they drove further down the road and then parked alongside it. They walked through dry, foot-high grass and thistles towards a hill a couple of hundred yards away. Then the three men split up. Bernstein walked to the right around the base of the hill; Leonard started up the hill past ageing nopal cacti and stunted mesquite trees; Taylor hung back.

The author later retraced Leonard's steps, ducking under strands of barbed wire at roadside and gathering thistles on his stockings and pantlegs as he waded through a field unchanged and uncultivated in three decades. When he was twenty yards up the hill, the author stopped where Leonard had, turned to his right as Leonard had done at the last instant, and looked down at where Fred Taylor would have stood. What was surprising was how close the two men were as Leonard looked at Fred, who had one eye closed, the other squinting along the sight line of his swiveling, 12-gauge Franchi shotgun. The last thing that Leonard remembered were the barrels pointing at him as Fred squeezed the trigger. Leonard slumped bleeding to the ground, shot in the face and upper body.

Fred Taylor shouted for Bernstein and the two of them half-carried Leonard to his car. Back in San Miguel, they drove Leonard to the office of Dr. Olsina, but Paco was on vacation. They found another doctor, named García, on San Francisco Street. The doctor counted eight No. 6 pellets in Leonard's face and more than a dozen in his chest and right arm. More were imbedded in or deflected by the heavy canvas hunting cap Leonard wore.

Other buckshot shattered and bounced off his glasses. His right eye was bruised. García gave Leonard a sedative and tried to remove the pellets but ended up leaving most of them in his face. Leonard believed the lead from the pellets caused the facial skin cancers which, for the rest of his life, had to be removed periodically. Bothered by his teeth, Leonard went to a dentist who discovered a pellet imbedded in his gums. It was cut out. Months later he was still complaining of soreness in his arm.[24]

There is little doubt that Leonard could have been killed.[25] Had Taylor been a bit closer or if the shooting had occurred earlier in the day, death would probably have been a certainty. As the shooting took place late in the day, the buckshot cooled more quickly than it would have in the daytime heat and hit with less penetrating power. Leonard, who was in and out of consciousness, believed Fred might have mumbled that he had been following a flight of quail when he pulled the trigger. But a hunter as well versed as Fred then was would have known better than to shoot uphill, given the difficulty of determining the flight path of birds when earth and not sky is the background.

By the time they left García's office, the three men and the doctor had agreed that no report would be made to the police and that no one would be told of the shooting. As far as is known, Taylor never mentioned the incident, nor did it ever come up in conversation with the Brooks. Fred ran into Reva on the street a week after the incident and told her he had just been shooting again. Like the fallen rider who immediately remounts his horse before losing his nerve, Fred wanted to make sure he was still capable of firing a gun. Leonard never again went hunting nor picked up a shotgun.

Within weeks of the shooting, Leonard told three of their mutual friends what had happened: Frank Echlin, Fred's friend since grade one, Eldon Grier, the Montreal poet, and York Wilson. "It was always portrayed to us as an accident, but we knew there was a motive behind it," said Letitia Echlin. "Fred was a man of tremendous feelings and passion, wild, almost an impeccable exterior, English gentleman. But there was this raging fiend within him."[26] The Griers thought likewise. "Gut reaction. Bang! He had received so many barbs from Leonard," said painter Sylvia Tait, Eldon's wife.[27]

When, many years later, Fen Taylor was told of the incident, the author suggested to her that Fred might have subconsciously shot Leonard. "I don't think that Fred did things subconsciously," she said.[28] Before knowing about the shooting, she used the word "rage" to describe Fred's feelings toward Leonard.[29]

"There was some great anger within," said Noreen Taylor, Charles' widow, upon learning of the shooting. "This great gentleman in spirit had to shoot out

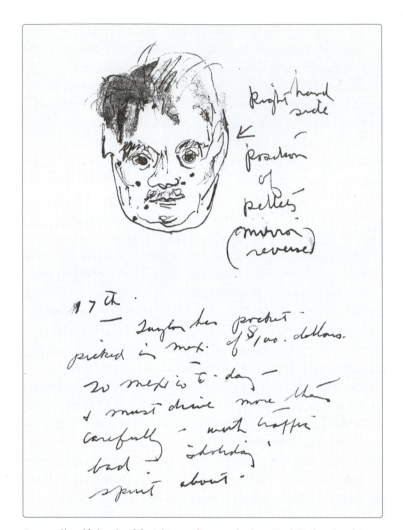

Leonard's self-sketch of facial wounds caused when Fred Taylor shot him while quail hunting in 1969.

of anger."[30] Charles had been told of the shooting by Leonard but did not tell his wife.

John Bland, an assistant to the director of McGill's school of architecture when Taylor taught there, was unaware of the shooting when he said, "One did not fool with Fred Taylor."[31] While friends and colleagues recognized Taylor's anger, Fred himself told them that he gave up boxing because he lacked a killer instinct. "Of all of the people I knew, I thought he was one of the ones who had [the killer instinct]," said Joan Roberts, widow of his good friend, fellow painter Goodridge Roberts.[32]

Perhaps Harry Mayerovitch, who knew Fred for almost sixty years, put into perspective this Canadian drama that unfolded in the Mexican countryside: "Fred had a suppressed violence. We always felt he had something bottled up that wanted to explode. Leonard had to get rid of some of his hostilities and Fred was an easy target, I guess. Isn't that sad. Imagine, poor Fred, moneywise having no problems, having a certain amount of recognition, still being very unhappy. He couldn't get the things he really wanted. I guess a psychologist would say he needed his father's approval."[33]

And Leonard's approval. He received neither. So whose broad back appeared in Fred Taylor's gun sight that late afternoon in December?

While Leonard believed there was intent behind the shooting, Reva tended to ignore the incident, because she genuinely liked Fred. Like so many of the ladies in San Miguel, she was captivated by his courtly manners and gentlemanly charm. As a result, the frequent dinner invitations exchanged between the Brooks and the Taylors continued. Since the shooting occurred on the eve of the Christmas season, Leonard could not avoid the many social appearances. He wore sunglasses, put Band-Aids over the pellet holes and explained he had been in an accident. That was how he appeared on 22 December for dinner at the Taylors. Ironically, the main course was duck, shot by Fred. "Lousy duck dinner," wrote Leonard.[34] He often penned derogatory notes about Taylor in his diary. "What a dope he is at times." "I know I'm in for a dull time." Fred, for his part, would be his usual polite self at a dinner or party with the Brooks in attendance, but he came home ranting about Leonard. "Fred always returned home up-tight and angry about something that was said or done by Leonard," said Fen.[35]

Despite the benevolent climate in San Miguel, Fred's arthritis worsened, even though he always looked robust. Eventually he was unable to hunt and sold all his guns except his favourite, the Franchi.

Taylor's marriage to Nova also deteriorated, and in 1980 she left him and moved in with the Echlins. But the following year Nova was diagnosed with liver cancer and they reunited for the final year of her life.

Taylor had already met Elinor (Fen) Lasell, a German-born, American-raised illustrator of children's books who had moved to San Miguel after a divorce. Twenty-four years his junior, Fen married Fred in February 1983, six weeks after Nova's death on Christmas morning. When Leonard met her, he said she reminded him of another German-born woman, Helga Overoff, his good friend during his war artist period in London.[36] "Fred was married and his wife Fen seems to be very congenial for him," Reva wrote to the Wilsons. "It augurs well for the future."[37]

Fen had planned to fly to the United States for the 1987 wedding of her son and discouraged Fred from accompanying her as his behaviour had become erratic of late. Because of hip surgery the previous year, he often needed the use of a wheel chair when travelling.

Reva jotted down on the back of an envelope what happened before Fen's departure for the wedding:

A gentleman to the end, Fred Taylor, still in his pyjamas, between 8:00 and 9:00 a.m., Tues. April 21, 1987, turned off the coffee on the stove and told his wife Fen that he would have it later. He had been upset and nervous since the night before, had been looking for his keys that morning. Then he went into the garage and got his shotgun and shot his head off through his mouth. Certainly he had been in a crazed state since the night before, had not slept well, and Fen had forebodings. He was deranged at the thought that she was going to leave him for a trip up north. He wanted her nearby all the time.

Fred had taken the same gun with which he had shot Leonard, put the barrel in his mouth and with his long arms and fingers reached down and pulled both triggers.

The author and his wife were houseguests of the Brooks at the time and were in the kitchen having breakfast with them when Fen called. Reva returned to the kitchen and announced Fred had died in a fall in his home. "Poor Fred," Leonard said. By the time of the interment the next day, everyone knew it was a suicide.

An unbeliever, Taylor had not wanted a funeral service of any kind, but Letitia Echlin, also an unbeliever, had insisted with Fen. "You can't just stick him in the ground with no attention paid," she said. That afternoon, there were perhaps forty people, dressed in their finery, in the foreigners' corner of the dusty San Miguel cemetery, divided in two generational groups, those who knew Fred, and the friends of his widow. Frank Echlin recalled his friendship with Fred going back to primary school. Linda Keogh, a Canadian puppeteer and long-time San Miguel resident, said a few words. Then Letitia Echlin, a former actress, read an eulogy from Act IV, Scene II of Shakespeare's *Cymbeline*.

> Fear no more the heat o' th' sun,
> Nor the furious winter's rages;
> Thou thy worldly task hast done,
> Home art gone, and ta'en thy wages.
> Golden lads and girls all must
> As chimney-sweepers, come to dust.

Leonard did not speak at the brief service, but that evening he wrote in his diary: "A strange ending to the Fred T. life – and when I think how I was shot in the face by him in the hunting 'accident' – and survived."[38] After the shooting, Leonard never again asked Fred how his hunting was going.

∼ *50* ∼
Things continue to work out well for us here

A week after the shooting, Leonard patched his face to hide his wounds, donned sunglasses and drove Reva to Mexico City for a reception at the Canadian embassy in preparation for her first, major photographic show. As the embassy did in Leonard's case five years earlier, it agreed to co-sponsor along with the Mexican government a show at the Palace of Fine Arts. Reva was nervous and apprehensive about the show, becoming angry with Leonard when he joked about it in a vain attempt to get her to relax.

Featuring one hundred photographs, mainly from the 1947-50 period, the show opened 10 January 1970 to excellent press reviews. *Novedades* art critic Jorge J. Crespo de la Serna gave Reva the ultimate accolade, likening her to famed French photographer Henri Cartier-Bresson, a leader in modern photography.[1] The weekend supplement *Revista de la Semana* said: "It is really surprising the sensitivity of the Canadian photographer Reva Brooks in capturing the faces and scenes of provincial Mexico."[2] Mexico City's *News* critic Toby Joysmith, himself a painter, said of the show: "Nearly all of her beautiful prints refer to the illustration of a mood or an emotion."[3] J.C. Schara of *México en la Cultura* wrote: "Mrs. Brooks, even though she arrived late to the marvellous world of photography, manages to show us, with great sensitivity, findings of great artistic value in the different faces that she captures on film."[4]

But the greatest accolade came from Rufino Tamayo, the leading Mexican painter of the day, who wrote in the catalogue notes:

To those who think that photography is merely the mechanical recording of images, the contemplation of the work of this outstanding photographer must inevitably be a revelation leading often to instant conversion.

Those of us who are aware of the importance of photography as a modern medium of expression, find in her admirable work a convincing affirmation of this.

A true artist, Reva Brooks subjects the machine to the dictates of her sensitivity, making use of mechanical precision to accentuate the nature of her subjects, giving them a poetic quality of unsuspected depth.

In evidence of this we have her studies of different types of the people of my race in which she has managed to capture in masterly fashion all the shades of expression from youthful expectation to the faithful portrayal of Mexican tragedy.

Her photographs are living records which speak to our hearts and make us feel the joy of living as well as the intense suffering of death. This is why they will endure.

After closing in Mexico City, the show moved in February to the fine arts cultural centre in San Miguel, but Leonard reported to Earle Birney that the "raves" did not translate into sales in either venue. After receiving the catalogue from Reva's show, Earle replied, "It was wonderful to see those tremendous photographs strung together at last, Reva – it should have happened 25 years ago, and been the precursor of many more. But that can still be."[5]

If Reva's sales were non-existent, Leonard's were booming. He reported that the Roberts Gallery had sold fifty-five of his paintings the previous year, including fifteen old ones dating back to the 1930s. "Maybe I'd better just learn to paint old vintage Brookses and age them a bit ... hardly any left at all now," he told Birney.[6] Besides the sales at Roberts, the Horizon Gallery in Massachusetts sold fifteen works and he sold thirty out of his studio, bringing the total for 1969 to one hundred, his best year to date. As well, he added two new galleries during the year, Wallack's in Ottawa and the Kensington Fine Arts Gallery in Calgary, Alberta, although neither had reported sales when he made his calculation.

Despite the critical success of her show, Reva dropped into depression and again had recourse to a notebook diary. "Have wanted to write here for some time now, passing through another bad time of almost engulfing depression,"[7] she wrote. "After a very strenuous few months of getting my photograph exhibition on, all the work with the catalogue, the many trips to Mexico, EVERYTHING that has gone into the whole thing, because of various and complicated reasons, I have been feeling very down for weeks." The reasons included her renewed desire to buy a property and build a new house and an independent studio. Leonard did indeed need a new studio because he was forced in February to leave the one facing the *Jardín*, or town square, that he had occupied for eight years. He rented another one near Juárez Park, but found it too humid. Leonard was opposed to Reva's plans – "Reva worrying me about building another house here"[8] – and even proposed they move to Cuernavaca, fifty miles south of Mexico City. Cuernavaca already had a small foreign art colony and Leonard had an occasional dealer there, Sam Renel.

During the nearly quarter of a century that the Brooks had lived there, San Miguel had changed greatly, having been discovered by, among others, hippies. *The New York Times* reported that some of the town's bearded artists now appeared clean-shaven so as not to be confused with the hippies, mainly American but including some from France. The hippies took over the Cucaracha bar, long-time hangout for American and Canadian artists, who felt displaced. Mayor Antonio Gil attempted to discourage the hippies by having the police forcibly cut their long hair. Occasionally he would personally wield the shears, drawing plaudits and even financial contributions from appreciative members of the foreign community. When an American doctor attending a psychiatrists' convention in Mexico City went to San Miguel to complain that his son's hair had been cut when he was visiting the town, the police cut the father's hair too. Periodic roundups would be made of the most obnoxious hippies and they would be deported. "Americans here find the presence of hippies embarrassing," said the *Times*.9

Not only hippies but also their predecessors – beatniks – found a haven in San Miguel. Neal Cassady, the model for the hero of his friend Jack Kerouac's novel *On the Road*, brought a degree of notoriety to San Miguel in 1968 when he died there of exposure after drinking *pulque* and taking Seconals. He had told a lover with whom he was staying that he was going to walk to Celaya, counting the railway ties on the fifteen-mile route, to pick up a bag he had left at the train station. A group of Indians found him the next day by the tracks a mile-and-a-half outside of San Miguel. Comatose, he died later that day in a nearby hospital.10

San Miguel authorities would periodically seek the deportation of even permanent residents deemed undesirable, an immigration death sentence as the deportees could never again legally return to Mexico. The largest roundup occurred 3 April 1960 when sixteen foreigners were deported, some of them in night clothes after being rousted out of bed. "They made a list of customers of the Cucaracha bar," said San Miguel resident Tom Andre, whose mother, Georgia, was deported, even though she had immigrant status and ran a beauty shop. Agents from *Gobernación*, the same ministry responsible for the deportation of the Brooks, put the deportees in station wagons and drove them to the border. They included Canadian artist Jack Wise. Another was a homosexual American businessman. The only one who managed to return was a retired American veteran named Otto Dobbs whose Mexican mother-in-law worked for a year to get the deportation order rescinded. Andre, who was in San Miguel at the time, said the deportations came during a period of anti-Americanism. "They wanted to put the gringos in their place," he said.

"There was a lot of drinking and I think some citizens thought we were wrecking the town."[11]

Despite whatever misgivings Leonard had about staying in San Miguel, he finally agreed to the acquisition of land for a new house. "The best thing really, if we are to continue in San Miguel is to find a large piece of land and build a large studio separate from the house," Reva told the Wilsons. "This is what I have been saying for the past five or more years, but it is just lately that L. is reluctantly coming around to agreeing with me."[12]

Leonard must have voiced his discontent with San Miguel to Jules Léger, the under-secretary of state for External Affairs. The future Governor General said he had contacted York University, among others, to see if Leonard could be a visiting professor.[13] A former ambassador to Italy, Léger also tried unsuccessfully to get a fellowship for Leonard through the Italo-Canadian Institute in Rome.

Jack Wildridge wrote Leonard on 2 July that interest in his works had fallen off. He suggested that Leonard bring up some new works for a show sometime in 1971 in an attempt to revive sales.[14] Leonard replied that he was not surprised as Canadian and American colleagues had given him similar reports about their sales. "Personally I have no complaints, work has gone along well, picture sales and books continue ... and we keep well," he said.[15] Leonard followed Wildridge's suggestion and in the fall took to Toronto new works as well as twenty-four early oil paintings, the last ones he had from the 1937–43 period.

When the Brooks returned to San Miguel, they started plans for a musical trip to Italy by boat with Ken Harvey and other musicians. The result would be a virtual nervous breakdown for Reva, but this time she would seek help.

Troubled Travels

~ 51 ~
How are you Canucks?

It was Ken Harvey's idea. The Sacramento orchestra leader suggested that a group of musicians get together and play music on a slow boat to Italy, via the Panama Canal. Leonard and Reva quickly signed on. But they were unable to go in time to San Francisco, the port of departure for the Italian freighter *Antonio Pacinotti*, so they arranged to board it in Mazatlán, Mexico. They took a midnight taxi to Celaya where they caught a train to Mazatlán and, on 22 February 1971 embarked with four suitcases, Leonard's violin, Reva's camera case and a canvas bag with painting gear. Two other San Miguel couples had boarded in San Francisco, violinist Tom Sawyer and wife Jackie and cellist Michael Bancroft and wife Beryl. They were joined by Harvey, his wife, Marian, daughter Hiliry, aged fifteen, who brought her cello, and two friends, conductor Jim Robertson and his wife, Jean, a viola player.

The trip started off badly for the Brooks. After settling into their cabin, Leonard and Reva joined the others on shore for an evening stroll to see the festivities, as this was carnival week. Leonard's wallet was stolen, and though it contained no money, he lost his car registration papers and other documents. After a few drinks during dinner on board, Leonard decided to give a speech, which drew a rebuke from Reva. That brought on one of his "nasty self" outbursts, targeting Reva. "He stood up and screamed at the top of his lungs and used the foulest language," recalled Hiliry. "He just got bright red in the face and eventually stomped off."[1]

Although shocked at the outburst, Hiliry soon developed what she called a "special bond" with Leonard. Since she had been taken out of school for the trip, Harvey asked Leonard to be his daughter's aesthetics teacher. "I wasn't that excited about the trip when I first started, but within a few weeks I was having a wonderful time," Hiliry said. "I spent so many days with Leonard; he literally took me under his wing. We'd be looking at a vista and he'd say, 'Don't look at it that way. Look at the pattern, look at the shape, look how one colour melts into the other colour.' Then we wrote limericks together."[2]

Previous page: Reva oversaw the construction of the Brooks' new house on a former football field, c. 1975.

Hiliry was not the only person on board whom Leonard inspired and helped. He discovered that the engineer, Micaeli (Mike) Supono, was also a painter. Always at ease with the working man, Leonard spent hours with Supono, lecturing him about art and critiquing his works. He even gave Supono one of the more than forty paintings he did on the voyage. Leonard's interest obviously encouraged Supono to soon abandon the sea and become a successful artist in Italy. On the last day of the month-long voyage, Leonard and Supono ordered everyone out of the common room, tacked brown paper on the walls and drew scenes of the trip, like the women awkwardly getting into a tender to go ashore in Panama. Then the farewell party started. "We had a lot of fun on that boat," recalled Sawyer, a retired radio station owner who had paid his way through university by playing the violin.[3]

One of the fourteen passengers on board definitely did not have an enjoyable trip. He was an Italian named Julio who told the others he was returning to his native village in Italy to find a virgin bride to bring back to the United States. He hated classical music. Every day the Pacinotti Quartet, as the revolving group of musicians called themselves, played for three hours, and every day Julio complained to the captain about the noise. As the passengers disembarked in Genoa, Julio and Leonard, both sixtyish, almost came to blows. "Next time shove your violin up your ass,"[4] the Italian shouted at Leonard.

Waiting for the Brooks at the train station in Rome was travel writer Kate Simon, who had offered to find them a place to rent. Kate knew Rome as few Romans did, having researched it for her book, *Rome: Places and Pleasures*. The Brooks had wanted an apartment in Trastevere, an old district of parks, gardens, and cafes in the heart of Rome that was home to musicians and artists. The only requisite was that it have enough space for Leonard to set up a studio. Kate had visited numerous places, some of them rooms rented by down-on-their-luck Italian aristocrats, and was almost ready to give up when she found a potential landlord with an apartment just one block from her own Trastevere place: British writer Anthony Burgess. He and his beautiful Italian wife, Liana, had just purchased a tiny apartment in an old building at No. 16A Piazza di Santa Cecilia, on the south side of the Tiber River. But before settling in, the author had to go to the United States to lecture at Princeton University. Kate arranged for the Brooks to meet the Burgesses at his favourite coffee-house.

Leonard and Reva arrived first and were anxiously awaiting Burgess, with whose appearance they were familiar from photographs. Kate must have described the Brooks to Burgess because a voice boomed out, "How are you

Canucks?"⁵ Liana shortly joined them and then left to do some shopping, accompanied by Reva. "Buzz off, women, we want to talk," Burgess had commanded.

"Do you have a death wish?" was Burgess's opening question to Leonard. Before Leonard could reply, Burgess assured him that a good cup of espresso and the cigar he was offering would help whatever might be bothering him. Burgess himself had no death wish that morning as he exuberantly revealed he had just received a cheque for movie rights to his 1962 novel *Clockwork Orange*, which was to be filmed that year. The two men strolled over to Apartment No. 5, a third-floor walk-up. There was a kitchen, small living area and two smaller rooms that could be used as bedrooms. One of the rooms had a small cot, one of the apartment's few pieces of furniture. Leonard visualized one of the small rooms as a studio, although it was not large enough to accommodate big canvases on an easel. When a shaken Reva showed up – Liana had been in four near traffic accidents on their shopping expedition – they agreed to a six-month lease at $210 a month plus utilities. They moved in 1 April. The Burgesses returned two days later with a can opener, sheets for the cot and their barefoot, nine-year-old son, who proceeded to shoot an arrow into a beanbag chair, showering the room with plastic pellets. "See what happens when you have a son who has spirit? Aren't the pavements hot on your feet? Get in and wash them – you little bugger – get in the bathroom," Burgess ordered. The son detoured to the bathroom via the studio and proceeded to pick up Leonard's expensive sable watercolour brushes and dip them in oil paint, ruining them.

Before going to the United States, the Burgesses lived in a villa outside of Rome, but Burgess also had a trailer he would park in front of the apartment and work in, going upstairs to use the Brooks' bathroom. He would join Leonard of an evening and talk literature, art, and music. Once he brought Leonard an autographed copy of *Shakespeare*, his latest book. "But Anthony never brought the little bugger back with him when he visited," Leonard said.⁶

Not at all in awe of their landlord, Reva also wrote a letter of complaint to Burgess about the lack of amenities in the apartment. He wrote back that he and his wife were desperately sorry about the flat not being as habitable as it could have been. "It's a near miracle that there are even such minimal things as beds and furniture," he said.⁷

Several years later, Reva was still writing to Burgess to get back the eighty-dollar deposit they had given. She reminded Burgess that he had promised to send them a personal cheque covering the deposit, less whatever bills were

owed, when the lease was up. A gas bill was the only one pending when they left. Burgess insisted nothing was owed and no cheque was forthcoming.

The Brooks had just been living in the Burgess apartment two days when Leonard, hungover after a party, turned on the gas stove, which exploded. Given the noise of the blast, municipal authorities were called to check what had happened.[8]

The Brooks soon were participating in an active social life which revolved, one piazza away, around the apartment of Toronto composer Harry Somers and his actress wife, Barbara Chilcott. It was at the Somers' Toronto home where Leonard had celebrated after his 1969 show at Roberts. Among those they met at the Somers were Barbara's brother, actor Donald Davis, and Canadian photographer Roloff Beny.

Somers, who composed two operas derived from Canadian history, *Louis Riel* and *The Firebrand*, based on the life of William Lyon Mackenzie, used to walk the streets of Rome with Leonard, talking art and music. "I was always amused and curious that Leonard, while I was looking up, was always looking down for bits of debris or junk or whatever for his collages," Somers recalled. He said that he was so impressed by Leonard's use of a red spot in some of his works that he tried it in his music. Somers explained how. "The spot of red would bring the whole scheme together. Then why not do this in a musical work in which one instrument only appears for a few seconds comparatively speaking in relation to the whole work? Well, I did it, but musicians aren't too happy to sit around. It's a different perspective. But Leonard stimulated my way of thinking at that time."[9]

The following year, Leonard explained to a television producer the *raison d'être* behind his scavenging:

I found that by actually incorporating part of the very essence of the thing itself, I was able to move a little closer to the interpreting what to me was my Roman experience. I went out to Piazza Nero ... and I saw on the middle of the road a beautiful piece of blue plastic with lovely texture, and it was a plastic egg crate that had been run over by a thousand trucks, flattened out, cerulean blue, lovely rough texture. It looked like a piece of ocean with nice rolling waves. So dodging between the traffic, people thought I was perhaps a garbage collector, I rushed over and got this piece of plastic. A few feet away I also saw a lovely piece of yellow netting, which was part of, I suppose, a fruit basket or something. I thought, now if we could just get that piece of netting and the blue together, and get this on the kind of background which I saw this blue on, this cobbled old road which has a nice brownish texture, there's the start of something there that could be pretty exciting. So this kept up for an hour or so and

Marian and Ken Harvey, Sacramento, California, band-leader who helped Leonard at the music department. Harvey was Ronald Reagan's favourite bandleader when the future president was governor of California.

COURTESY HILIRY HARVEY

by this time I didn't care whether people thought I was collecting garbage or not, because I had it all under my arm.[10]

The result was a collage that Leonard kept for himself, seldom showing it to anyone because it hung behind the door of his studio. Unless he closed the door when visitors were inside, they could not see it. The collage *was* Rome for Leonard and he obviously wanted to enjoy it himself.

Leonard managed to gain access to the Necropolis, the burial place of ancient popes far beneath Rome's streets, where he did rubbings of ancient calligraphy. These he used in his paintings, the best known of which were *Necropolis* and *Ostia Antica*. Sometimes he married the ancient and the new, juxtaposing the ancient rubbings with acrylic colours of modern day Rome.

When a garbage strike threatened Rome, the Brooks accepted an invitation from the Harveys to drive to Sicily and take a ferry to Yugoslavia. The Harveys had purchased a Volkswagen station wagon for use during their European trip. "Beneath an erupting Mount Etna, we had our cocktails each night," recalled Marian Harvey. Near the volcano, Ken bought a large keg of red wine that they put in the luggage rack next to Hiliry's cello before boarding the ferry. "For three weeks we bounced around southern Yugoslavia, finally going as far north as Belgrade, before returning to Rome," Marian wrote.[11]

The Yugoslavian guidebooks touted the presence of Gypsy violinists who would play for tourists. Green patches on maps indicated scenic areas where the Gypsies presumably could be found. "We could never find the Gypsies," recalled Hiliry, "so eventually Leonard became our Gypsy violinist who would serenade us." Because Reva would pick lilacs along the side of the road, the others started referring to her as a member of The Lilac Gang, a take-off on Alec Guinness's 1951 movie, "The Lavender Hill Mob." Soon they called

themselves The Lilac Gang. "She had a really nice innocent air about her on the trip," said Hiliry. "She glowed with this beautiful naïveté. Her face shone and her laughter, it was as if she were sixteen, on her first date. She just had a wonderful time on that trip."[12]

The laughter died for Reva when they returned to Rome.

～ 52 ～
Part of me wishes to end it all

The size of the Burgess apartment probably had a lot to do with it. Back in San Miguel, the Brooks had separate bedrooms so that Reva would not disturb Leonard with her nocturnal wanderings. During the day, she was concerned with sales of Leonard's paintings, she had her Mexican help to supervise, social calls to make, and even time in the darkroom. She had none of this in Rome. Even Leonard later recognized the need for one's own space. "I go down to the studio every morning at nine o'clock because if you're in close quarters with anybody all day, every day, as we are most of the time, as we were in Rome, it's difficult," he said.[1] Nor was the apartment *theirs*. It was Leonard's studio in Rome they were living in.

That this was not going to be a Roman holiday for Reva was evident even before the Brooks went to Yugoslavia with the Harveys. Leonard's "glooms" probably started the day they moved into the apartment. He was shocked that day to learn of the death of his good friend Harry Kelman, a colleague from the Navy Show days with whom he had travelled across Canada. Then Reva started to complain that he was "ticking her off" in public after he had a few drinks. "Glooms and a bit desperate today – and am heading nowhere – and will have to shake out of this mood again ... partly Reva who says I 'belittle' her in front of people – partly general apathy of feeling from a lack of direction – and general getting 'old' sense – which is not surprising, to say the least," he told his diary.[2] Then came the night of 28 April. Leonard had a "bad blow up" and threw his paintings on the floor.[3]

By mid-June, Leonard reported "Reva not well" but he had bounced back from *his* depression. "I am full of life and vitality – and I *want* to go on," he said.[4] When Reva wrote to the Wilsons in early July, she made no reference to her health except to complain of a serious infection in the root of one of her

front teeth. But her discontent was evident. "The traffic and noise around this district of Trastevere is really too much for me," she told them. "It is quite hazardous walking around the streets trying to take photographs of people. The young hoodlums whisk by on their motorcycles and fast little cars and snatch purses – they especially go after older ladies!"[5]

On 9 July Reva did what she had done in the past when faced with depression: she got out a notebook and started to write down her thoughts and feelings in the hope this exercise would restore her mental well-being:

My whole head is aching and throbbing with a feeling of pressure ... Leonard is working well and we are in a good state of peaceful rapport and I do my best to hide my depression from him. He has had three "explosions" since we've been here, one very serious when he went completely out of control ... My enormous difficulty here now is trying to find the subjects, the people, the juxtaposition of people and things that I need to make the kind of photographs I want to do. There is something terribly wrong ... I grieve over my failures. I want to do better than the best I've done before. I walk the streets, the traffic is overwhelming and now the summer heat. Constant state of frustration about my photography, so much so that I feel ill at times about it.[6]

Two days later Reva said that she was disappointed by the fact that she and Leonard did not partake more fully in the Roman life by spending more time in *trattorias* talking with friends and visiting places. She said Leonard could not paint as well as he did if they went out as much as she wanted:

Last night after a big day of work L. had quite a few drinks, talked to me of his deepest feelings, became most excitable, sang at the top of his voice and generally let himself go. This "letting go" explosively seems to be a real necessity for him and usually occurs in the evening after a few drinks. Many things he says often hurt me deeply – in fact many of these explosions are directed against me.

Reva added a note at the bottom of a page: "Being L.'s wife and being a photographer is my way of being in the world, and I have to *come back* on those terms."[7] That her stalled photographic career bothered her came in another jotting three days later: "Let me write all the 'unspeakable' things, let me grovel in the dust for not having made a greater effort to realize my full potential, but I must hide it, and leave L. in peace to be himself, to be able to work well and enjoy, as he is doing." She said she was taking Valium 5 at night in an attempt to relax.

A person who seldom discussed her problems with others, Reva now wrote to the Harveys, with whom she must have felt intimate after the voyage and trip together to Yugoslavia. "I must admit I was (am) in a constant turmoil about my photography, wanting to take 'my kind' of picture when it was so difficult and impossible to do so. I realize my [camera] equipment is bulky and heavy for travelling."[8]

She returned several days later to her lack of interest in photography and hinted at suicide. "Maybe if I could break through to FEEL like taking photographs, that would make me feel better," she wrote. "Face it, Reva, you are feeling about as low as you ever have, a feeling of giving in, giving up, ending it all."[9]

Leonard, in his correspondence, was either oblivious to Reva's agony or reluctant to admit all was not well with her. Writing to Jack Wildridge of the Roberts Gallery, he compared the Burgess apartment unfavourably with No. 109 Quebrada, "but Reva manages well." "Getting away into this 'anonymous' kind of hidden life in a great city seems good for me – and I am able to reduce life to essentials – and keep working daily in privacy – happy as a lark," he said. Reva added a note: "[Leonard] keeps in a wonderful mood of creativity. The right kind of change can do wonders for him."[10]

By 6 August Reva realized that suicide was not the solution to her problems. "Now I feel the physical strain of carrying that camera weight, the mental and emotional excitement of looking for and trying to capture 'my kind of photograph,' coping with traffic, crowds, noise, this intense heat," she wrote. "So at 58 I have to decide that I cannot 'kill' myself over it, and to realize that I will have to try to do my work at the pace which is possible consistent with my health and well-being."[11]

After nearly five months in Rome, Reva decided to seek help. She turned to Barbara Chilcott, who had been giving instruction in Transcendental Meditation to members of Rome's foreign community. Chilcott, who had met Leonard and Reva when she was a dancer in the Navy Show, had studied T.M., a technique for achieving deep relaxation and eliminating stress, when she and husband Harry Somers lived in London. "Her guidance is utterly giving, gentle, beautiful, and devoted," Reva reported in her notebook.[12]

Chilcott believed that Reva's concentration on sad photographic subjects like the impoverished Indians inevitably depressed her. "I don't think you can spend that much time and emotional energy trying to capture the negative and not be affected by it," she said. "Reva's work was all about very depressed subjects. And those were the ones she only thought worthwhile; anything else was frivolous. It's as if she was obsessed with the dark side of life."[13] Van Deren

Coke, former director of the photography department of the San Francisco Museum of Modern Art and a Brooks' friend since 1948, seconded her opinion. "People who deal with the subject and make other people aware that these people are alive and they are living this unforgiving life close to the soil can affect your own view of life," he said.[14] San Miguel writer Robert Somerlott attended a show of Reva's in Mexico City and found all the photographs sombre except one, *Felicidad, a Mexican Madonna*, a photo of a smiling mother and her infant child. "The single happy picture of my collection," Reva conceded to Somerlott.[15]

Reva herself admitted that the plight of her subjects affected her. "I had a profound and almost overwhelming sadness about the poverty [in Mexico] and it made me feel so strongly that I think I tried to capture it, and it just sort of happened to me."

Like Esther Birney, Barbara Chilcott soon came to the conclusion that Reva lost her moorings when she travelled abroad. "Reva requires a certain order in her life, and she did not have the support of the servants and the people she was accustomed to dealing with in Mexico, and she was having to deal in another language," said Barbara. "My own feeling was it was largely due to an identity crisis. I think Reva was used to a very ordered life."[16]

Reva wanted not only an ordered life, but she wanted to be the one to control it, both for herself and Leonard. She obviously found herself in Rome in the unusual position of *not* being indispensable for Leonard. She was the gatekeeper in San Miguel, the person who decided who saw Leonard and who did not, the person who ruled on their social life. Leonard did not need a gatekeeper in Rome.

If Reva thought things could not get worse, they did. The Brooks had accompanied Florita Botts, a photographer who worked for the United Nations' Food and Agriculture Organisation, on a drive into the countryside where the two women were to take photos while Leonard sketched. Botts parked her car on the side of the road near Anguillana and the three of them went down a ravine to get water. When they returned, they found someone had broken into the car and stolen Reva's camera bag and Florita's two Leicas. Reva became hysterical over the loss and, at one point, Leonard shook her to get her calmed down.[17] Later, she wrote, "Yes, you do feel the loss of your intimate, familiar, yes, even dearly cherished equipment with which that very week you were mentally and emotionally ready to get into it again, and go on better than ever."[18]

During this period, Reva borrowed a book she saw at the Somers' apartment, *Sex Perfection and Marital Happiness*, a seminal book on sexuality

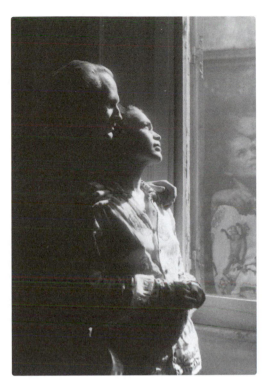

Toronto composer Harry Somers and actress wife Barbara Chilcott, who helped Reva through a rough time in Rome.

ANTHONY BUCKLEY – COURTESY BARBARA CHILCOTT

written in 1949 by Dr. Rudolf von Urban. Reva must have taken note when she came to a question-and-answer reference on page 231 to artists and musicians as lovers:

Question: In what profession do you find the poorest lovers?
Answer: *In the Physiology of Sex* by K. Walker you will find the right answer, which agrees with my own experiences: "Sexuality is usually more vigorous amongst those in whose lives emotions and sensory impressions play an important part, as among poets, musicians and artists, while amongst scientists, philosophers, intellectuals it is found at its lowest. More surprising is that the life of movement, in sports, athletics, and games makes poor lovers."[19]

After putting into practice the book's teachings, Reva told her diary, "With the help of reading a book by Rudolf von Urban we have been able to approach a better sexual achievement – a revelation after all these years. I am grateful."[20]

Whatever boost Reva received did not last long as within days she was again talking of suicide:

At supper L. exploded with me and told me the brutal hard truths about how he feels about my behaviour. He is right – I tell myself the same things even more so, but it's hell to hear it from him and to see him so upset ... I have everything to live for and the best husband. But there is some weakness, I hope not fatal, that has hold of me. Part of me wishes to end it all and envisions L. with someone "ideal."[21]

Reva felt that part of her depression was due to the tooth infection, so Leonard traded a painting for $350 of dental work, which included a new dental plate for himself.

Because Leonard had produced such a large body of work in Italy – 270 paintings and drawings – and the freighter back to Mexico was delayed, the Brooks decided to fly to Toronto at a cost of $869. This way Leonard would be able to leave the paintings at the Roberts Gallery for a spring 1972 show. They contracted the services of Bolliger Transport for $169 to arrange for the shipping of two crates of paintings to Toronto. When the Brooks arrived at the Rome airport 15 October for their departure, they were told they were overweight. Leonard did what he would have done in Mexico under similar circumstances: he gave a 2,000-lira bribe to the clerk.

Then disaster struck.

The Brooks arrived in Toronto but the two crates did not. Six days after their return, they called Bolliger Transport in Rome to complain. Bolliger had shipped the crates on a Pan American World Airways flight to Paris' Orly airport where they were to be transferred to an Air Canada flight to Malton Airport – now the Lester B. Pearson International Airport – in Toronto. After a search at Orly, one crate was discovered, but the second containing 116 works was missing. Leonard was frantic. He wrote to the president of Pan Am, Najeeb E. Halaby.[22] At Leonard's request, the Canadian Department of External Affairs started an investigation. Interpol got involved. The Brooks returned to San Miguel, Leonard convinced that half of his Italian output was lost forever. Then, two months later, they received a telegram from Bolliger Transport: WE ARE PLEASED TO INFORM YOU THE MISSING PACKAGE HAS BEEN LOCATED AND WILL BE REFORWARDED TO YOUR ADDRESS IN A FEW DAYS. The Brooks were never told where the crate had been found.

The location of the missing crate enabled Reva to write an upbeat, positive letter to Kate Simon in Rome: "I feel lucky that I received so much understanding, patience, and help. Actually, my upset had a beneficial effect of enabling me to understand myself better, and I now have the complete confidence that I will never have to go through such a painful ordeal again."[23]

Reva was right. Never again was she so distraught that only a notebook could hold her feelings, although she continued to write spur-of-the-moment thoughts – that might have been construed as cries for help – on the back of envelopes or in guest books or whatever else was handy, even at 3:00 a.m.

~ 53 ~

I raised Alicia like my daughter

The Brooks had a social engagement that day, but before leaving Leonard wanted to install on the lawn a ring-toss set that he had bought for Alicia, the maid's young daughter. Usually Reva was the one who was slow getting dressed, so she was surprised to find Leonard was not ready to leave by the time she was. When she looked out the window and saw what he was doing, she marched outside, hit him in the back, yanked up the stakes he had driven into the ground and threw them into a bush. Shortly afterward, the Brooks departed, leaving a tearful young girl behind.

Born on 23 March 1975, Alicia Sánchez Govea was the daughter Leonard never had. He was the person who brought her home from the hospital. Like the character Kayo in the old "Moon Mullins" comic strip, the infant Alicia slept in the bottom drawer of a chest of drawers in the maid's room occupied by her mother, Carmen, a former nun of the Dominican order. Until Carmen moved from San Miguel, Alicia spent fourteen years with the Brooks, either living on the premises with her mother, spending the day there or visiting.

Reva was never motherly – or grandmotherly – to Alicia. Rather, she was the stern school teacher who wanted success for her pupil, but showed little affection towards her. As soon as Alicia could crawl, Reva had the handyman, Raúl Godinez, build a fence to pen her in and prevent her from entering the house, much to the displeasure of her mother. Whenever Reva went out, Carmen would remove Alicia and let her crawl free. Reva would become angry if she found Alicia roaming about, so Godinez loosened slats on the fence so that, should Reva come home early, they could tell her that Alicia had escaped on her own.

But it was different with Leonard. "I raised Alicia like my daughter," he would say. Leonard must have been aware that Reva resented the time he spent

with Alicia. Whenever he took her for a walk, he would wait until they were out of sight of the house before taking her hand, obviously so that Reva could not see them. When the Brooks had guests, Alicia would crawl onto Leonard's lap, only to be removed by Reva; as soon as Reva left the room, Leonard would welcome her back. Leonard built a cardboard dollhouse for Alicia and went downtown with her to buy figurines to occupy it. He did miniature paintings for the walls. "I've got to admit I enjoyed playing 'house' with her as much as anything I've done lately," he told the Wilsons.[1] One day Reva destroyed the dollhouse. "Reva became jealous of the attention being paid Alicia," said Reva's brother, David.[2] Alicia's mother echoed the sentiment: "[Reva] was jealous because the child was the maid's daughter. Alicia loved [Leonard] as if he were her father. [Reva] never showed the same affection."[3] Alicia's own father, Francisco Sánchez, was a sometime baker and odd jobs man whose health often prevented him from working. A severe diabetic, he died when Alicia was fifteen.

Leonard bought Alicia a rocking horse, made her a wagon, using lawn-mower wheels, and bought her a tricycle and many dolls. Reva's gifts tended to be more practical, like a dictionary and a school bag.

By age two she was allowed to go to Leonard's studio, where she picked up a pen and made her first drawing on the inside cover of his studio journal. "Not bad either!" he reported.[4] A year later, armed with scissors and a glue pot, she made collages while Leonard painted.

"What a lovely time with little Alicia," Leonard reported to his diary. "We get along so well. Tells me what happened – my miserable Spanish manages to get some of it. Puts her arms around me. Confidence in me and knows my sense of humour."[5]

As he had done with their goddaughter Erica Brossard in the 1950s, Leonard stimulated Alicia's imagination. He would put her on the terrace with a stick in her hand representing a microphone and have her simulate a broadcast. After her parents divorced, Erica often spent time with Leonard, who would take her to his studio and give her a subject and ask her to weave a story for him as he painted. "The girls could live in a fantasy world of their own creation," he explained.

Dramatizing the story of Alice in Wonderland, Leonard once took Alicia – Alice in English – to the garden to search for the hole she might have fallen through. When they found a hole by a tree, Alicia stuck her arm in and brought out a tin can filled with coins. Leonard wondered what supernatural powers were helping him impress Alicia until he discovered the gardener, Jesús Arzola, had buried the can containing his savings.

When Alicia was five, Carmen gave birth to a son who died within hours. The following day Leonard and Reva joined Carmen, her husband, sister Felicitas and Alicia for the burial. "Sad little funeral in the cemetery with the dead child in its tiny white coffin," noted Leonard.[6]

Leonard used to take Alicia with them on social occasions, whether she was invited or not. When local Congresswoman Lupe Rivera de Iturbide, painter Diego Rivera's daughter, held a reception for 150 people to meet state governor Enrique Velasco Ibarra, Leonard took Alicia. "The governor kissed Alicia when we were introduced," Leonard told his diary. "We had a good time."[7] A good time was not had when the Brooks, with Alicia, then eight, in tow, showed up for dinner at the Fred Taylors. Taylor said he did not want to feed the girl, whereupon Leonard blew up and left the dinner. Taylor telephoned the next day to apologize. "We patched it up," said Leonard.[8]

Leonard and Alicia would chase butterflies in the park. They worked together on jigsaw puzzles. He taught her to play chess; after a few weeks, she consistently beat him. He took her to the ballet. They often went to Taboada, a nearby spa with a hot spring and Olympic-size swimming pool, where he taught her to swim. On one outing she swallowed water and nearly drowned. Sylvia Tait recalled going to Taboada with Leonard and Alicia and how Leonard looked after the girl. "He whittled pens out of sticks and dipped them in ink and drew for her," she said.[9] Reva, who seldom accompanied Leonard to Taboada, had joined them that day, but not to swim. Dressed up in normal streetwear, including stockings, she wandered about with her camera while the others frolicked.[10]

One day Alicia broke the mannequin that Leonard used in his studio and Reva, called upon by Leonard to discipline her, slapped her. "It was difficult because the *señora* would explain to me why discipline was necessary and then the *señor* would come along and spoil me," Alicia recalled.[11]

Alicia's presence in Leonard's life obviously tapped deep emotions. "Little Alicia – skipping off to school – as she says goodbye – makes me want to cry – why? Is it because I am so old now, can feel the hurts and strains against such innocence? Or is it because I am feeling such innocence?"[12]

When Alicia was seven, Reva asked her what she wanted to be. A tape recorder captured the exchange:

Alicia: A scientist, a doctor, a teacher, a lawyer.
Reva: A lawyer is very good because a lawyer deals with all aspects of life. You can express yourself in business, real estate, litigation, or criminology.
Alicia: Criminology?

Reva: It deals with the laws of Mexico. There are people who rob, who kill.
Alicia: Criminals. You have to investigate. For example, there are persons they say killed someone and they didn't kill anyone.

It was an unlikely dream for the daughter of a maid, but Alicia was to become a lawyer.

Leonard's frequent appearance at the school to take Alicia home created confusion among teachers as to the financial status of her family. One year, when Alicia was eight, her teacher nominated her to be a princess in the Spring Queen contest, believing – erroneously – that this honour would somehow result in either Leonard or Carmen contributing money to the school. "It was very sad for me because I was all alone, a princess without subjects," recalled Alicia. The families of the queen and the other princesses were present at the spring festival, but no one accompanied Princess Alicia.

It was probably Reva, more than Leonard, who instilled in Alicia a love for education. By the time she started kindergarten, she could read and write. "I remember the Brooks once asked me to make a list of all the books I had read," she said. "I was ten or eleven and already had read eight hundred books. I would never have had that opportunity if it had not been for them."

Although Carmen worked for the Brooks until Alicia was seven, increasingly she was not a live-in maid but returned nightly with her daughter to the room her husband rented. Once when Leonard took Alicia home he saw a sow and ten piglets in the room. "Perhaps if I had lived permanently with the Brooks I would have had a better life and a greater opportunity to acquire culture," Alicia said. "But then I would not have known the other world."

That other world was one of abject poverty. Carmen was the main support of her family and that of her sister, Felicitas. After leaving the Brooks, Carmen became a Fuller Brush peddler. Once, when income was short and there was little money for food, Carmen went with Alicia to the Brooks, hoping that Reva would give them a meal. Reva turned them away, telling Carmen to telephone before coming over next time. "It was humiliating for my mother," Alicia said.

Like a father, Leonard worried whenever Alicia became ill. "I pray there is nothing really serious here as I don't know how I could take *this*," he said during one illness.[13] That time he took her himself to the doctor, who discovered she was anaemic.

When Alicia was twelve, her aunt Felicitas died. Carmen took in Felicitas' young children and it fell to Alicia to help raise them.

The Brooks' former maid, Carmen Govea, left, and daughter Alicia at the traditional Latin American coming out party for fifteen-year-olds. Leonard raised Alicia as if she were his own daughter.

Two years later, the family moved to Morelia. Leonard did not put up a Christmas tree that year. "Sad feelings that we do not have Alicia to see us," Leonard lamented.[14] But Alicia came back to celebrate with the Brooks her fifteenth birthday, the traditional coming out age of girls in Latin America. She wore a long white dress at the party held at the home Reva's brother, David, owned in San Miguel. For the occasion, the Brooks gave her a locket, some clothes, and a cheque.

While a law student at the University of Morelia, where tuition was free, Alicia visited the Brooks and wrote in their guest book: "Today I'm in the home where I spent the greatest part of my childhood, with the people who formed part of my life that I understand is only a moment in space, but my principles I learned in this place."[15] On another visit, she wrote, "I had the opportunity of being born here, near the beautiful creations of two artists. I dream of a world full of beautiful things where the soul of man can expand and vibrate tenderly, like the bird that sings and the waves of the ocean."[16]

Alicia had been gone from San Miguel and the Brooks' daily life for five years when Leonard did an "Alicia" collage, "a riot of strange colour and

shapes."[17] Local gallery owner Latiné Temple immediately purchased the painting.

The author met Alicia, now a lawyer, in Querétaro, an hour's drive from San Miguel. She was managing a student hostel, but her ambition was to operate a school for promising poor children, as she herself had been. When the author asked if she would like to sit in a restaurant while they talked, she replied, "No. If I can choose between a restaurant and a park, I always choose the park." Leonard or Reva could have said the same thing. She led the way to a shaded park with cobblestoned paths.[18]

~ 54 ~

We certainly are Canadian citizens

The Brooks' good friend, Mexican painter Gunther Gerzso, was probably right when he said Reva was one of those people who started building whenever they smelled wet cement. "She was crazy about cement and bricks," he said.[1] After the trauma of the 1971 trip to Italy, Reva now looked more kindly on San Miguel as a permanent home. "Being away so long this year has given us a fresh perspective and I must admit San Miguel is a good place to live and work," she told Jack Wildridge of the Roberts Gallery. "The weather is ideal and everyone eventually comes here."[2] Leonard was receptive to building a new house when his year-end calculations showed a 1971 income of $30,000, despite the fact they were away from San Miguel and the important studio sales for ten months. The trip cost $8,000. He also did an inventory of his assets and discovered he was worth $133,000, "a staggering sum for me."[3] While Reva's main reason for wanting a new house was to build a separate studio for Leonard, he now had reasons of his own for wanting to move from Quebrada Street. His neighbour, German-born sculptor Lothar Kestenbaum, husband of Canadian painter Mai Onnu, made too much noise with his chiselling and hammering. Another reason was the fact that cobblestoned Quebrada Street had become a noisy bus route.

Reva found an isolated soccer field at the base of a hill, a fifteen-minute walk from downtown, for which they paid $20,800 for 55,700 square feet. "I might as well have a little blaze of glory in a 'country' home – for the years I have left if I can manage it without going broke," Leonard told his diary.[4] Reva

named the property *La Quinta de los Arroyos*, Spanish for Country House of the Brooks, *arroyo* meaning brook; there happened to be a brook running along one side of the property. The town subsequently used the name for the street, Calle de La Quinta. The Brooks had to put in the block-long road as there had been none there before.

The decision to build a new house had raised questions back in Canada as to whether the Brooks had renounced their Canadian citizenship and were now Mexicans. That brought a testy reply from Reva when the Wilsons raised the subject. "Yes, we certainly *are* Canadian citizens and will always be," she wrote.[5] Then Jack Wildridge, who never telephoned, called to ask confirmation that Leonard was still a Canadian. The Toronto-Dominion Bank wanted to buy one of his paintings provided he was.

Leonard felt the 6,000-square-foot house was becoming more sumptuous than needed, prompting constant arguments with Reva about the cost. "General hassle with Reva about house – etc. – which I cannot really see – if income and life goes on the way it is going these days."[6] "Tangle verbally with Reva when I feel that we are overestimating our time and capital to go into this new land and building "[7] "A time of stress and troubles on the home front."[8] Reva conceded in a letter to the Wilsons that "'unimportant' things in life turn [Leonard] into a different person, especially if they have anything to do with house construction, repairs, superficial social and material problems."[9] The fact that Reva had definitely abandoned her photography – probably using the building project as an excuse for not resuming her work – bothered Leonard. "Big argument with Reva who will not listen to a word of criticism re work – photography or anything but her point of view," he noted in his diary.[10] Finally, Reva's brother, David Silverman, bought half the land for $15,000, which provided more funds for the construction.

The 1,200-square-foot separate studio had a kitchen, bedroom, and living area, so Leonard often spent the night there, even before the electricity was installed. He invited David to join him one night and the two men talked and drank a bottle of rum. The next morning, the telephone rang, and since it had recently been installed and no one but Reva knew the number, David correctly assumed it was his sister calling. "I affected a female voice," he recalled. "Reva hung up immediately."[11] Leonard and David thought it was hilarious, but Reva, who wanted a studio on the property so Leonard would not be away from home, must have been furious, even if she recognized she was having her leg pulled. Leonard and Reva would eventually set up house-keeping in the studio themselves, allowing Reva to better oversee work on the main house.

Upon seeing for the first time giant tapestries on the walls of the completed house, visitors would invariably ask if it had been designed especially to accommodate these works. While the construction was underway, Leonard had started a series of tapestries, "transpositions" of his collages, which would eventually reach nineteen in number. The largest were fourteen feet high. "I built this house so I'd have a fourteen-foot ceiling," he told an interviewer. "I couldn't hang these [tapestries] in the other house I had."[12] Although Leonard often exhibited the tapestries, he refused to sell any of them, even though they would have commanded far higher prices than his paintings.

Leonard enlisted a team of weavers from Evelyn Anselevicius, a designer for Knoll Associates, a New York interior decorating firm. Anselevicius was teaching weaving at the Instituto Allende when she was sought out by Mario Valenzuela, a local weaver who soon became her disciple and master weaver of her works.

Many of the collages Leonard chose to transpose were from a series entitled *Seven Moons*, the moon seen during different seasons of the year. The series was inspired by the 1969 moon landing by American astronaut Neil Armstrong. Other collages had a musical theme.

Leonard went daily to the weaver's studio, helping Valenzuela choose the yarn, signing off on the dyes – some collages contained eight shades of black – and overseeing the actual weaving on an ancient loom. Valenzuela bought sheep's wool in the market and prepared the European dyes himself. "My collages are hard to interpret in weaving," explained Leonard.

Over a two-year period, Valenzuela and his brothers produced fifteen tapestries. Then the project came to a halt when Mario, at age thirty-five, died of a brain tumour. Leonard had another weaver do four more tapestries, but abandoned the project as they "looked like rugs" compared to Mario's textured works.

Leonard had his second one-man show – *Transposiciones* – at the Palace of Fine Arts in Mexico City in 1976, this time a combination of tapestries and the collages from which they were transposed. José Chávez Morado, the Mexican artist and the Brooks' first landlord in 1947, said of Leonard's tapestries, "I know of no other non-Mexican artist who has been able to relate so harmoniously both to the country of his adoption and to his native land. Without sacrificing his origins, Leonard has drawn from his environment the colour, the rhythm, the softness, and the Mexican solemnity of the high plains."[13] Leonard was delighted with the show, the press coverage and the way he comported himself at a dinner for forty people hosted by Canadian ambassador

James Langley. "Behaved well – not too much to drink – or too much talk and survived it all – though tiring."[14]

Leonard had another one-man show of his tapestries at Mexico City's Galería Kin the following year. "It is always interesting to see a painting reproduced in another medium," wrote owner and tapestry expert Carmen Padín in the show's catalogue. "Rarely are the results so successful as the tapestries made from the paintings and collages of Leonard Brooks." Said *Novedades* art critic Jorge J. Crespo de la Serna: "Leonard Brooks is present with his inexhaustible creative versatility. He is the complete artist, he lacks nothing. He can create, in every theme, all the imaginable colours."[15]

When *The Magic of Tapestry*, a history of Mexican tapestry, was published in 1988, Leonard and Evelyn Anselevicius were the only foreigners to have their works included.

Despite the tributes in Mexico, Leonard was thwarted when he offered an article on the tapestries to *Canadian Art* magazine. The editor replied he was not interested. "Standard indifference of Canada – in press – etc. – insular and indifferent," Leonard said.[16]

While the house was under construction, Jack Wildridge arranged for Leonard to have a one-man show 25 April–5 May 1972. The news media approach to the arts was changing in Toronto, where the critic, who used to rub shoulders with artists at the Arts and Letters Club, had become an endangered species. If anyone was assigned to cover an artist, it was usually a reporter looking for a news story, not an art critic. The exception was *The Globe and Mail*, where Kay Kritzwiser, an old friend, critiqued Leonard's show: "Brooks is a sensitive collagist. His collection of paintings, now at Roberts Gallery, is a brilliant synthesis of his response to ten months in Rome."[17]

When Leonard was interviewed by non-critic Wayne Edmonstone of *The Toronto Star*, he criticized the art establishment, as he had in the past. "It sometimes strikes me as odd that I'm represented alongside contemporary Mexican painters at the Museum of Modern Art in Mexico City (he stresses the word 'contemporary') but not in Canada, either at the National or Ontario galleries," he told the reporter. "Mind you ... I'm not bitter ... I no longer feel that I have to prove anything to anyone here, not even myself. Finally, three years ago, I decided it was time to pit myself against 'stone-faced Toronto' again. That exhibition was a success – and now I'm back."[18]

While staying with Reva in the basement of her sister Sophie's home, Leonard wrote a whimsical poem putting everything into perspective:

From the basement apartment
where I am lying
I hear the feet
of those above me
creaking as they walk about
Of course, to them
my ceiling is their floor
which only goes to show
how relative things are
– and not to take them seriously.[19]

Reva had two exhibits in 1972, the first a show of one hundred of her photographs at the Children's Gallery of the Royal Ontario Museum when they were in Toronto for Leonard's opening. Many of the photos were of Leonard's music students. The second show, at the Lowenstein Library of Fordham University at New York's Lincoln Center, was serendipitous. Fordham professor Vivian T. Wechter had discovered Reva's photographs while interviewing Leonard for the half-hour weekly radio program she conducted. Upon returning to New York, she started organizing a show for Reva that opened in October: "Photographs of Mexico and Documentary Music Theme."

Most of the eighty-nine photos were of Leonard's music students, highlighted by the Aguascalientes brothers, getting bathed or playing the violin. One of the pictures hangs on the wall of the San Miguel home of Anselmo Aguascalientes, the family patriarch. It is a framed, yellowing clipping from a Mexican magazine.

If Leonard was unhappy with his painting career, he was delighted with his musical career. He now played with the professional Guanajuato Symphony in the state capital of Guanajuato. Leonard, Tom Sawyer, Ken Harvey, his daughter, Hiliry, and an American named Lynn Serdahely played in a summer series of fourteen concerts over a six-week period. Leonard and his companions were invited to be guest artists because he had recruited several symphony members to be adjunct teachers at the music department of the fine arts school. They drove over to Guanajuato – a drive of more than an hour each way over mountain roads – on Thursday nights for rehearsals and Saturday nights for the concerts. Harvey and Leonard shared the driving.

"My dad or Leonard would bring liquor," recalled Hiliry. "But nobody could have any of it until we got over the most winding part of the road. Then they'd break out the drinks and everybody kind of glided home in the car."[20]

Lynn Serdahely once baked cookies laced with marijuana and passed them out on the drive over. Serdahely, then in her forties, died unexpectedly during the season and the symphony played Beethoven's Ninth in her honour at a concert in San Miguel.

Leonard wrote in his studio journal:

I must write about the thrill of being part of the orchestra – there I sit – violin under chin – out in front of a few hundred listeners – in the back row of the 1st violins – playing away like mad – I look up at the conductor – I hear the man next to me – I see the soloist – and try and be part of him – I know when I am playing well – and when I have to fake a passage – too fast for me – ... I revel in being part of something essentially profound and great – and glory in it – knowing I can do it – and have the privilege of being alive – vibrant – concentrating and giving out something so lovely as music ... the sense of satisfaction when it really comes off (a good quartet will do it more than anything) is irreplaceable – and painting and writing – and the other arts don't provide this direct response which disappears in the air immediately ... the live moment is the thing I love most – and cherish.[21]

Many times Leonard and Reva had accompanied Miguel Malo, the director of the cultural centre, to look for pre-Columbian artefacts near San Miguel. The Mexican Treasury department in May accused Malo of selling national treasures – some of his artifacts – to foreigners. After destroying all 5,000 pieces in his collection, Malo fatally shot himself. As part of the reorganization that followed Malo's death, Leonard was offered the post of director of "painting and artistic activities" while remaining head of the music department. He declined. But he did start getting paid – against his wishes – for his work in the music department. Because of regulations, he was obliged to become an employee of the Mexican government, receiving the sum of 1,000 pesos – about eighty dollars – a month.

Leonard also met his ultimate employer, Mexican president Luis Echeverría, in a bizarre incident at the Canadian embassy. Echeverría was on the dais with then ambassador Saul Rae when Leonard purposely made eye contact with him. "This was one time when I had an opportunity of looking a president in the eye," Leonard recalled later, reflecting his disdain for authority. "I looked at him and thought, 'Here you are, the great president, and here I am, little old Leonard Brooks. Let's see what we can do.' He blinked first. I loved it."

When Reva told Jack Wildridge that everyone came to San Miguel, she was not exaggerating, for increasingly well-known Canadians were trekking to the mountainside town. One who came that fall was the National Film Board's

Norman McLaren, a 1952 Academy Award winner, who liked Reva's photographs but showed no interest in Leonard's paintings. Poet Al Purdy came the next year. Two visitors, mass communications guru Marshall McLuhan and actor Bruno Gerussi, became good friends of Leonard. "We have a common spirit," said Leonard of Gerussi. "It's as if we've known each other all our lives."[22] Former Canadian Prime Minister Joe Clark, in Mexico on a trade mission, met the Brooks.

That fall, the Royal Ontario Museum agreed to finance a film on the Brooks by Amaranth Productions of Toronto. The company's partners, Barry Gray, Rick Wincenty, and Gary Johnson, plus producer Tommy Bond, spent several weeks in San Miguel, following the Brooks around and interviewing them. Reva was very open with the crew, relating Leonard's abstract works to his emotional outbursts:

I like my husband's paintings more as he becomes more and more intensely abstract, and to me it's more spiritual, it's more meaningful, it's more philosophical ... he started out by being a landscape painter and what you might call an expressionist painter of nature, and very fine and so on, but they never were as moving to me as some of the ones that he does now when he is in these moments and moods of tension, where he has to release something, and eventually it's released in an abstract way and it's very meaningful.[23]

For Reva, the reward she received for being the usual target of Leonard's "nasty self" was the satisfaction of seeing him do his best work, and the paintings she most preferred, his abstract expressionism.

The film was shown on the CBC Television's "The Lively Arts Series" during the 1974–5 season.

PART TWELVE

Recognition at Last

\mathcal{I} think it came too easily to her

The two letters sent to Reva Brooks from California could not have been more different. The first was from photographer Ansel Adams, threatening to cancel her membership in the Friends of Photography, of which he was president, unless she paid her dues.[1] The second was from the San Francisco Museum of Art, which selected Reva as one of the top fifty women photographers of all time. The museum was then unaware of it, but Reva's photographic career was already behind her, as evidenced by her lack of interest in continuing her association with the California movement led by Adams, who had succeeded the late Edward Weston as the leading photographer in the United States.

The idea for a book and exhibits of the works of female photographers came from Margery Mann, lecturer in the history of photography at the San Francisco Art Institute. The museum's curator John Humphrey embraced the idea, and nominations were invited. Photographer Van Deren Coke, an old friend, suggested Reva's name. "We had known her work intimately," said Coke, future director of the museum's photography department but at the time head of Kodak's George Eastman House in Rochester, New York.[2] The museum sent a representative, whom the Brooks met at the Mexico City airport, to interview Reva. At the request of the museum, Reva submitted five photographs: *Doña Chencha, Sara, Ramón, Elodia,* and *Dead Child*. From one thousand candidates, Reva was one of fifty women selected. Others included pioneering photographer Julia Margaret Cameron (1815-79), *Life* photographer Margaret Bourke-White and Diane Arbus, controversial American photographer who committed suicide in 1948 at the age of forty-eight.

Women of Photography: An Historical Survey was published coincident with the opening of an exhibit of the women's works 18 April 1975. Reva's *Dead Child* appeared in the book and it and the other four photographs were part of the exhibition. The accompanying text said, "There are few Mexican photographers. One thinks only of Manuel Álvarez Bravo. The painting tradition is so strong that most young artists want to be painters. Reva Brooks' work certainly shows

Previous page: Leonard and Reva, 1976.
MICHAEL ZABÉ

the influence of Mexican painting. The people dominate the picture plane. They are seen directly. They are solid, yet vulnerable. The photographs are uncompromisingly honest, yet they are poetic."[3]

Writing in the introduction of the book, Margery Mann said: "The twentieth century Women of Photography have been strong women, independent, imaginative, versatile, and conspicuously unconventional. The twentieth century women have above all been capable of immersing themselves so completely in the project at hand that they transform it with their creative energy and make it their own."[4]

When Reva designed a darkroom for the new house, it was assumed she had decided to resume her photography, but it was not to be. "I've always tried over the years to encourage her, especially after they built the new house and she had a darkroom, to go ahead and expand on what she had already done," Coke said. "But Reva's a person you couldn't lead."[5]

The author, at the time based in Mexico City as the regional manager for the United Press International news agency, heard complaints from Reva that her darkroom was not ready for use. So he asked Lou García, UPI's Latin American picture manager, to help put the darkroom in working order. Said García:

She complained a few times about the difficulty in focusing, etc. The real problem was that the darkroom was too dark. I suggested buying two or three more safelights or one of the new bright safelights that had just come on the market to brighten up the entire room. We also agreed that she should get hot water in the darkroom and an exhaust fan blowing fresh air *into* the darkroom.

Her photography was an achievement, a triumph, but she could take it or leave it. I don't think it was ever a passion. I believe she wanted the comfort of having a darkroom and had convinced herself she would continue dabbling in photography whenever she "found time."[6]

Reva's niece, Nancy Sherman, felt the passion all along was for Leonard, not photography. "She was probably caught between her passion for Leonard and her enjoyment of photography, something that became very important because people said it was," she said.[7]

Toronto photographer and printer Jeremy Taylor, Fred Taylor's son, had occasion to study Reva's complete major works. "It looked like the cut-off date for her photography was 1962," he said. "She had sincere, powerful and true works for a fifteen-year period, 1947–1962. She had a great Stage I in her career. There was no Stage II."[8] Reva's best work was done in 1947–50 when

she and Leonard travelled around Mexico with Stirling Dickinson. Aside from photographs she took of Leonard's music students in the 1960s, those early pictures would remain the backbone of her exhibitions and shows.

Esther Birney could not recall the exact period, but it was probably during a 1961 trip to San Miguel when Reva told her, "I have to choose between my career and his. I choose his."⁹ Said Esther: "I grieved when she gave it up because, as she told me, it became a barrier between them. She so quickly achieved a fame that was larger than his."¹⁰ Possibly a clue to Reva's willingness to forsake her career can be found in a letter to the Griers upon learning that Eldon, who had given up a painting career to become a poet, was now thinking of trying photography. "I don't really approve of a poet-painter bothering about photography as it certainly is not creative in the same sense as writing and painting," Reva told him.¹¹ Perhaps she genuinely believed that Leonard's art was more worthy than her photography.

Asked if she felt a rivalry with Leonard, Reva would say, "I never felt a rivalry with Leonard. I didn't want to superimpose myself. I was very recognized very soon." Why did she give up her photography? "Loyalty, helpfulness really, strengthening Leonard because he didn't have that much faith in himself." Reva broke down in tears when asked how she felt when she gave up photography.¹²

Eldon Grier disagreed with Reva's seeming abandonment of her career and, in one of his poems, "For the Photographer Reva Brooks," urged her to dedicate herself to photography:

Reva those
priorities of yours
husband first
Ibsen would have
typed you a Leica
just to turn it
on that stacked morality
anti-life he'd say
what an act
holding themes by
neckscruff twisting
Jewish scenes
from superstition
values out of boiling void
standing cocked and ironed
in the circle underneath

or
seated while the basking
father-figure cuts
your smile shades
the trees for glitter[13]

Leonard now tried to get Reva more interested in her photography. He wrote in his diary, "Big argument with Reva who will not listen to a word of criticism re work – photography or anything but her point of view."[14] Over the years, other such diary entries would follow, such as: "Reva touchy and unable to talk without – scrapping – and need to say nothing – or retire into shell rather than mention problems which involve her photography."[15] "She does nothing about photography – dark room – involved in dozens of other problems – an excuse for not facing herself."[16] "Reva's disinterest in photography now – and darkroom has been shut and untouched for a few years – as though I never opened my violin case."[17]

Reva did not actively cultivate the support of people like Van Deren Coke who could have helped promote her career. Quite the contrary, at times. Once Coke accompanied Leonard to Pozos, a mining town near San Miguel, and took photographs while Leonard sketched. "After we got back I saw his sketches, which were really very lively with insight in them," recalled Coke. "He asked which one I liked, and I picked out one of them. Reva came running into the room and took it out of my hands. 'No way,' she said to Leonard. 'You're not going to give that away.'"[18] Another time she arranged for a taxi to go from San Miguel to the Mexico City airport to pick up Coke, without advising him beforehand. She failed to tell the driver what flight Coke was on, so they never got together. However, she insisted Coke reimburse her for the taxi fare.

At the same time Reva was being honoured in the United States, she was also being honoured in the two neighbouring countries, Mexico and Canada. First, the museum of the National Autonomous University of Mexico selected her among thirty-five artists – others included painters Rufino Tamayo and José Luis Cuevas – for an exhibition on art and death. The museum asked to exhibit her series on the death of the infant boy. Reva was the only foreigner to exhibit on a subject close to the Mexican psyche. Reva wrote on the announcement of the show: "Remarkable exhibition – really most unusual and profound."

Commemorating International Women's Year, the National Film Board of Canada (NFB) included seven of Reva's photographs in its *Photography 1975*

book. There were 175 photographs from eighty-two photographers; Reva's contribution was disproportionately high. Among her photographs were several from her dead baby series, including *Elodia, the mother,* and *Dead Child.* The NFB paid Reva $753 for the photographs, which went into the National Gallery's permanent collection. *Dead Child* was also among sixteen photographs from the book reproduced in *Camera Canada* magazine.[19]

When photographic historian Naomi Rosenblum wrote her monumental *A History of Women Photographers* twenty years later, she said, "More than thirty Mexican women participated in documentation and photojournalism during the late 1970s as photography in this region assumed greater importance."[20] But Reva's name was absent from the book. Asked why, Rosenblum replied, "I did not consider Reva Brooks when I put together the material for the book and, later, the exhibition. I was familiar with her name from the San Francisco Museum of Art catalogue, but I had not heard of her since that time."[21]

Coke said of Reva's selection for *Women of Photography,* "Reva didn't progress beyond the things she did all in a period of three years. She made one body of work; everybody was very impressed by it and thought it would be a direction that was worth following to a much, much deeper degree than she followed. I think it came too easily to her. She took the camera and just went out and made these pictures almost intuitively and after that I don't think there was the drive to do it because it seemed so easy."[22] Almost wistfully, Coke added, "She didn't spread her wings at all. She could have developed more than that small body of work had she gone on."[23]

～ 56 ～
Sometimes I feel a thousand years old

Leonard signed a contract in 1976 for what would be his last art book, *The Many Ways of Water & Color.* The publisher was North Light Publishers of New York, since Reinhold was getting out of the art-book business. His Reinhold editor, Jean Koefoed, wrote to him on 26 March. "I am afraid I have bad news," he said. "My management has ordered me to cut back on our art book program and I am sorry it will not be possible for us to publish your book *The Many Ways of Water & Color.*"[1] Koefoed said Reinhold had experienced a "great decline" in the sale of art books, which Leonard could well appreciate from the

amount of his 1975 royalties: $130, the lowest since his first book was published eighteen years earlier. "The end of a long haul of my books – which I must face," he said.[2] North Light Publishers acquired Reinhold's art-book titles and gave Leonard an advance of $1,000 on a press run of 5,000 copies. The first run sold out in six months and North Light printed an additional 3,500 copies.

Compared to his relations with the Roberts Gallery, Leonard always enjoyed those with Reinhold. He wrote a whimsical poem when he finally received a box of books from Reinhold that had *not* been damaged in shipment:

What has changed his author's looks?
(He only has a lot more books).
Perhaps we'll ask him - "*Señor*, why?"
This time there is no need to cry.
So packed with love and carefully wrapped.
(Unpacking them, he nearly flapped).
No dog-ears here - nor tortured wrappings.
Survived the bumps and airplane's flappings.
Took the shocks of Mexican buses,
Avoided all the Custom's fusses.
So grateful thanks the author gives,
As long as such a fine packer lives.[3]

One result of Leonard's books was representation by two American art galleries in the 1970s. Jean Gronbeck, owner of the Gronbeck Gallery in Morro Bay, California, and Norman J. Miller, of the Miller Gallery in Cincinnati, Ohio, both painters themselves, discovered Leonard through his books. Gronbeck told Leonard she had been in a dry spell after painting for twenty years and was renewed upon reading *Painting and Understanding Abstract Art*. Leonard shipped some of his paintings to the Gronbeck Gallery, but his inspiring Gronbeck to resume painting backfired on him. Four years later she closed the gallery to paint full time. Miller's experience was similar. He said he was "turned on" to resume painting after reading *Oil Painting: Traditional and New*.[4] He, too, represented Leonard for four years.

Leonard's books also brought him to the attention of other art-book authors who asked to reproduce his works in their books. Dona Z. Meilach and Elvie Ten Hoor reproduced Leonard's *Hidden Treasures* collage in their 1973 book *Collage and Assemblage: Trends and Techniques*. Meilach and Bill and Jay Hintz used one of Leonard's posters in their 1975 book *How to Create Your Own Designs*.

Jack Wildridge planned a 1976 one-man show, but Leonard had his usual reservations, especially about going to Toronto. "It's just as foreign as being in Rome in most ways – although I can speak the language," he wrote of Toronto.[5] "If [the show] doesn't work – so what? Fuck Canada – and come back and forget it."[6]

Leonard took up to Toronto fifty paintings in the fall; returning for the April opening, they spent less than a month in Canada. "Show a success – $10,000 sale in 10 days – not *too* bad – and general reception good," he reported.[7] Leonard was so pleased that for the first time he wrote Jack Wildridge a letter of thanks:

As you know – it is always a trying time for the artist – apart from sales – business – it is a little like appearing in public with one's pants down – or at least unzipped! Between that – and the showing of the film to nearly 100 people – again – I must admit I did feel exposed at times – But there were many pleasant moments and I did feel the general reaction was good – mature and genuine to my efforts.[8]

"Thank God for Roberts – and continuance there," Leonard told his diary.[9] He was not happy three weeks later when Wildridge raised his sales commission from 33$^1/_3$ to forty percent.

On the eve of his sixty-fifth birthday, Leonard made an upbeat assessment of his life in a diary entry:

Reputation – not sullied
Survival – many paintings down and out in world
Music – a joyful thing to do
Financially – really well off with savings and property
Health – quite good apart from usual breakdown of teeth and oldster's
 symptoms of tiredness, skin rash, etc.
Memories – past has been filled with travel and good times
Friends – many

One of those many friends, a merchant seaman and amateur violinist named Paul Warfield who had retired to San Miguel, willed Leonard one of his prized possessions, an original edition of a music book written in 1756 by Mozart's father, Leopold.

Although the Brooks had not yet started to sleep in the new house, Reva invited twenty-six people for a late afternoon lunch, a tour of the premises and grounds, and a visit to Leonard's studio to spur interest in sales of his paintings,

a duty she had been neglecting because of construction priorities. The guests that last Sunday of January 1978 were a mixture of foreign residents and Canadian and American snowbirds. That night, Leonard felt an electric shock in his lower back that rendered him unable to stand. He was given shots of cortisone for a herniated disk in his lower vertebrae that was affecting the sciatic nerve.

Leonard was still confined to bed a month later when he suffered a fainting spell and started to haemorrhage. Doctors Paco Olsina and Frank Echlin rushed him to a hospital in nearby Querétaro, Echlin driving in his car. The attending physician at the hospital looked at the compulsory blood typing on Leonard's Mexican driver's licence but decided to do a test himself before giving him a transfusion, most certainly saving Leonard's life. The blood type on the driver's licence was incorrect, a fatal error if the wrong blood were used. After a radio appeal was made for the correct blood, a Mexican woman and a youth visiting from Alaska presented themselves at the hospital. Leonard was given three litres of blood to replace what he had lost from what was diagnosed as a bleeding ulcer. Leonard believed it was triggered by an overly strong dose of cortisone for his bad back.[10]

Aside from looking down the barrels of Fred Taylor's shotgun, this was probably the first time in his life that Leonard seriously contemplated his mortality. Groggy from painkillers, he took pen in hand – his left hand, as his right was immobilized by the catheter for the blood transfusion – and scratched out a poem synthesising his life and his uncertain future:

Years, time, tears
Hopes, doubts, fears
Days, nights, hours
Sun, water, flowers
Old, young or fair
All things be rare
Stars, skies and love
Flash of a dove
Smile of a child
Woods tangled wild
Joys I have known
Hates overthrown
Life enchanting
Fate unknown
Friends about us
Never moan.

"I'm a bit of a coward, I know, and a high strung type – even my veins are *'fina'* they say – Reva is strong and goes through this with me nobly," Leonard wrote.[11] He spent two weeks in the hospital and more than a month in bed back home. By early May he had his first drink in more than three months, a whiskey and water, "a consolation prize for all my troubles."[12]

One of the people who visited Leonard during his convalescence and played the violin with him as his health improved was Tom Sawyer. A New Englander from a poor Irish family, Sawyer had become wealthy in the radio industry and retired early after circling the world looking for paradise. He found it in San Miguel in 1966. Anxious to take up his bow and violin once again, he had joined Leonard's chamber music quartet.

Leonard had created the musical ambience in San Miguel; a musician with an entrepreneurial spirit, Sawyer now wanted to capitalize on the interest. While visiting England, he had listened to a chamber music group and decided San Miguel should, like Italy's Spoleto, host an annual music festival. Upon his return, he mentioned his idea to Leonard and went to see Leonard's boss at the fine arts school, director Carmen Masip. Masip and Sawyer co-founded the Chamber Music Festival, inaugurated in 1979.

Leonard suggested that the Fine Arts Quartet of Chicago be the first group invited. He knew the quartet's cellist, George Sopkin, who was part owner of La Rinconada, the original house the Brooks had rented in 1947. Another co-owner was Ellie Martin, one of Leonard's art patrons. She was generous in her financial support and managed to convince the Fine Arts Quartet to participate. A photograph was used for the poster for the inaugural festival. Leonard did collages for the next ten festival posters, which were sold to bring in revenue.

The budget for the first festival was just $5,000. But it eventually grew to more than $100,000 as the event earned international recognition. Besides the Fine Arts Quartet, groups participating included the Manhattan String Quartet, and the Tokyo String Quartet.

Leonard put down his brushes and became a musician for the first festival, playing up to six hours a day in classes given by quartet members. "Another test over. Played for group in the theatre and managed fine with one break – and one bad passage of playing," he said. "George [Sopkin] came back and shook hands with me to congratulate me on surviving if not knowing my nervousness."[13]

Leonard sold $2,680-worth of paintings to five people attending the festival. He was so energized by the festival that he painted five works during the first week back in the studio. "Sometimes I feel a thousand years old – and at times younger than some of the disillusioned youngsters I meet," he told Eldon

Grier and wife Sylvia in a report on the festival.[14] He was moved to write another poem, but this one upbeat:

When I think of all the thoughts I've thunk
Millions of joys and fears
When I think of all the drinks I've drunk
Barrels of rum and beer
When I think of all the food I've ate
Bread and cheese and meat
When I think of the smoke that passes
Carbon and nasty gasses
When I think of all the time I've spent
Worked or wasted away
When I think of all the sleep and dreaming
Lying awake in the dark
When I think of all the walks I've taken
Roaming in the park
When I think of all the friends I've known
The children who laugh when they play
When I think of all the dogs I've had
What more is there to say?
I think I'll turn on my back again
And quietly listen – as I love to do
To the sound of reluctant rain.

Leonard also became involved in the Festival de San Miguel, which Texas-born cellist Gilberto Munguía organized and ran for eleven years. Until it ended in 1997, the festival attracted internationally known young musicians during their December vacation break. Munguía, who was one of Leonard's most important patrons, used three of his works for festival posters. Leonard also loaned his tapestries to Munguia to decorate the converted granary where the ten-day event was held.

Leonard's illness resulted in a postponement of a show at the Roberts Gallery, scheduled for April–May, 1979. Jack Wildridge realized that Leonard did not have enough time to produce a new body of work, so the dealer suggested the date be pushed back."[15] Leonard agreed. "I *am* feeling better than I did a few months ago, but my back troubles continue and I must go slowly as I tire easily, as the sciatica from the pinched nerve in the herniated disc continues," he told Wildridge.[16]

Wildridge did have some good news to report. The brokerage house of McClean McCarthy & Co. had purchased a large work, *Golden Wall*, for its boardroom, and Maple Leaf Mills bought a painting entitled *Nocturnal*.

Leonard and Reva flew to Toronto in the fall for seven weeks, taking with them works for a 1980 one-man show.

As he recovered from his bad back and bleeding ulcer, Leonard sombrely wondered whether he had made a mistake in becoming an artist. "You should have remained where you came from – become a clerk in the railway as your father was – or an insurance man like your brother – or if must be – at least stayed as a safe teacher in a school you once taught in at 23 as a full-fledged (how miraculous) teacher," he told himself.[17]

~ *57* ~
They're known as the Canadian royalty

Through a combination of talent, personality, and perpetual boyish enthusiasm, Leonard Brooks always attracted supporters who wanted to do for him something he was reluctant to do for himself: promotion. Like Toronto advertising executive Jack Spitzer before him, Kenneth Saltmarche envisioned the National Gallery in Ottawa sponsoring a nation-wide tour of the Brooks' works. A painter who had visited the Brooks in San Miguel, Saltmarche was director of the Art Gallery of Windsor in Windsor, Ontario, when he wrote to Richard Graburn, chief of the National Gallery's national program: "Leonard Brooks, and his photographer wife, Reva, are Canadian artists who left Toronto about 35–40 years ago in despair and settled in San Miguel de Allende ... It seems to me that these people should be accorded greater recognition in their own country and, accordingly, I have initiated conversations with them with a view to a joint show here in 1979 with the hope that it might circulate thereafter for a period of time."[1] Saltmarche suggested the National Gallery take the show nation-wide after the Windsor opening, but he was no more successful in his efforts than was Spitzer.

Saltmarche mounted the show in 1980. As part of the promotional publicity, he arranged for the local daily newspaper, *The Windsor Star*, to interview the Brooks in Mexico. Wrote reporter David Quinter: "By some, they're known as the Canadian royalty of San Miguel de Allende and, indeed, receiving an

invitation to visit their comfortable art- and photography-choked home is said to be the best the inland Mexican resort can offer. Leonard and Reva Brooks, he a noted exiled Ontario painter, she a one-time Torontonian, now a photographer of world renown, among the leaders of the town's intellectual and arts community, will be the featured artists at this fall's annual Art for All show and sale at the Art Gallery of Windsor."[2]

The Art for All show was an annual fund-raiser featuring one artist – two, in the case of the Brooks – but with works of others also offered. Buyers bid on the work or works they wished to buy. Leonard exhibited a record 103 paintings, of which he sold more than half – fifty-two – for $22,650 less a twenty-four percent commission, probably his most remunerative show. Reva showed thirty-four photographs, but none were purchased. The Brooks were not physically present, but the gallery showed the videotape of the film made by Amaranth Productions. Saltmarche told the Brooks, "Hundreds are streaming through the place, the videotape of your fine film is going daily, we hear your interviews and announcements on radio from both sides of the river – so you are here, all the time."[3] Reva's lack of an apprenticeship in photography showed as Saltmarche discovered she had given some pictures several different names. "[I] had to resort to a process of elimination, ending up with a toss of the dice as to the title of the beautiful, moving portraits reproduced in this catalogue," he said.[4] Saltmarche gave a one-hour talk one evening devoted entirely to the Brooks. Catie Allan of the gallery staff told Leonard that a painting he had donated for a raffle brought in over $2,000. "As you know from your conversation with Ken," she said, "your paintings were a huge success."[5]

Unbeknownst to Leonard, his mother Nell had been assiduously following his career in the newspapers until her death the following spring at age ninety-eight in a retirement home in Hamilton, Ontario. The Brooks did not attend her funeral; Reva had wanted to go, even though she had been the favourite target of Nell's invective. When they flew to Canada that fall and Leonard looked at the worldly goods Nell had left behind, he discovered that she had faithfully kept a scrapbook of his exploits. Even if she had not understood his artistic ambitions, she had been proud of him.

After his mother's death, Leonard gave a painting, *Frosted Garden*, to the city of North Bay in his parents' memory. It was hung next to York Wilson's *Mexican Market* in the new three-million-dollar city hall. "Friends together again," said North Bay high school mate William Kennedy, who headed the city's art advisory committee which bought the Wilson work as well as two of Leonard's paintings, *Golden Flower* and *Musical Mood*, for the new building.

~

When Canadian ambassador Claude Charland planned the 1982 inauguration of the new embassy at No. 529 Schiller Street in Mexico City's exclusive Polanco district, he wanted to involve Leonard in the activities. Leonard loaned the embassy one of his tapestries, *Ascendant*, and a large painting, *Fiesta*, which were hung in the main patio of the embassy. Prime Minister Pierre Trudeau, a friend of the family of Charland's wife, Marguerite, agreed to officially open the embassy along with Mexican President José López Portillo. "Speeches and back pattings and lively feeling of two countries doing well with each other," Leonard noted.[6] The Brooks talked afterwards to Trudeau, whom they had met during his 1976 state visit to Mexico, and he commented on the tapestry. Reva mailed brochures on Leonard and herself to the Prime Minister's Office and received a reply that said, in part, that they had succeeded in fostering important cultural relations between Mexico and Canada.[7] Charland's predecessor, James Langley, had recognized the role Leonard played in Mexican–Canadian relations and had recommended him for the Order of Canada in 1979.[8]

The agility of Reva's mind came into play during their initial meeting with Trudeau at a state dinner at the embassy residence in 1976. Thinking of the attractions Mexico must have for artists, Trudeau had said to Reva, "You must live in San Miguel because of the light." "No, Mr. Prime Minister," she replied, "because of the quality of the *life*. Light has nothing to do with it."[9]

When Miguel de la Madrid replaced López Portillo as president of Mexico, the Brooks received a telephone call from Los Pinos, the Mexican White House. Leonard at first thought it was a hoax. The president's son, also named Miguel, wanted to take photographs while accompanying his father on a trip to Egypt. Could Reva give him photography lessons? De la Madrid – "Call me Miguel" – spent six days working with Reva in San Miguel, security agents discreetly keeping the Brooks' compound under surveillance. She sent de la Madrid, a man in his twenties, out on photo assignments, worked with him in the darkroom and critiqued the final product. After the trip to Egypt, he returned to San Miguel to proudly show Reva his prints. It was one of the few times Reva used her new darkroom.

~

Leonard held an opening at the Roberts Gallery in 1980, clearing $8,250, and again in 1983 at what would be his last one-man show at the gallery. He had $28,000 in sales, but after paying for the framing, reception, advertisements in *The Globe and Mail* and commission to the Roberts Gallery, Leonard was left

with just $8,300. "Never will I [again] go through all that work – investment – and exposure on such terms," he said.[10] He did an inventory of his works in Canada. Roberts had fifty pieces; the Kensington Fine Arts Gallery in Calgary had thirty-five; the Thielsen Galleries in London, Ontario, which started representing him in 1977, had forty; the Kastel Gallery in Montreal, with which he was newly associated, had fifteen; and thirty were stored at brother-in-law David's farm in Elora. "Canadian disinterest and disregard of what I have done seems to grow with time – and I must learn to accept this completely – and not expect it to get better – but only worse to come ... there will be *no* point in taking more work north to add to that already going begging on gallery shelves ..."[11]

While recognition in Canada remained elusive, it was increasing in the United States and Mexico. Owner Herbert Schultz of the New York Graphic Society, the world's largest distributor of art reproductions, honoured Leonard by asking him to submit works for the company's 1983 catalogue. He submitted *Amaryllis and Cat*, (71 × 63 cm), *Iris and Pond* (76 × 48 cm), and *Time Pendulum* (81 × 60 cm) to be reproduced in Milan, Italy. Leonard was the only Canadian artist represented in a catalogue that included works going back to Leonardo da Vinci. The three paintings would eventually be posted on the company's Web site on the Internet.

A new Canadian ambassador, J. Russell McKinney, did what Kenneth Saltmarche had suggested: a show opening in the capital and then travelling throughout the country. But the country was Mexico, not Canada, and the show was a thirty-year retrospective of Leonard's works. Not only did it travel throughout the country but – ironically – it was part of the celebrations marking the fiftieth anniversary of the National Institute of Fine Arts, Mexico's equivalent of Canada's National Gallery. The show opened on 4 June 1984 at the embassy in Mexico City and then travelled for more than two months to Monterrey and Guadalajara, Mexico's second and third largest cities, and to Aguascalientes, Morelia, and San Luis Potosí. It consisted of sixty-nine oils, acrylics and collages, and five tapestries. There were many ambassadors among the two hundred dignitaries at the Canadian embassy to hear McKinney anoint Leonard as one of theirs: "As the true Canadian that he is, Leonard Brooks is as much an ambassador of my country as I am myself."[12]

The cultural centre in San Miguel later did its own retrospective of Leonard's work. Javier Barros Valero, director of the National Institute of Fine Arts, inaugurated the show at Bellas Artes, where Leonard was stepping down as director of the music department after twenty-five years. "It is a pleasure to observe the 125 works of this man of seventy-five fruitful years," said Barros Valero. It

was fitting that the most eloquent words were not spoken by a government official but by a former music student, Estela Macías, who recognized what Leonard and Reva had done for the town's underclass: "He helped us not only in music and painting, but also economically, including clothes and food and in other kinds of studies. Thanks to them, I was granted a scholarship by the American embassy to enter the British Hospital as a nurse. In San Miguel, we all owe them something."[13]

~ 58 ~
The senseless, brutal, and bloody murder

"Death," Reva Brooks once wrote about Mexico, "comes suddenly and often, so is more fatalistically accepted than by we northern people."[1] Reva encountered death in its crudest form at 10:20 p.m., Thursday, 21 June 1984. She and Leonard had retired to their bedrooms half an hour earlier; he was sleeping when their dogs started barking. Reva, who had been listening to a radio newscast, walked out onto the terrace and shouted in Spanish to the dogs, "Kill the thieves," words she had used for years to frighten off any nocturnal prowlers. When she heard a tinkling of broken glass, she went downstairs in her nightgown, opened the front door and walked down towards Leonard's studio. By the corner of the house she saw Payaso, one of their dogs, protecting the bloodied body of Jesús Arzola, their gardener. He had been hacked to death with his own machete.

Reva awakened Leonard. She did not tell him of the murder but that she thought there was a man outside, so Leonard went out and he too came upon the body. They called the police, turned on all the lights on the property and waited. After the police inspected the murder scene, the Brooks accompanied them to the station with Jesús' daughter, Chabela, who worked for them as a maid, and their handyman, Raúl Godinez. Godinez was jailed overnight.

The Brooks ordered new locks on all the doors and made plans to raise the eight-foot-high stone wall that surrounded the compound. They also contacted the London law firm of Wiggin & Company, which represented the Duke of Bedford, owner of the abandoned next-door property where they thought the killers had sought refuge. The property, which once belonged to singer José Mojica, was a known hangout for undesirables. "Bad low day," reported

After the murder of their gardener, Leonard did some "horror" paintings, like this one, 1984.

Leonard. "Reva quarrels when I tell her how I feel and how I must get away somehow before long – and get a new start."[2] Leonard did what he called a "horror" portrait of himself and the murdered gardener.

A little over two weeks after the murder, the police awakened the Brooks at 4:00 a.m. to inform them the case had been solved. The alleged murderer had fled to the United States, but his accomplice was in custody. The following day five police agents brought over the handcuffed, twenty-year-old suspect to re-enact the crime. The motive: a quarrel between the alleged murderer and the fifty-eight-year-old gardener.

The accomplice later fled while out on bail. The alleged killer returned to San Miguel fourteen years later, but the murder charge was not pressed.

Although the Brooks had encountered violence in San Miguel, including the murders of their neighbours on Quebrada Street, this was the first time

they had been personally affected. Nor would it be the last time. Reva was particularly traumatized by the event. Finally, on 4 October, she wrote an account of the killing and sent copies to friends and relatives:

It is fifteen weeks since the Thursday night that we were faced with the senseless, brutal, and bloody murder of our gardener, Jesús Arzola. Since then, I have wanted to write to the family about it, but I have found it too difficult to do so. We have been gradually recovering from the shock, and are now feeling better, and now I find I can do so. We were strong and looked after all the necessary things – judicial, religious, financial for him and the family, and the turmoil that followed. For weeks I have felt suspended, "in limbo," and heartsick, mystified by it all. After this, some weeks later, I had a disturbing reaction of weakness, but with time, both Leonard and I have gone through a process of healing ourselves, and we have now recovered as much as one can after such an experience, and learning to live with the memory of it.[3]

The Brooks' sense of personal security was shattered again when they returned from a concert and interrupted burglars who were ransacking the upstairs bedrooms. They took Reva's jewellery, a radio, a typewriter and a painting. For the first time Leonard talked of leaving Mexico. "At the moment I would sell up everything and go elsewhere if we had the strength and offers – as it spoils our going out comfortably at night, etc. and smears our privacy," he wrote. "Lucky we were not attacked."[4] Reva told Lela Wilson: "I am trying to get over the shock of the burglary – a violation of our privacy and security in the part of the house we thought was impenetrable. The loss of all my precious gold jewellery of irreplaceable sentimental value is so hard to accept. The aftermath with the judicial police, paperwork etc. is almost unbearable."[5] Three months later the Brooks received a telephone call from a man offering to sell them their stolen property. They did not accept the offer. "I'd like to blow their heads and balls off," said Leonard.[6]

The next crime was perpetrated on Reva herself as she walked down a lane at the base of the hill behind their property. A young man tried to snatch her cloth shoulder bag. He dragged the bag and Reva along the rocky ground, pulling her right arm out of its socket. Her screams finally alerted a neighbour who scared off the purse-snatcher.

Reva called the maid, Chabela, who brought clothes to replace the torn and dirtied ones she was wearing. She did not tell Leonard about the incident but instead repaired to her bedroom where she wrote a letter addressed to him and her brother, David, who was visiting at the time. The letter said in part: "The

criminal yelled that I must give him my money not being able to pull off my bag after pulling violently. The criminal attacker became angry, hoarsely demanded that I find my money and give it to him ... I feel it is my duty to let you both know I need to cry so please don't come upstairs."[7]

Leonard himself wrote an open letter to the Mexican authorities that was probably never mailed:

This is a letter I thought I would never have to write. To not do so would be an insult to myself ... we have tried to help bridge the differences in our Canadian cultural ways with the Mexicans and have had many happy years of interchange – as we have had with Americans – from the time of the GI "invasion" after the last [world] war. Therefore, it is not as an "outsider" that I write these words ... within a few yards of my house – on a 12 o'clock sunny day on Friday Aug. 30 my wife was attacked and brutally assaulted by a 20–25 year old coward male. Thrown to the road and roughed up in a struggle to rip her bag from her – her screaming fortunately brought a nearby neighbour to her rescue ... disillusionment does not overwhelm me – only a sickness of heart – for Reva, myself – and all of us San Miguelenses.[8]

But it was an illness, possibly triggered by the trauma of the murder and its aftermath, that now threatened Reva's life. She thought she was suffering from influenza, but when her fever did not abate and she became delirious, she was taken by ambulance to a hospital in San Luis Potosí, a two-hour drive from San Miguel. Since she needed someone to attend her in her room – a Latin American tradition to compensate for the paucity of nursing staff – and did not want Leonard there, Aileen Harris, a visiting Torontonian, stayed with her. Reva was found to have a kidney so infected that the hospital asked the name of her priest, in case the last rites had to be administered. They assumed she was Catholic.

Harris could only stay for three days, so Leonard relieved her, although he obviously did not look forward to being an *acompañante* in Reva's room. "Reva depressed – looking a hundred years old and not moving," he wrote in his diary.[9] A mutual friend asked a Mexican lady named Beba Treviño, a resident of San Luis Potosí, to drop by and cheer up the Brooks. Leonard became smitten with her. "Beba Treviño saved my days – we talked and confided and I fell for her sad eyes – and honesty – and revealed things one can only do when under pressure and in such emergencies and stresses," Leonard wrote.[10] Once Reva was back home and recuperating upstairs, Leonard invited people for dinner, including Beba Treviño. Reva must have realized the attraction because she insisted on being brought downstairs and placed on a mattress

Left to right, Frank Echlin, Lela Wilson, Letitia Echlin, Fred Taylor, Reva Brooks, Leonard Brooks, and Spencer Clark after some of York Wilson's ashes were spread outside Leonard's studio.

so she could be a member of the party. Beba later married a Canadian and moved to Canada.

The year of the gardener Jesús' murder also brought another death, that of York Wilson, who for many years suffered cardiac problems. Only Lela Wilson was more affected by York's death than was Leonard. "I think Leonard felt it because it was part of himself," said Lela.[11] "It has been a privilege and a joy for me to have spent the time we have together – never competing, enjoying each other's success," Leonard wrote to York during the final year of his life.[12]

Because the Wilsons considered thirteen to be their lucky number, Lela decided to have York's ashes scattered in thirteen of his favourite countries. When the Brooks were informed, they offered to hold a ceremony, and Leonard chose the tree closest to his studio – a pomegranate – for the resting-place of the ashes. Lela gave Leonard the honour of scattering them. He swept his arm in an arc and the ashes formed a "perfect cross" when they settled at the base of the tree.[13] Then the dozen mourners sang "For He's a Jolly Good Fellow" and adjourned to toast their departed friend.

*T*hinking of my "place" in Canada

One morning as the Brooks were sitting down to breakfast two couples from Fort Worth, Texas, rang the bell at the gate to their compound and asked if they could see Leonard's paintings. By the time Leonard returned to the main house for his fruit, boiled egg, and coffee, he was richer by $14,000, tax-free. The couples had purchased six of his works. During August of 1991, Leonard sold $31,000 worth of paintings from his studio, which he calculated would have required over $60,000 of sales at the Roberts Gallery to net the same amount. "No dealers, no frames, no big hassle of transportation," he said.[1]

Canadian painter Marion Perlet, who moved to San Miguel in the late 1980s, calculated that she had to sell $20,000 worth of paintings in Toronto just to break even on the costs of staging a show. She would take up twenty to twenty-five rolled-up oils to be framed at a cost of $10,000. Insurance added $2,000, invitations another $1,000, plus gallery commissions, not to mention transportation from Mexico and hotel and meals in Toronto. Like Leonard, she had preferred to sell out of her studio. During the 1990s, Leonard calculated he made fifty dollars in sales out of his studio for every dollar in Canada, even though four galleries were handling his works there.

Inevitably, many of Leonard's works had Mexican themes, which also encouraged studio sales as opposed to gallery sales in Canada. Collectors visiting Mexico were more predisposed to buying a painting with a Mexican theme, while buyers in Canada still preferred Canadian themes. Other Canadian painters based in San Miguel had similar experiences. "Both my wife and I run into the same problem with Mexican subject matter," said Calgary artist and art professor John Hall, who spent half the year in Canada and the rest in Mexico. "If it's a landscape, they want it to be a Canadian landscape, and so on. It's a problem for the dealers."[2] Toronto painter Cleeve Horne was blunter: "Nobody is going to buy work by a painter living in Mexico and painting Mexican pictures. They want to buy Canadian work by Canadian artists living in Canada. This is something Leonard didn't realize or didn't recognize. The Roberts Gallery did recognize that and was very concerned that he was not selling as his name was being forgotten."[3]

Although Leonard visited galleries whenever he travelled and subscribed to art magazines, he was still at a disadvantage about what was happening in the

art world in Canada, and elsewhere. As painter Ron Bolt, based in Baltimore, Ontario, put it, "Leonard missed a number of developments in Canadian art: the East coast realism and the West coast with Jack Shadbolt, Gordon Smith, and others. The Painters Eleven was just coming to the fore when he left the country, so he was pre-empted by all those happenings."[4] Not that Leonard wanted to follow the trends; he did not. But he was not as *au courant* of the trends as he would have been had he lived in a major art centre, rather than an isolated colony.

During more than half a century in Mexico, Leonard only held six one-man shows at the Roberts Gallery, while his friend York Wilson had one every other year. Sometimes Wilson would have an opening elsewhere in Canada during the off-year. From a strictly business point of view, studio sales, managed by Reva, as opposed to shows in Toronto, were a tremendous success, but at a cost to Leonard's reputation in Canada. "This has not been a marketing plan for recognition, it's been a marketing plan for a way of life," said Toronto gallery owner David Mitchell, who visited Leonard in San Miguel.[5] "I don't think you can have it both ways. Galleries put you in the fore," said Ron Bolt. "They hang you with your contemporaries, good ones, and they build you a reputation."[6] "Studio sales work very well in terms of generating income," said John Hall. "But they don't work in terms of generating profile. The works go onto the wall of a private collector and they're never seen. You need – particularly in Canada – to generate profile, records of exhibitions, the publishing of catalogues, that sort of thing, reviews, all of the public activity surrounding the events."[7]

The distancing from the Toronto art scene was exacerbated by Wildridge's death in December 1991. Although Leonard remained with the Roberts Gallery, he felt a generational gap in his dealings with Jack's son and heir, Paul. Leonard wrote the following for a memorial exhibition for Wildridge: "Jack W. was known to be one of the most honourable, ethical, and reliable art dealers in Canada. He was always generously ready to give advice and help to anyone who asked him. Some people misunderstood his low-keyed, diffident manner as perhaps disinterested in promoting the artists who exhibited with him." But in his diary he wrote, "Roberts has never really been a dealer for me ... they have never bought a painting from me for a show – never phoned me in Mexico ... they have not advertised or promoted my work."[8]

Leonard was encouraged when some of his paintings from 1939 were sold at auction in Toronto for up to $1,000, compared to the original thirty-five-dollar sale price.[9]

Leonard joined a group of former music students who came at dawn on his eightieth birthday to serenade him with Las Mañanitas, *the Mexican birthday song, 1991.*

While Leonard publicly professed his belief that his reputation in Canada suffered because of lack of support from the art establishment, privately he accepted part of the blame. "Thinking of my 'place' in Canada – last night – and how it has not added up to much in Canada – partly because I have not been there or kept up with the Joneses – and have spent my life in Mexico," he told his diary.[10] He and Reva realized that if his reputation and hers were to be burnished in Canada, they would have to do something about it themselves.

Back in 1963, when his financial success as an artist was established, Leonard had contacted Toronto estate planner Norman Cowan about setting up a series of music scholarships for Mexican students. Since he was proud of the fact he had succeeded as an artist without any scholarships or government grants, he was not going to fund any struggling painters. Musicians were different. "To play a violin," he explained, "you have to be very capable, disciplined, and know what you're doing."[11] Although the Brooks went as far as to draw up their wills leaving money for scholarships, the plan fell through. Now, they revived the scholarship plan under the Leonard and Reva Brooks Foundation, which found a home at Queen's University in Kingston, Ontario, in 1992. As stated, the purpose of the foundation was:

To ensure the care, maintenance, display, and publication of the Leonard and Reva Brooks core art and photography collection, and an important archival textual and photographic collection portraying their international artistic life;

to disseminate and promote Canadian art;

to establish scholarships, bursaries, and other forms of student aid for qualified students of Mexican nationality who have been accepted to study music at Queen's University.

The agreement was later amended when the Brooks decided that the National Gallery in Ottawa would be a more appropriate repository for Reva's vintage prints and negatives.

Reva, who was the prime mover, found an additional justification for the foundation: "Having the Brooks Foundation at Queen's University, Kingston, Ontario, Canada for the benefit of future generations could be a solace to me for the intense pain I feel about not having Leonard's children."[12]

While the Brooks were considering where their foundation should be established, they made a final, short trip to Italy, travelling with Jim Harmon, an American painter and art supply store owner, and his wife, Esperanza. The Harmons had a home in San Miguel and a mountain-top house and studio in Tuscany where the Brooks were guests for six weeks. An early riser, Esperanza would encounter Leonard at 6:00 a.m. doing a watercolour. "I would compare Leonard to Lope de Vega, the seventeenth century Spanish writer and playwright who used to get up and write an entire play before breakfast," she said.[13] Afterwards, recalled her husband: "He'd paint in the studio until lunch; have lunch; paint after lunch; have a siesta; paint after the siesta; paint before dark outdoors; paint in the studio at night. He's one of the most productive artists I've ever known."[14] Harmon also introduced Leonard to monotypes which he enjoyed doing. Leonard noted: "Experimented with monotypes on Plexiglas – a strange and wonderful session ... all the equipment, press, etc. in the studio and I had a ball, day and night and did fifty impressions."[15] The Brooks capped the trip by spending three days in Rome with Canadian ambassador Claude Charland, who had been transferred from Mexico to Italy, and his wife, Marguerite. "It was like a visit by relatives," she recalled.[16]

Leonard turned into a Canadian diplomat when the embassy in Mexico City launched an eighteen-month tour of his works to coincide with the debate on the North American Free Trade Agreement (NAFTA) linking Mexico, the United States, and Canada. Leonard even gave one of his paintings to the printer when the embassy budget came up $1,000 short to cover the cost of printing the catalogue. Ambassador David J.S. Winfield opened the exhibition

before three hundred people at the embassy on 27 November 1992. "Ex. over and went better than I had hoped – a splendid catalogue," said Leonard. "David Winfield gave a fine speech about us and I saw numerous friends – had TV interviews, photographs etc. and was able to handle this public appearance without making too many slips in deportment or Spanish."[17] Leonard would have other occasions to use his Spanish as he often opened the show himself when it moved to the interior and no one from the embassy was present. He would extol the friendship between Mexico and Canada.

Jim Langley, the former ambassador to Mexico, failed in his attempt to obtain the Order of Canada for Leonard. But he was on hand at the staid Rideau Club in Ottawa in 1992 when a tieless Leonard showed up to receive the Governor General's Medal. Although the medal carried no official weight, Gabrielle (Gaby) Léger, the widow of Governor General Jules Léger, thought Leonard should have one, especially as it had been designed by a fellow war artist, Alex Colville. Léger also had been an ambassador to Mexico where he and his wife had became close friends of the Brooks. The maître d' was shocked that a member of the former First Lady's party was not dressed according to Rideau Club custom. There was debate at the table as to whether Leonard should feign a sore throat that could not stand the pressure of a tie or whether his appearance should be justified by his status as an artist. Finally, Langley took off his tie too. When Mme Léger presented Leonard with the medal, she told him, "My husband intended this. We always wanted to do this for you. This should be yours."[18]

Leonard's feistiness and combativeness were not diminished by age. When he was eighty-two, he challenged a fellow artist half his age. The confrontation occurred at the horse ranch of Canadian millionaire Marie Trott on the outskirts of San Miguel. Leonard had taken Toronto composer Milton Barnes there on a visit and wanted to show him a piano in one of the guesthouses. Leonard entered without knocking and was faced by a couple, a woman who liked to exercise the Trott horses and a friend of hers, British artist Andrew Rogers. As Leonard attempted to show the piano to Barnes, Rogers ordered him out of the house, using a few expletives. Leonard headed for the door, stopped and turned on Rogers. "Don't talk to me like that, you son of a bitch," he said.[19] As the two men stood face to face, Barnes, who towered over both of them, was prepared to intervene, but Rogers backed off. Trott ordered the woman, who had been staying at the house for two years free of charge, off the property.[20]

Leonard could also defuse a potentially dangerous situation through audacity, as he did when he and Reva visited the author in Puerto Rico for their

fiftieth wedding anniversary. Leonard set up his easel and was painting on the beach in San Juan's Condado district while the author jogged. At one point, the author looked over and saw that a group of young toughs who preyed on tourists had surrounded Leonard. As the author approached, he heard one of the youths say, "I know how to draw." Leonard handed him his sketchbook and the youth drew one of the towers of El Morro, the Spanish fort in Old San Juan. Leonard looked at the drawing, did a few corrective strokes and handed it back. "You've got the perspective wrong," he said. Catching the author's eye, he packed his easel and walked away, leaving the youths to study the sketch.

~ 60 ~

He could have been much more highly placed

Jack Wildridge of the Roberts Gallery once called Leonard Brooks an artist's artist, which Leonard took as the highest of compliments. What other artists thought of his work was always more important to Leonard than what critics said. While he depended on the public to buy his works and provide him with a livelihood, he paid no attention to popular tastes in matters of art. He felt that if he were true to himself and had the talent, he would eventually be recognized in Canada, despite the handicap of more than half a century of self-imposed exile in Mexico.

When he left Toronto in 1947, he was becoming famous for his watercolours of the Canadian landscape, much in the tradition of the Group of Seven. Judged by his Mexican output, he would probably be best remembered for his abstracts and collages. "I think he probably fits into what was going on in Canadian art landscapewise in the forties and fifties," said Vancouver painter Toni Onley. "He's a person to be reckoned with historically for that period. He's a wonderful watercolour painter. He has done some beautiful work."[1]

Gunther Gerzso, one of Mexico's most acclaimed artists, always envied Leonard's ability to paint watercolours. "I never do them; they're too difficult," he said. "Leonard has this incredible ability and dexterity to do watercolours. It's not easy."[2]

"Leonard is one artist who cannot do a bad painting, even if he tried," said German-born, Quebec painter Helmut Gransow, who had a studio in San Miguel. "He tackles landscapes I wouldn't dare to try because I feel it's just too

difficult. He just sits down and paints. Whatever he produces, it's always of a superior quality."[3]

"People like Leonard who were outdoors people and watercolourists were more productive than people like me," said fellow war artist Jack Nichols. "I used to marvel at this."[4]

"When we first met in Elora [Ontario], we arranged to go on a sketching trip," recalled painter D. Mackay Houstoun. "I worked on a more finished painting while Leonard was knocking off eight or nine things that I thought were excellent. He wrote the book on watercolour painting."[5]

"Leonard's formal work – the paintings, the collage paintings, and the straight oil paintings – are fine, but they tend to be stylistically very, very specific," said Calgary painter John Hall. "They're very, very professional works, but when he does perceptual watercolours, they are extraordinary."[6]

"Maybe he is too versatile," offered Latiné Temple, American painter and art gallery owner in San Miguel who donated eight of Leonard's works to the Museum of East Texas in Lufkin. "He can speak too many languages. I could say that maybe it's because he hasn't made his own language, but for me he has: his collages. I love them and know of no others I would compare with them."[7]

"His collages are just wonderful," said Vancouver artist H. Eberhard (Ebe) Kuckein. "I think he's one of the grand masters in it."[8]

"Leonard had the ability of taking the ideas of abstract expressionism and building it into beautiful paintings," said painter Will Allister. "He's one of my idols."[9]

Leonard himself seemed to have a special fondness for watercolour. "There is a satisfaction from watercolours which no other medium gives – when it works – it is so difficult – and the chances of a 'mess' are always present. Even at that it is never really successful and can always be so much better. Perhaps one should do the same one over a thousand times and perhaps a conclusion could be reached."[10] But he would agree with Reva that what he did best were his abstracts. "I do say years of 'abstract' work – is the basis of the best I do – and comes – though buried – and hidden – into all I do," he said.[11]

As an artist's artist, Leonard earned the gratitude of colleagues of like ideas whom he encouraged and helped. When Eric Brittan, painter and art teacher at Sheridan College in Oakville, Ontario, spent a sabbatical in Mexico with his family, Leonard would go regularly to his studio. He let Brittan have a prized possession, York Wilson's easel, and tried to interest the Roberts Gallery in his works. "Leonard wouldn't be keeping company with artists who were doing the kind of work he didn't believe was substantial," Brittan said.[12]

James Bessey, a Stouffville, Ontario, artist who left the business world to paint full time, wrote to Leonard in 1992 after buying and using his book on abstract expressionism. After Leonard replied, Bessey started sending samples of his work for critiques. Leonard sent Bessey an eight-by-ten inch abstract and a sketch explaining its evolution. "I am very grateful to Leonard for his kindness and generosity for passing along great words of wisdom, which have been and continue to be very inspirational," Bessey acknowledged.[13]

Perhaps Leonard's most unusual pupil has been Alfredo Arzola, a barely literate son of the slain gardener, Jesús. Leonard recognized in Arzola, a carpenter's assistant, an artistic talent as a wood carver and sculptor. He encouraged Arzola to dedicate himself to his art, let him stay rent-free in the compound's guesthouse and gave him a workshop in which to carve. Every evening Leonard would give Arzola a lecture, sometimes on Mexican history, sometimes on world history, but usually on art. He taught him how to do linocuts and also gave him lessons on watercolour and oil painting. "He teaches me everything," said Arzola.[14]

Leonard arranged customers for Arzola's elaborate tableau carvings of birds, insects and flora, helped him set a price and keep track of the hours worked so he could show a profit. When artists came to visit, Leonard made sure they met Arzola as a colleague. "This is a beautiful side of Leonard," said painter Joy Laville, who also sculpts. "He will find a spark in people and nurture it. He is very generous this way."[15]

When David J.S. Winfield was named Canadian ambassador to Mexico, he wanted to recognize the achievements of Canada's expatriate artists. Since Leonard was the dean of expatriate artists, Winfield wanted him to have the first show at the embassy. Leonard declined. He said that honour should be given to Arnold Belkin, a Calgary, Alberta, artist who went to Mexico as a teenager and was now terminally ill with cancer. Belkin had a show at the embassy in 1991, a year before he died at age sixty-two. Leonard also helped the ambassador arrange a show for Marion Perlet, a Canadian painter based in San Miguel.

Where will Canadian art history eventually place Leonard Brooks? The Art Gallery of Ontario's Christine Boyanoski, who has written about Canadian artists who went to Mexico, felt recognition in Canada eluded Leonard because he was a loner who lived abroad and was not associated with any group back home. "His sensitivity to international art currents, beyond the restrictions of the Canadian art world of his day, made him popular with many collectors, but may also account for his absence from most histories of Canadian art," she said.[16]

Said Joan Murray, American-born author of seven books on Canadian art, including one on the Group of Seven: "Leonard could have been much more highly placed than the Group of Seven, but it takes investing in yourself and having the faith to do so. I think his watercolours are dreamy. I love his figure subjects. I love his collages; I think they're very subtle. There's no doubt he's the real thing."[17]

But Leonard could not – or would not – invest in self-promotion, nor did he have a gallery in Canada that aggressively promoted its artists.

∼ 61 ∼

The Brooks have been surprisingly overlooked in Canada

Anyone wandering into the San Miguelito bar that April evening in 1994 might have been excused for asking why two obviously foreign octogenarians, seated in the box of honour, were being serenaded by a group of Mexican musicians. Tears ran down the man's ruddy cheeks; his long white hair rustled and his giant eyebrows, protruding like canopies on an art deco building, moved up and down as he kept time to the music, holding the woman's hand in his. He knew all the music being played, Mozart, Bach, Vivaldi, the Gypsy airs, and the Mexican songs, for he had taught them to the five musicians.

Since they seldom kept late hours, Leonard and Reva Brooks had not wanted to go to the San Miguelito bar, the town's newest nightspot. But owner Servando Canela was persuasive. He had called to say the Aguascalientes brothers, all of whom had studied music with Leonard at the cultural centre, were making a rare appearance in San Miguel and would be playing at the bar for two nights. The Brooks could be his guests that evening. "This is going to be very, very special," Canela had assured them. After all, the building on the corner of the *Jardín* housing the bar had, in an earlier incarnation, been the site of Leonard's long-time, second-floor studio. Canela met them at the door and, to their surprise, escorted them to the box of honour – "The Celebrities Balcony" – eight feet above the stage. As soon as they seated themselves in ornate, gold-inlaid wicker chairs, the Aguascalientes brothers strolled onto the stage, and stood below them. For those present, Canela explained that Leonard's former students were honouring him that night. As the brothers,

stars of Mexican television, serenaded Leonard, he acknowledged them with a wave and a shake of his head. Patrons who jammed the one hundred and fifty-seat bar joined in the singing. Although used to going to bed early, Leonard and Reva stayed until 1:30 a.m. "All very unreal," said Leonard. "The present and past of our lives. I felt like a historic monument."[1]

Canela had heard of the increasingly reclusive Brooks, but learned more from the Aguascalientes brothers when he contracted them to perform in his recently opened bar. "Leonard was their first teacher and they were very appreciative of what he had done for them," Canela explained. "They told me about the lovely job he did helping poor young musicians." As a businessman with several establishments in the tourism sector, he was appreciative of the drawing powers the Brooks exerted during their early years in San Miguel. "Many people came to San Miguel over the years just because the Brooks were here."[2] So he decided to pay homage to them, inviting local dignitaries and personalities to the San Miguelito for the occasion.

That same year the Canadian embassy in Washington sponsored works by Canada's war artists that toured the United States for two months. While Leonard was being feted in Mexico, the embassy had him listed as deceased (1911-65) in the show's catalogue.

After Leonard's eighteen-month travelling exhibition for the Canadian embassy in Mexico ended, a series of other shows took place in that country. He had his first opening in twenty-five years at a commercial gallery in San Miguel, the Temple Art Gallery. A lanky Texas millionaire Latiné Temple had opened his upscale gallery at No. 2 Jesús Street – "a small gallery for serious collectors" – almost as a retirement project. He said of Leonard in the catalogue:

Leonard Brooks is a bi-national treasure: in Canada, whence he came in 1947 and in Mexico, where he has painted, shown, and taught these 47 years. He is claimed and honoured at the highest levels in both countries. His is a buoyant, redoubtable intellect that forever rejoices in the arts. As a painter he is so much master of different modes and schools that he has adapted and continues to adapt them at will to express his unique genius.

Brooks' abstract paintings and collages are the province of this aficionado's keenest appreciation. Brooks has told him, "This is what I do when I have fun!" What better clue to the essence of this creative spirit expressed with the means he commands?[3]

When Temple wrote that Leonard had been honoured in Canada, he must have assumed that it had to have occurred if he was being honoured in Mexico.

Leonard showed at the Casa del Diezmo in nearby Celaya in the fall of 1994, and he and Reva were honoured by the State of Guanajuato the following spring with simultaneous shows at the Casa Diego Rivera, the museum in the three-storey birthplace of the artist in the state capital. "Both of us a bit worn and tired but it's done and over – and went very well," Leonard reported.[4] CANTE, an ecological group newly moved to a three-century-old building in San Miguel, asked Leonard and Reva to help with an inaugural show in the conference hall. Reva mounted photos of their early activities in San Miguel and Leonard showed watercolours from that period. The State of Aguascalientes honoured him with a show at the Casa Terán in the capital, Aguascalientes, as did the State Watercolour Museum in Toluca, State of Mexico.

The cultural centre in San Miguel did back-to-back exhibitions, first of Leonard's works, in a room reserved until then for Mexican artists, and then of eighty-seven of Reva's photographs. Reva had exhibited her photographs so infrequently in San Miguel that they were a revelation to most people. "When we looked at her works, a whole world opened up, her world," recalled Carmen Masip, the fine arts school director who put on the shows.[5] Reva felt faint at the opening of the show on 6 January 1997 and was given some oxygen. She was eventually hospitalized for cardiac arrhythmia and had a pacemaker installed.

More than ever, the Brooks found themselves reversing their roles. Reva, who had always run the household and was Leonard's business manager and social secretary, slowly had to relinquish these duties as her short-term memory started to fail her. Now, for the first time in their married life, Leonard had to take charge of everything, even doing the food shopping. He was forced to cut down the time spent in his studio and all but abandoned his music.

During this period in the lives of the Brooks, there arrived in San Miguel two middle-aged women who, through happenstance, would make it their goal to see that Leonard and Reva received recognition in Canada as they had in Mexico. While an art teacher at the Tecumseh High School in Chatham, Ontario, Karen Close had accompanied a colleague to the Art for All show at the Art Gallery of Windsor in 1980. The friend was intent on buying a York Wilson work, but as they passed through the main show room Karen's attention was drawn to one of Leonard's collages, *First Snow*. She thought it captured the feeling of fresh snow in a treed area like the ones where she and her husband took their two small children cross-country skiing. She put in her bid and bought the work for $350.

She and a best friend from kindergarten onwards, Jill Kilburn, had promised themselves a trip together once their children were grown up, so September of 1996 found them in San Miguel. Karen wanted to meet the Brooks. "When we arrived, they were exceedingly friendly," Karen said. "Reva took us into her office to show us her photographs. It just overwhelmed us. It was a disaster. We're looking at these gorgeous photographs and they're just in a mess, all covered in dust."[6] On a visit to Leonard's studio, she bought two paintings, promising to send a cheque for $1,000 once she got back to Shanty Bay, Ontario, where she lived with her businessman husband, Tom. That might have been her last contact with the Brooks had not someone stolen the cheque from the mail and cashed it, prompting a series of telephone conversations with Leonard. During one of those calls, Leonard mentioned that David McTavish, director of the Agnes Etherington Art Centre at Queen's University, was in San Miguel on Brooks Foundation business. Since Leonard sounded upset, Karen impulsively asked if he would like her help. "That would be wonderful," Leonard replied. So Karen, who had never travelled alone in her life and spoke no Spanish, flew to Mexico City and took the four-hour bus ride to San Miguel. She soon found herself becoming the current No. 1 promoter of the Brooks.

Leonard discovered in Karen a younger Reva Brooks, another blunt, take-charge person who took no prisoners on the march to her goal. "Reva always referred to me as the surrogate Reva Brooks," Karen said. She told Leonard, "Your works won't sell very well, I hate to tell you, because nobody knows who you are, so you should probably have a show. We need to do something."[7] So, under the Brooks' direction, she became involved with the Brooks Foundation at Queen's, telling the university the foundation needed a pro-active board to get the Canadian public reacquainted with the Brooks.

What Leonard was most interested in was recognition for Reva, so, once back in Canada, Karen flew to Ottawa, where Jill Kilburn lived. They went to see Martha Hanna, director of the Canadian Museum of Contemporary Photography, who would eventually arrange an exhibition of Reva's photographs in Ottawa and elsewhere in Canada. She would say of Reva, "Her photographs exhibited a very direct and precise artistic sense. It is this aspect of her photography that surely secured the admiration of her peers. Contours and forms took shape in a gentle and sensitive portrait of a young boy or girl. Compositions, contrived by light and texture, fixed the timeless profile of [Mexico's] people. Still other photographs were more immediate and responsive to the personality and strength of the person before the camera. In all, it

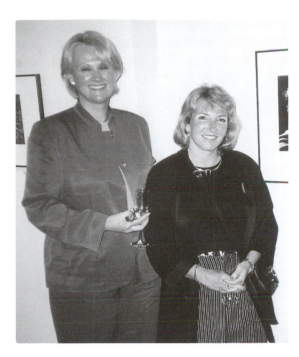

Jill Kilburn, left, and Karen Close, best friends who arranged Toronto shows for Leonard and Reva in 1998.
COURTESY JOHN VIRTUE

seemed as if her art form had emerged, fully developed, from an internal wealth of thought and study."[8]

Hanna had known Reva since the 1976 Canadian women's photography show, but she was unable to schedule an early exhibition. Not wanting to wait, Karen and Jill asked for recommendations of Toronto photography galleries and were given the names of newcomer Stephen Bulger and veteran Jane Corkin. They opted to contact Bulger, who agreed to put on a show if Reva's negatives could be found in good condition so that contemporary prints could be made. Karen returned to San Miguel with Toronto photographer Marilyn Westlake, a friend of the Brooks who knew her way around Reva's darkroom, and together they found the negatives after a three-day search. Marilyn sleeved and catalogued the negatives. Bulger then went to Mexico and personally selected and brought back the vintage prints to be displayed.

Now that a show was planned for Reva in 1998, Leonard said he would like one as well. Bulger suggested the Edward Day Gallery, a Kingston, Ontario, gallery that had recently opened a showroom in Toronto. Soon the word spread among Toronto's art cognoscenti that Leonard Brooks was thinking of leaving the Roberts Gallery after more than forty years. The author was present when Leonard received a telephone call from Paul Wildridge about the

rumours. Leonard was evasive in his reply, but ended the conversation by asking, "Paul, how's your golf?" He could not resist the temptation to needle Wildridge, an avid golfer, just as he did Fred Taylor about his hunting.

Two weeks later, Leonard wrote to Wildridge to advise him that he was, indeed, severing relations. "There seems to be little interest in my work that you have at present ... I would like to clear the books."9 As opposed to the previous two ruptures in relations with Roberts, it was Leonard's decision this time.

Karen and Jill returned to San Miguel in October of 1997 and spent a month of ten-hour days cataloguing nearly one thousand of Leonard's paintings, making sure they all bore his signature and had a title. The studio was organized in January by the time the Day Gallery's Donald Day and his partner, Mary Sue Rankin, travelled to San Miguel to select the works to be exhibited.

Karen went through Reva's closets and decided she needed a new wardrobe for the openings in Toronto. She and Jill took Reva to La Cosecha, a dress shop in San Miguel, to have five outfits tailor-made. As they waited for a taxi, a municipal bus stopped, so they decided to board it. An American woman seated behind Reva on the bus exclaimed, "You're Reva Brooks!" "Yes, my dear," she replied. "Reva Brooks, the photographer."10

Ironically, the person Stephen Bulger chose to make the new prints for Reva's show was Jeremy Taylor, Fred's son, whose first photography teacher was Reva. "During my time printing Reva's negatives, I imagined the harsh critique that might come from my first teacher," Taylor wrote in the catalogue for the show. "However, while studying the finished prints, I began to feel that I was on the right track because the emotional power hidden in the negatives was coming through." He made twenty-five copies each of twenty-seven prints, the most recent the 1961 photograph *Train to Calais*.

Leonard gave his approval to the press release announcing their shows, conceding something he normally would have been reluctant to admit in public: "Although well known in the u.s. and Mexico, the Brooks have been surprisingly overlooked in Canada." They were interviewed by the Canadian Broadcasting Corporation – radio and television – by tv Ontario, *The Globe and Mail*, and *Maclean's*, Canada's national magazine, among others.

Over 200 people, the largest turnout ever at the small Bulger Gallery at 700 Queen Street West, spilled out onto the sidewalk on 10 June 1998 for the opening of Reva's show. More than 450 people passed through the Day Gallery on Hazelton Avenue two nights later for Leonard's opening, co-sponsored by the Mexican Consulate in Toronto. A stranger walking into the gallery would have immediately recognized who was the artist: the man wearing the cream-coloured jacket and a blue silk foulard knotted at his throat. Just as *mariachi*

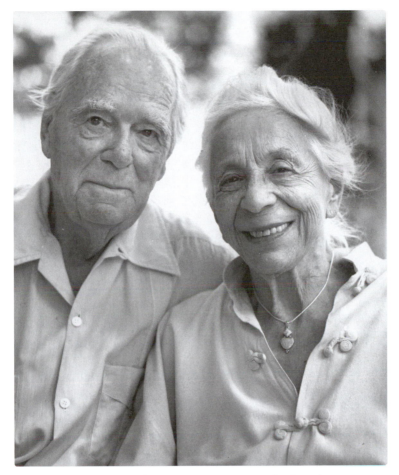

Leonard and Reva, just before their return to Toronto for their shows, 1998.
COURTESY PHOTOGRAPHER MARILYN WESTLAKE

musicians had first greeted the Brooks in Mexico fifty-one years earlier, a group wearing the wide-brimmed Mexican *sombreros* played at the gallery. "To see the welcome we have received has really moved us tremendously," Leonard told those in attendance. "I'm proud to be part of this interchange between Mexico and Canada. We feel that we're part of Mexico and part of Canada."

Then the Brooks were driven to Kingston in a white, stretch limousine for a joint show at the Day Gallery there and a dinner hosted by Queen's University.

If Reva felt obliged to abandon her photographic career so as not to compete with Leonard, there was a certain ironic similitude in their reception by

the public. Each sold ten works at their respective Toronto openings and six at the Kingston opening.

One of Leonard's worries was whether Reva's memory could withstand the pressure of the interviews with the Toronto news media. When a radio interviewer asked what they should talk about, Reva replied, "If you ask intelligent questions, I'll give you intelligent answers."

Leonard beamed. Afterwards, during the car ride back from the interview, he took her hand and told her, "Reva, I've never been more proud of you."

Reva expressed her feeling toward Leonard in a jotting on the back of a brochure from the Leonard and Reva Brooks Foundation: "Dear Leonard – You're my EVERYTHING. Everything. You're the SONG I sing and the book I read."

～ Notes ～

1 You have thrown in your lot with me

1 David J.S. Winfield, former Canadian ambassador to Mexico, to J.V., interview 12 June 1998.
2 R.B. told J.V. of the conversation.
3 L.B. told J.V. in an interview. Unless otherwise noted, quotes from L.B. and R.B. are from interviews with J.V. over a five-year period.
4 Siegfried Sassoon, *The Heart's Journey* (London: William Heinemann Ltd. 1928).
5 R.B. to Amaranth Productions, filmed interview 1972.
6 *Ibid.*
7 Donald Day, co-owner of the Edward Day Gallery in Toronto.
8 Written by R.B. on the back of a used envelope.
9 Allison Brigden told J.V. in an interview 22 June 1998 that the Jamaican was the son of a man who worked in her father's accounting firm.
10 Probably *The Toronto Telegram*. (The name of this newspaper changed a number of times during its life. It is referred to here by its name when it ceased publication in 1973, regardless of the date of the reference.)
11 "Toronto's History of Racism," *The Globe and Mail* 15 Aug. 1996, 10.
12 L.B. to J.V., recalled conversation.
13 Berul Sugarman to J.V., interview 17 Sept. 1995.
14 Bill Hollowell to J.V., interview 5 Nov. 1995.
15 Sophie Sherman to J.V., interview 7 May 1995.
16 David Silverman to J.V., interview 11 May 1995.
17 Sophie Sherman to J.V., interview 7 May 1995.
18 Sylvia Marks to J.V., interview 5 June 1996.
19 Sophie Sherman to J.V., interview 7 May 1995.

2 He's a robin's egg in a sparrow's nest

1 Donald Brooks to J.V., letter 1 Feb. 1995.
2 Bert Brooks to J.V., interview 9 May 1998.
3 Queenie Chard, Leonard's cousin, to J.V., letter quoting Ethel Thomas, Bristol historian, 26 April 1995.
4 This and other letters from France are with the Brooks Papers, Queen's University, Kingston, Ontario.
5 L.B. to Ken Harvey, interview in San Miguel de Allende, Mexico, 1975.
6 L.B. diary entry 2 Oct. 1988.
7 L.B. to Peter Varley, interview in Toronto, 1969.
8 L.B. wrote this account some time in the mid-1990s.
9 L.B. diary entry 25 May 1965.
10 Leonard Brooks, *Watercolor: A Challenge* (New York, Reinhold Publishing Corp. 1957), 10.

11 Sylvia Marks to J.V., interview 5 June 1996.
12 Bert Brooks to J.V., interview 19 Jan. 1999.
13 L.B. diary entry 24 Aug. 1966.
14 L.B. to Ken Harvey, interview in 1973.
15 Danny Marks to J.V., interview 6 June 1996.

3 She was two people

1 George Silverman to J.V., interview 4 June 1996.
2 Sophie Sherman to J.V., interview 7 May 1995.
3 *Ibid.*
4 *Ibid.*
5 David Silverman to J.V., interview 11 May 1995.
6 R.B. diary entry 20 July 1966.
7 *Ibid.*
8 Goldie Sherman to J.V., interview 26 June 1998.
9 Sophie Sherman to J.V., interview 7 May 1995.
10 R.B. to Karen Close and Jill Kilburn, taped interview in 1997.

4 From now on, I'm going to be a painter

1 William Kennedy to J.V., interview 23 Nov. 1996.
2 Herb Brooks told his son Bert of the conversations and Bert told J.V., interview 14 Jan. 1995.
3 Bert Brooks to J.V., interview 28 March 1995.
4 William Colgate, *Bridle & Golfer* magazine, Jan.-Feb. 1939 issue.

5 I'm a real artist and I'm being paid

1 Joan Murray to J.V., interview 2 Dec. 1997.
2 L.B. to J.V., recalled conversation.
3 Nell Brooks to L.B., letter 4 May 1972.
4 Bill Hollowell to J.V., interview 5 Nov. 1995.
5 L.B. to William Colgate, article in *Bridle & Golfer* magazine, Jan.-Feb. 1939.
6 L.B. to J.V., recalled conversation.
7 Evan Greene to J.V., interview 24 Oct. 1998.
8 Bob Hunter to J.V., interview 11 Nov. 1995.
9 L.B. to William Colgate, article in *Bridle & Golfer* magazine, Jan.-Feb. 1939.
10 Bert Brooks to J.V., interview 14 Jan. 1995.

6 You've got to get out of this environment

1 Frank Brooks to brother Herb, letter 6 June 1933, Brooks Papers, Queen's University, Kingston, Ontario.
2 Donald Brooks to J.V., interview 4 Nov. 1995.
3 L.B. recounted the conversation on several occasions to J.V.
4 L.B. journal entry 13 May 1934.

5 L.B. journal entry 5 June 1934.
6 There was no identification of the newspaper, but it was obviously in Toronto.
7 L.B. journal entry 21 Aug. 1934.
8 L.B. recalled the conversation during an interview with J.V. 25 June 1994.
9 London *Express*, 8 March 1934.
10 L.B. to J.V., recalled conversation.

7 *Dad, I'll come through all right*

1 Mark Zuehlke, *The Gallant Cause* (Vancouver/Toronto: Whitecap Books 1996).
2 "Pyrenees Nightmare," *Canadian National Railways Magazine*, March 1935.
3 L.B. journal entry 4 May 1934.
4 L.B. journal entry 13 May 1934.
5 L.B. journal entry 14 May 1934.
6 L.B. journal entry 15 May 1934.
7 L.B. journal entry 22 May 1934.
8 L.B. journal entry 5 June 1934.
9 "Knapsack and Ropecoil," Toronto *Star Weekly*, 18 May 1935.
10 L.B. journal entry 17 June 1934.
11 *Ibid.*

8 *I raffled off your paintings*

1 L.B. to J.V., recalled conversation.
2 Greene moved back to Canada in the mid-thirties with his wife and infant son, staying with the Brooks until he found a place for his family. Leonard helped him find several jobs, which he subsequently lost. Then Leonard saw scribbled on the wall of the men's room of the Arts and Letters Club, in Greene's distinctive handwriting, phrases such as "Leonard Brooks is a bastard" and "Down with Leonard Brooks." Greene eventually became a cover illustrator for comic books.
3 Frank Lewis to L.B., letter 7 Aug. 1956, Brooks Papers, Queen's University, Kingston, Ontario.
4 L.B. to Ken Harvey, interview 1975.

9 *No wealthy parent bolstering his courage with monthly cheques*

1 *Toronto Globe* 16 Dec. 1934.
2 *The Toronto Star* 16 Dec. 1934.
3 David Silverman to J.V., interview 11 May 1995.
4 *The Toronto Telegram* 11 May 1935.
5 *The Toronto Telegram* 7 June 1935.
6 *The Toronto Star* 18 May 1935.

10 *Gentlemen, give me a test*

1 Naomi Adaskin to J.V., interview 8 May 1995.
2 Miriam Waddington to J.V., interview 5 May 1996.

3 Mildred Selznick to J.V., interview 11 Nov. 1995.
4 Murray Stewart to J.V., interview 25 Nov. 1995.
5 Gordon Laws to J.V., interview 25 Nov. 1995.
6 Thomas Chatfield to J.V., interview 11 May 1995.
7 Christopher Chapman to J.V., interview 27 May 1995.
8 James Houston to J.V., interview 16 Jan.1995.
9 L.B., "A Personal Memoir," 5 Dec. 1974.
10 L.B. to J.V., recalled conversation.
11 Cleeve Horne to J.V., interview 3 June 1996.

11 *I didn't want to be stuck like A.Y. Jackson*

1 *The Toronto Star* 26 May 1936.
2 *The Toronto Telegram* 21 April 1937.
3 *Saturday Night* May 1937.
4 *The Toronto Telegram* 29 May 1937.
5 *Bridle & Golfer* Oct. 1937.
6 *The Toronto Telegram* Oct. 1937.
7 Esther Birney to J.V., letter 31 March 1995.
8 Esther Birney to J.V., interview 5 May 1996.
9 Wailan Low to J.V., interview 7 May 1995.
10 From one of L.B.'s 1980s catalogues.
11 Esther Birney to J.V., interview 23 April 1995.
12 Naomi Adaskin to J.V., interview 8 May 1995.
13 Sophie Sherman to J.V., interview 30 Nov. 1997.
14 Esther Birney to J.V., interview 15 April 1995.
15 L.B. to J.V., recalled conversation.
16 *The Toronto Star* 13 April 1940.
17 Irma Coucill to J.V., interview 1 March 1997.
18 *The Globe and Mail* 29 April 1939.
19 *The Toronto Star* 29 April 1939.
20 *The Toronto Telegram* 29 April 1939.
21 *Saturday Night* 29 April 1939.
22 *Bridle & Golfer* Jan.-Feb. 1939.

12 *It was devastating for Reva*

1 *The Globe and Mail* 13 April 1940.
2 *The Toronto Star* 13 April 1940.
3 *The Toronto Telegram* 13 April 1940.
4 Harry Mayerovitch to J.V., interview 2 Sept. 1997.
5 Christine Boyanoski, *The 1940s: A Decade of Painting in Ontario* (Toronto: Art Gallery of Ontario 1984), 12.
6 Frances Smith, *André Biéler* (Toronto: Merritt Publishing Co. Ltd. 1980).
7 Catalogue note from the Addison Gallery of American Art in Andover, Massachusetts.

8 L.B. to Sammy Hersenhoren, letter 10 Oct. 1976, Brooks Papers, Queen's University, Kingston, Ontario.
9 Jean Horne to J.V., interview 3 June 1996.
10 David Silverman to J.V., interview 11 May 1995.

13 *We were handsome young men in our white shorts*

1 "An Artist on the Great Lakes," *Canadian Art* Feb.-March 1944.
2 *The Toronto Star* 20 April 1943.
3 L.B. to Fred Taylor, letter 22 April 1943, Frederick B. Taylor Papers, National Archives, Ottawa.
4 Fred Taylor to L.B., letter 11 Aug. 1943, Brooks Papers, Queen's University, Kingston, Ontario.
5 *Hamilton Spectator* 20 Feb. 1943.
6 L.B. to Fred Taylor, letter 9 May 1943, Frederick B. Taylor Papers, National Archives, Ottawa.
7 L.B. to Earle Birney, letter 6 June 1943, Earle Birney Papers, Thomas Fisher Rare Book Library, University of Toronto.
8 Ruth Phillips, *The History of the Royal Canadian Navy's World War II Show* (Toronto 1973)
9 L.B. to Earle Birney, letter 14 July 1943, Earle Birney Papers, Thomas Fisher Rare Book Library, University of Toronto.
10 R.B. to Earle Birney, letter 2 Aug. 1943, Earle Birney Papers, Thomas Fisher Rare Book Library, University of Toronto.
11 L.B. to Fred Taylor, letter June 1943, Frederick B. Taylor Papers, National Archives, Ottawa.
12 Barbara Chilcott to J.V., interview 1 June 1996.
13 *The Globe and Mail* 6 Sept. 1943.
14 *The Toronto Star* 3 Sept. 1943.
15 L.B. to Earle Birney, letter 14 Oct. 1943, Earle Birney Papers, Thomas Fisher Rare Book Library, University of Toronto.
16 R.B. to Fred Taylor, letter 19 Sept. 1943, Frederick B. Taylor Papers, National Archives, Ottawa.
17 R.B. to Earle Birney, letter 13 Feb. 1944, Earle Birney Papers, Thomas Fisher Rare Book Library, University of Toronto.

14 *The gods have looked down*

1 L.B. to J.V., recalled conversation.
2 *Ibid.*
3 Kathleen McKay, who looked after Varley in his later years and established a museum in Unionville, Ontario, bought the painting in 1971 for $8,000.
4 *The Times*, London 16 Feb. 1944.
5 *The Gazette*, Montreal 11 Sept. 1944.
6 Leonard Brooks, *Painter's Workshop* (New York: Von Nostrand Reinhold Company 1969), 36.
7 L.B. to J.V., recalled conversation.
8 Lieutenant Alan B. Beddoe to Captain John Connolly, letter 24 May 1944, National Archives, Ottawa.
9 Sub-Lieutenant E.A. Wilkinson in a personnel evaluation 25 July 1944, National Archives, Ottawa.
10 George Silverman to J.V., interview 4 June 1996.
11 David Silverman to J.V., interview 11 May 1995.

12 L.B. to Earle Birney, letter 4 Sept. 1944, Earle Birney Papers, Thomas Fisher Rare Book Library, University of Toronto.

15 *I was terrified*

1 L.B. to J.V., evening conversation 29 Aug. 1981.
2 *Ibid.*
3 Michael Forster to J.V., interview 14 Oct. 1995.
4 L.B. to J.V., recalled conversation.
5 Christine Boyanoski, *The 1940s: A Decade of Painting In Ontario* (Toronto: Art Gallery of Ontario 1984), 26.
6 Joan Murray, *Canadian Artists of the Second World War* (Oshawa, Ontario: The Robert McLaughlin Gallery 1981), 8
7 *Ibid,* 9.
8 L.B. to Joan Murray, interview 25 Oct. 1977.
9 Clyde Gilmour to J.V., interview 25 Nov. 1994.
10 L.B. to Norman Levine, letter 27 March 1991.
11 George Silverman to J.V., interview 4 June 1996.
12 David Silverman to J.V., interview 11 May 1995.
13 Michael Forster to J.V., interview 31 July 1995.
14 Jack Macbeth, *Ready, Aye, Ready: An Illustrated History of the Royal Canadian Navy* (Toronto: Key Porter Books 1989).
15 L.B. to Joan Murray, interview 25 Oct. 1977.

16 *Frankly, I think you'll fall flat on your face*

1 Joan Murray, *Canadian Artists of the Second World War* (The Robert McLaughlin Gallery, Oshawa, Ontario, 1981), 10.
2 Commander C. E. Todd, confidential report, Sept. 1945.
3 *Saturday Night* 15 Nov. 1949.
4 L.B. to Earle Birney, letter 18 Nov. 1945, Earle Birney Papers, Thomas Fisher Rare Book Library, University of Toronto.
5 *Halifax Herald* 15 Nov.1945.
6 L.B. to Earle Birney, letter 11 Dec. 1945, Earle Birney Papers, Thomas Fisher Rare Book Library, University of Toronto.
7 L.B. to Earle Birney, letter 11 Feb. 1947, Earle Birney Papers, Thomas Fisher Rare Book Library, University of Toronto.
8 *Saturday Night* 21 Sept.1946.
9 Leonard Brooks, *Painting and Understanding Abstract Art* (New York: Reinhold 1968), 22.
10 Tom Wood to J.V., letter 26 Dec.1995.
11 Jack Nichols to J.V., interview 4 June 1996.
12 Molly Bobak to J.V., interview 27 May 1996.
13 Earle Birney to L.B., 1 Feb. 1947, Earle Birney Papers, Thomas Fisher Rare Book Library, University of Toronto.
14 Marie Trott to J.V., interview 5 Oct. 1995.

15 L.B. to Earle Birney, letter 16 Dec. 1946, Earle Birney Papers, Thomas Fisher Rare Book Library, University of Toronto.

16 *Halifax Herald* 8 Dec. 1946.

17 *Who's Who in American Art* to L.B., letter 4 Aug. 1946.

18 L.B. to Earle Birney, letter 11 Feb. 1947, Earle Birney Papers, Thomas Fisher Rare Book Library, University of Toronto.

19 L.B. to Esther Birney, letter March 1947, Earle Birney Papers, Thomas Fisher Rare Book Library, University of Toronto.

20 Christine Boyanoski, *The 1940s: A Decade of Painting in Ontario* (Toronto: Art Gallery of Ontario 1984), 7.

21 *Ibid*, 8.

22 Cleeve Horne to J.V., interview 5 July 1995.

23 R.B. jotting 7 July 1951.

24 Esther Birney to J.V., interview 15 April 1995.

25 Gavin Henderson to J.V., interview 5 Nov. 1995.

26 Lela Wilson, *York Wilson: His Life and Work, 1907-1984* (Ottawa: Carleton University Press 1997), 59.

27 L.B. to Amaranth Productions, filmed interview 1972.

28 R.B. in later years would write to this effect in the pages of guest books or on the back of used envelopes.

29 L.B. to Karen Close and Jill Kilburn, interview in 1997.

30 L.B. to Amaranth Productions, filmed interview 1972.

17 *We haven't made a mistake*

1 Leonard Brooks, "Report from Mexico" in a Toronto Board of Education in-house publication, 1948.

2 *San Miguel de Allende* (National Institute of Anthropology and History 1968), 3.

3 Christine Boyanoski, *The Artists' Mecca* (Toronto: The Art Gallery of Ontario 1992), 1.

4 Leonard Brooks, "In and Out of Mexico" (unpublished manuscript 1952), 14.

5 *Ibid*, 15.

6 Felipe Cossio del Pomar, *Cossio del Pomar en San Miguel de Allende* (Madrid: Editorial Playor S.A. 1974), 42.

7 Undated Spanish-language radio interview from the 1980s.

8 Felipe Cossio del Pomar, *Cossio del Pomar en San Miguel de Allende* (Madrid: Editorial Playor S.A. 1974), 65.

18 *I am beginning to feel the colour*

1 MacKinley Helm, *Journeying Through Mexico*, (Boston: Little Brown and Company 1948), 18.

2 Mona Gould, *Saturday Night* 27 Nov. 1948.

3 L.B. to Earle Birney, letter 10 Dec. 1947, Earle Birney Papers, Thomas Fisher Rare Book Library, University of Toronto.

4 R.B. jottings made in the 1990s.

5 Lysia Brossard Whiteaker to J.V., interview 3 Nov. 1996.

6 Stirling Dickinson to J.V., interview 8 Feb. 1996.

7 Leonard Brooks, "In and Out of Mexico" (unpublished manuscript 1952).
8 *The Toronto Telegram* 11 Oct. 1947.
9 *Canadian Art* Christmas 1947.
10 L.B. to Earle Birney, letter 12 Dec. 1947, Earle Birney Papers, Thomas Fisher Rare Book Library, University of Toronto.

19 *I have sold quite a number of my photographs*

1 R.B. to J.V., recalled conversation.
2 Marilyn Westlake, *Art Focus* magazine Fall issue 1998, 9.
3 The phrase is photographer Henri Cartier-Bresson's.
4 R.B. to Amaranth Productions, filmed interview 1972.
5 R.B. jottings made in the 1990s.
6 R.B. to Earle Birney, letter 24 Nov. 1948, Earle Birney Papers, Thomas Fisher Rare Book Library, University of Toronto.
7 Robert Somerlott, writing in the *The News*, Mexico City, 5 Sept. 1982.

20 *I would rather have this letter than one from Picasso*

1 Dotty Vidargas to J.V., interview 7 Feb. 1997.
2 Jefferson Sulzer to J.V., interview 7 March 1998.
3 Gordon Chabot to J.V., interview 15 Jan. 1998.
4 Lysia Brossard Whiteaker to J.V. interview 2 Dec. 1995.
5 Charles Allen Smart, *At Home in Mexico* (New York: Doubleday and Company 1957), 172.
6 Leonard Brooks, "In and Out of Mexico" (unpublished manuscript 1952), 56.
7 *El Nacional*, Mexico City 12 May 1948.
8 *Revista de Revistas*, Mexico City 30 May 1948.
9 *El Día*, Mexico City 1 July 1948.
10 Dr. Francisco Olsina to Jack Zolof of the CBC, interview May 1964.
11 L.B. to Earle Birney, letter 30 April 1948, Earle Birney Papers, Thomas Fisher Rare Book Library, University of Toronto.
12 L.B. to Earle Birney, letter 7 August 1948, Earle Birney Papers, Thomas Fisher Rare Book Library, University of Toronto.
13 David Alfaro Siqueiros to L.B., letter 24 Nov. 1948.
14 Esther Birney to J.V., interview 5 May 1996.

21 *Mucho gusto, Señor Presidente*

1 Philip Stein, *Siqueiros: His Life and Works* (New York: International Publishers 1994), 163.
2 *Atención* newspaper, San Miguel 3 June 1994.
3 *Time* 14 July 1949.
4 Philip Stein, *Siqueiros: His Life and Works* (New York: International Publishers 1994), 167.
5 Jefferson Sulzer to J.V., interview 7 March 1998.
6 *Ibid.*
7 Leonard Brooks, "In and Out of Mexico" (unpublished manuscript 1952).
8 Stirling Dickinson to J.V., interview 6 Feb. 1995.

9 Leonard Brooks, "In and Out of Mexico" (unpublished manuscript 1952).

10 Charles Allen Smart, *At Home in Mexico* (New York: Doubleday and Company 1957), 130.

11 Leonard Brooks, "In and Out of Mexico" (unpublished manuscript 1952).

12 Felipe Cossio del Pomar, *Cossio del Pomar en San Miguel de Allende* (Editorial Playor, S.A. 1974)

13 Philip Stein to J.V., interview 20 July 1996.

14 Leonard Brooks, "In and Out of Mexico" (unpublished manuscript 1952).

15 Charles Allen Smart, *At Home in Mexico* (New York: Doubleday and Company 1957), 128.

16 *Excelsior*, Mexico City 6 Aug. 1949.

17 L.B. to Earle Birney, letter 5 Aug. 1949, Earle Birney Papers, Thomas Fisher Rare Book Library, University of Toronto.

18 Leonard Brooks, "In and Out of Mexico" (unpublished manuscript 1952), 90.

22 *I no longer consider Leonard a Canadian painter*

1 L.B. to Earle Birney, letter 10 April 1949, Earle Birney Papers, Thomas Fisher Rare Book Library, University of Toronto.

2 Leonard Brooks, "In and Out of Mexico" (unpublished manuscript 1952), 140.

3 *Saturday Night*, 15 Nov. 1949.

4 *Canadian Art*, Spring 1950.

5 Franklin (Archie) Arbuckle to J.V., interview 12 May 1995.

6 Jean Horne to J.V., interview 3 June 1996.

7 Cleeve Horne to J.V., interview 3 June 1996.

8 Walter Moos to J.V., interview 3 Dec. 1997.

9 Herbert Whittaker to J.V., interview 6 January 1996.

10 L.B. to Gregory Strong, biographer of Toni Onley, 1996.

11 Lela Wilson to J.V., interview 20 Oct. 1994.

12 L.B. to Earle Birney, letter 1 Sept. 1949, Earle Birney Papers, Thomas Fisher Rare Book Library, University of Toronto.

23 *They were a wicked pair together*

1 L.B. to J.V., recalled conversation.

2 Lela Wilson to J.V., interview 16 Feb. 1996.

3 Wallack Galleries, *York Wilson* (Ottawa: Wallack Galleries 1978), 67.

4 Lela Wilson to J.V., interview 20 Oct. 1994.

5 Helen Watson to J.V., interview 30 June 1995.

6 Scott Symons to Lela Wilson, letter 6 Feb. 1995.

7 Jim Hawkins to J.V., interview 27 March 1996.

8 Edmund Fuller to J.V., interview 26 Jan. 1996.

9 Bunny Baldwin to J.V., interview 1 Nov. 1995.

10 Leonard Brooks, *Watercolor: A Challenge* (New York: Reinhold Publishing Corp. 1957), 116.

11 Sorel Etrog to J.V., interview 8 Dec. 1995.

12 L.B. journal entry 1959.

13 R.B. to Amaranth Productions, filmed interview 1972.

24 *Vámanos! Now!*

1 *Excelsior*, Mexico City 31 July 1950.
2 *Ibid*, 9 Aug. 1950.
3 Bunny Baldwin to J.V. interview 1 Nov. 1995.
4 *Ultimas Noticias*, Mexico City 7 July 1950.
5 Cassie Bowman to J.V., interview 3 Oct. 1995.
6 Kay McKeen to J.V., interview 30 Nov. 1996. She is the widow of Gil Boa, who won a Bronze Medal in shooting for Canada at the 1956 Olympic Games in Melbourne, Australia.
7 Dotty Vidargas to J.V., interview 7 Feb. 1998.
8 Leonard Brooks, "In and Out of Mexico" (unpublished manuscript 1952), 104.
9 L.B. to Charles Allen Smart, letter March 1950, Brooks Papers, Queen's University, Kingston, Ontario.
10 Manuscript of "The Neighbour You Take for Granted," Brooks Papers, Queen's University, Kingston, Ontario.
11 L.B. to Earle Birney, letter 1950, Earle Birney Papers, Thomas Fisher Rare Book Library, University of Toronto.
12 L.B. to Earle Birney, letter 1950, Earle Birney Papers, Thomas Fisher Rare Book Library, University of Toronto.
13 *Christian Science Monitor* 15 April 1950.
14 *Boston Sunday Herald* 7 May 1950.
15 *The Toronto Telegram* 6 May 1950.
16 *The Vancouver Sun* 23 June 1950.
17 L.B. to Charles Allen Smart, letter 5 July 1950, Brooks Papers, Queen's University, Kingston, Ontario.
18 L.B. to York Wilson, letter 9 Aug. 1950, Lela Wilson's files.
19 Stirling Dickinson to J.V., interview 6 Feb. 1995.

25 *You can go back anytime*

1 *The New York Times* 14 Aug. 1950.
2 Stirling Dickinson to J.V., interview 6 Feb. 1995.
3 Leonard Brooks, "In and Out of Mexico" (unpublished manuscript 1952), 150.
4 *Ibid*.
5 *Ibid*.
6 *Ibid*.
7 Stirling Dickinson to J.V., interview 6 Feb. 1995.
8 *Novedades*, Mexico City 15 Aug. 1950.
9 *El Universal Gráfico*, Mexico City 16 Aug. 1950.
10 *Excelsior*, Mexico City 21 Aug. 1950.
11 *Time* 28 Aug. 1950.
12 *The Laredo Times* 17 Aug. 1950.
13 L.B. to Charles Allen Smart, letter 20 Aug. 1950, Brooks Papers, Queen's University, Kingston, Ontario.
14 *Ibid*.
15 Leonard Brooks, "In and Out of Mexico" (unpublished manuscript 1952), 182.

16 *Ibid*.
17 R.B. to Earle and Esther Birney, letter 4 Oct. 1950, Earle Birney Papers, Thomas Fisher Rare Book Library, University of Toronto.
18 Gilberto Munguía to J.V., interview 17 July 1999.
19 Rev. Richard C. Nevius to J.V., letter 15 April 1995.

26 *Darling, I am dying*

1 Webster's New Universal Unabridged Dictionary.
2 Mary Elmendorf to J.V., interview 5 Feb. 1997.
3 Lysia Brossard Whiteaker to J.V., interview 22 Feb. 1997.
4 Kay Tremaine to J.V., letter 10 May 1987.
5 u.s. cultural historian Ann Douglas, *The New York Times*, 17 October 1998, A17.
6 *Novedades* 8 September 1957.
7 From copy of wire dated 9 September 1957 obtained by Stirling Dickinson.
8 Copy obtained by Stirling Dickinson.
9 Interview 6 February 1995.

27 *Our existence is idyllic at the moment*

1 R.B. diary entry 2 Dec. 1967.
2 *Excelsior*, Mexico City 22 Aug. 1950.
3 L.B. to Charles Allen Smart, letter 20 Aug. 1950, Brooks Papers, Queen's University, Kingston, Ontario.
4 Leonard Brooks, "In and Out of Mexico" (unpublished manuscript 1952), 187.
5 L.B. to Earle Birney, letter 9 Nov. 1950, Earle Birney Papers, Thomas Fisher Rare Book Library, University of Toronto.
6 L.B. to Charles Allen Smart, letter Oct. 1950, Brooks Papers, Queen's University, Kingston, Ontario.
7 *The North Bay Nugget* 29 Sept. 1950.
8 R.B. to Lela Wilson, letter 15 Feb. 1951, Lela Wilson's files.
9 Fred Varley to L.B., letter 21 March 1951, Brooks Papers in San Miguel de Allende.
10 Will Allister to the cbc, interview in San Miguel in 1964.
11 Carl Migdail to J.V., interview 2 Nov.1996.

28 *My girl, you've got it*

1 Probably written in 1949 and used in several of Reva's catalogues.
2 L.B. to J.V., repeated in several interviews.
3 *Reva Brooks Photographer*, catalogue, June 1998, 3.
4 R.B. to Karen Close and Jill Kilburn, interview June 1997.
5 Abe Rothstein to J.V., interview 4 May 1996.
6 R.B. expressed this opinion in conversations with Karen Close and Jill Kilburn, June-Nov. 1997.
7 *Ibid*.
8 R.B. to Amaranth Productions, filmed interview 1972.
9 Joy Laville to J.V, interview 11 Feb. 1997.

10 R.B. to Karen Close and Jill Kilburn, taped interview June 1997.
11 L.B. to Monty Lewis, filmed interview in the 1980s.
12 R.B. to Karen Close and Jill Kilburn, taped interview June 1997.

29 *Mexican or American citizenship*

1 Clipping does not contain the name of the newspaper or date, Brooks Papers, Queen's University, Kingston, Ontario.
2 *The Vancouver Sun* 6 July 1951.
3 Broadcast 19 July 1951.
4 Esther Birney to J.V., interview 15 April 1995.
5 Jack Shadbolt to J.V., interview 20 May 1995.
6 Ebe Kuckein to J.V., interview 16 Nov. 1996.
7 *The Globe and Mail* 20 July 1951.

30 *I wanted to destroy all those memories*

1 L.B. to Earle Birney, letter 26 Sept. 1951, Earle Birney Papers, Thomas Fisher Rare Book Library, University of Toronto.
2 Aba Bayefsky to J.V., interview 25 Jan. 1998.
3 L.B. to Earle Birney, letter 1 Aug. 1951, Earle Birney Papers, Thomas Fisher Rare Book Library, University of Toronto.
4 L.B. would again keep a daily diary and a studio journal in 1955.
5 L.B. to Earle Birney, letter 26 Sept. 1951, Earle Birney Papers, Thomas Fisher Rare Book Library, University of Toronto.
6 R.B. in conversation with Karen Close and Jill Kilburn, June-Nov. 1997.
7 R.B. to Earle and Esther Birney, letter 16 Aug. 1951, Earle Birney Papers, Thomas Fisher Rare Book Library, University of Toronto.
8 Sylvia Tait to Karen Close, letter March 1998.
9 Sylvia Marks to J.V., interview 5 June 1996.
10 Aileen Harris, who was present, to J.V., interview 23 Oct. 1994.
11 R.B. to Karen Close, interview June 1997.
12 Nancy Sherman to J.V., interview 7 May 1995.
13 R.B. to Karen Close, interview June 1997.
14 R.B. to Marilyn Westlake, conversation 15 Feb. 1999.
15 Clyde Gilmour to J.V., interview 25 Oct. 1994.
16 L.B. to Earle Birney, letter 3 Dec. 1951, Earle Birney Papers, Thomas Fisher Rare Book Library, University of Toronto.
17 *Ibid.*
18 Letter dated 26 Oct. 1951, Archives of the Center for Creative Photography, University of Arizona.

31 *The two are friendly rivals*

1 "Everybody had this totally against them," Bunny Baldwin, widow of painter Jack Baldwin, to J.V., interview 20 July 1996.
2 Lysia Brossard Whiteaker to J.V., interview 2 Dec. 1995.

3 Helen Watson to J.V., interview 30 June 1995.

4 Jean Horne to J.V., interview 3 June 1996.

5 Betty Anne Affleck to J.V., interview 2 Sept. 1997.

6 R.B. to Amaranth Productions, filmed interview 1972.

7 R.B., jotting on the back of an envelope, 1996.

8 Nancy Sherman to J.V., interview 5 May 1995.

9 Earle Birney to L.B., letter 10 Oct. 1951, Brooks Papers, Queen's University, Kingston, Ontario.

10 L.B. to Earle Birney, undated 1951 letter, Earle Birney Papers, Thomas Fisher Rare Book Library, University of Toronto.

11 Earle Birney to L.B., letter 22 Nov. 1951, Brooks Papers, Queen's University, Kingston, Ontario.

12 Lela Wilson to J.V., interview 20 Oct. 1995.

13 Jennie Wildridge to J.V., interview 9 Nov. 1995.

14 Charles Morton to R.B., letter 17 Oct. 1951, Brooks Papers, Queen's University, Kingston, Ontario.

15 Carl Bakal to R.B., letter 30 Oct. 1951, Brooks Papers, Queen's University, Kingston, Ontario.

16 L.B. to J.V., recalled conversation.

17 Marion Carnahan to R.B., letter 13 Sept. 1954.

18 *The News-Herald*, Vancouver 19 July 1952.

19 *The Province*, Vancouver 15 Aug. 1952.

20 L.B. to Jack Wildridge, letter 16 Oct. 1952, Roberts Gallery files.

21 L.B. to Earle Birney, letter 10 July 1952, Earle Birney Papers, Thomas Fisher Rare Book Library, University of Toronto.

22 R.B. to York and Lela Wilson, letter 16 Dec.1952.

32 *Leonard is a world-class watercolourist*

1 *The Toronto Telegram* 5 June 1954.

2 *The Globe and Mail* 5 June 1954.

3 Paul Duval to J.V., interview 9 May 1995.

4 Robert Maxwell to J.V., interview 3 Oct. 1995.

5 Bunny Baldwin to J.V., interview 20 July 1996.

6 Nell Fernández to J.V., interview 6 Feb. 1997.

7 Bunny Baldwin to J.V., interview 20 July 1996.

8 Barbara Dobarganes to J.V., interview 7 Feb. 1997.

9 Charles Allen Smart, *At Home in Mexico* (New York: Doubleday and Company 1957), 175.

10 L.B. diary entry 27 July 1992. Former Canadian Auditor-General Maxwell Henderson misplaced the roll.

11 Edward Steichen form letter to photographers, 31 January 1954.

12 *The New York Times Book Review* 19 June 1955.

13 James Bagby to R.B., letter 9 April 1956, Brooks Papers, Queen's University, Kingston, Ontario.

33 *Oh, I could handle the bed part*

1 L.B. to Earle Birney, letter 3 Nov. 1955, Earle Birney Papers, Thomas Fisher Rare Book Library, University of Toronto.

2 L.B. to Monty Lewis, videotaped interview in San Miguel, early 1990s.

3 Joan Murray to J.V., interview 2 Dec. 1997.
4 L.B. to Earle Birney, letter 10 Oct. 1954, Earle Birney Papers, Thomas Fisher Rare Book Library, University of Toronto.
5 Charles Allen Smart to L.B., letter 16 Aug. 1960.
6 L.B. to J.V., recalled conversation.
7 R.B. to Claire Watson, letter 15 July 1955 with copies to Earle and Esther Birney, Earle Birney Papers, Thomas Fisher Rare Book Library, University of Toronto.
8 Claire Watson to J.V., interview 24 April 1997.
9 From the complete version of a poem Birney wrote for the announcement of one of Leonard's shows. Brooks, Papers, Queen's University, Kingston, Ontario.
10 Elspeth Cameron, *Birney: A Life* (Toronto: Viking 1994), 359.
11 Esther Birney to J.V., letter 31 March 1995.
12 Wailan Low to J.V., interview 7 May 1995.
13 Birney, in need of money, sold the property the next year to a Dr. Betell.

34 *I resent spending money needlessly*

1 L.B. to Philip T. Clark, letter Jan. 1955, Brooks Papers, Queen's University, Kingston, Ontario.
2 L.B. entry in 1989-91 studio journal.
3 L.B. and R.B. to David Turpin, vice principal of Queen's University, letter 2 Feb. 1998: "After appraisal from experts we estimate the worth of our estate to be in excess of five million dollars." Brooks Papers, San Miguel de Allende.
4 L.B. to Maxwell Henderson, letter 8 Oct. 1989.
5 Bert Brooks to J.V., interview 28 March 1995.
6 Franklin (Archie) Arbuckle to J.V., interview 12 May 1995.
7 Leonard Brooks, *Watercolor: A Challenge* (New York: Reinhold Publishing Corp. 1957), 11.
8 R.B. to Fred Taylor, letter 7 Feb. 1956, Frederick B. Taylor Papers, National Archives, Ottawa.
9 R.B. to Earle Birney, letter 14 Dec. 1955, Earle Birney Papers, Thomas Fisher Rare Book Library, University of Toronto.
10 R.B. to Fred Taylor, letter 20 June 1955, Frederick B. Taylor Papers, National Archives, Ottawa.
11 R.B. to Earle Birney, letter 15 Sept. 1955, Earle Birney Papers, Thomas Fisher Rare Book Library, University of Toronto.
12 L.B. to Earle Birney, letter 10 Sept. 1955, Earle Birney Papers, Thomas Fisher Rare Book Library, University of Toronto.
13 *The Gazette*, Montreal 8 Oct. 1955.
14 L.B. to Earle Birney, letter 15 Oct. 1955, Earle Birney Papers, Thomas Fisher Rare Book Library, University of Toronto.
15 Bert Brooks to J.V., interview 28 March 1995.
16 Earle Birney to L.B., letter 1 Dec. 1955, Brooks Papers, Queen's University, Kingston, Ontario.

35 *Overboilings*

1 L.B. to Earle Birney, letter 7 March 1956, Earle Birney Papers, Thomas Fisher Rare Book Library, University of Toronto.

2 Sylvia Tait to J.V., interview 3 June 1995.

3 Eldon Grier to J.V., interview 3 June 1995.

4 L.B. to Amaranth Productions, filmed interview 1972.

5 Eldon Grier to J.V., interview 3 June 1995.

6 Sylvia Tait to J.V., interview 3 June 1995.

7 Joan Murray, *Art in Hard Times: The Canadian Group of Painters* (Oshawa: The Robert McLaughlin Gallery 1993), 6.

8 York Wilson to L.B., letter 23 May 1956, Brooks Papers, Queen's University, Kingston, Ontario.

9 Alan Jarvis, catalogue note 17 March 1956.

10 Miriam Waddington to L.B. and R.B., letter 30 April 1956, Brooks Papers, San Miguel de Allende.

11 *Louisville Courier-Journal* 8 Jan. 1956.

12 L.B. diary entry 4 May 1956.

36 *Professor Brooks – not that by God*

1 L.B. to Earle Birney, letter 8 Feb. 1956, Earle Birney Papers, Thomas Fisher Rare Book Library, University of Toronto.

2 Earle Birney to L.B., undated letter, Brooks Papers, Queen's University, Kingston, Ontario.

3 L.B. to R.B., letter 25 Aug. 1956, Brooks Papers, Queen's University, Kingston, Ontario.

4 L.B. to R.B., letter 14 Sept. 1956, Brooks Papers, Queen's University, Kingston, Ontario.

5 L.B. to R.B., letter 17 Sept. 1956, Brooks Papers, Queen's University, Kingston, Ontario.

6 L.B. to R.B., letter probably 6 Oct. 1956, Brooks Papers, Queen's University, Kingston, Ontario.

7 L.B. to Fred Taylor, letter 9 Oct. 956, Frederick B. Taylor Papers, National Archives, Ottawa.

8 L.B. to Earle Birney, letter 9 Oct. 1956, Earle Birney Papers, Thomas Fisher Rare Book Library, University of Toronto.

9 L.B. to R.B., letter 8 Oct. 1956, Brooks Papers, Queen's University, Kingston, Ontario.

10 L.B. diary entry 17 Oct. 1956.

11 L.B. to R.B., letter 1 Oct. 1956, Brooks Papers, Queen's University, Kingston, Ontario.

12 *The Post-Standard*, Syracuse 9 Dec. 1956.

13 L.B. to Charles Allen Smart, letter 11 Dec. 1956, Brooks Papers, Queen's University, Kingston, Ontario.

37 *We have a real hit on our hands*

1 William W. Atkin to L.B., letter 11 April 1957, Brooks Papers, Queen's University, Kingston, Ontario.

2 L.B. to Earle Birney, letter 15 Aug. 1957, Earle Birney Papers, Thomas Fisher Rare Book Library, University of Toronto.

3 *Hamilton Spectator* 29 June 1957.

4 *Canadian Art* June 1957.

5 *Christian Science Monitor* June 1957.

6 L.B. to R. Austin, letter 17 April 1957, Brooks Papers, Queen's University, Kingston, Ontario.

7 Charles Morton to R.B., letter 24 May 1957, Brooks Papers, Queen's University, Kingston, Ontario.

8 R.B. to Charles Morton, letter 6 June 1957, Brooks Papers, Queen's University, Kingston, Ontario.

9 L.B. to Fred Taylor, letter 8 Aug. 1957, Frederick B. Taylor Papers, National Archives, Ottawa.

10 L.B. to J.V., recalled conversation.

11 *Ibid.*

12 L.B. diary entry 28 Feb. 1958.

13 L.B. diary entry 26 March 1958.

14 L.B. diary entry 8 April 1959 recalling what had occurred a year earlier.

15 L.B. diary entry 30 March 1958.

16 Jean Townsend-Field to J.V., interview 8 March 1997.

17 L.B. diary entry 8 April 1959.

18 L.B. to Fred Taylor, letter 2 May 1958, Frederick B. Taylor Papers, National Archives, Ottawa.

19 R.B. to Fred Taylor, letter 19 May 1958, Frederick B. Taylor Papers, National Archives, Ottawa.

20 R.B. to Esther Birney, letter 1 May 1958, Earle Birney Papers, Thomas Fisher Rare Book Library, University of Toronto.

21 Earle Birney to L.B., letter 7 May 1958, Brooks Papers, Queen's University, Kingston, Ontario.

22 *The Toronto Star* 24 Nov. 1959.

23 Lysia Brossard Whiteaker to J.V., interview 3 Nov. 1996.

24 Sylvia Tait to J.V., interview 9 May 1996.

25 Nancy Sherman to J.V., interview 7 May 1995.

38 *Henry Miller went mad about my watercolours*

1 L.B. reconstructed the conversation in an interview with J.V. 5 Feb. 1995.

2 L.B. to J.V., conversation 22 Nov. 1998.

3 L.B. and R.B. to J.V., interviews at various times.

4 L.B. to Earle Birney, letter 12 Dec. 1959, Earle Birney Papers, Thomas Fisher Rare Book Library, University of Toronto.

5 *The Province*, Vancouver sometime in 1959.

6 L.B. diary entry 20 Jan. 1960.

7 Esther Birney to R.B., letter 9 June 1960, Brooks Papers, Queen's University, Kingston, Ontario.

8 L.B. diary entry 8 April 1959.

9 L.B. diary entry 15 Aug. 1959.

10 *Montreal Star* 2 April 1960.

11 *The Windsor Star* 10 Oct. 1959.

39 *He so violently gives vent to all his feelings*

1 L.B. diary entry 17 May 1960.

2 R.B. to Lela Wilson, letter Oct. 1972, Lela Wilson's files.

3 L.B. diary entry 1 June 1969.

4 L.B. journal entry May 1960.

5 L.B. journal entry 10 May 1960.

6 *Ibid.*

7 L.B. diary entry 14 May 1960.

8 L.B. diary entry 2 June 1960.

9 L.B. diary entry 10 June 1960.

10 L.B. diary entry 12 June 1960.

11 R.B. diary entry 4 Aug. 1971.

12 R.B. to Amaranth Productions, filmed interview 1972.

13 L.B. diary entry, 19 Dec. 1985.

14 Nancy Sherman to J.V., interview 7 May 1995.

15 Miriam Waddington to J.V., interview 5 May 1996.

16 Charles Allen Smart, *At Home in Mexico* (New York: Doubleday and Company 1957), 177.

17 L.B. to J.V., conversation 26 March 1996 after violinist friend Tom Sawyer started dating local pharmacy owner Consuelo (Chelo) Agundis.

18 L.B. diary entry 13 July 1970.

19 Joy Laville to J.V., interview 27 Oct. 1997

20 Letitia Echlin to J.V., interview 8 Feb. 1995

21 Kate Simon papers, Hunter College, New York.

22 Scott Symons, who was present, to J.V., interview 30 May 1996.

40 *There would have been no music without Leonard*

1 L.B., interview in *The Globe and Mail* April 1972.

2 L.B. to J.V., recalled conversation.

3 Daniel Aguascalientes to J.V., interview 18 Feb. 1998.

4 Rafael Aguascalientes to J.V., interview 18 Feb. 1998.

5 Gregorio Aguascalientes to J.V., interview 18 Feb. 1998.

6 Mai Onnu to J.V., interview 21 June 1997.

7 Carl Migdail to J.V., interview 2 Nov. 1996.

8 Helen Watson to J.V., interview 30 June 1995.

9 Joy Laville to J.V., interview 11 Feb. 1997.

10 Reminiscences of Stanley Fletcher 1984.

11 L.B. to Amaranth Productions, filmed 1972 interview.

12 Itzvan Anhalt to J.V., interview 14 Aug. 1997.

13 Naomi Adaskin to J.V., interview 8 May 1995.

14 The date was 9 March 1968.

15 Liona Boyd to J.V., interview 4 June 1998.

16 Liona Boyd to J.V., letter Jan. 1996.

17 Bobby Haggart to J.V., interview 7 Aug. 1997.

18 Warren Benson to R.B., letter 9 Dec. 1987.

19 *Ibid.*

20 Carmen Masip to J.V., interview 3 Feb. 1997.

21 Hiliry Harvey to J.V., interview 9 Oct. 1997.

22 Will Allister to J.V., interview 9 May 1996.

23 L.B. diary entry 13 Dec. 1960.

41 *I am not and have never been a communist*

1 I.N.S. letter to R.B., 21 Feb. 1961.
2 Stirling Dickinson to L.B., telegram 24 Feb. 1961, Brooks Papers, Queen's University, Kingston, Ontario.
3 James T. Doyle to R.B., letter 19 July 1961, Brooks Papers, Queen's University, Kingston, Ontario.
4 Undated catalogue note.
5 Lela Wilson, *York Wilson: His Life and Work* (Ottawa: Carleton University Press 1997), 147.
6 Albert Plécy to R.B., letter June 1962, Brooks Papers, Queen's University, Kingston, Ontario.
7 R.B. diary entry 15 May 1961.
8 Marcelle Ferron to J.V., interview 3 Aug. 1996.
9 R.B. to Fred Taylor, letter 7 Sept. 1961, Frederick B. Taylor Papers, National Archives, Ottawa.
10 Lela Wilson to J.V., interview 8 May 1995.
11 L.B. diary entry 17 Oct. 1961.
12 L.B. diary entry 11 Oct. 1961.
13 L.B. diary entry 22 Aug. 1961.
14 L.B. to Ken Harvey, interview in 1975.
15 L.B. diary entries 3 and 11 Dec. 1961.
16 L.B. to Earle Birney, letter 20 Dec. 1961, Earle Birney Papers, Thomas Fisher Rare Book Library, University of Toronto.
17 R.B. to Amaranth Productions, filmed interview 1972.
18 R.B. diary entry 2 Dec. 1967.
19 L.B. diary entry 3 Jan. 1962.

42 *Then they started to do tourist crap*

1 Lois Hobart to J.V., interview 11 Nov. 1997.
2 L.B. diary entry 23 July 1962.
3 L.B. to Jean Koefoed, letter 20 Aug. 1962, Brooks Papers, Queen's University, Kingston, Ontario.
4 Jean Koefoed to L.B., letter April 1966, Brooks Papers, Queen's University, Kingston, Ontario.
5 Joy Laville to J.V., interview 24 Nov. 1995.
6 Ibargüengoitia was killed 27 Nov. 1983 in a plane crash while en route from Paris, where he and Joy then lived, to Bogotá, Colombia.
7 Joy Laville to J.V., interview 11 Feb. 1997.
8 L.B. to Earle Birney, letter Nov. 1962, Earle Birney Papers, Thomas Fisher Rare Book Library, University of Toronto.
9 *Ibid.*
10 Sylvia Samuelson to J.V., interview 2 Feb. 1997.
11 Will Allister to J.V., interview 9 May 1996.
12 Bobby Haggart to J.V., interview 7 Aug. 1996.
13 Harry J. Boyle to L.B., letter 25 March 1963, Brooks Papers, Queen's University, Kingston, Ontario.

14 L.B. to Earle Birney, letter 28 Aug. 1963, Earle Birney Papers, Thomas Fisher Rare Book Library, University of Toronto.
15 Mona Allister to J.V., interview 9 May 1996.

43 *What new worlds do you want to conquer?*

1 *Houston Chronicle* 29 June 1965.
2 L.B. to York Wilson, letter 21 July 1965, Lela Wilson's files.
3 L.B. diary entry 17 July 1965.
4 L.B. diary entry 25 May 1965.
5 Joy Laville to J.V., interview 11 Feb. 1997.
6 Joy Laville to R.B., letter 18 June 1965, Brooks Papers, Queen's University, Kingston, Ontario.
7 L.B. to ambassador Herbert F. (Temp) Feaver, letter 30 Nov. 1965, Brooks Papers, Queen's University, Kingston, Ontario.
8 R.B. to Lela and York Wilson, letter 15 Nov. 1965, Lela Wilson's files.
9 L.B. diary entry 29 Dec. 1966.
10 L.B. diary entry 28 Feb. 1962.
11 Sylvia Warner, Ellie's sister, to J.V., interview 13 April 1996.
12 L.B. diary entry 11 April 1966.
13 Will Allister to J.V., interview 9 May 1996.
14 Jack Spitzer to L.B., letter 3 July 1962.
15 Jack Wildridge to L.B., letter 4 Nov. 1963.
16 L.B. diary entry Sept. 1965.
17 L.B. to York Wilson, letter 22 Aug. 1963, Lela Wilson's files.
18 R.B. to Naomi Adaskin, letter 15 June 1963.
19 Abe Rothstein to J.V., interview 4 May 1996.
20 Robert Maxwell to J.V., interview 3 Oct. 1995.
21 Mona Allister to J.V., interview 9 May 1996.
22 Joy Laville to J.V., interview 11 Feb. 1997.
23 *The Gazette*, Montreal 30 Jan. 1965.
24 R.B. to Lela and York Wilson, letter 17 Feb. 1965, Lela Wilson's files.
25 Earle Birney to L.B., letter 13 March 1965, Earle Birney Papers, Thomas Fisher Rare Book Library, University of Toronto.

44 *I don't blame him for getting fed up.*

1 L.B. diary entry 10 July 1966.
2 Esther Birney to R.B., letter 11 Aug. 1966.
3 L.B. diary entry 14 April 1966.
4 L.B. diary entry 16 July 1966.
5 L.B. diary entry 10 March 1966.
6 Esther Birney to L.B. and R.B., letter 4 March 1966.
7 Sylvia Marks to L.B. and R.B., letter 17 March 1966.
8 Marian and Ken Harvey to L.B. and R.B., letter 15 June 1966.
9 Comment to Karen Close and Jill Kilburn, 20 Oct. 1997.

45 *Born physically from his mother and continually reborn by me*

1 Arnold Mazelow to R.B., letter 11 Aug. 1966, Brooks Papers, Queen's University, Kingston, Ontario.
2 R.B. to Arnold Mazelow, letter 7 Sept. 1966, Brooks Papers, Queen's University, Kingston, Ontario.
3 L.B. diary entry 20 Aug. 1966.
4 Esther Birney to R.B., letter 11 May 1966, Brooks Papers, Queen's University, Kingston, Ontario.
5 R.B. to Lela and York Wilson, letter 2 June 1967, Lela Wilson's files.
6 L.B. diary entry 4 July 1967.
7 L.B. to Earle Birney, letter 28 July 1997, Earle Birney Papers, Thomas Fisher Rare Book Library, University of Toronto.
8 R.B. diary entry 3 Oct. 1967.
9 L.B. diary entry 22 July 1967.
10 R.B. diary entry 8 Aug. 1967.
11 Ellie Martin to R.B. and L.B., letter received 17 Aug. 1967.
12 R.B. diary entry 26 Aug. 1967.
13 R.B. diary entry 6 Sept. 1967.
14 L.B. diary entries 8, 9, 10 Aug. 1967.
15 R.B. diary entry 14 Sept. 1967.
16 L.B. diary entries 19, 22 Sept. 1967.
17 R.B. diary entry 30 Sept. 1967.
18 R.B. diary entry 3 Oct. 1967.
19 Esther Birney to R.B., letter 13 Dec. 1967, Brooks Papers, Queen's University, Kingston, Ontario.
20 R.B. diary entry 2 Dec. 1967.
21 Mai Onnu to J.V., interview 21 June 1997.

46 *You live in Leonardbrooksland*

1 Walter Moos to J.V., interview 3 Dec. 1997.
2 R.B. to Helene Mazelow, letter 30 Aug. 1967, Brooks Papers, Queen's University, Kingston, Ontario.
3 Helene Mazelow to R.B., letter 26 Sept. 1967, Brooks Papers, Queen's University, Kingston, Ontario.
4 York Wilson to L.B., letter 12 Dec. 1967, Brooks Papers, Queen's University, Kingston, Ontario.
5 R.B. to Helene Mazelow, letter 8 March 1968, Brooks Papers, Queen's University, Kingston, Ontario.
6 R.B. to Esther Birney, letter 25 March 1968, Earle Birney Papers, Thomas Fisher Rare Book Library, University of Toronto.
7 R.B. to Helene Mazelow, undated letter, Brooks Papers, Queen's University, Kingston, Ontario.
8 Jack Spitzer to L.B., letter 28 April 1968, Brooks Papers, Queen's University, Kingston, Ontario.
9 L.B. to Stanley Fletcher, letter 20 July 1968, April Fletcher's files.
10 R.B. to Lela and York Wilson, letter 4 June 1968, Lela Wilson's files.

11 L.B. to Earle Birney, letter 11 Dec. 1968, Earle Birney Papers, Thomas Fisher Rare Book Library, University of Toronto.
12 L.B. diary entry 17 Oct. 1968.
13 Esther Birney to R.B., letter 28 Dec. 1968, Brooks Papers, Queen's University, Kingston, Ontario.
14 R.B. to Esther Birney, letter 12 Feb. 1969, Earle Birney Papers, Thomas Fisher Rare Book Library, University of Toronto.
15 *The Globe and Mail* 22 April 1969.
16 L.B. diary entry 15 April 1969.

47 You have so much to be talked about

1 R.B. diary entry 1 June 1969.
2 Johanna Echlin to J.V., interview 30 May 1998.
3 R.B. to Esther Birney, letter 14 April 1969, Brooks Papers, Queen's University, Kingston, Ontario.
4 Jack Spitzer to L.B., letter 10 June 1969, Brooks Papers, Queen's University, Kingston, Ontario.
5 L.B. diary entry 22 Sept. 1969.
6 L.B. diary entry 26 Oct. 1969.

48 Fred was not a man who would weave or avoid a punch

1 Frederick B. Taylor, unfinished autobiography manuscript.
2 Richard Rohmer, *E.P. Taylor* (Toronto: McClelland and Stewart Limited 1978), 21.
3 Letitia Echlin to J.V., interview 8 Feb. 1995 in which she told the story of Fred Taylor being called a sissy.
4 Harry Mayerovitch to J.V., interviews 2 Sept. 1997 and 30 Aug. 1999.
5 Walter Klinkhoff, *Reminiscences of an Art Dealer* (Montreal: private publication), 47.
6 Noreen Taylor to J.V., interview 3 Dec. 1997.
7 Merrily Weisbord, *The Strangest Dream* (Toronto: Lester & Orpen Dennys Ltd. 1983), 146.
8 *Montreal Star* 26 March 1973.

49 How's the hunting, Fred?

1 L.B. to Fred Taylor, letter 27 July 1958, Frederick B. Taylor Papers, National Archives, Ottawa.
2 Fred Taylor to L.B., letter 12 Sept. 1958, Brooks Papers, Queen's University, Kingston, Ontario.
3 Fred Taylor to L.B., letter 25 Sept. 1958, Frederick B. Taylor Papers, National Archives, Ottawa.
4 Fred Taylor to L.B., letter 6 Oct. 1958, Frederick B. Taylor Papers, National Archives, Ottawa.
5 Sylvia Samuelson to J.V., interview 4 Oct. 1995.
6 Eldon Grier to J.V., interview 3 June 1995.
7 Robert Maxwell to J.V., interview 3 Oct. 1995.

8 Jim Hawkins to J.V., interview 27 March 1996.

9 *Montreal Star*, 26 March 1973.

10 Letitia Echlin to J.V., interview 7 Feb. 1997.

11 Fen Taylor to J.V., interview 17 June 1995.

12 Will Allister to J.V., interview 9 May 1996.

13 Fred Taylor to Yvonne Housser, letter 2 Jan. 1972, Frederick B. Taylor Papers, National Archives, Ottawa.

14 Fred Taylor to York Wilson, letter 17 Feb. 1982, Frederick B. Taylor Papers, National Archives, Ottawa.

15 Walter Klinkhoff to J.V., letter 2 Dec. 1996.

16 Charles Taylor to Scott Symons. When the author asked Taylor 3 June 1996 for confirmation about the "bully" statement, he replied, "No comment."

17 Eldon Grier to J.V., interview 9 May 1996.

18 Helen Watson to J.V., interview 30 June 1995.

19 Lupe Powell to J.V., interview 24 Sept. 1996.

20 Will Allister to J.V., interview 9 May 1966.

21 L.B. diary entry, 1 Aug. 1962.

22 Jim Hawkins to J.V., interview 27 March 1996.

23 L.B. diary entry 4 Dec. 1969 and to J.V., interview.

24 L.B. diary entry 24 July 1970.

25 Paul Shaw, President of the Shooting Federation of Canada, said in a letter 21 Aug. 2000 to J.V. that a shotgun blast from a distance of 20 yards is sufficient to kill someone. He noted, however, that only a forensic expert could determine this with certainty by making tests no longer possible as the shotgun has passed through several hands and is no longer locatable. Key factors would include barrel length, choking mechanism on the shotgun, and the composition of the shell.

26 Letitia Echlin to J.V., interview 26 March 1996.

27 Sylvia Tait to J.V., interview 9 May 1996.

28 Fen Taylor to J.V., interview 17 Feb. 1998.

29 Fen Taylor to J.V., interview 17 June 1995.

30 Noreen Taylor to J.V., interview 3 Dec. 1997.

31 John Bland to J.V., letter Sept. 1999.

32 Joan Roberts, to J.V., interview 23 Oct. 1999.

33 Harry Mayerovitch to J.V., interview 2 Sept. 1997.

34 L.B. diary entry 23 Dec. 1969.

35 Fen Taylor to J.V., interview 17 June 1995.

36 L.B. diary entry 4 Feb. 1983.

37 R.B. to Lela and York Wilson, letter 15 Feb. 1983, Lela Wilson's files.

38 L.B. diary entry 22 April 1987.

50 *Things continue to work out well for us here*

1 *Novedades*, Mexico City 16 Jan. 1970.

2 *Revista de la Semana*, Mexico City 11 Jan. 1970.

3 *The News*, Mexico City 1 Feb. 1970.

4 *México en la Cultura*, Mexico City 22 Feb. 1970.

5 Earle Birney to L.B., letter 20 Feb. 1970, Brooks Papers, Queen's University, Kingston, Ontario.

6 L.B. to Earle Birney, letter 28 Feb. 1970, Earle Birney Papers, Thomas Fisher Rare Book Library, University of Toronto.

7 R.B. diary entry 3 March 1970.

8 L.B. diary entry 22 April 1970.

9 *The New York Times* 25 Jan. 1970.

10 William Plummer, *The Holy Goof* (Englewood Cliffs, N.J. Prentice-Hall Inc. 1981), 157.

11 Tom Andre to J.V., interview 13 July 1997.

12 R.B. to Lela and York Wilson, letter 11 May 1970, Lela Wilson's files.

13 Jules Léger to L.B., letter 6 May 1970, Brooks Papers, Queen's University, Kingston, Ontario.

14 Jack Wildridge to L.B., letter 2 July 1970, Brooks Papers, Queen's University, Kingston, Ontario.

15 L.B. to Jack Wildridge, letter 13 July 1970, Roberts Gallery files.

51 *How are you Canucks?*

1 Hiliry Harvey to J.V., interview 9 Oct. 1996.

2 *Ibid*.

3 Tom Sawyer to J.V., interview 17 June 1995.

4 L.B. to J.V., recalled conversation.

5 L.B. wrote of the exchange in a 1976 journal.

6 The description of meeting the Burgesses is from a story draft by Leonard, interviews with him, and diary entries.

7 Anthony Burgess to R.B., letter 18 May 1971, Brooks Papers, Queen's University, Kingston, Ontario.

8 L.B. diary entry 2 April 1971.

9 Harry Somers to J.V., interview 1 June 1996.

10 L.B. to Amaranth Productions, filmed interview 1972.

11 Marian Harvey, recollections written in 1971.

12 Hiliry Harvey to J.V., interview 9 Oct. 1996.

52 *Part of me wishes to end it all*

1 L.B. to Amaranth Productions, filmed interview 1972.

2 L.B. diary entry 15 April 1971.

3 L.B. diary entry 29 April 1971.

4 L.B. diary entries 13 and 10 June 1971.

5 R.B. to Lela and York Wilson, letter 5 July 1971, Lela Wilson's files.

6 R.B. diary entry 9 June 1971.

7 R.B. diary entry 11 July 1971.

8 R.B. to Marian and Ken Harvey, letter 18 July 1971, Hiliry Harvey's files.

9 R.B. diary entry 3 Aug. 1971.

10 L.B. to Jack Wildridge, letter 23 July 1971, Roberts Gallery files.

11 R.B. diary entry 6 Aug. 1971.

12 R.B. diary entry 11 Aug. 1971.

13 Barbara Chilcott to J.V., interview 1 June 1996.

14 Van Deren Coke to J.V., interview 15 Feb. 1997.

15 *The News*, Mexico City 5 Sept. 1982.

16 Barbara Chilcott to J.V., interview 1 June 1996.

17 David Silverman, who was told of the incident by Leonard, to J.V., 1 June 1996.

18 R.B. diary entry 22 Aug. 1971.

19 Rudolf von Urban, *Sex Perfection and Marital Happiness* (New York; Dial Press, Inc. 1949), 231.

20 R.B. diary entry 19 Aug. 1971.

21 R.B. diary entry 1 Sept. 1971.

22 Halaby was the father of the future Queen Noor of Jordan.

23 R.B. to Kate Simon, letter 9 Jan. 1972, Brooks Papers, Queen's University, Kingston, Ontario.

53 *I raised Alicia like my daughter*

1 L.B. to Lela and York Wilson, letter 25 July 1977, Lela Wilson's files.

2 David Silverman to J.V., interview 1 June 1996.

3 Carmen Govea to J.V., interview 18 Feb 1998.

4 L.B. diary entry 1 Sept. 1976.

5 L.B. diary entry 8 June 1979.

6 L.B. diary entry 4 April 1980.

7 L.B. diary entry 27 April 1979.

8 L.B. diary entry 23 June 1983.

9 Sylvia Tait to J.V., interview 9 May 1996.

10 Sylvia Tait to Karen Close, e-mail 1 Oct. 1999.

11 Alicia Sánchez Govea to J.V., interview 16 Feb. 1999.

12 L.B. diary entry 6 Dec. 1981.

13 L.B. diary entries 6 and 7 Dec. 1982.

14 L.B. diary entry 29 Jan. 1988.

15 Alicia Sánchez Govea, guest book entry 3 Sept. 1993.

16 Alicia Sánchez Govea, guest book entry 25 Dec. 1995.

17 L.B. diary entry 19 March 1994.

18 Alicia Sánchez Govea to J.V., interview 16 Feb. 1999.

54 *We certainly are Canadian citizens*

1 Gunther Gerzso to J.V., interview 19 June 1995.

2 R.B. to Jack Wildridge, letter 13 Dec. 1971, Roberts Gallery files.

3 L.B. diary entry 1 Jan. 1972.

4 L.B. diary entry 31 March 1972.

5 R.B. to Lela and York Wilson, letter Oct. 1972, Lela Wilson's files.

6 L.B. diary entry 20 Sept. 1972.

7 L.B. diary entry 5 Oct. 1972.

8 L.B. diary entry 10 May 1973.

9 R.B. to Lela and York Wilson, letter Oct. 1972, Lela Wilson's files.

10 L.B. diary entry 18 Dec. 1972.

11 David Silverman to J.V., interview 11 May 1995.
12 L.B. to Monty Lewis, videotaped interview 1990s.
13 Publication not noted, Sept. 1876.
14 L.B. diary entry 22 Sept. 1976.
15 *Novedades*, Mexico City 9 Feb. 1977.
16 L.B. diary entry 12 March 1977.
17 *The Globe and Mail* 5 May 1972.
18 *The Toronto Star* 29 April 1972.
19 L.B. diary entry 30 April 1972.
20 Hiliry Harvey to J.V., interview 9 Oct. 1996.
21 L.B. journal entry 8 Aug. 1972.
22 L.B. diary entry 16 Feb. 1990.
23 R.B. to Amaranth Productions, filmed interview 1972.

55 *I think it came too easily to her*

1 Ansel Adams to R.B., letter 1 May 1973.
2 Van Deren Coke to J.V., interview 15 Feb. 1997.
3 John Humphrey, *Women of Photography: A Historical Survey* (San Francisco: San Francisco Museum of Art 1975).
4 *Ibid.*
5 Van Deren Coke to J.V., interview 15 Feb. 1997.
6 Lou Garcia to J.V., letter 2 Aug. 1995.
7 Nancy Sherman to J.V., interview 5 May 1995.
8 Jeremy Taylor to J.V., interview 9 June 1998.
9 Esther Birney to J.V., interview 15 April 1995.
10 Esther Birney to J.V., letter 31 March 1995.
11 R.B. to the Griers, letter 5 Dec. 1966.
12 R.B. to Karen Close and Jill Kilburn, taped interviews 1997.
13 Eldon Grier, *The Assassination of Colour, Poems by Eldon Grier* (Fiddlehead Poetry Books 1978).
14 L.B. diary entry, 18 Dec. 1972.
15 L.B. diary entry 14 April 1979.
16 L.B. diary entry 14 May 1981.
17 L.B. diary entry 3 Dec. 1994.
18 Van Deren Coke to J.V., interview 15 Feb. 1997.
19 *Camera Canada* Sept. 1975.
20 Naomi Rosenblum, *A History of Women Photographers* (New York: Abbeville Press 1994).
21 Naomi Rosenblum to J.V., letter 30 March 1997.
22 Van Deren Coke to J.V., interview 15 Feb. 1997.
23 *Ibid.*

56 *Sometimes I feel a thousand years old*

1 Jean Koefoed to L.B., letter 26 March 1976, Brooks Papers, Queen's University, Kingston, Ontario.

2 L.B. diary entry 4 Dec. 1975.

3 L.B. to Jean Koefoed, letter 1973, Brooks Papers, Queen's University, Kingston, Ontario.

4 Jean Gronbeck, to L.B., letter 10 May 1973, Brooks Papers, Queen's University, Kingston, Ontario.

5 L.B. diary entry 3 July 1975.

6 L.B. diary entry 4 Aug. 1975.

7 L.B. diary entry 16 May 1976.

8 L.B. to Jack Wildridge, letter 21 May 1976, Roberts Gallery files.

9 L.B. diary entry 6 July 1976.

10 L.B. to Stanley Fletcher, letter 18 April 1978, April Fletcher's files.

11 L.B. diary entry 9 March 1978.

12 L.B. diary entry 6 May 1978.

13 L.B. diary entry 6 June 1979.

14 L.B. to Eldon Grier and Sylvia Tait, letter 22 July 1979, Griers' files.

15 Jack Wildridge to L.B., letter 11 July 1978, Brooks Papers, Queen's University, Kingston, Ontario.

16 L.B. to Jack Wildridge, letter 12 Aug. 1978, Roberts Gallery files.

17 L.B. journal entry 7 Dec. 1978.

57 *They're known as the Canadian royalty*

1 Kenneth Saltmarche to Richard Graburn, letter 20 Sept. 1977, Brooks Papers, Queen's University, Kingston, Ontario.

2 *The Windsor Star* 1 May 1980.

3 Kenneth Saltmarche to L.B., letter 8 Nov. 1980, Brooks Papers, Queen's University, Kingston, Ontario.

4 *Ibid.*

5 Catie Allan to L.B., letter 17 Dec. 1980, Brooks Papers, Queen's University, Kingston, Ontario.

6 L.B. diary entry 15 Jan. 1982.

7 Pierre Trudeau to L.B. and R.B., letter 8 Feb. 1982, Brooks Papers, Queen's University, Kingston, Ontario.

8 L.B. diary entry 21 April 1979.

9 L.B. and R.B. to J.V., interviews on several occasions.

10 L.B. diary entry 25 Aug. 1983.

11 L.B. diary entry 20 Sept. 1983.

12 J. Russell McKinney, speech 4 June 1984.

13 *The News*, Mexico City 9 Aug. 1986.

58 *The senseless, brutal, and bloody murder*

1 R.B. note written 14 Aug. 1982 on a catalogue for a photographic show.

2 L.B. diary entry 29 June 1984.

3 R.B. to relatives and friends, letter 14 Oct. 1984, Brooks Papers, Queen's University, Kingston, Ontario.

4 L.B. diary entry 22 July 1989.

5 R.B. to Lela Wilson, letter 29 Sept. 1989, Lela Wilson's files.

6 L.B. diary entry 2 Jan. 1990.

7 R.B. to L.B. and David Silverman, letter 30 Aug. 1991, Brooks Papers, Queen's University, Kingston, Ontario.

8 L.B. to Mexican authorities, letter 1 Sept. 1991.

9 L.B. diary entry 21 Nov. 1986.

10 *Ibid.*

11 Lela Wilson to J.V., interview 16 Feb. 1996.

12 L.B. to York Wilson, letter Feb. 1983.

13 Letitia Echlin, one of the mourners, to J.V., interview 8 Feb. 1995.

59 *Thinking of my "place" in Canada*

1 L.B. diary entry 31 Aug. 1991.

2 John Hall to J.V., interview 5 Feb. 1997.

3 Cleeve Horne to J.V., interview 5 July 1995.

4 Ron Bolt to J.V., interview 11 Nov. 1995.

5 David Mitchell to J.V., interview 11 May 1995.

6 Ron Bolt to J.V., interview 11 Nov. 1995.

7 John Hall to J.V., interview 5 Feb. 1997.

8 L.B. diary entry 22 Dec. 1991.

9 L.B. diary entry 18 May 1994.

10 L.B. diary entry 17 Aug. 1989.

11 L.B. to J.V., interview 24 March 1996.

12 R.B., jotting on the back of an envelope 4 Nov. 1994.

13 Esperanza Harmon to J.V., interview 18 May 1997.

14 Jim Harmon to J.V., interview 18 May 1997.

15 L.B. diary entry 9 April 1988.

16 Marguerite Charland to J.V., interview 20 March 1998.

17 L.B. diary entry 28 Nov. 1992.

18 Gabrielle Léger to J.V., interview 18 Nov. 1995.

19 Milton Barnes to J.V., interview 12 May 1995.

20 Marie Trott to J.V., interview 5 Oct. 1995.

60 *He could have been more highly placed*

1 Toni Onley to J.V., interview 10 May 1996.

2 Gunther Gerzso to J.V., interview 19 June 1997.

3 Helmut Gransow to J.V., interview 3 Feb. 1997.

4 Jack Nichols to J.V., interview 4 June 1996.

5 D. Mackay Houstoun to J.V., interview 2 March 1996.

6 John Hall to J.V., interview 5 Feb. 1997.

7 Latiné Temple to J.V., letter 21 March 1995.

8 Ebe Kuckein to J.V., interview 16 Nov. 1996.

9 Will Allister to J.V., interview 9 May 1996.

10 L.B. diary entry 10 Nov. 1989.

11 L.B. to James Bessey, letter 4 Aug. 1992.

12 Eric Brittan to J.V., interview 12 Sept. 1997.

13 James Bessey to J.V., letter 20 Oct. 1996.

14 Alfredo Arzola to J.V., interview 20 Feb 1998.

15 Joy Laville to J.V., interview 12 Feb. 1997.

16 Christine Boyanoski to J.V., e-mail 16 Sept. 1999.

17 Joan Murray to J.V., interview 2 Dec. 1997.

61 *The Brooks have been surprisingly overlooked in Canada*

1 L.B. diary entry 2 April 1994.

2 Servando Canela to J.V., interview 27 March 1999.

3 The show at the Temple gallery was June 1994.

4 L.B. diary entry 6 April 1995.

5 Carmen Masip to J.V., interview 3 Feb. 1997.

6 Karen Close to J.V., interview 12 Dec. 1998.

7 *Ibid*.

8 Martha Hanna, e-mail to J.V., 2 Oct. 2000. The Canadian Museum of Contemporary Photography held a show of Reva's works in the spring of 2000. Leonard also participated in a 2000 show of Canadian War art which opened at the Canadian Museum of Civilization.

9 L.B. to Paul Wildridge, letter 11 Nov. 1998, Brooks papers in San Miguel.

10 Karen Close to J.V., interview 12 Dec. 1998.

~ *Chronology* ~

1911 Birth of Frank Leonard Brooks, 7 November, in Enfield, England, to Ellen (Nell) Barnard and her husband, Herbert Brooks.

1913 Birth of Reva Brooks, 10 May, in Toronto, Canada, to Polish-Jewish immigrants, Jenny Kleinberg and her husband Moritz (Morris) Silverman.
Nell and Herb Brooks and infant son arrive steerage in Montreal May 21 aboard the *Megantic* and settle in Toronto.

1916 Herb Brooks joins the Canadian Expeditionary Force and the family returns to England for the duration of the Great War. Leonard is passed from aunt to aunt while his mother stays near London.

1919 Upon returning to Canada, Leonard is put back into grade one, where he is teased and taunted for his "Limey" accent and odd clothes.
His mother gives him a violin for his eighth birthday.

1920 Friends of the Brooks give Leonard a watercolour set for Christmas and he immediately does his first sketch.

1923 Leonard becomes the only Gentile in Eugene (Jackie) Kash's School Boys Band in Toronto.

1925 Herb Brooks is transferred to North Bay, Ontario, where Leonard falls in love with the Canadian landscape.

1927 Leonard quits school in grade nine and returns to Toronto, where he washes dishes in Eaton's cafeteria while studying art at night at Central Technical High School.

1928 Reva quits school at age fifteen, finds a secretarial job at Rogers Radio Tubes and moves out on her own.
Leonard's artistic talents are recognized and he is transferred to Eaton's art department.

1929 After saving money while working on a Trans-Canada Highway survey crew, Leonard enrols at the Ontario College of Art for six months.

1931 Unable to return to Eaton's art department because of Great Depression cutbacks, he is hired as a clerk in the boyswear department; he resigns after being criticized by the manager for talking to friends and ignoring customers.

1933 Leonard and a college friend, Evan Greene, work their way to England on a cattle boat.

1934 Feeling that the drinking and partying in London are detracting from his painting efforts, Leonard accepts an invitation to a Mazdaznan commune in the Spanish Pyrenees mountains.
British watercolourist Frank Brangwyn sends him money to enable him to return to England and home. He meets Reva as he plans for a show in Toronto.

1935 Leonard holds the first of seven one-man shows over the next eight years at Eaton's College Street art gallery.
Leonard does a watercolour of the Dionne quintuplets' home that is reproduced and sold world-wide, virtually none of the profits going to him.
18 October, Leonard and Reva marry.

1937 Leonard obtains his teaching certificate and is hired by Northern Vocational High School at a salary $1,800 a year.

1938 The Brooks meet poet Earle Birney and wife Esther, with whom they develop a close friendship.

Leonard is among painters asked to submit works for a show entitled "A Century of Canadian Art" at the Tate Gallery in London, England.

He is elected a member of the Arts and Letters Club in Toronto.

1939 Leonard is among fifty-three artists showing at the Canadian pavilion at New York's World's Fair. He is elected to the Royal Canadian Academy of Arts and the Ontario Society of Artists.

He throws down a flight of stairs a German who makes anti-Semitic remarks.

The Second World War begins.

1942 Leonard is among artists asked to show at the one-hundredth anniversary of the Roberts Gallery in Toronto.

1943 Leonard joins the navy as a petty officer and is assigned to the Navy Show as set director.

Reva loses child in an ectopic pregnancy.

1944 Leonard risks a court martial by quitting the Navy Show when forced to sell tickets in Winnipeg, Manitoba.

He is assigned to the Navy Art Service studio in Ottawa, where he befriends the Group of Seven's Fred Varley, then penniless.

Named an official war artist, he is promoted to sub-lieutenant and transferred to England.

1945 Leonard is Canada's most productive navy artist, credited with 113 works in nine months, done on the spot or in a studio in London, where he is allowed to work while most others were assigned to the Isle of Wight.

After the end of hostilities, he volunteers to take the surrender of one of fifteen fully-manned German submarines at Scapa Flow in Scotland.

1946 Leonard and Reva settle in Halifax while he finishes his war painting.

He meets Canada's new Governor General, Viscount Alexander, at an exhibition of Canadian war art in Ottawa.

1947 After Reva loses a second child to an ectopic pregnancy, Leonard obtains a study grant from the Department of Veterans Affairs; they go to San Miguel de Allende, Mexico, on a one-year sabbatical leave to study at the Fine Arts School.

Leonard buys Reva a used Rolleicord camera to record his paintings.

1948 An article in *Life* magazine on "GI Paradise" brings 6,000 applications to the school.

Leonard is recruited by school director Stirling Dickinson to teach.

Leonard and colleague Ray Brossard are feted at a joint art exhibition in Mexico City.

Reva launches her photography career with series of photographs of a dead child in a casket.

Leonard resigns from Northern Vocational and obtains an extension from Veterans Affairs to continue studies in Mexico.

1949 Leonard and other teachers walk out of the school in support of David Alfaro Siqueiros, Mexican muralist and prominent communist, who broke with school owner Alfredo Campanella over a mural he was painting there.

More than 100 students boycott the school, effectively closing it down.

Accompanied by Siqueiros, Leonard and the student council president present a petition to Mexican President Miguel Alemán.

Mexican government approves the opening of a new school, but the American embassy refuses accreditation because of Siqueiros' communist affiliation, so ex-GIs cannot study there.

Leonard has his first one-man show in the United States at the Cowie Gallery in Los Angeles.

The Brooks visit Toronto, where Leonard and Reva have shows at Eaton's art gallery.

Toronto painter York Wilson joins Leonard in Mexico.

1950 The Brooks and six other art school teachers – Reva was teaching Spanish – are deported at gunpoint after the owner of the closed school buys off government officials. Siqueiros and former munitions minister Ignacio Beteta, friends of Leonard, work successfully to get the deportation order lifted. *The New York Times* quotes American embassy officials as saying the teachers were supporting Siqueiros in his communist activities.

1951 Edward Weston, the reigning photographer in the United States, invites Reva to apprentice with him in California, but Leonard persuades her to reject the offer.

Appalled at the disorder in the apartment the Brooks had sublet in Toronto, Leonard, in a fit of rage, destroys all his diaries and journals – he missed one – plus wartime correspondence with Reva and some paintings that he had stored there.

Edward Steichen buys one of Reva's photographs for New York's Museum of Modern Art.

1952 The Brooks meet California photographer Ansel Adams, who praises Reva and buys one of her prints.

Leonard and Reva teach summer extension courses at the University of British Columbia in Vancouver.

Leonard agrees to be represented by the Roberts Gallery in Toronto.

1953 An ex-president of Paraguay, Natalicio González, publishes in Mexico a limited edition of twelve *Posadas*, or traditional Mexican Christmas scenes, painted by Leonard; all 2,000 portfolios quickly sell out.

1954 Leonard has his first one-man show at the Roberts Gallery. Leonard gives the first of many workshops in Texas.

1955 Leonard signs a contract with Reinhold Publishing in New York for an art book, *Watercolor: A Challenge*.

Reva exhibits her photographs at Eaton's in Montreal.

1956 Leonard joins the Canadian Group of Painters.

Leonard teaches three art courses for a semester at Wells College in Aurora, N.Y.

Reva is represented by the Gamma photo agency in New York.

MS Camera's annual reproduces two pages of Reva's photos.

1957 *Watercolor: A Challenge* is published to enthusiastic reviews.

Brooks move to 109 Quebrada Street to a new house they have built.

Film director John Huston buys eleven of Reva's prints and two of Leonard's paintings.

1958 Jack Wildridge, the owner of the Roberts Gallery, rejects Leonard's latest works, severing relations; Reva steps in and achieves a reconciliation.

Leonard has a speaking part in the movie "The Wonderful Country" with Robert Mitchum filmed partly in San Miguel.

1959 Leonard's second art book, *Oil Painting: Traditional and New,* is published.

The Brooks meet author Henry Miller on a trip to California; he wants them to stay as guests.

1960 Leonard starts to give free music lessons in his home to poor Mexican children.

Following Leonard's lead, Canadian painter Fred Taylor settles in San Miguel.

1961 Blacklisted, Reva is denied entry to the United States when a Europe-bound freighter they are aboard docks in Beaumont, Texas; a Federal Bureau of Investigation file shows she was alleged to have participated in communist activities in San Miguel. The u.s. State Department advises Reva to see the embassy in Mexico City, which eventually clears her.

Leonard experiments with collage for the first time in Paris.

Reva has difficulty finding faces that appeal to her to photograph.

Leonard publishes his third and fourth art books, short ones titled *Course Casein Painting* and *Course Wash Drawing.*

1962 The Mexican government asks Leonard to become the first director of the music department at the new Fine Arts School in San Miguel.

Reva's photographs win critical praise at the "Great Photographers of Our Time" exhibition in Versailles, France.

1963 Leonard joins other foreign painters to found a co-operative art gallery in San Miguel, but shortly resigns in protest over the quality of paintings being accepted for sale.

1964 Leonard publishes his fifth art book, *Painting and Understanding Abstract Art.*

1965 Neighbours across the street, former Hollywood script writer Ashmead (Scotty) Scott and actress wife Tig, are murdered during a burglary; Leonard is summoned by a maid who discovers the bodies.

The upscale Horizon Gallery in Rockport, Massachusetts, has a show of Leonard's works.

Leonard has a show at the Palace of Fine Arts in Mexico City.

1966 Jack Wildridge removes all of Leonard's works from the Roberts Gallery, severing relations; he says he does not feel strongly about Leonard's new output.

Mazelow Gallery in Toronto shows interest in representing Leonard.

1967 Brooks travel to Greece on a freighter on a seven-month trip.

Feeling deeply depressed, Reva takes Valium 5; part of problem is unexpected death of art dealer Arnold Mazelow.

As in France, Reva has difficulty finding photographic subjects.

1968 Leonard resumes relations with the Roberts Gallery after Jack Wildridge visits him in San Miguel.

Leonard is hospitalized in Mexico City with a bleeding ulcer.

1969 Leonard has his first one-man show at the Roberts Gallery in fifteen years.

Leonard's sixth art book, *Painter's Workshop,* is selected Art Book of the Month.

Fred Taylor shoots Leonard in the face while quail hunting.

1970 Reva has a well-received show at the Palace of Fine Arts in Mexico City.

1971 The Brooks travel to Italy on a freighter with chamber music colleagues.

The Brooks rent the apartment of British novelist Anthony Burgess.

Reva suffers near nervous breakdown, seeks guidance in Transcendental Meditation from Canadian actress Barbara Chilcott.

Reva's inability to find subject matter for her photographs is exacerbated by theft of her camera equipment.

Leonard's seventh art book, *Oil Painting: Basic and New Techniques*, is published.

1972 Brooks pay $20,800 for a 56,000-square-foot lot on which to build a house and separate studio for Leonard.

Leonard plays first violin in fourteen concerts with the Guanajuato Symphony.

Amaranth Productions does film on Brooks for the Royal Ontario Museum.

1973 Ansel Adams threatens to drop Reva from his Friends of Photography association for non-payment of dues.

1974 Leonard has a show of his tapestries at the Galería Kin in Mexico City.

Reva is only foreigner invited with thirty-five Mexican artists for a show on death, "Mexican Expressions of an Enigma."

1975 Reva is selected by the San Francisco Museum of Art as one of the top fifty women photographers of all time.

The National Film Board of Canada selects seven of Reva's works for an exhibition by Canadian photographers.

1976 Leonard has showing of his tapestries at the Palace of Fine Arts in Mexico City.

1977 Brooks move to their new house and studio.

1978 Leonard throws out his back, his medical condition later compounded by a bleeding ulcer; he receives blood transfusions.

Leonard's eighth and last art book, *The Many Ways of Water and Color*, sells all 5,000 copies of the first run in six months.

1979 Canadian ambassador James Langley unsuccessfully recommends Leonard for the Order of Canada.

The first annual Chamber Music Festival is held in San Miguel.

1980 Leonard is the lead artist at the Art for All show at the Art Gallery of Windsor, where more than half his 103 works are sold.

1981 Nell Brooks, Leonard's mother, dies at age ninety-eight.

1982 A Brooks tapestry and a Brooks painting are on loan as Prime Minister Pierre Trudeau opens the new Canadian embassy in Mexico City.

The New York Graphic Society, the world's largest distributor of art reproductions, contracts three of Leonard's works.

1983 Leonard holds his sixth and final one-man show at the Roberts Gallery, selling $28,000-worth of works.

1984 Leonard has a two-month show of paintings and tapestries at the Canadian embassy; the show later travels throughout Mexico.

Reva finds the body of their gardener, hacked to death on their property.

The son of Mexican President Miguel de la Madrid asks Reva to give him photography lessons.

1985 Some of York Wilson's ashes are scattered at the base of a tree next to Leonard's studio.

1986 The head of the Mexican government's National Institute of Fine Arts is present in San Miguel for a show of three decades of Leonard's works.

Leonard resigns as director of the music department on his seventy-fifth birthday.

Gravely ill with a kidney infection, Reva is taken by ambulance to a hospital in San Luis Potosí.

1987 Fred Taylor commits suicide, using the shotgun with which he shot Leonard eighteen years earlier.

1988 The Brooks spend a month in Italy.

1989 Returning from a concert, the Brooks disturb burglars ransacking the upstairs quarters.

1991 Reva is mugged in a lane behind the Brooks' house by a would-be purse snatcher. During month of August, Leonard sells $31,000 of his paintings out of his studio.

1992 The Leonard and Reva Brooks Foundation is established at Queen's University, Kingston, Ontario.
Leonard has a show at the Canadian embassy that later travels for eighteen months throughout Mexico.

1995 Leonard and Reva have separate shows at the birthplace/museum of painter Diego Rivera.

1996 Leonard has show at the Fine Arts Cultural Centre in San Miguel in the room reserved for Mexican artists.

1997 Reva suffers an erratic heartbeat at the opening of a show of her works at the fine arts centre and subsequently has a pacemaker implanted.

1998 Reva has her first one-person show in Canada in over twenty-five years and Leonard his first in fifteen, both in Toronto. Each sells ten works opening night.

2000 Both are involved in shows in Ottawa: Reva has a one-person show at the Canadian Museum of Contemporary Photography, while Leonard is represented at a show of war art at the Canadian Museum of Civilization.

∼ *Exhibitions* ∼

Leonard's one-man exhibitions

1933 Chelsea Old Church, London, England
1934 132 Paseo de Gràcia, Barcelona, Spain
1934 Swan Inn, London, England
1935 Eaton's Art Gallery, Toronto
1936 Eaton's Art Gallery, Toronto
1937 Eaton's Art Gallery, Toronto
1939 Eaton's Art Gallery, Toronto
1940 Eaton's Art Gallery, Toronto
1941 Eaton's Art Gallery, Toronto
1942 Eaton's Art Gallery, Toronto
1944 Zwicker's Granville Gallery, Halifax, Nova Scotia
1945 Zwicker's Granville Gallery, Halifax, Nova Scotia
1949 Cowie Gallery, Los Angeles
1949 Eaton's Art Gallery, Toronto
1949 Elsie Perrin Williams Gallery, London, Ontario
1950 Childs Gallery, Boston
1950 University of Ohio, Athens, Ohio
1950 Vancouver Art Gallery
1950 Arts Centre Gallery, Victoria, British Columbia
1951 University of British Columbia, Vancouver
1951 Carpenter Galleries, Dartmouth College, Hanover, New Hampshire
1952 Santa Barbara Museum of Art, Santa Barbara, California
1954 Roberts Gallery, Toronto
1954 Witte Memorial Museum, San Antonio, Texas
1957 London Regional Art Gallery, London, Ontario
1957 Wells College, Aurora, New York
1960 Fine Arts Centre, San Miguel de Allende, Mexico
1965 Palace of Fine Arts, Mexico City
1965 Horizon Gallery, Rockport, Massachusetts
1969 Roberts Gallery, Toronto
1972 Roberts Gallery, Toronto
1974 Kin Gallery, Mexico City
1975 British Institute, Aguascalientes, Mexico
1976 Roberts Gallery, Toronto
1976 Palace of Fine Arts, Mexico City
1977 Kin Gallery, Mexico City
1977 Fine Arts Centre, San Miguel de Allende, Mexico
1979 Fine Arts Centre, San Miguel de Allende, Mexico
1980 Roberts Gallery, Toronto

1982 Canadian Embassy, Mexico City
1983 Roberts Gallery, Toronto
1983 State Art Gallery, Celaya, Mexico
1984 Canadian Embassy, Mexico City
1986 Fine Arts Centre, San Miguel de Allende, Mexico
1992 Canadian Embassy, Mexico City
1994 Casa del Diezmo, Celaya, Mexico
1994 Temple Art Gallery, San Miguel de Allende, Mexico
1995 Diego Rivera Museum, Guanajuato, Mexico
1996 Fine Arts Centre, San Miguel de Allende, Mexico
1997 Casa Cultural, Aguascalientes, Mexico
1998 Edward Day Gallery, Toronto
1998 State Watercolour Museum, Toluca, Mexico

Leonard's joint exhibitions

1936 Royal Canadian Academy, Toronto
1937 New York World's Fair
1937 Art Gallery of Ontario, Toronto
1937 Royal Institute Galleries, London
1938 Tate Gallery, London
1938 Royal Canadian Academy, Toronto
1939 Royal Canadian Academy, Toronto
1940 Ontario Society of Artists, Toronto
1941 Ontario Society of Artists, Toronto
1941 Art Gallery of Ontario, Toronto
1943 Canadian Seamen's Union, Toronto
1944 Arts Club, Montreal
1945 National Gallery touring exhibition of war art
1947 Ontario Society of Artists, Toronto
1948 Mexican-North American Institute, Mexico City
1949 Clardecor Gallery, Mexico City
1950 Instituto Allende, San Miguel de Allende, Mexico
1954 Witte Memorial Museum, San Antonio, Texas
1956 Canadian Artists Abroad, Art Gallery and Museum, London, Ontario
1957 Wells College, Aurora, New York
1958 Mexican Biennial, Mexico City
1961 Fourth Biennial Exhibition of Canadian Artists, National Gallery, Ottawa
1961 Fort Worth (Texas) Art Center
1966 Witte Memorial Museum, San Antonio, Texas
1972 British Institute, Mexico City
1980 Windsor Art Gallery, Windsor, Ontario
1997 CANTE, San Miguel de Allende, Mexico
1998 Edward Day Gallery, Kingston, Ontario
2000 Canadian Museum of Civilization, Hull, Quebec
2000 Kennedy Gallery, North Bay, Ontario
2001 Cuevas Museum, Mexico City

2001 Art Gallery of Sudbury, Sudbury, Ontario
2001 Art Gallery of Ontario, Toronto, Ontario

Collections
The National Gallery, Ottawa
Department of External Affairs, Ottawa
Art Gallery of Ontario, Toronto
London Regional Art Gallery, London, Ontario
Worcester Art Museum, Worcester, Massachusetts
The Robert McLaughlin Gallery, Oshawa, Ontario
Glenbow Museum, Calgary, Alberta
Vancouver Art Gallery
Winnipeg Art Gallery
De Cordova Museum, Lincoln, Massachusetts
Dartmouth College, Hanover, New Hampshire
Ohio University, Athens, Ohio
East Texas Museum, Lufkin, Texas
Museum of Fine Arts, St. Petersburg, Florida
Museum of Modern Art, Mexico City
Toronto Dominion Bank
Canadian Bank of Commerce
Imperial Oil
Ayala and Samuel J. Zacks Collection

Books published
Watercolor: A Challenge, 1957
Oil Painting: Traditional and New, 1959
Course in Wash Drawing, 1961
Course in Casein Painting, 1961
Painting and Understanding Abstract Art, 1964
Painter's Workshop, 1969
Oil Painting: Basic and New Techniques, 1971
The Many Ways of Water and Color, 1977

Reva's one-woman exhibitions
1951 British Council, Mexico City
1951 Carpenter Galleries, Dartmouth College, Hanover, New Hampshire
1955 Eaton's Art Gallery, Montreal
1957 University of Florida, Gainesville
1970 Santa Barbara Museum of Art, Santa Barbara, California
1970 Anglo-Mexican Institute, Mexico City
1970 Witte Museum, San Antonio, Texas
1970 Palace of Fine Arts, Mexico City
1971 Bathhouse Gallery, Milwaukee, Wisconsin
1972 Casa de Cultura, Aguascalientes, Mexico
1972 Universidad de Guanajuato, Guanajuato, Mexico

1972 Fine Arts Centre, San Miguel de Allende, Mexico
1972 The Lowenstein Library art gallery, Fordham University, New York
1972 Royal Ontario Museum, Toronto
1995 Casa Diego Rivera, Guanajuato, Mexico
1997 Fine Arts Centre, San Miguel de Allende, Mexico
1997 Casa Cultural, Aguascalientes, Mexico
1998 Stephen Bulger Gallery, Toronto
2000 Canadian Museum of Contemporary Photography, Ottawa

Reva's joint exhibitions

1949 Eaton's Art Gallery, Toronto
1949 Elsie Perrin Williams Gallery, London, Ontario
1955 Museum of Modern Art, New York
1954 Witte Memorial Museum, San Antonio, Texas
1956 Carpenter Galleries, Dartmouth College, Hanover, New Hampshire
1957 Wells College, Aurora, New York
1961 Bibliothèque Nationale, Paris, France
1962 Great Photographers of Our Times, Versailles, France
1967 Expo '67, Montreal
1974 Mexican Expressions of an Enigma, Mexico City
1976 National Gallery, Ottawa
1976 San Francisco Museum of Art, San Francisco
1980 Windsor Art Gallery, Windsor, Ontario
1982 Consejo Mexicano de Fotografía, Mexico City
1992 Art Gallery of Ontario, Toronto
1997 CANTE, San Miguel de Allende, Mexico
1998 Edward Day Gallery, Kingston, Ontario
2000 International Photography Art Dealers, New york
2000 Kennedy Gallery, North Bay, Ontario
2001 Photo LA, Los Angeles, California
2001 Art Gallery of Sudbury, Sudbury, Ontario
2001 Art Gallery of Ontario, Toronto, Ontario

Collections

Bibliothèque Nationale, Paris
Museum of Modern Art, New York
National Institute of Fine Arts, Mexico City
Canadian Museum of Contemporary Photography, Ottawa
David Alfaro Siqueiros, Mexico City
Rufino Tamayo, Mexico City
John Huston, Ireland
Henry Miller, Carmel, California
Edward Weston, Carmel, California
Ansel Adams Carmel, California
Helen Hayes, New York
Rico Lebrun, Los Angeles
MacKinley Helm, Santa Barbara, California

~ *Bibliography* ~

Bobak, Molly Lamb (1978) *Wild Flowers of Canada*. Toronto, Pagurian Press Limited.

Boyanoski, Christine (1984) *The 1940s: A Decade of Painting in Ontario*. Toronto, Art Gallery of Ontario.

– (1990) *Towards a New Lyrical Abstraction: The Art of L.A.C. Panton*. Toronto, Art Gallery of Ontario.

– (1992) *The Artists' Mecca: Canadian Art and Mexico*. Toronto, Art Gallery of Ontario

Bridle, Augustus (1945) *The Story of the Club*. Toronto, The Arts & Letters Club.

Brooks, Leonard (1952) "In and Out of Mexico," San Miguel de Allende, Mexico, Unpublished manuscript.

– (1957) *Water Color: A Challenge*. New York, Reinhold Publishing Corporation.

– (1959) *Oil Painting: Traditional and New*. New York, Reinhold Publishing Corporation.

– (1961) *Course in Wash Drawing*. New York, Reinhold Publishing Corporation.

– (1961) *Course in Casein Painting*. New York, Reinhold Publishing Corporation.

– (1964) *Painting and Understanding Abstract Art*. New York, Reinhold Publishing Corporation.

– (1969) *Painter's Workshop*. New York, Reinhold Publishing Corporation.

– (1971) *Oil Painting: Basic and New Techniques*. New York, Van Nostrand Reinhold Company.

– (1977) *The Many Ways of Water & Color*. New York, North Light Publishers.

Cameron, Elspeth (1994) *Earle Birney: A Life*. Toronto, Penguin Group.

Cossio del Pomar, Felipe (1974) *Cossio del Pomar en San Miguel de Allende*. Madrid, Editorial Playor, S.A.

Duval, Paul (1984) *Canadian Watercolour Painting*. Toronto, Burns and MacEachern.

– (1972) *Four Decades: The Canadian Group of Painters and their Contemporaries – 1930-70*. Toronto. Clarke, Irwin & Company Limited.

– (1990) *Canadian Impressionism*. Toronto, McClelland and Stewart Inc.

Gironnay, Sophie (1996) *Frederick B. Taylor: Graveur Réaliste Radical*. Montréal, Les Presses de l'Université Laval.

Goldsmith, Lawrence C. (1980) *Watercolor Bold and Free*. New York, Watson-Guptill Publications.

Guerin, John. "A G.I. Paradise: San Miguel de Allende 1947-8." Austin, Texas. Unpublished manuscript.

Hayes, Bartlett H. Jr. (1942) *Aspects of Contemporary Painting in Canada*. Andover, Mass., Phillips Academy.

Helm, MacKinley. (1946) *A Matter of Love*. New York, Harper and Brothers Publishers.

– (1948) *Journeying Through Mexico*. Boston, Little, Brown and Company.

Humphrey, John (1975) *Women of Photography: A Historical Survey*. San Francisco, San Francisco Museum of Art.

Klinkhoff, Walter H. (1993) *Reminiscences of an Art Dealer*. Montreal, Private publication.

Macbeth, Jack (1989) *Ready, Aye, Ready: An Illustrated History of the Royal Canadian Navy.* Toronto, Key Porter Books.

Maddow, Ben (1973) *Edward Weston: His Life.* New York, Aperture Foundation.

Marnham, Patrick (1998) *Dreaming With His Eyes Open: A Life of Diego Rivera.* New York, Alfred A. Knopf, Inc.

McCarthy, Doris (1990) *A Fool in Paradise.* Toronto, MacFarlane Walter & Ross.

– (1991) *The Good Wine.* Toronto, MacFarlane Walter & Ross.

Meilach, Dona Z. and Hoor, Elvie Ten (1973) *Collage and Assemblage: Trends and Techniques.* New York, Crown Publishers Inc.

Meilach, Dona Z. and Hintz, Bill and Jay (1975) *How to Create Your Own Designs.* Garden City, N.Y., Doubleday & Company Inc.

Monk, Lorraine (1975) *Photography 1975.* Montreal, National Film Board of Canada.

Murray, Joan (1981) *Canadian Artists of the Second World War.* Oshawa, Ont. The Robert McLaughlin Gallery.

– (1987) *The Best Contemporary Canadian Art.* Edmonton, Hurtig.

– (1993) *Art in Hard Times: The Canadian Group of Painters.* Oshawa, Ont. The Robert McLaughlin Gallery.

– (1996) *Confessions of a Curator.* Toronto, Dundurn Press.

Phillips, Ruth (1973) *The History of the Royal Canadian Navy's World War II Show.* Toronto, private publication.

Plummer, William (1981) *The Holy Goof.* Englewood Cliffs, N.J., Prentice-Hall Inc.

Robertson, Heather (1977) *A Terrible Beauty.* Toronto, James Lorimer and Co.

Rohmer, Richard (1978) *E P. Taylor.* Toronto, McClelland and Stewart Limited.

Rosenblum, Naomi (1994) *A History of Women Photographers.* New York, Abbeville Press.

Sassoon, Siegfried (1928) *The Heart's Journey.* London, William Heinemann Ltd.

Simon, Kate (1982) *Bronx Primitive: Portraits in a Childhood.* New York, The Viking Press.

– (1986) *A Wider World: Portraits in an Adolescence.* New York, Harper & Row.

– (1990) *Etchings in an Hourglass.* New York, Harper & Row.

Smart, Charles Allen (1957) *At Home in Mexico.* New York, Doubleday & Company.

– (1969) *Letter to a Sunday Writer.* Cleveland, The Rowfant Club of Cleveland.

Smith, Frances K. (1980) *André Biéler: An Artist's Life and Times.* Toronto, Merritt Publishing Company Limited.

Steichen, Edward (1955) *The Family of Man.* New York, The Museum of Modern Art.

Stein, Philip (1994) *Siqueiros: His Life and Works.* New York, International Publishers.

Taylor, Charles (1977) *Six Journeys: a Canadian Pattern.* Toronto, Anansi.

Thomas, Ethel (1977) *Down the 'Mouth: A History of Avonmouth.* Bristol, Burleigh Press Ltd,

Tippett, Maria (1998) *Stormy Weather. F.H. Varley: A Biography.* Toronto, McClelland and Stewart Inc.

Town, Harold (1974) *Albert Franck: Keeper of the Lanes.* Toronto, McClelland and Stewart Limited.

Varley, Christopher. (1981) *F.H. Varley: a Centennial Exhibition.* Edmonton, Edmonton Art Gallery

Von Urban, Rudolf (1949) *Sex Perfection and Marital Happiness.* New York, The Dial Press.

Wallack Galleries (1978) *York Wilson.* Ottawa, Wallack Galleries.

Weisbord, Merrily (1983) *The Strangest Dream.* Toronto, Lester & Orpen Limited.

White, Anthony D. (1994) *Siqueiros.* Encino, Calif., Floricanto Press.

Whittaker, Herbert (1993) *Whittaker's Theatricals*. Toronto, Simon & Pierre.

Wilson, Charis (1998) *Through Another Lens: My Years with Edward Weston*. New York, North Point Press.

Wilson, Lela (1997) *York Wilson: His Life And Work, 1907-1984*. Ottawa, Carleton University Press.

Zuehlke, Mark (1996) *The Gallant Cause*. Vancouver/Toronto. Whitecap Books.

⁓ *Permission* ⁓

The author and the publisher acknowledge the following for permission to include material:

Leonard and Reva Brooks for their correspondence, diaries, and journals; Art Gallery of Ontario, *The 1940s: A Decade of Painting in Ontario* and *The Artists' Mecca: Canadian Art and Mexico*, Christine Boyanoski; Art Gallery of Windsor, Catie Allan correspondence; Barbara Levy, "The Heart's Journey," Siegfried Sassoon; Boston Herald; Canadian Art; Carl Sandburg Family Trust; Carleton University, *York Wilson: His Life and Work*, Lela Wilson; Eldon Grier, poem entitled "For the Photographer Reva Brooks"; Galerie Walter Klinkhoff for *Reminiscences of an Art Dealer*, Walter Klinkhoff; Harry Boyle for his correspondence; Houston Chronicle; Instituto Nacional de Antropologia e Historia, Mexico City, *San Miguel de Allende*; James Bessey for his correspondence; Joy Laville for her correspondence; Lela Wilson for the York Wilson correspondence; Little, Brown and Company, *Journeying Through Mexico*, McKinley Helm; Los Angeles Times; Miriam Waddington for her correspondence; Mrs. Anthony Burgess for the Anthony Burgess correspondence; Naomi Rosenblum for *A History of Women Photographers*; North Bay Nugget; Penguin Books Canada, *Earle Birney: A Life*, Elspeth Cameron; Paul Taylor for the Frederick B. Taylor correspondence; Richard Rohmer for *E.P. Taylor*; San Francisco Museum of Modern Art, *Women of Photography*; Saturday Night; The Christian Science Monitor; The Gazette, Montreal; The Globe and Mail, Toronto; The New York Times; The Post Standard, Syracuse, New York; The Province, Vancouver; The Robert McLaughlin Gallery, *Canadian Artists of the Second World War* and *Art in Hard Times: The Canadian Group of Painters*, Joan Murray; The Windsor Star; Time-Life; Wailan Low, correspondence and poem of Earle Birney.

Every effort has been made to obtain permission from the copyright holders of the material reprinted or referred to in this book and not acknowledged above.

~ *Index* ~